access to life

MAGNUM

access to life

aperture

Investing in our future
The Global Fund
To Fight AIDS, Tuberculosis and Malaria

MAGNUM
PHOTOS

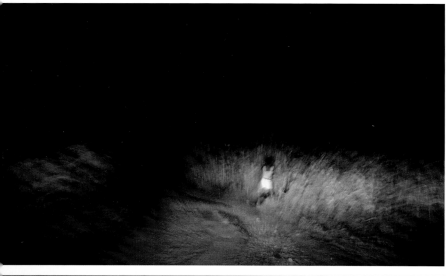
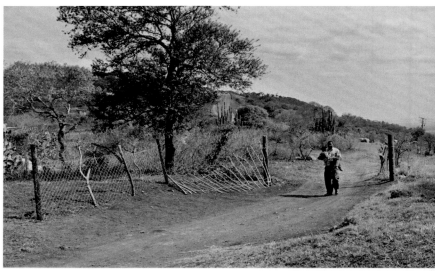
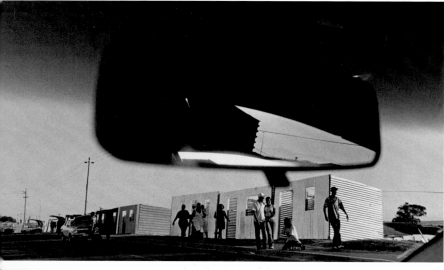
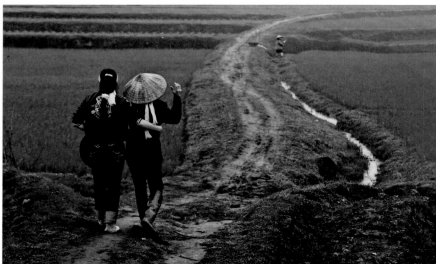

PREFACE BY DESMOND TUTU

It is far too rare that our world comes together in solidarity with those who suffer from tragedy and injustice. The global challenges that have been solved during the past century through concerted actions of generosity and humanism are few and far between. Sometimes they seem like isolated islands in a world driven by short-sighted national interests and expediency. When the world does come together to help, it is most often in reaction to catastrophes such as the Asian tsunami in this decade or the African famine of the 1980s. It has proven even harder to mobilize political will and resources to attack the more complex and pervasive global problems.

It is therefore all the more heartening that the first decade of the 21st century has seen a truly global, humanitarian effort to provide life-saving treatment to the millions of poor people suffering from AIDS. In 2002, only a few people outside wealthy countries had access to the medicines that could turn AIDS from a death sentence to a chronic condition. As I write this, more than three million people in the developing world have been given the opportunity to take these drugs for free. They owe their lives to this medicine. They owe their lives, as well, to the efforts of thousands of health and community workers around the world who make sure the drugs—and the care that goes with them—are available and affordable, and to the millions of taxpayers who make the money available through their countries' development assistance.

Far too little is known about the quiet revolution in health care now taking place around the world thanks to the efforts to make antiretroviral AIDS drugs available. I am grateful to the eight extraordinarily skillful photographers who have gone out into the world and documented this revolution in these pages. It is important that we see (and therefore can more easily understand) the effect AIDS treatment has on the individuals who receive it. It is important to see the people behind the numbers: their lives, their hopes, dreams, and struggles.

This book shows AIDS treatment in all its complexity. Not all stories end well. Not all experiences are life-altering for those who go through them. Treatment is only part of the effort needed to overcome this pandemic. But AIDS treatment allows those struggles to go on. It brings life, and in doing so it brings hope. This is the message we can take away from these exceptionally poignant images.

FACES FROM A QUIET REVOLUTION

AIDS is the most recent of the world's dreaded diseases, having been diagnosed less than 30 years ago. Yet in that short time, it has become the largest health catastrophe in history since the great plagues. It has infected well over 60 million people, of whom nearly 30 million have died.

How has AIDS wreaked such havoc on our world in such a short time? Why can't we control this disease at the turn of the 21st century, when science and health care have reached a level of sophistication far beyond that of any other time in human history?

It is testimony to the particularly insidious nature of this disease that it so far has defeated all our efforts to control it. Its virus stays inactive in the body for years, making it hard for people to link their risky behavior with the devastating consequences of the disease when the latter finally emerge. It spreads mainly through sexual contact and contaminated blood, exploiting human taboos and cultural norms to hide and deny its existence until it is too late. It kills slowly and gruesomely by weakening the body's immune system to the point where any opportunistic infection can lead to death. And, finally, AIDS is incurable, contributing to the fear and stigma that tear families apart and condemn its victims to destitution and loneliness.

AIDS attacks the powerless and the outcast. In Africa, while men drive the epidemic, the majority of its victims are women. It also preys on sexual minorities, injecting drug users, and people rejected by society. In the worst-hit countries in southern Africa, it is threatening the fabric of whole societies by killing more teachers and nurses than can be educated to replace them and reducing national life expectancy by more than 20 years.

Yet since the turn of this century, a quiet revolution has taken place in the fight against AIDS. Effective treatment that holds the virus at bay has become available to millions of people in the developing world. This advance has turned AIDS from a certain death sentence into merely another chronic disease.

The first antiretroviral drugs (ARVs), which drastically reduce the amount of HIV (the AIDS-causing virus) present in the body, were tested on patients in the late 1980s. In the mid-1990s, these drugs had become available to most people living with HIV in wealthy industrial countries. But at US $15,000 or more per person per year, the high cost meant that only those countries with well-developed health-insurance systems could afford to provide this treatment to everyone who needed it.

Soon, a growing number of people around the world—many of them benefiting from ARVs themselves—raised their voices against the impossible moral dilemma that, while life-saving drugs existed, millions of people continued to die simply because the drugs were too expensive.

The voices coalesced into a movement, and the movement rapidly achieved results. Trial programs were set up in such countries as South Africa and Haiti. They showed that ARV treatment, despite being a highly complicated outpatient procedure, was possible even in very poor settings. Demonstrations, lawsuits, and campaigns pushed pharmaceutical companies to lower the prices of ARVs and pressured world leaders to drastically increase funding to fight AIDS and other infectious diseases globally.

In 2002, the Global Fund to Fight AIDS, Tuberculosis and Malaria was created to channel billions of dollars in additional resources into effective health programs worldwide. In 2003, the United States started its own emergency plan to fight AIDS, funneling added billions into paying for ARV treatment in 15 of the hardest-hit countries.

Since 2003, three million people have been given access to ARVs. The consequences of this global rollout have been impressive. The price of ARVs has plunged to as low as under US $100 per person per year for some drug combinations. Hospitals that recently overflowed with AIDS patients have seen the stream of new patients dry up, enabling these facilities to focus on other health problems. As more people live healthy lives thanks to the new drugs, stigma and fear are slowly declining, and acceptance slowly grows that it is possible to live with HIV—not just die from it. In countries such as Malawi, the availability of ARV treatment

has meant that, for the first time in a decade, the country has been able to educate more nurses than it loses to AIDS.

Yet nobody has documented these changes in a systematic way—let alone compared the experiences of people in various countries—until the Global Fund and Magnum Photos teamed up to do so. Over a period of five months, the eight photographers featured in this book, together with nine field producers, twice visited AIDS treatment programs supported by the Global Fund in nine countries around the world.

What they saw is presented here. *Access to Life* documents the progress of dozens of people around the world who began ARV treatment in late 2007. It follows them over the first four months of their treatment, chronicling the changes that took place in their lives—as well as in their bodies. It does not paint a rosy picture. Instead, it shows the complexity and challenges that face people sick with AIDS, as well as those who care for them, as they embark on a lifelong treatment program. It also shows how AIDS so often attacks those who already struggle with lives harder than most of us have ever known.

Clearly, as this book shows, the fight against AIDS is far from won. Providing access to ARVs for three million people in less than five years, often in countries that previously lacked access to even the most basic health care, is a monumental achievement, and thousands of health and community workers around the world should take immense pride in what they have accomplished. Yet three million people represent only one-third of those who need these drugs today. Moreover, for every person who gains access to ARV treatment, at least two others are newly infected with HIV.

AIDS treatment is a meaningful way to fight the disease only as long as it is part of a comprehensive strategy to prevent new infections and eventually control the epidemic. ARV treatment provides opportunities for more effective prevention of HIV—both because people on ARV treatment are less likely to infect others, and because the prospect of treatment encourages people to take HIV tests and reduces the stigma and fear of the disease, making it easier to discuss, and acknowledge, the sickness.

Roughly 8 out of 10 people starting ARV treatment in developing countries are still alive after two years. The 20 percent who don't make it often die because they begin the treatment too late; because they are too ill with other diseases—especially tuberculosis—to survive; or simply because their life situations make it too difficult for them to overcome AIDS. A big problem for many people on ARV treatment in developing countries is not being able to afford enough food to maintain their health, or to afford the transport and other costs involved in staying on treatment, even when the drugs themselves are free. For the unemployed, scraping together even the five or ten dollars each month for a trip to the clinic can be impossible. If it wasn't already apparent, the widespread introduction of ARV treatment has shown intimately the connection between poverty and ill health.

Still, what's going on truly is a revolution—a revolution in what we can expect health care in developing countries to achieve, and a revolution in the sense that families and even whole countries have reclaimed their future. But it is an unpublicized revolution. That millions of people die is very noticeable. But in a world in which disasters fill the headlines, that people *don't* die is much harder to notice. ARVs are restoring normal lives, and that is not very sensational.

So while the world has seen the large numbers of people now receiving ARV treatment, few have really taken in the enormous change that is going on in the lives of affected people and nations. We can fully grasp the importance of this revolution only if we can realize the changes that the drugs make to each person who receives them.

More than anything, this book shows the tremendous courage and dignity of these individuals as they fight for their lives. Together, they provide an indisputable case for why the world needs to continue the battle against AIDS—the largest health catastrophe in modern history. *—The Global Fund*

FIGHTING AIDS AND WINNING BY JEFFREY SACHS

Through the lens of eight great photographers, AIDS lays bare the human condition: poverty, death, the anguish of loss and separation, but also fortitude, hope, and revival. The AIDS pandemic is a pitched battle for our souls. Do we turn away from the faces in this stunning volume, pained by disease-ridden bodies and the frightened gaze of children looking on at their parents' plight? Do we grasp the miracle and the potential of the growing global network that delivers medicines and care to the poorest of the poor? Do we appreciate that the simple photograph of medicines in the hands of an HIV-infected African represents a chain of humanity that connects scientists and companies and caring individuals in rich countries with the poorest and most desperate individuals halfway around the globe? Do we appreciate the common fate of the planet, and the struggle to shape a truly global society, in those multiple acts of global collaboration?

The AIDS pandemic has shown both sides of the human condition—the massive and nearly incalculable loss of millions of lives, coupled with brazen neglect by those who could act but did not, as well as the heroism of HIV-infected individuals increasingly aided by a world that has also proved itself capable of acts of great foresight, expertise, and compassion. As late as 2000, there was perhaps not one single African on antiretroviral treatment as the result of a program sponsored by the government of a rich country or by an international agency. Millions were being left to die, backed by a combination of ignorance, prejudice, neglect, and shockingly misguided calculations aiming to show that treatment of afflicted individuals was not "cost effective."

The world has changed since then, in some ways miraculously. A turning point was reached in 2002 with the establishment of the Global Fund to Fight AIDS, Tuberculosis and Malaria. It was the first time that the world had put real money into the fight against AIDS. As with all great reforms, the skeptics were in abundance:

"AIDS can't be treated in poor countries."
"Compliance will be disastrously low."
"The cost of medicines will be prohibitive."
"The drug companies will block progress."

And, most notoriously, this from a leading U.S. official: Africans won't be able to tell time in order to take their medicines.

Yet there was also U.N. Secretary-General Kofi Annan, with his soft-spoken appeal to human goodness that could break down the mightiest barriers of neglect and misdirection. There were hundreds, and then thousands, of experts who said that yes, it could be done; treatment could come to the farthest reaches of the planet. There were far-sighted leaders of the pharmaceutical industry, both those whose companies hold patents and those who produce high-quality generic drugs, saying that the lack of treatment for all was a blight on the human soul and the world's conscience. There were economists who "ran the numbers," showing that treatment was affordable—and that neglect itself was the truly unaffordable option, the one that would bankrupt Africa and threaten the world.

This wonderful book records, in powerful images and an implicit narrative, what has followed in all parts of the world. First the Global Fund, then multiple additional efforts—the U.S. President's Emergency Plan for AIDS Relief, the World Bank, the international initiative called UNITAID (which uses revenue from air-travel taxes for medicines to fight AIDS, TB, and malaria), and others—have coalesced around the global goal of extending treatment, and therefore extending lives, to all parts of the world, most notably to the poorest and the voiceless. More than three million people are now on treatment in developing countries as a result of those efforts, and the numbers continue to rise steadily. The world has gone from almost complete neglect at the start of the decade to a global commitment to achieve universal access to AIDS treatment by the end of this decade. There is much work to do to realize this noble goal, but the commitments are made and the increased funding is coming on line.

The AIDS pandemic remains one of the world's most harrowing crises—one that might still claim tens of millions of lives and create millions of orphans before it is brought under control. There are setbacks amid the progress. Incidence remains high; prevention programs languish in many places; shortcomings in infrastructure slow the scaling up of treatment; the long-sought AIDS vaccine continues to elude scientists; and the ever-present threat of increased drug immunity casts a pall and proves a challenge to treatment efforts. We must combine strong compliance, effective management, and research and development of new drugs and diagnostics to keep ahead of the epidemic's path.

In the end, however, there is above all the human promise captured in the photographs of this unique project. Humanity harbors a dignity, resilience, strength of purpose, and commitment to one's children and parents that is at the core of our very being. Humankind is able to mobilize great acts of courage and cooperation. What has been achieved in expanding the treatment of AIDS can be matched in the control of many other diseases as well. Measles deaths in Africa are down by more than 90 percent this decade, and polio is on the brink of eradication, as is Guinea worm. Malaria control is on the upswing, with the potential for a vast breakthrough in reduced malaria deaths. And the world is committed in the United Nations' Millennium Development Goals to reducing extreme poverty, hunger, lack of schooling, and disease by the year 2015.

Gaze at the eyes of the people in this striking volume, therefore, and gain hope in what together we can accomplish to reduce suffering and create a world worthy of our children.

Prof. Jeffrey D. Sachs is Director of the Earth Institute at Columbia University and Special Advisor to U.N. Secretary-General Ban Ki-moon on the Millennium Development Goals. He was Director of the WHO Commission on Macroeconomics and Health (2000-1) and worked closely with then-U.N. Secretary-General Kofi Annan and WHO Director General Gro Harlem Brundtland on the launch of the Global Fund.

relnel

marie-sonie

haiti

autha

photographs by jonas bendiksen

MARIE-THÉRÈSE

ASSIGNMENT: HAITI

A lot of the work I do is about trying to reduce global statistics to the level of an individual, instead of talking about "how many millions" do this or do that. This assignment was an opportunity to try to bridge the gap between us sitting here and what it feels like to be hanging by a thread in a little hut 45 minutes' walk from a road in the middle of rural Haiti, and then suddenly entering the medical system.

You can hardly find a place that has as little physical infrastructure as the Central Plateau in Haiti—no electricity, no running water, no paved roads, potholes two meters deep. People live where you have to walk several hours to get to the nearest village, let alone to proper hospital facilities.

It was surprising to me that there is successful treatment in Haiti at all. Yet there is a well-organized medical infrastructure that exists far away from any paved roads, using local communities as tentacles stretching out of a central node. People very often get into that system way too late, however—often because they go to different "houngans," or voodoo priests, first, before they seek help at the clinics.

On the first trip I thought, "We're going to have five wonderful, positive stories of recovery and redemption." Three days after I left, the first of those five patients died. A few weeks later, the second died. They were too far along the trajectory of the disease to make it.

I hope that by telling these stories and personalizing this experience, it will help other people get appropriate treatment—and get it in time. Antiretroviral medicines are the key to successful treatment, but they are still only one piece of the puzzle. I realized the importance of the community structure in these places as well—ensuring that people are eating, that they are housed, that they have something to live for. That's as important as dropping a pill into your mouth. **—Jonas Bendiksen**

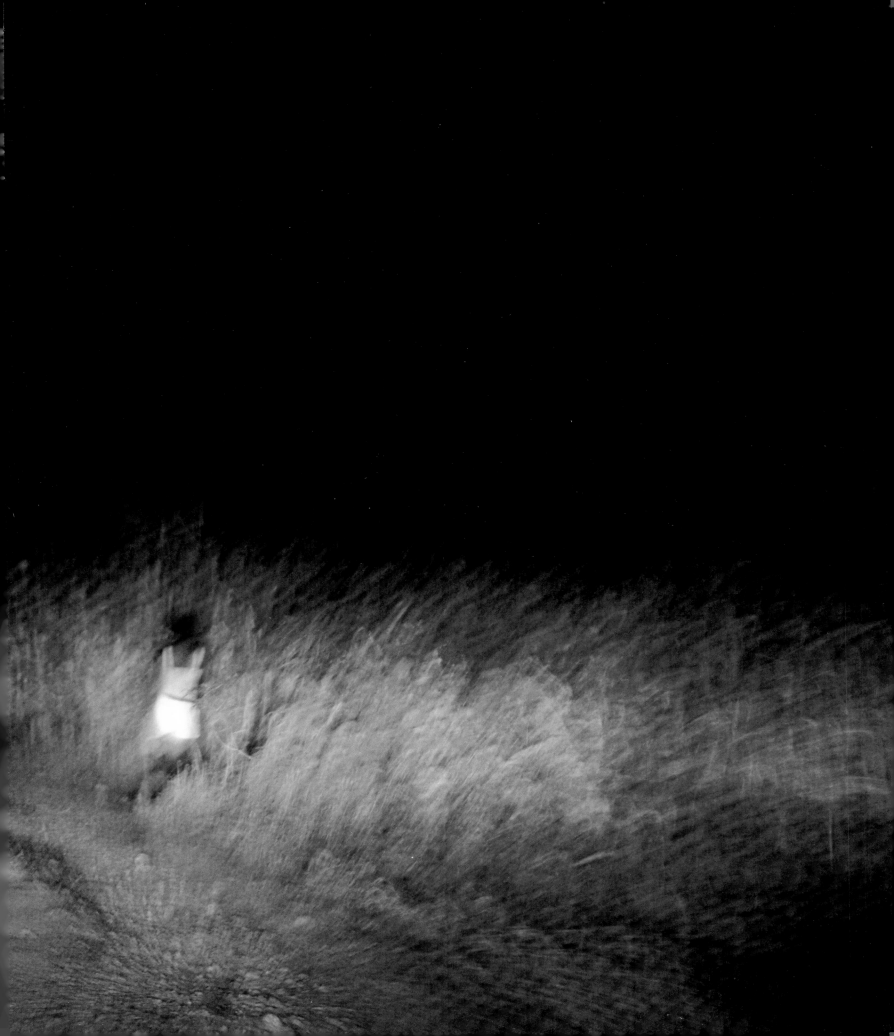

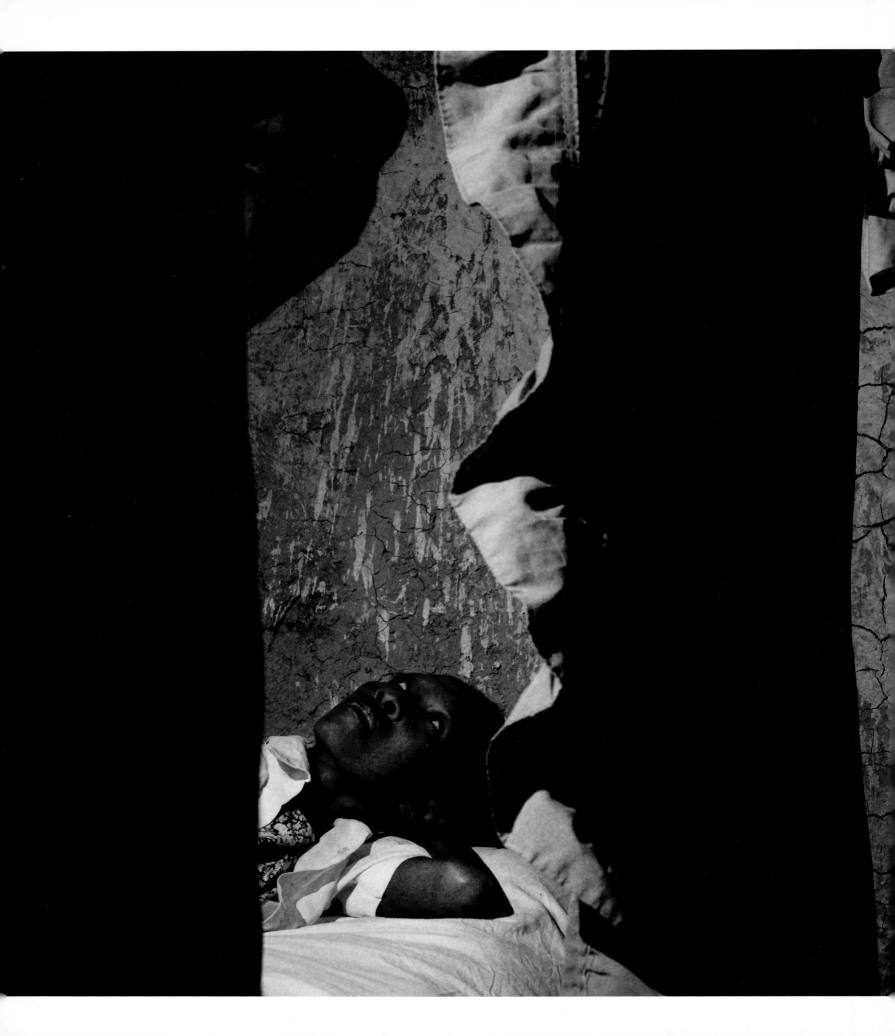

"I will tell my children when they are older. I will tell them about the disease and how to protect themselves against it. I will tell them how you get it and what they need to do to make sure they don't ever get it. I probably will tell them it's a disease to be afraid of. Even though there's medicine, there's no cure."

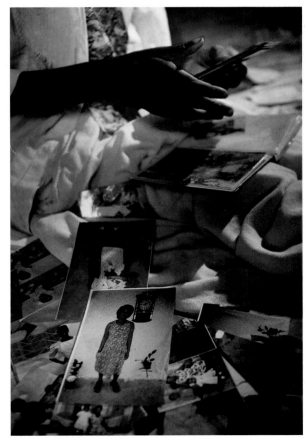

MARIE-SONIE ST-LOUIS, LOYÉ

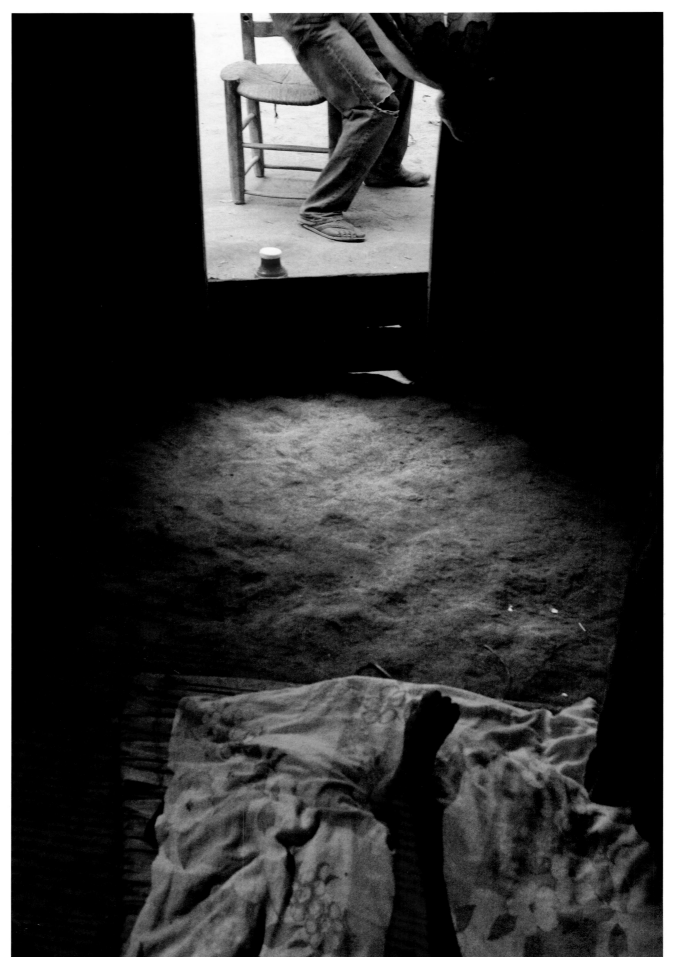

In December 2007, Marie-Sonie was weak and depressed, spending most of her time on the dirt floor of her mother's home *(right)*. A month later, after starting treatment, she was able to resume such household chores as sweeping the floor *(opposite)*.

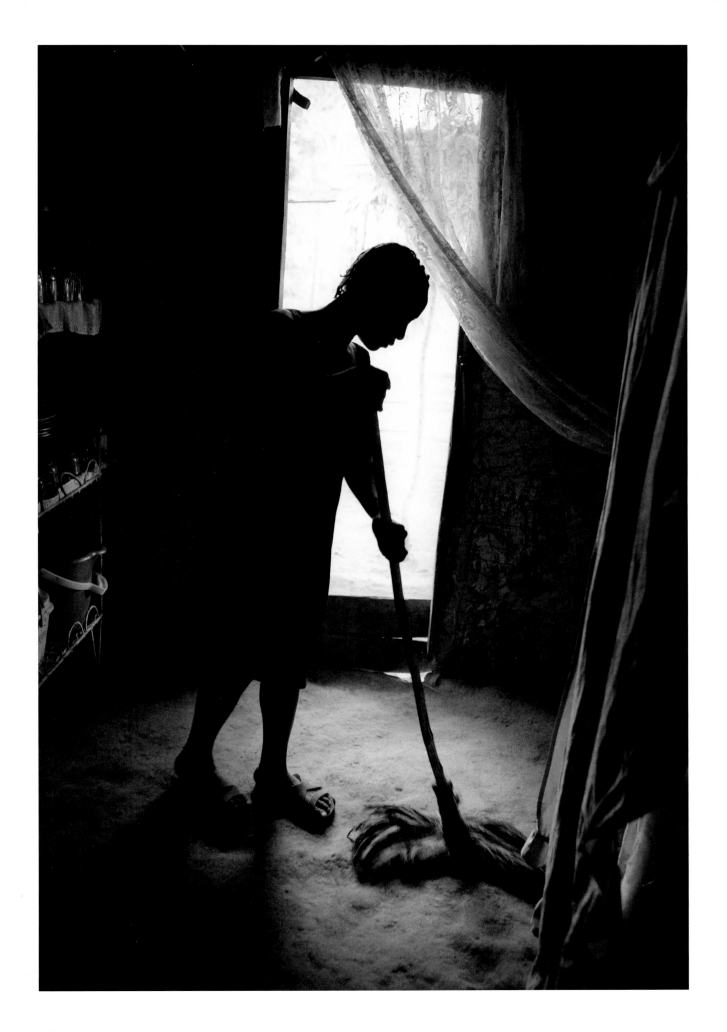

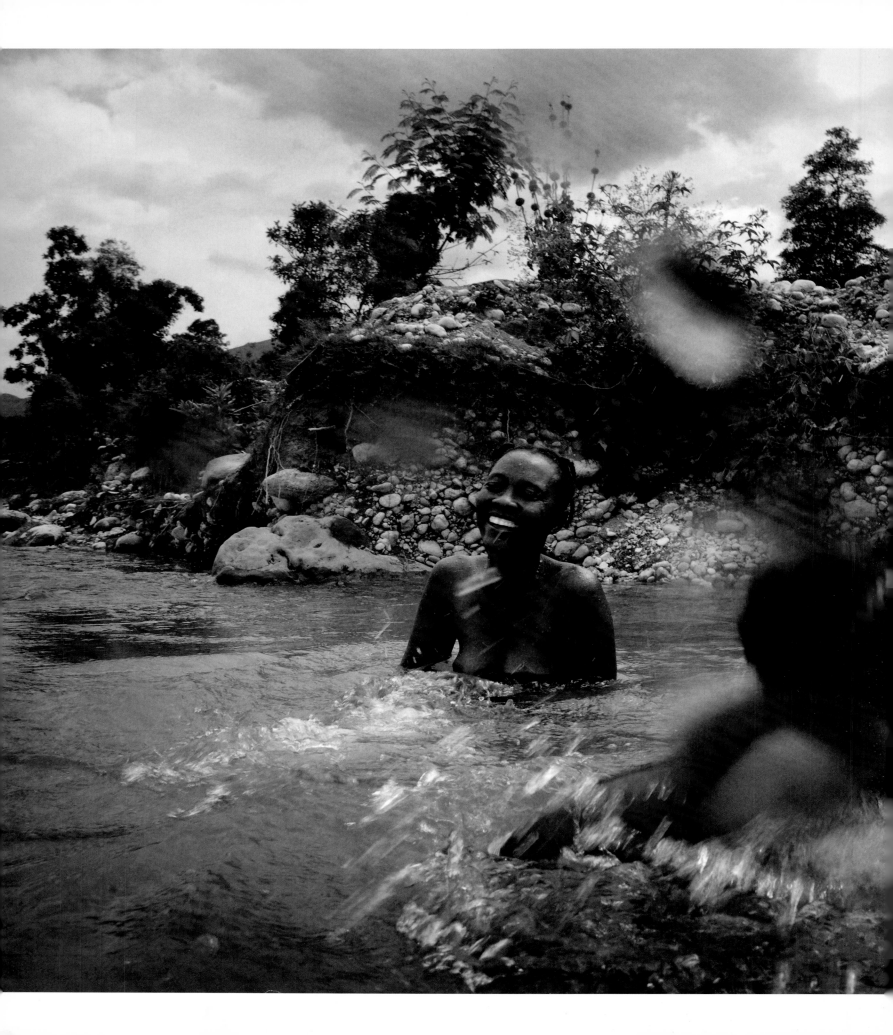

Marie-Sonie splashes
in a river close to home with her
son Ruebentz in March 2008.
Her family's homestead
is an hour's walk from the nearest
road and she has to cross
the river to get there.

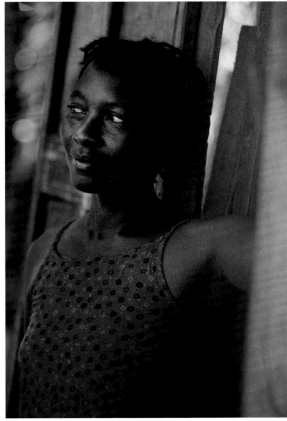

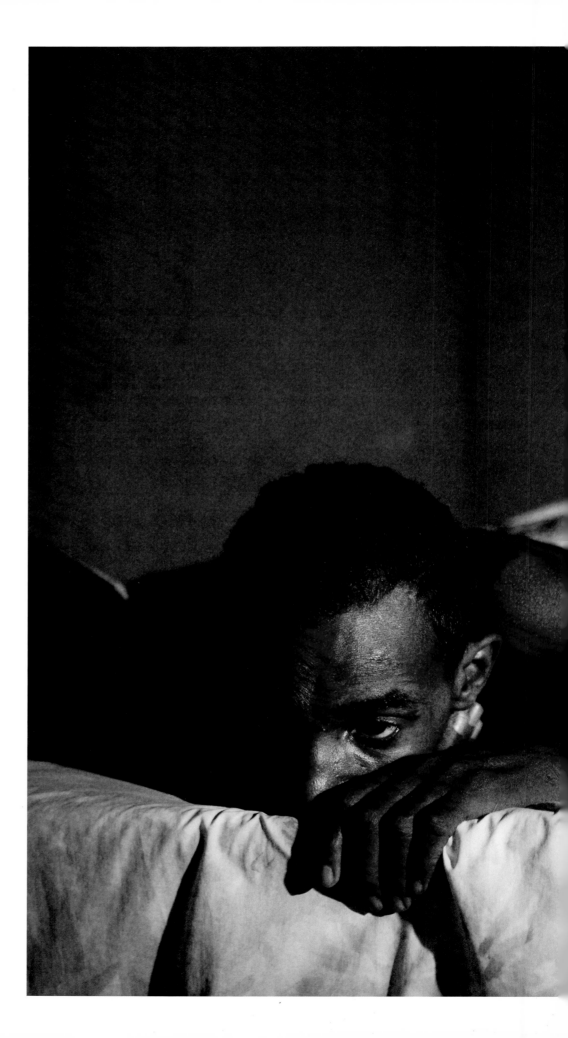

"He doesn't really talk. This whole time he's been sick he hasn't said much of anything. He puts his hand on the side of his head and he just sits there and doesn't say anything. I don't know if it's stress that's pressing down on him and that's what's gotten to him. But he doesn't really talk about anything."

—CLAUDETTE ST-JEUNE CHERY,
Relnel's wife, December 2007

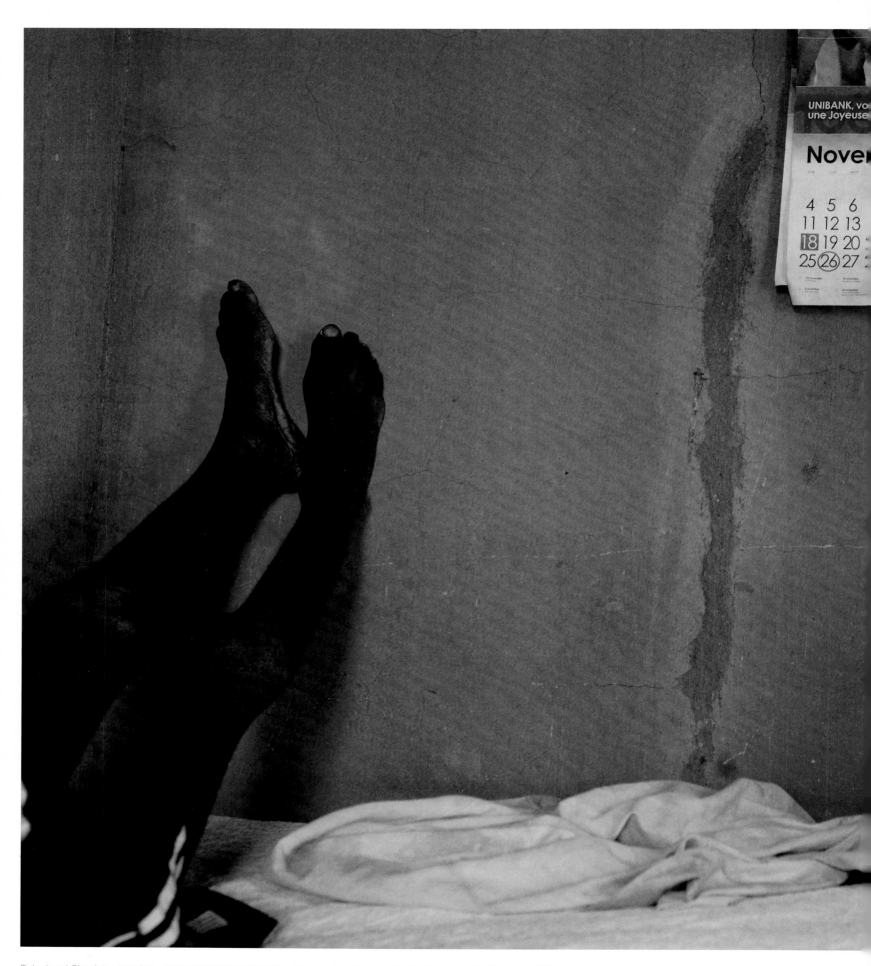

Relnel and Claudette together—but each alone in their thoughts—at Relnel's bedside. Their home in Haiti's Central Plateau *(opposite, center)* was where Claudette was born and raised.

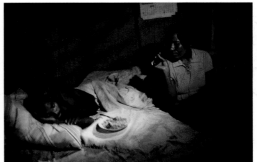
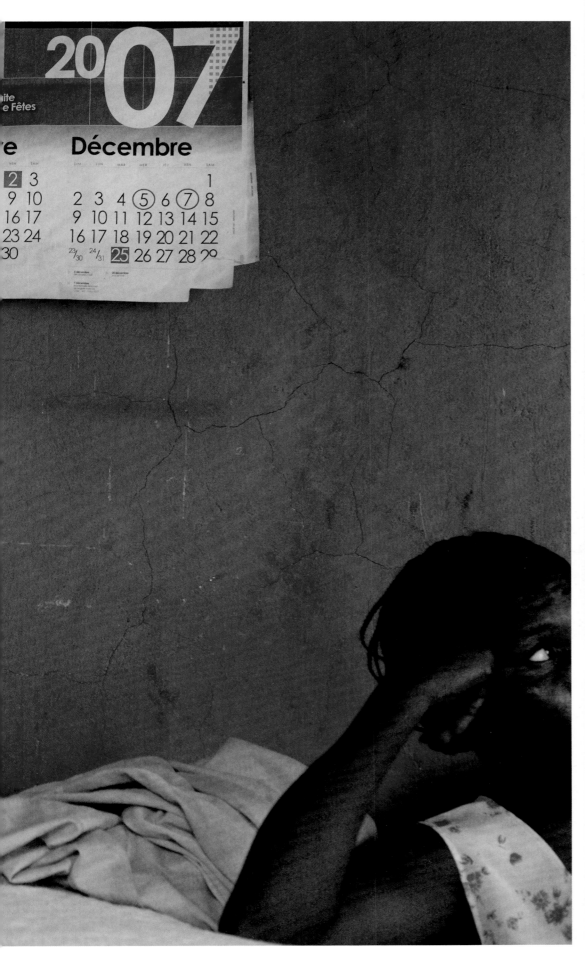

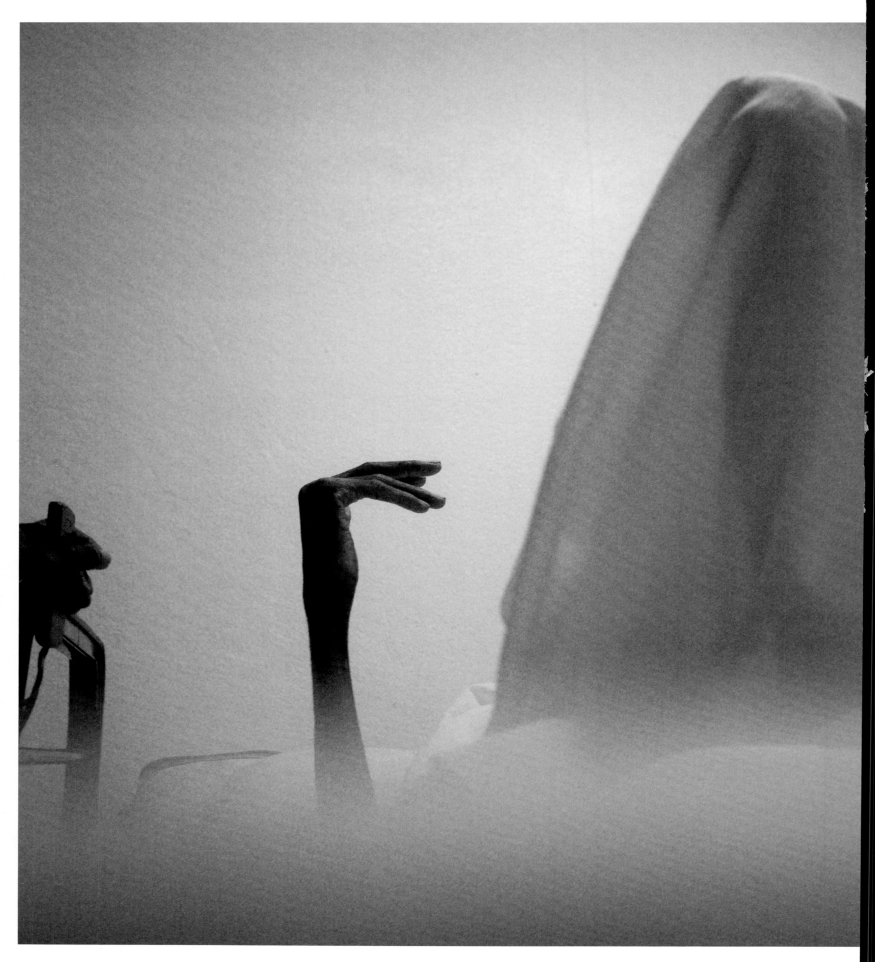

By March 2008, Reinel had been moved to a local clinic, five months after beginning treatment. He died two weeks later.

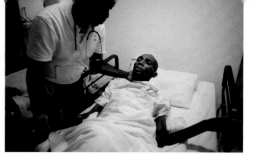

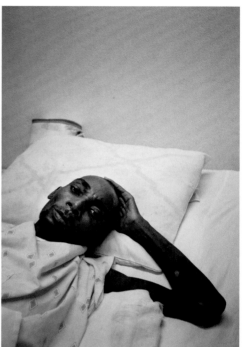

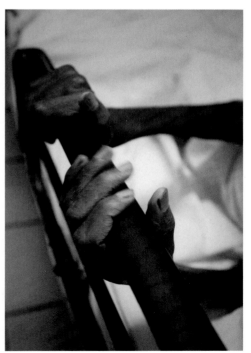

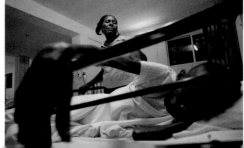

"She saw she wasn't getting better and she was worried. She told me that she was worried that if she died, Manuela [Marie-Thérèse's daughter] would end up in the street and there wouldn't be anyone to take care of her. I told her that I wouldn't let that happen. I asked her, 'If it was me who died, would you let my daughter be alone?'"

—MARIE-PRINCILIA,
Marie-Thérèse's older sister

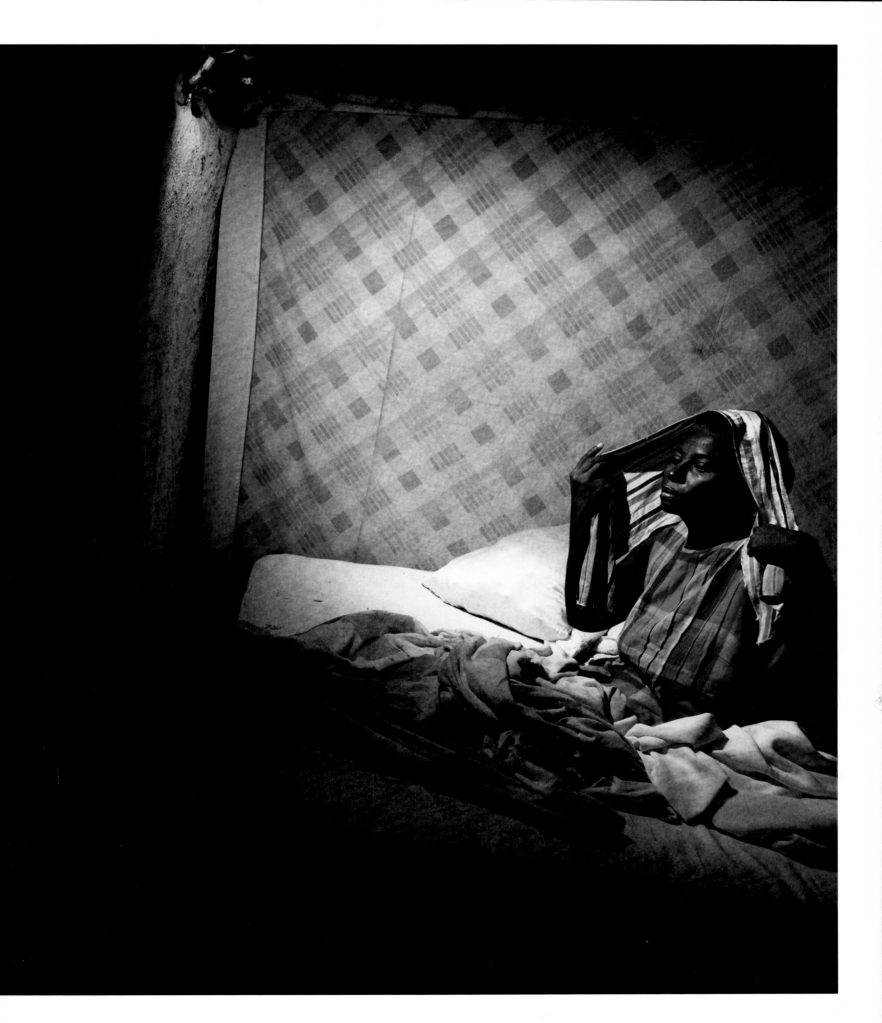

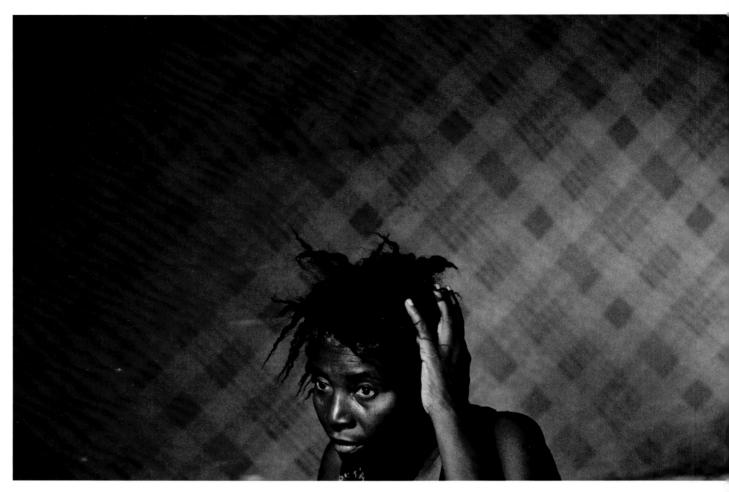

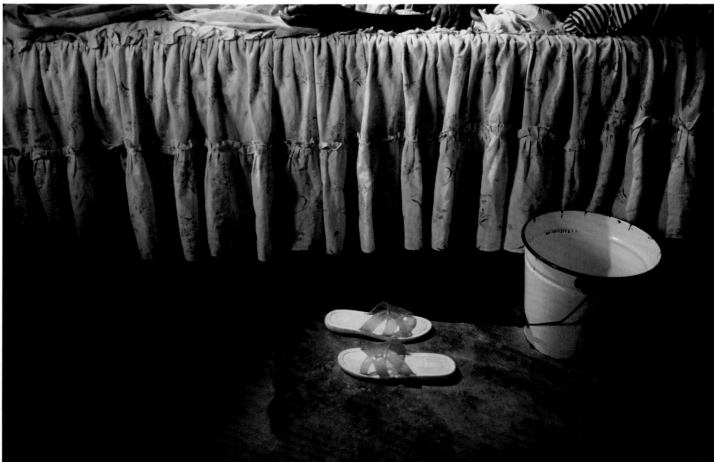

Marie-Thérèse's main complaint upon being admitted to the clinic was unstoppable diarrhea. Manuela *(in snapshot, opposite, bottom)* was seven when her mother died, the youngest of Marie-Thérèse's three children.

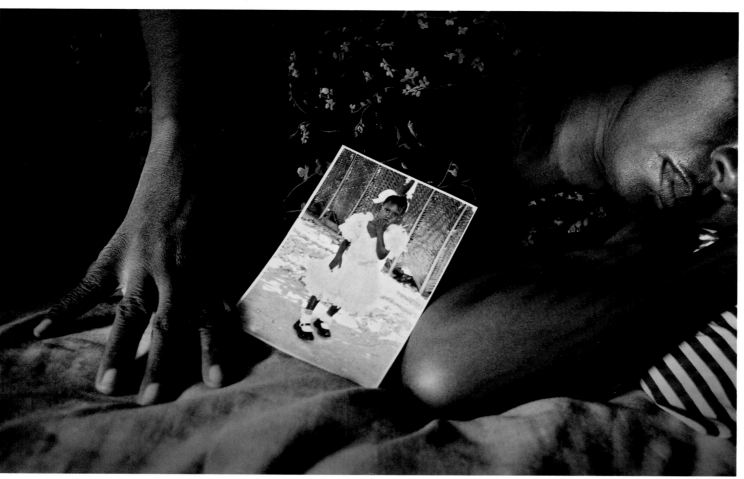

"I came home from the hospital and I was crying and Manuela saw me and saw that I was crying. She came up to me and she asked why I was crying. I said to her, 'Manuela, there is something I need to tell you…Your mother has died.' And I held her and I knew that I had to hold her because there was no one else and I told her that I wasn't going to let her go. I just held her and stayed with her until I knew that she understood what had happened."

—MARIE-PRINCILIA,
after her sister died in January 2008.

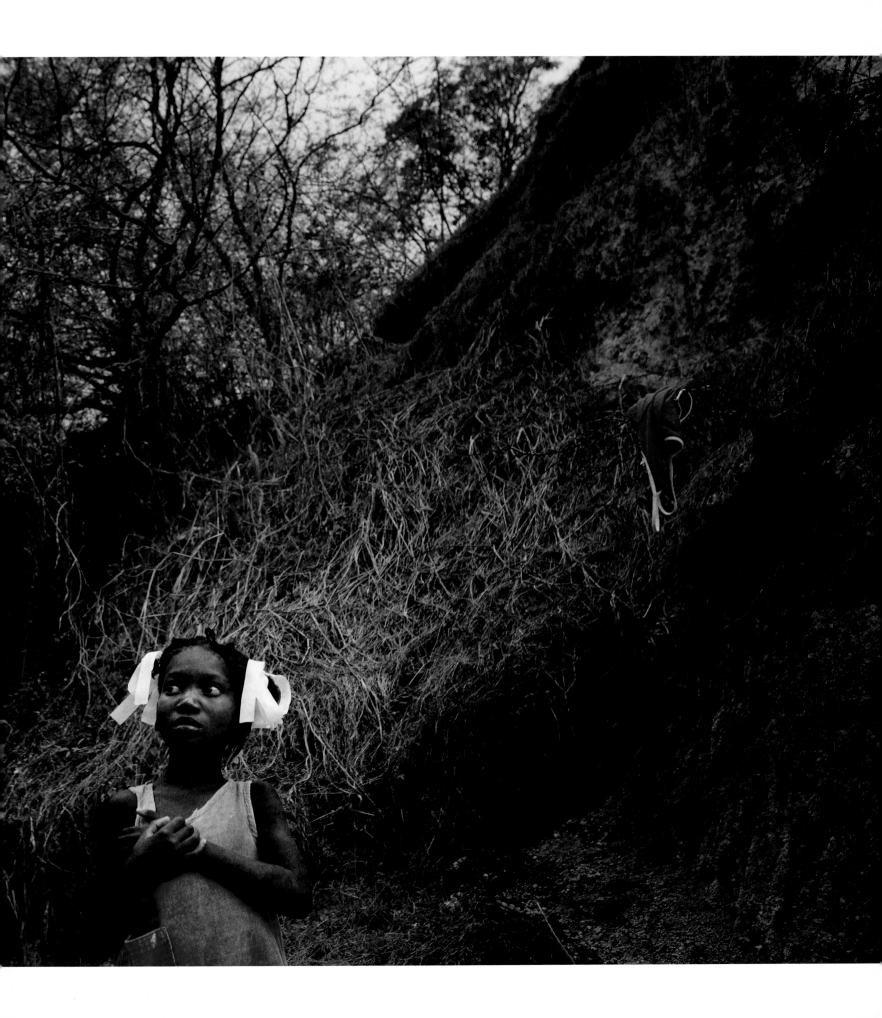

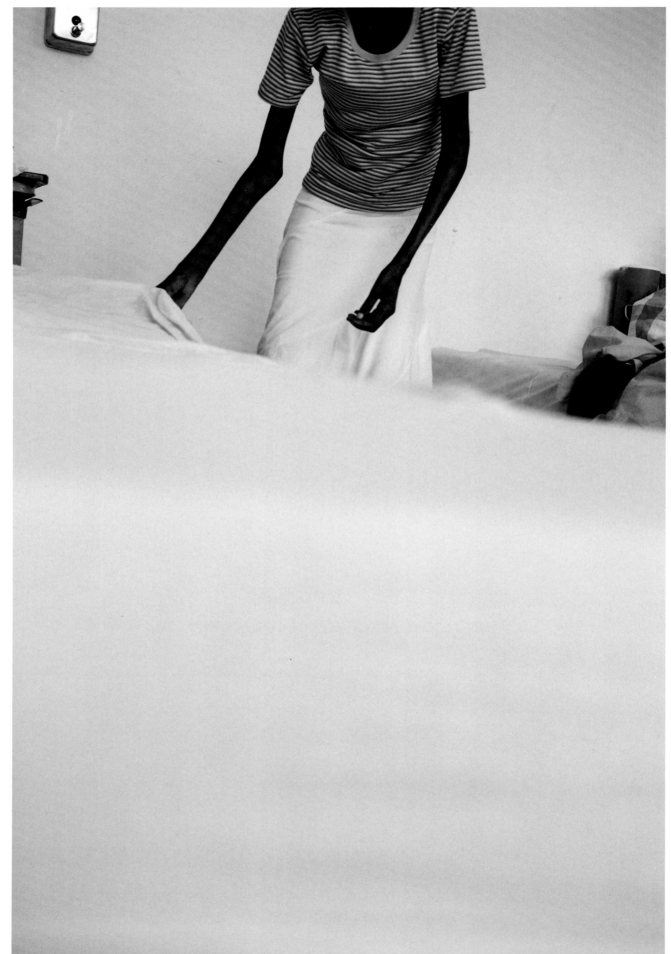

When Autha arrived at the Zanmi Lasante Hospital in November 2007, she was severely malnourished and, her doctors believed, close to death. Her ARV treatment was started immediately.

Following pages: The polaroids of Autha were taken by her "accompagnateur," a helper who came twice daily to administer her ARV therapy.

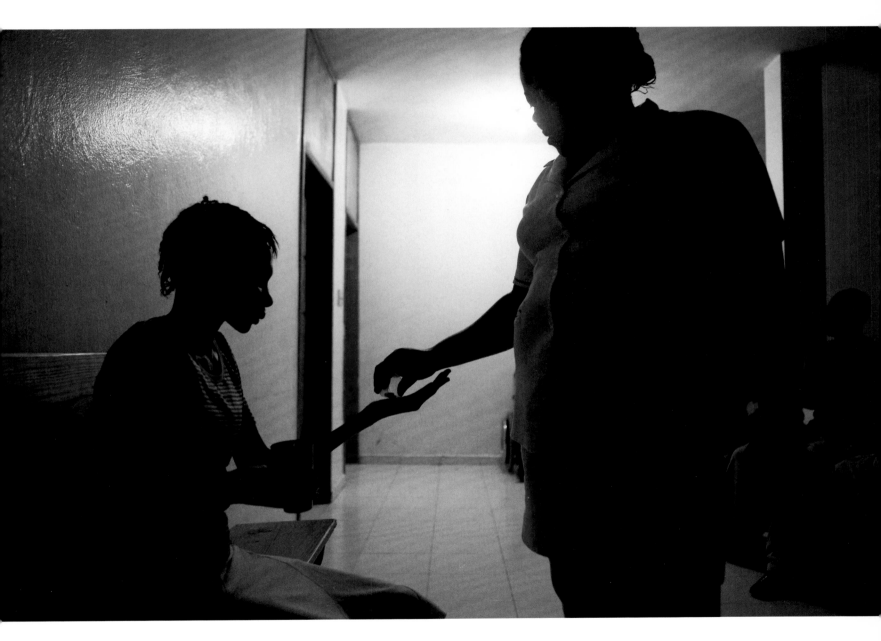

"This is a picture of a dead person.

She hasn't closed her eyes yet,

but this is a dead person, a person who is very sick.

It's a picture of sickness."

—OLDOR,

Autha's brother, looking at a photo of his sister in late 2007

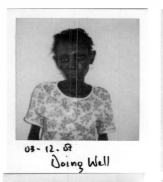 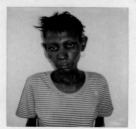 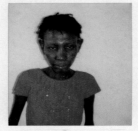 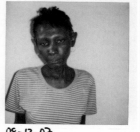 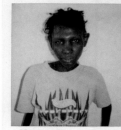

03-12-07 Doing Well 04-12-07 FINE 05-12-07 Fine 06-12-07 Fine. 08-12-07 Doing Well 09-12-07 Fine

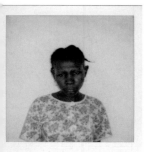 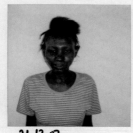 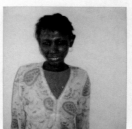 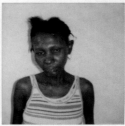 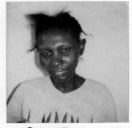 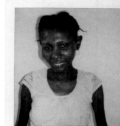

20-12-07 Doing Well 21-12-07 22-12-07 24-12-07 Doing Well 25-12-07 Doing Well 26-12-07 Doing Well

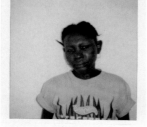 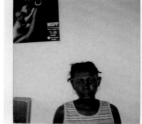 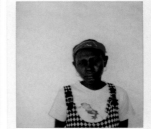 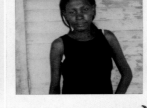 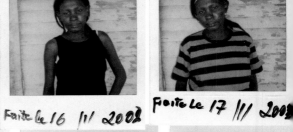

Faite le 16/11/2008 Faite Le 17/11/2008

23-01-07 2h 02 PM LE 23/1/2008 23-01-07 2h 00 PM Faite le 24=/11 2008 le 25/11/2008 le 26/11/200

 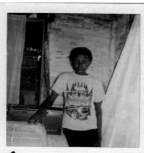 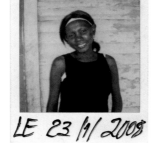 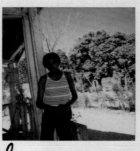 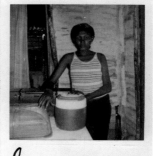 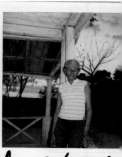

le 1er/12/2008 le 2-/12/2008 le 3 /21/2008 le 4-/21-2008 le-5-/21/2008 le 6/21/20

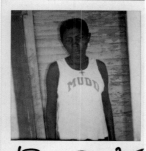 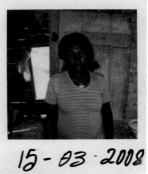 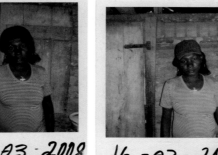 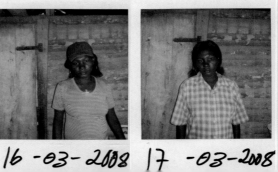 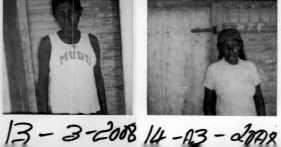 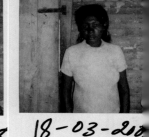

13-3-2008 14-A3-2008 15-03-2008 16-03-2008 17-03-2008 18-03-200

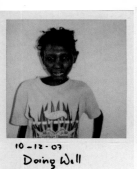 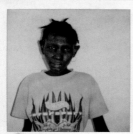 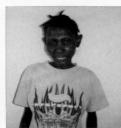 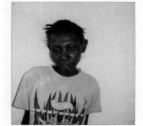 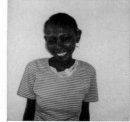

10-12-07
Doing Well

12-12-07
FINE.

13-12-07
Doing Well

17-12-07
FINE

18-12-07
Doing Well

19-12-07
Doing Well

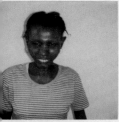 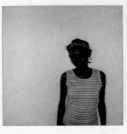 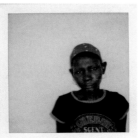 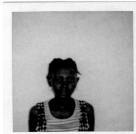 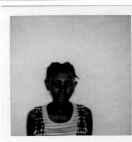

27-12-07
Doing Well

30/12/07

31-12-07

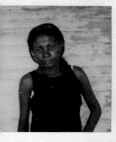 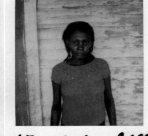 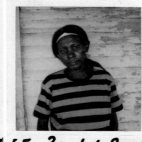 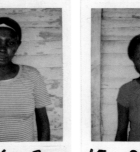 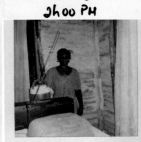

18 /11/2008 LE 19 /11/2008 LE 20 /11/2008 LE 21 /11/2008 LE 22 /11/2008 23-01-08
2h00 PM

 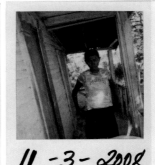

le 27 /11/2008 le 28 /11/2008 le 29 /11/2008 le 30 /11/2008 le 31 /11/2008

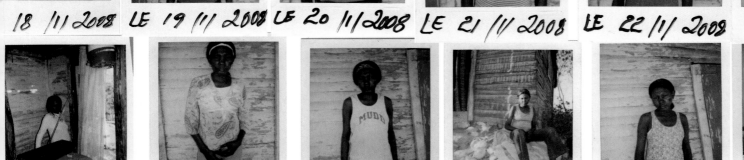

le 7 /12/2008 8 - 3 -2008 le 9 · 3 -2008 le 10 -3-2008 11 -3 -2008 12 - 3 -2008

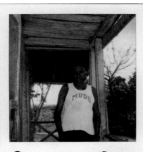 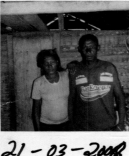 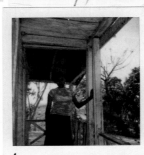 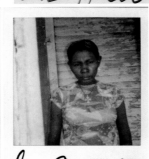

19 - 03 -2008 20 -03 -2008 21 - 03 -2008 22 -03 -2008 23 -03 -2008 24 -03 -2008

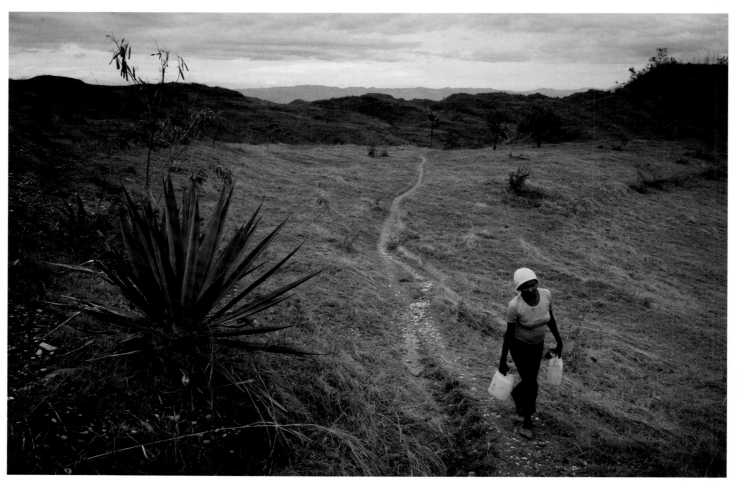

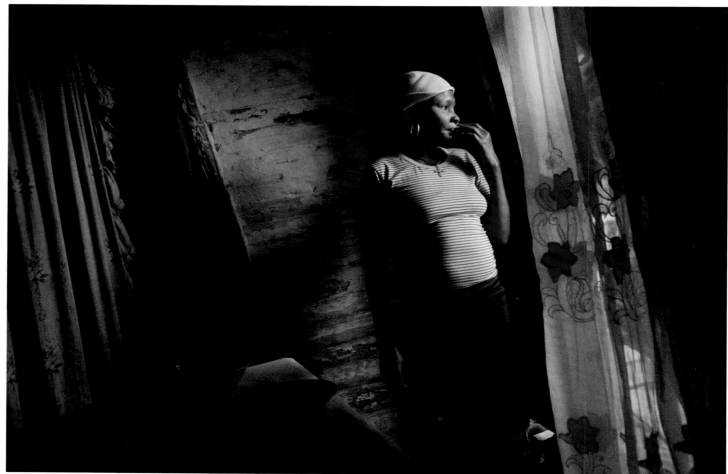

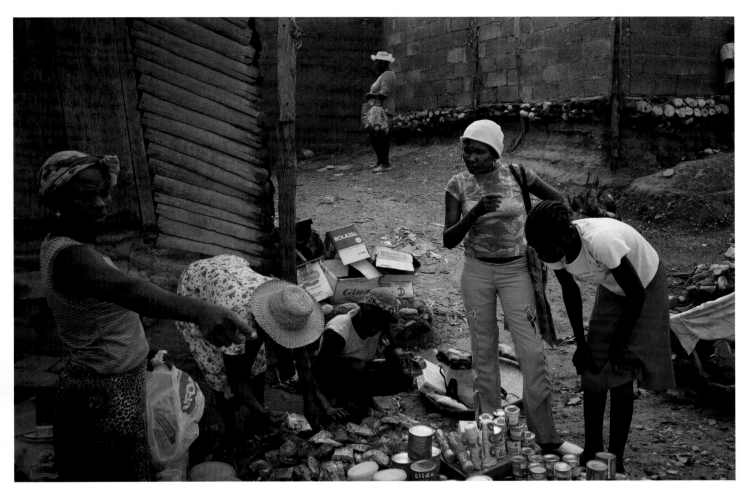

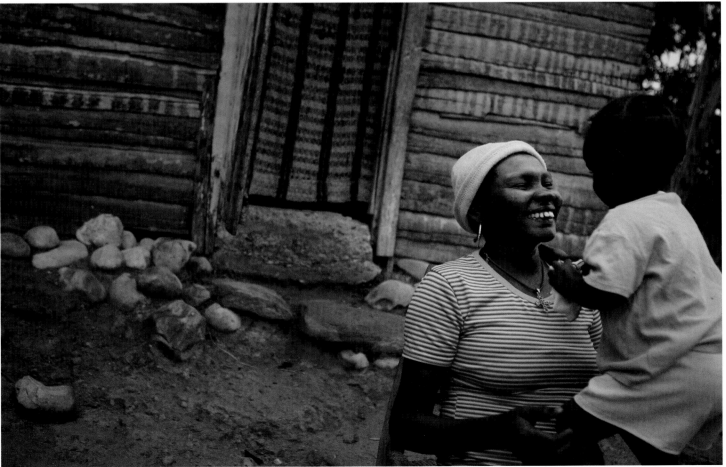

Autha feels that her illness has a spiritual dimension to it. Though she doesn't believe strongly in voodoo, she thinks that AIDS was something sent to her and that it was meant to bring her home. She used to work in the Dominican Republic.

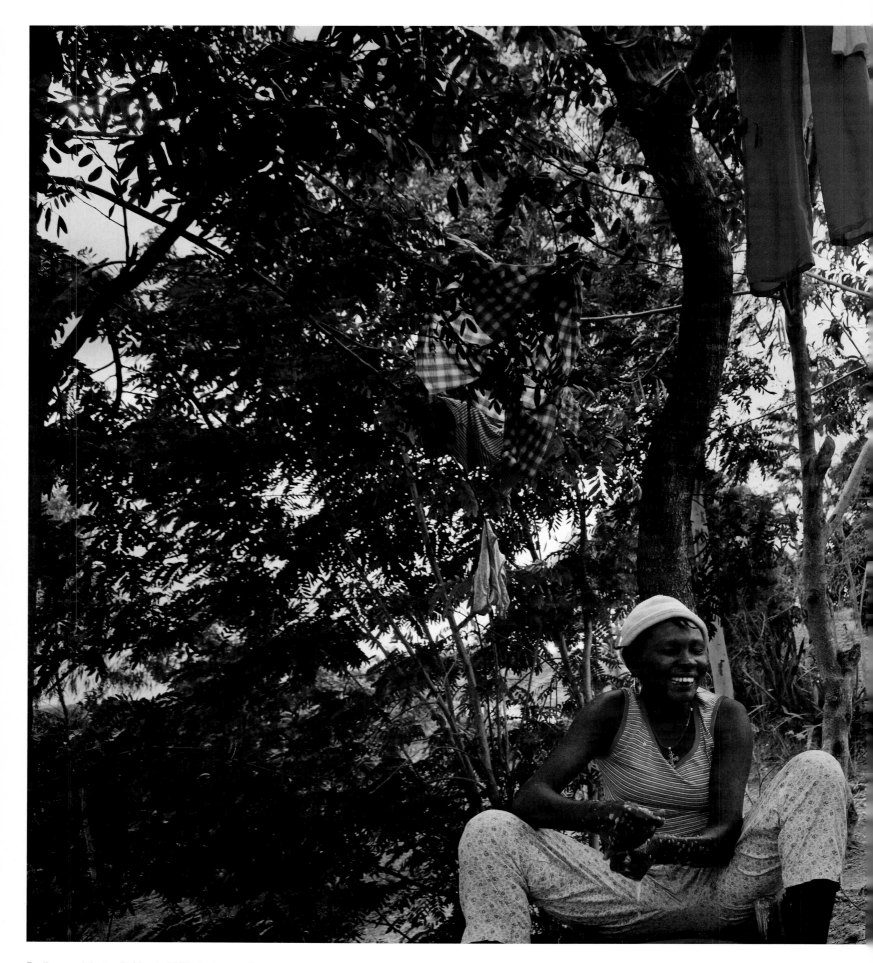

Feeling much better in March 2008, Autha now lives with her brother and his family. She wants to lead a quieter life, surrounded by her family.

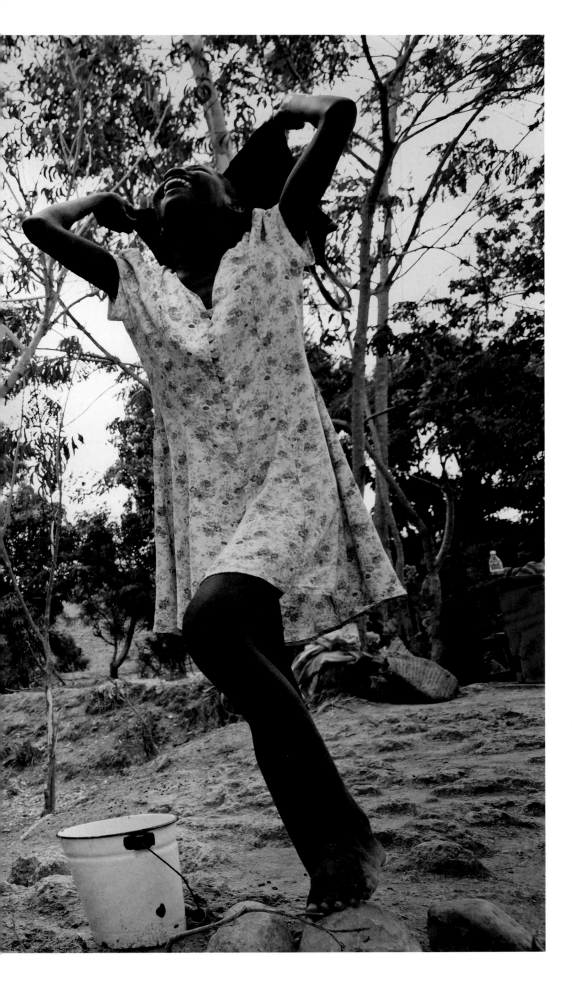

"Now, people treat me differently.
I'm like Lazarus and I've come
back and everyone's so happy.
Now, I want to help with everything.
I want to be working in the garden.
I want to be buying and selling,
and I feel good enough to do that."

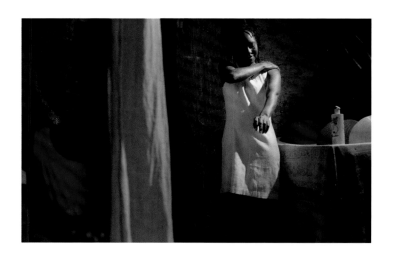

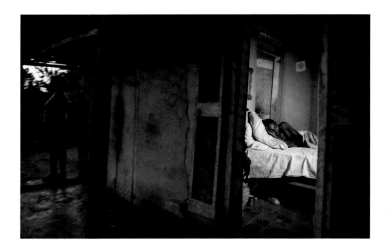

MARIE-SONIE ST-LOUIS, 33
OCCUPATION: Child-care worker

"Hearing I was HIV-positive broke my heart," says Marie-Sonie St-Louis. "I thought I was lost. I thought I was going to die." In the months following her diagnosis in November 2007, she almost did die. Life closed in to one small room in her mother's house. Almost an hour's walk from the nearest road, the house, in a small mud-and-wattle compound in a poor area of Haiti's Central Plateau, is reached by climbing hills and traversing a river. Because she was so weak, Marie-Sonie spent most of the day lying on a woven grass mat on the packed dirt floor, staring out the door. There was a bed in the room, but it was too high and hard to get in and out of. For most of the day, she was alone. Every morning, a community health counselor arrived just before 6 a.m. with the first round of her daily antiretroviral (ARV) therapy, reappearing in the early evening. In the late morning she tried to bathe. Sometimes she sat outside and watched her mother prune the citrus trees growing on the hill nearby.

Marie-Sonie's immune system was so weak that at first the doctors were amazed that she stayed alive. After she began ARV treatment in November 2007, however, her system rebounded strongly, though her confidence took longer to bounce back. She was also troubled by how she had contracted HIV: "I wasn't the kind of person who lived a fast and free life, so I really don't understand how this happened." Now, Marie-Sonie walks without a cane and has gone from listening to the life outside her confined room to being part of it. She helps look after the house, work the fields, and sees her two children, one of whom, Ruebentz, seven, has returned to live with her after staying with an uncle in Port-au-Prince. "When I was sick, I talked slow and low. If I wanted to get up, somebody had to help me. It was really like being in prison," she says. "Now, I'm totally different. I can sit here and talk like a regular person."

RELNEL CHERY, 38
OCCUPATION: Truck driver and mechanic

Not long ago, Relnel was a well-built truck driver and mechanic in the Port-au-Prince area who walked through life with a decidedly masculine swagger. He loved his work and the respect accorded him as a foreman at his trucking company. And he loved life, too. A sharp dresser, he spent evenings drinking rum with friends at neighborhood bars. He and his wife, Claudette, had been together since 1994, though Relnel admitted to having a number of affairs during his truck-driving days. They had a baby boy in 2004, who died the following year of an undiagnosed ailment, and Claudette discovered that she was HIV-positive. Then she became pregnant again, this time taking antiretroviral (ARV) medication to help prevent transmission of HIV to the child. Their daughter Rejika was born in May 2007.

Soon after their daughter's birth, Relnel fell sick but refused to be tested for AIDS. Instead of seeking help at a free public clinic, he spent his family's savings going to private physicians, one of whom diagnosed him as having typhoid fever and prescribed an expensive treatment. It was only after the treatment failed that Relnel finally visited the public clinic, where he learned that he was suffering from AIDS. "It was very hard to hear that news," he said. "We had just had a little baby and it worried me a lot."

Relnel began ARV treatment in October 2007, but it was too late. He spent his days lying on a bed, too weak and in too much pain to move. He suffered from neuropathy, a nerve degeneration that made it too difficult for him to stand or walk. Going to the toilet was torturous; each bout left him exhausted and near tears. His muscles atrophied; his skin became dry and scaly. He withdrew emotionally as well, and often seemed resigned to death. Six months after his treatment began, Relnel died. He was only 38.

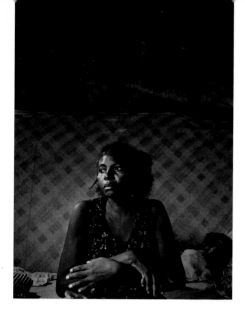

MARIE-THÉRÈSE NOËL, 41
OCCUPATION: Factory cleaning woman

Like many Haitians, Marie-Thérèse knew HIV was transmitted by sexual contact, but she also believed it was "a spiritual illness." When she fell sick, she first consulted a "houngan" (voodoo priest), spending two months and all her savings seeking a cure. But her condition deteriorated sharply. Finally, her older sister Marie-Princilia, who had been diagnosed as HIV-positive in 2005, and her husband, Jaye, himself a voodoo priest, brought Marie-Thérèse to the emergency room near their home.

Marie-Thérèse never knew how she contracted the disease. She had had only two sexual partners in her lifetime—the fathers of her three daughters, ages 20, 16, and 7. The likeliest possibility is that the father of her youngest daughter, Manuela, infected her. He died in 2004 after an intense fever. "I don't know how I got the disease because I wasn't an immoral person," Marie Thérèse said. "I wasn't living a very liberal, free life."

Once ill, Marie-Thérèse could no longer afford to support her children, particularly Manuela: "I feel terrible about Manuela not being able to go to school," she said. Confined to a room at her older sister's house in Fejea, Marie-Thérèse spent her days listening to the sounds of the dusty national road running past the family compound and thinking about her life, her children, and her illness. Her thoughts, she said, were sometimes worse than the disease. She began antiretroviral treatment in late November 2007, and doctors expected her to recover quickly. Though she was diligent about taking her medication, her condition worsened. After 10 days in the hospital, she died on January 18. The grim task of talking to Manuela fell to her aunt Marie-Princilia. "She wouldn't let me ever put her down," Marie-Princilia recalled. "Since then, Manuela's been very quiet."

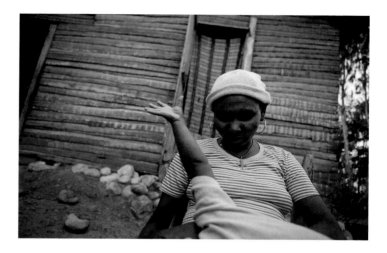

AUTHA ADOLPH, 26
OCCUPATION: Domestic worker

When Autha began antiretroviral treatment at the Zanmi Lasante Hospital in Thomonde, doctors doubted she would survive more than a few days. She weighed 75 pounds, suffered from chronic malnutrition, and could not walk. Her digestive system had shut down and her moments of lucidity were fleeting. Her skin was a collection of open sores—the result of mosquito bites that had failed to heal and begun to fester. Nor could she look to her fellow patients for hope. During her time in the hospital, nine people in her ward died.

But survive Autha did, becoming an inspiration for many others who had seen her near death. Now Autha, who lives with her brother, Oldor, and his family in Casse, walks a mile to fetch water from the stream near her brother's house, washes clothes, minds her brother's six children, prepares food, and even helps with field work. Some neighbors, who used to shun her because of the anti-AIDS stigma that persists throughout Haiti, are still suspicious, however, both of her illness and of her recovery.

As her strength grows, Autha, who grew up in the countryside but had worked in the Dominican Republic primarily as a maid for a wealthy family and then lived in Port-au-Prince, intends to return to her parents' house to farm their small plot of land and care for them: It is customary in rural Haiti for the youngest child to look after aged parents. She believes that she was infected by a former partner, who has since died. (Autha also had a baby in 2002, who died shortly after birth.) Chastened by her past and her fate, she says she will never marry or have children or even have a romantic relationship with another person again. "I have a disease and I don't want to give it to anyone else," Autha says. "I now know that I can live with this disease by myself."

SNAPSHOT: HIV AND AIDS IN HAITI

OVERALL POPULATION: 9.6 million

NUMBER OF PEOPLE LIVING WITH HIV AND AIDS: 115,000.
Haiti is the country hardest hit by HIV outside the African continent (though the numbers are starting to decline).

HIV PREVALENCE AMONG ADULTS: 2.2 percent*

NUMBER OF PEOPLE ON ANTIRETROVIRAL (ARV) TREATMENT: 14,514

NUMBER OF PEOPLE WHO NEED ARV TREATMENT: 36,000

GROUPS MOST AFFECTED BY THE HIV EPIDEMIC IN HAITI: As in the rest of the Caribbean, Haiti's epidemic began mainly among men who have sex with men and among those who received blood transfusions. In Haiti it quickly spread to the general population. Women now account for more than one third of all AIDS cases in the Caribbean.

HAITIAN SOCIAL ATTITUDES TOWARD HIV: There is still a significant social stigma and unwillingness to talk about HIV publicly, but support exists within families and among friends for individuals living with the disease.

AVAILABILITY OF TREATMENT: Widely available for the last few years throughout the country.

HIV TREATMENT CHALLENGES: Tuberculosis as a result of HIV infection is on the rise, and poverty limits access to sufficient food. What's more, the combination of a rural population, political instability, and weak infrastructure makes it difficult for many to access testing and treatment. A belief in traditional medicine—combined with the stigma of the disease—results in frequent delays in testing and treatment, so that treatment often begins too late.

*Prevalence figures for all countries come from UNAIDS, the joint United Nations Agencies on HIV and AIDS. Figures for the number of people currently on, or who need, treatment come from *Towards Universal Access: Scaling up priority HIV/AIDS interventions in the health sector, Progress Report 2008*, a joint publication of the World Health Organization, UNAIDS, and Unicef.

ntombizandile

AKHONA

south africa

LITHO

photographs by larry towell

bulelwa

AIDS became personal for me a couple of years ago, when I volunteered to photograph a relief group whose patients were struggling to come to terms with their status. The innocent and the vulnerable, the orphans and the widows affected me most. When the Global Fund asked me to participate in this project, I was already involved.

In South Africa, 18 percent of the population—and in Swaziland, 26 percent—is HIV-positive. Swaziland is a tiny country, but one that serves as a huge labor pool for South Africa. The percentage of people infected in Swaziland is larger than in any other country on Earth. The numbers are staggering. But the first thing you learn as a photographer is to ignore statistics and to look at the people. The second is to look at the place.

I was shocked by the "informal settlements." The miles of tin, wood, and cardboard shacks of the displaced and rural poor in the townships affronted me. I realized that the problem is deeper than AIDS.

South Africa has one of the few thriving economies on the continent, with Cape Town as one of its centers. Millions of migrants from rural areas and neighboring countries come to the cities looking for work and end up in the townships, where unemployment is high. The culture of unemployment, in places where people have little else to do, creates a situation where HIV transmission is rife.

Being involved in this project was an opportunity for me to find a bit of hope and a bit of beauty in the shantytowns that once overcame apartheid. Hope comes not from a place, but from within. **—Larry Towell**

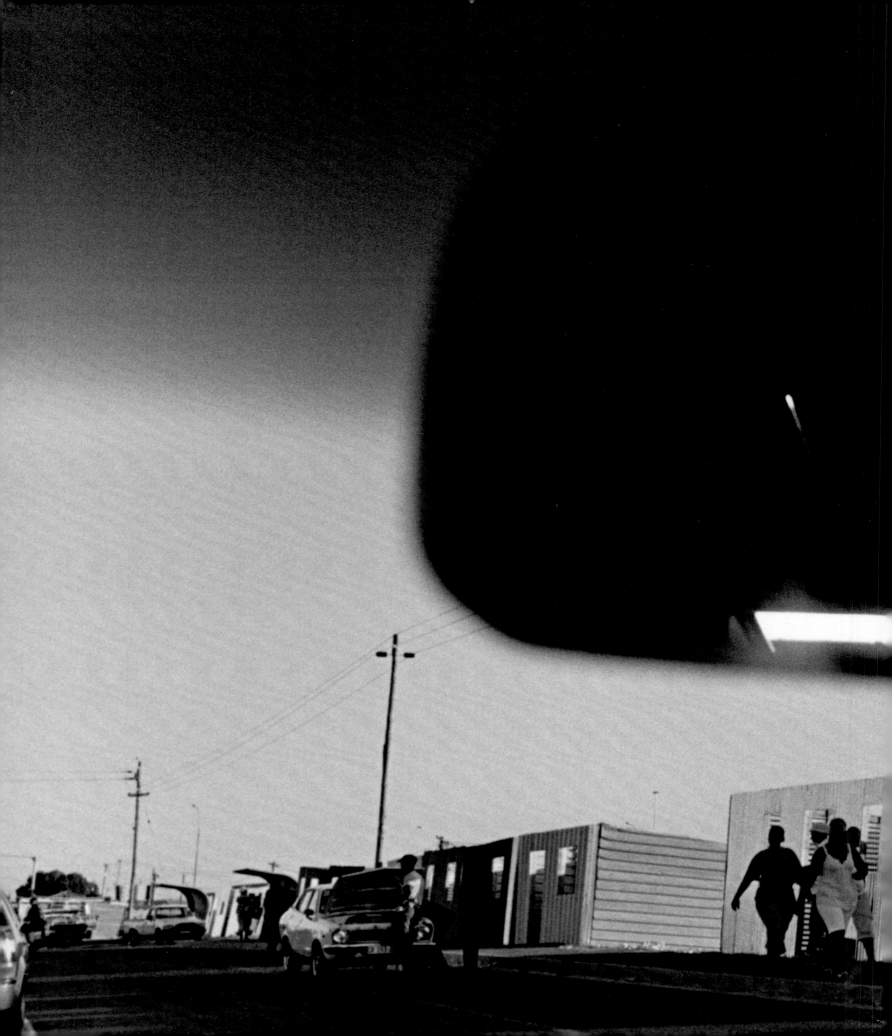

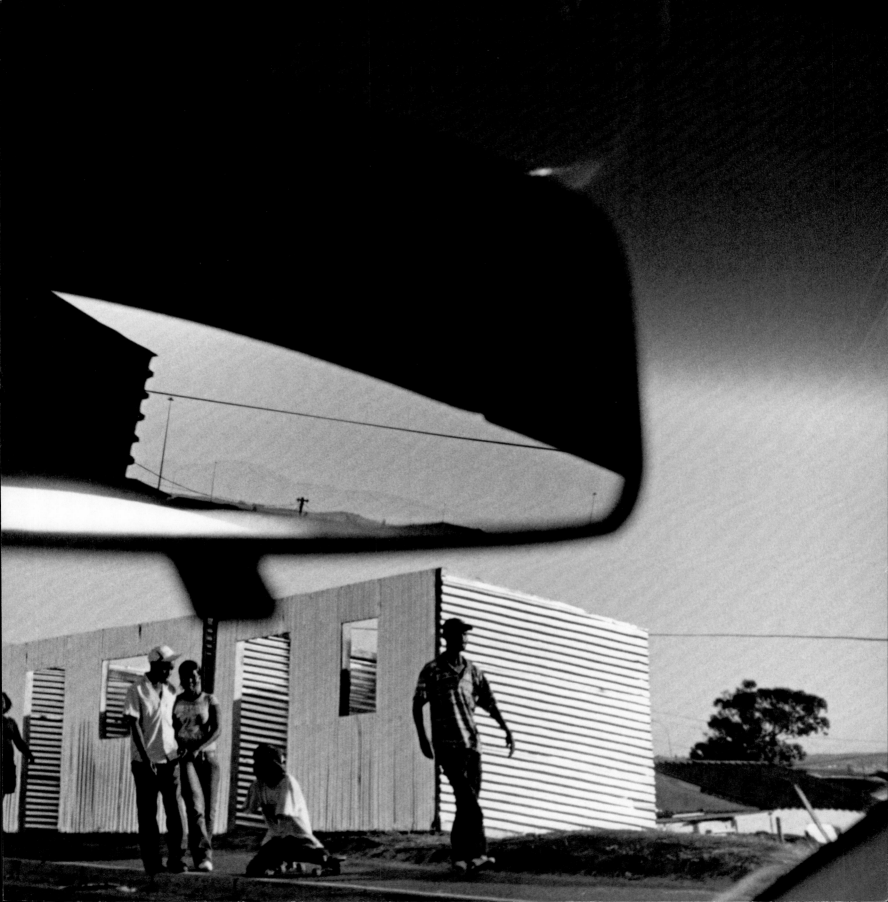

LITHO NYANDA,
GUGULETHU (CAPE TOWN)

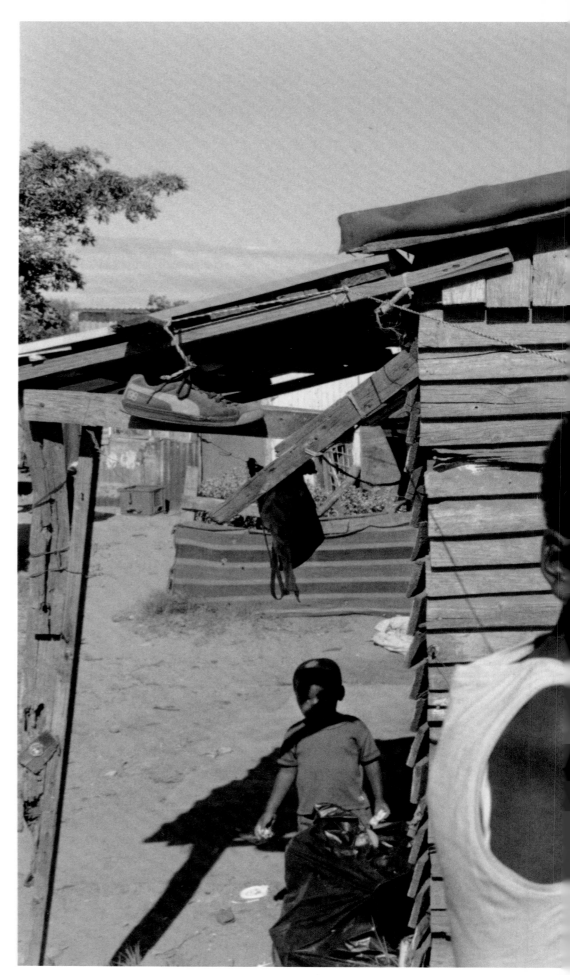

"I wake up every day, prepare the kids to go to school, wash them, feed them, and accompany them to school. My dreams are to return the dignity of my parents, get them a better place, have a steady job, and see to it that my brothers are also okay."

Litho *(right)* on domestic duty: She was a good student before disease made it impossible for her to continue at school.

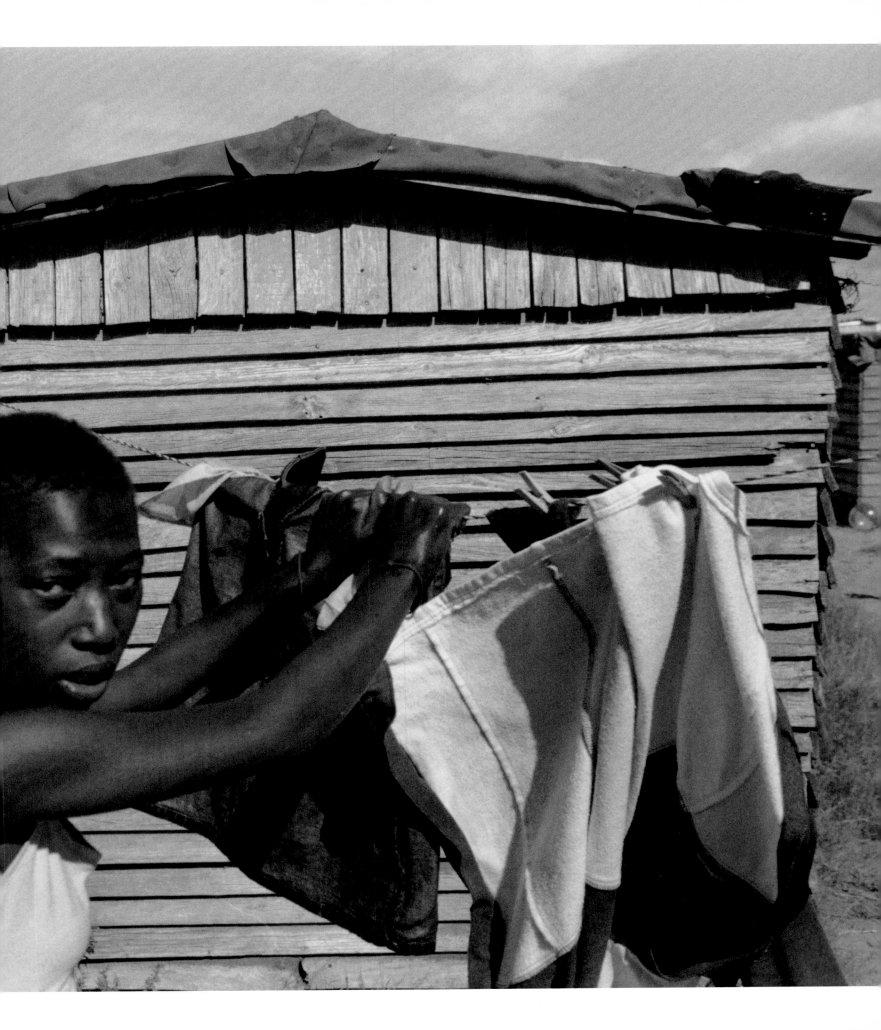

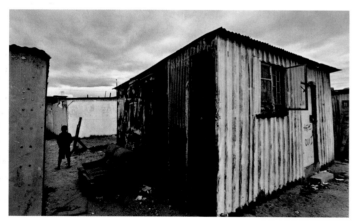

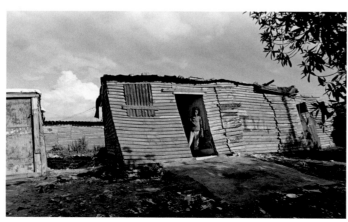

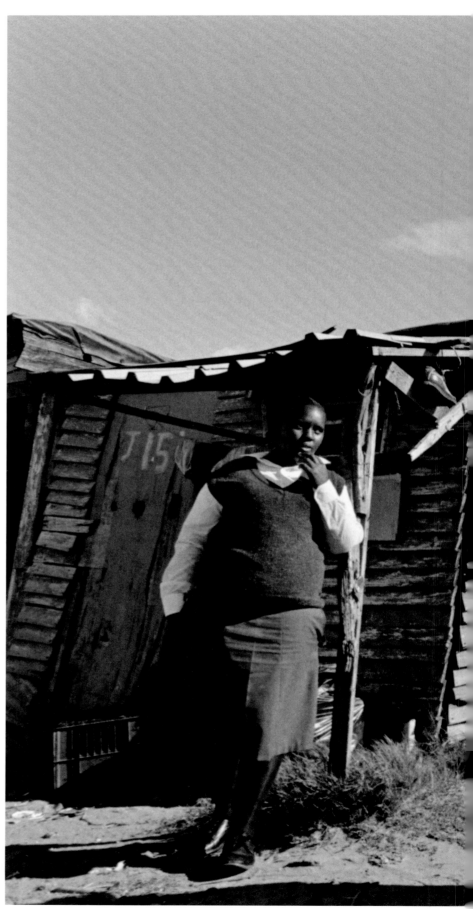

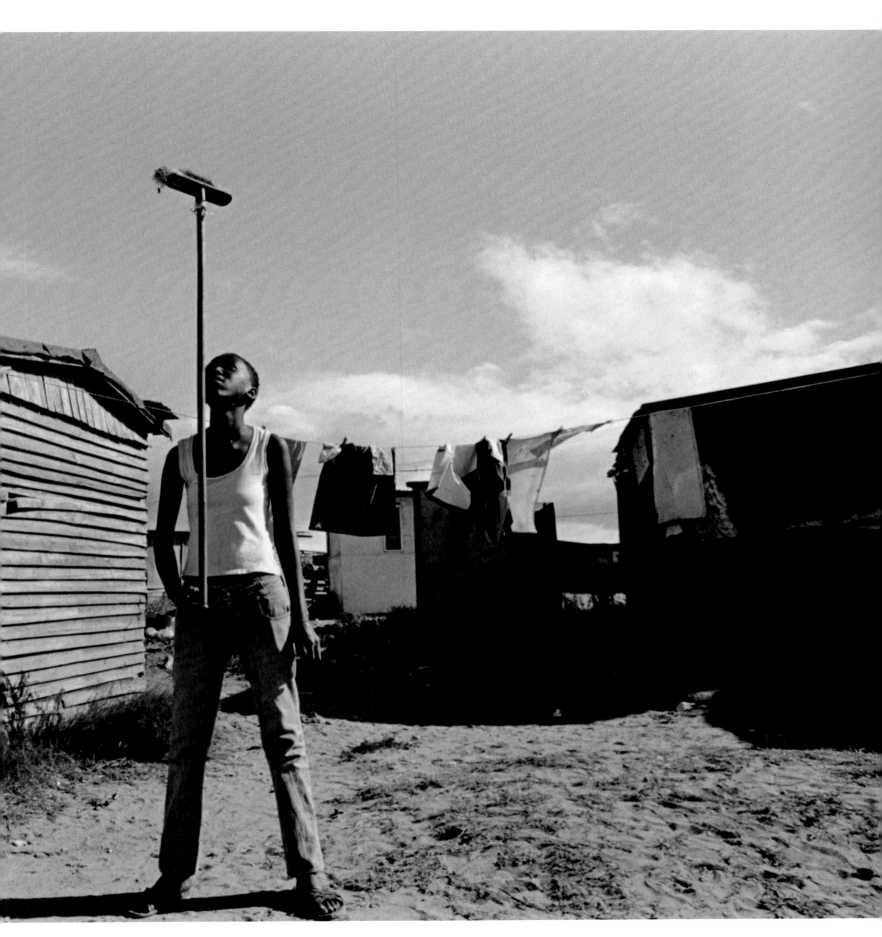

Litho with her sister next to the family's two-room house. Poverty and malnutrition are rife in their shantytown of Gugulethu.

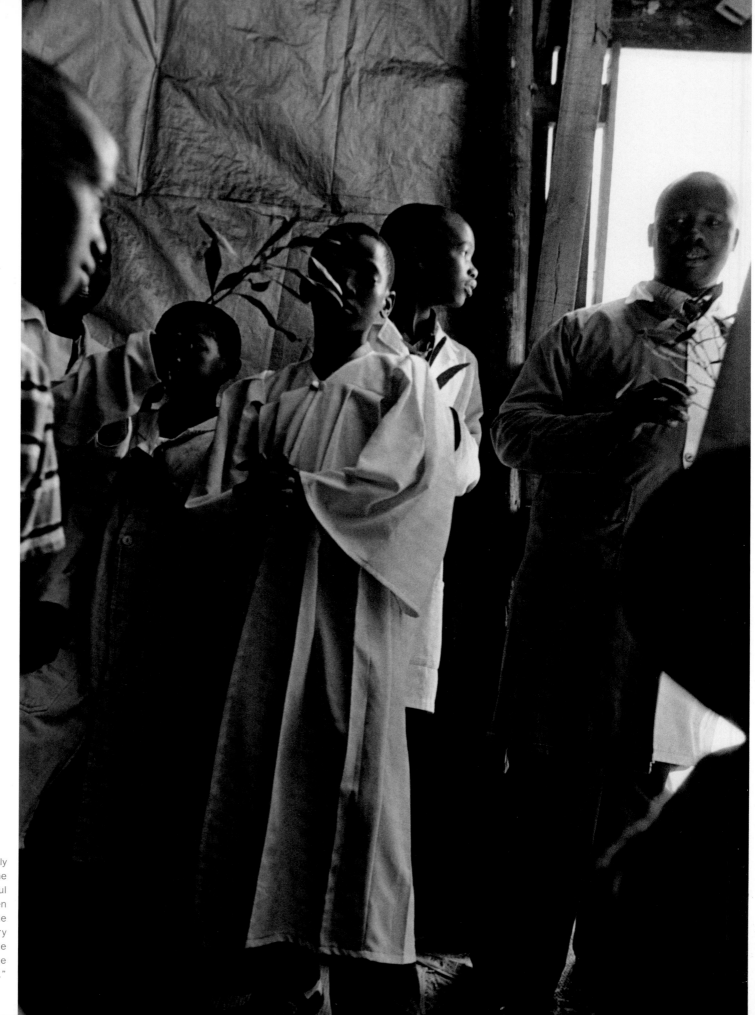

Litho is highly religious: "The most wonderful day was when I was lying in the hospital, very sick, and the *whole* church came to visit me."

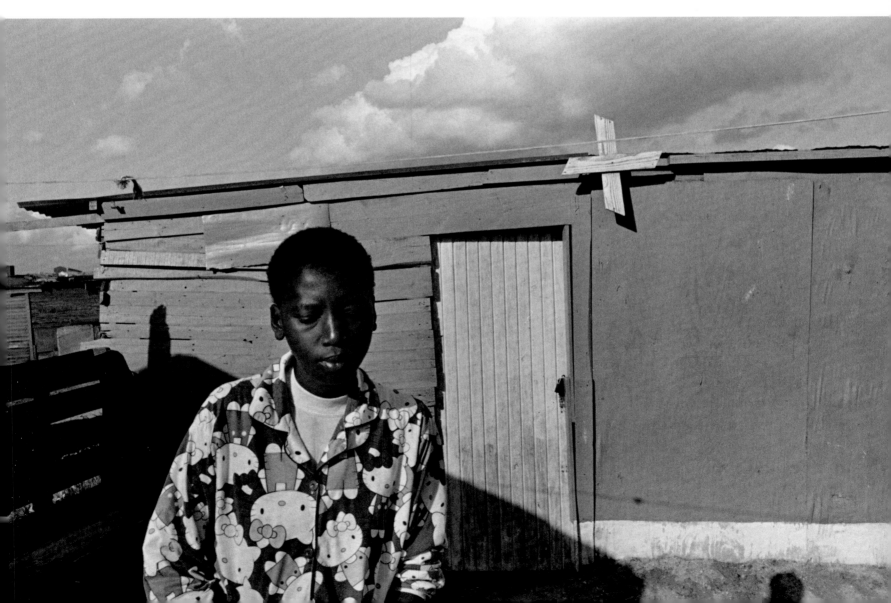

Roll-out of ARV
treatment has
already reduced
the number of
people dying from
AIDS in South Africa.
Some coffin-makers
are complaining
that the new drugs
are bad for their
business. Yet,
funerals are still
a common part
of township life,
where the community
comes together
to share their grief
and strengthen hope
and solidarity.

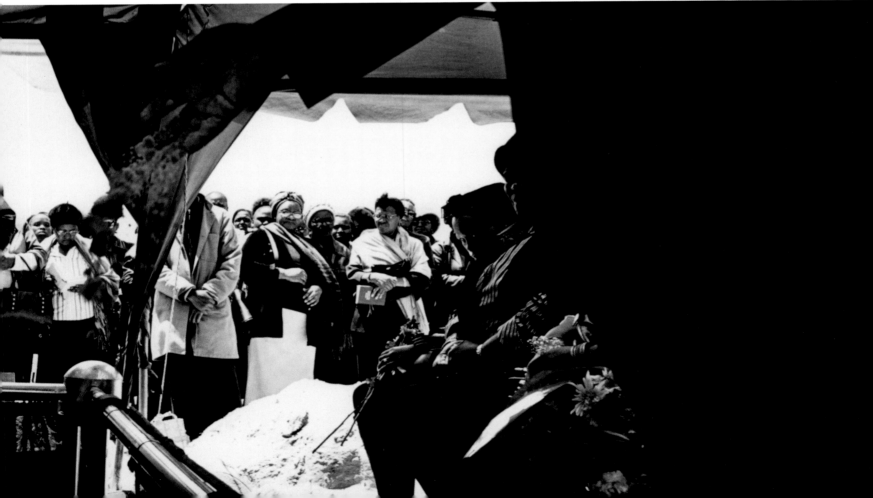

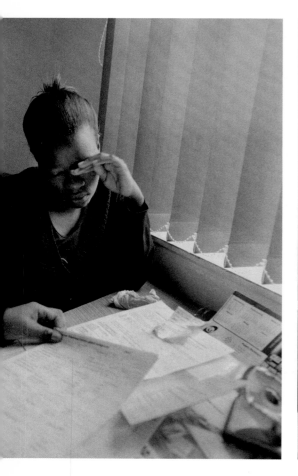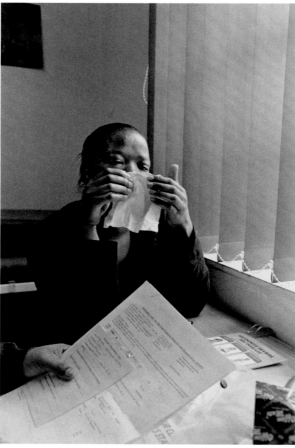

"I was pregnant, and it's a policy here in South Africa
that when you are pregnant, you've got to do an HIV test. So I gave my consent
to be tested and discovered that I was HIV-positive.
This is the biggest worry of my life, and the most challenging thing.
I didn't accept [the diagnosis] and I don't accept it."

An emotional Akhona in November 2007 (then eight months pregnant) at the Hannan Crusaid Clinic in Gugulethu *(above)* and at her cousin Nokuzona's house *(opposite)*.

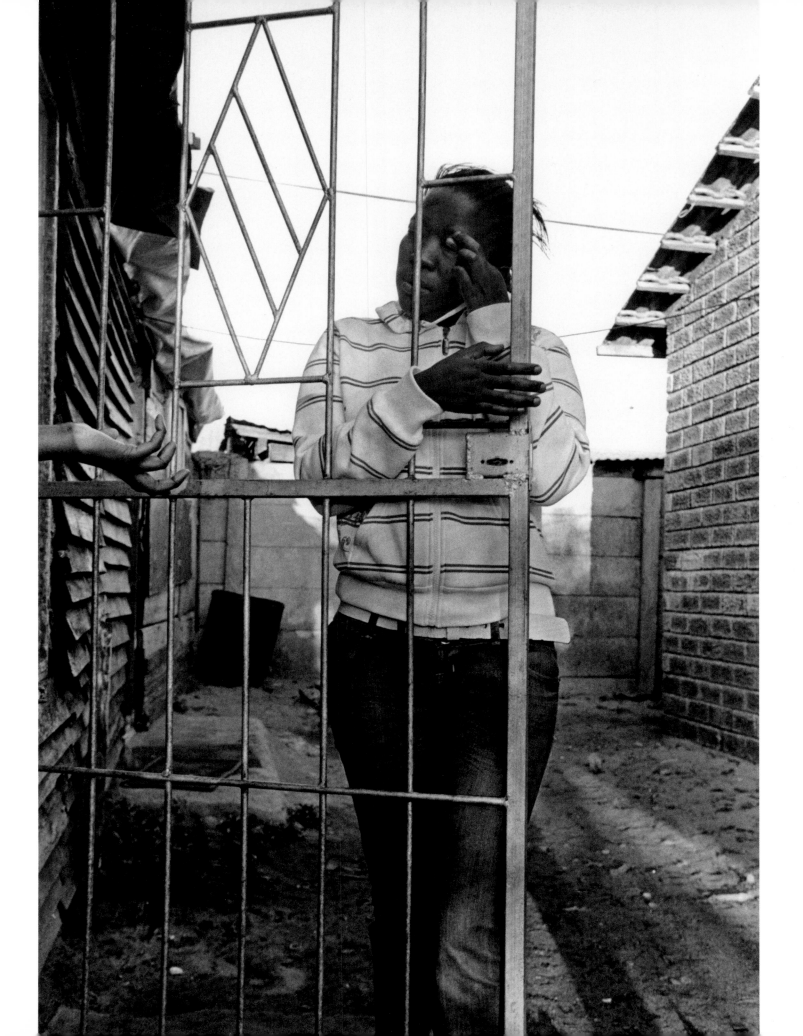

Akhona, awaiting
a session at the
clinic with her new
baby boy, Lutho, in
March 2008:
"I just want to
concentrate on
my son. I'm not
ready for any
relationships."

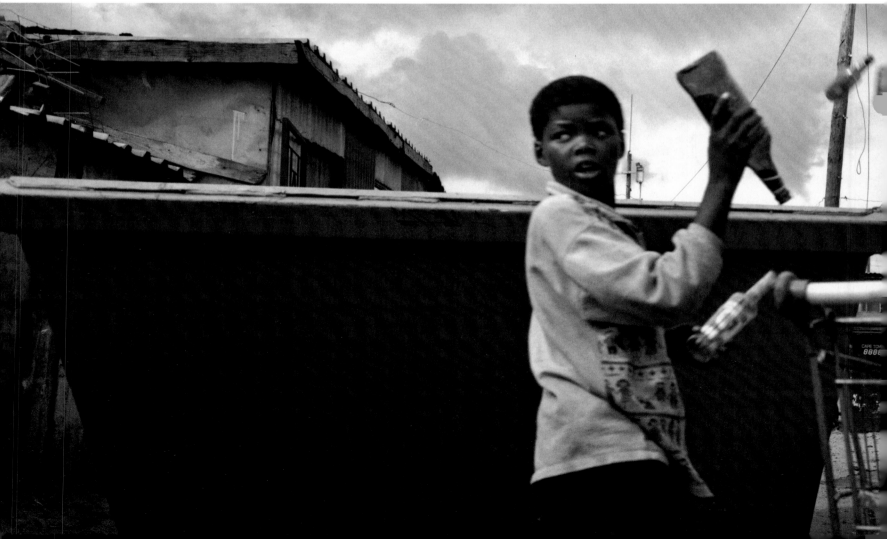

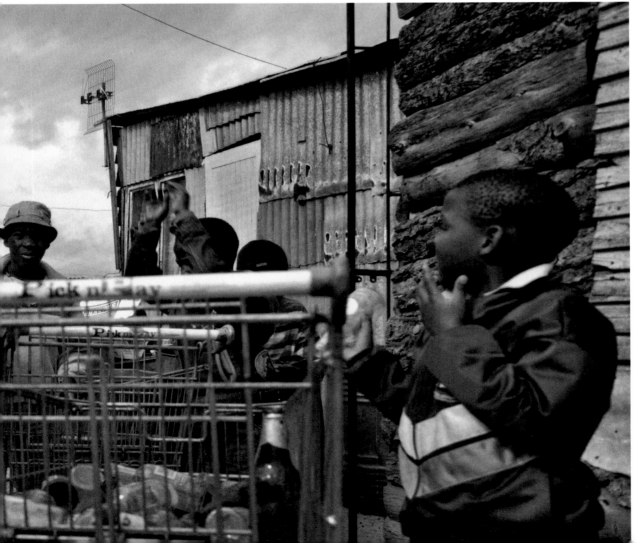

"If I was educated,
I would like a social-
work job. In the future
I would love to see
myself owning a
house, staying with
my baby, working
for my baby."

—AKHONA

Top left: Akhona and Nokuzona.
Bottom: Children collecting
bottles in the township.
(Following spread) The bar
scene in local houses, where
condoms are readily available
but HIV is still frequently
spread through casual,
unprotected sex.

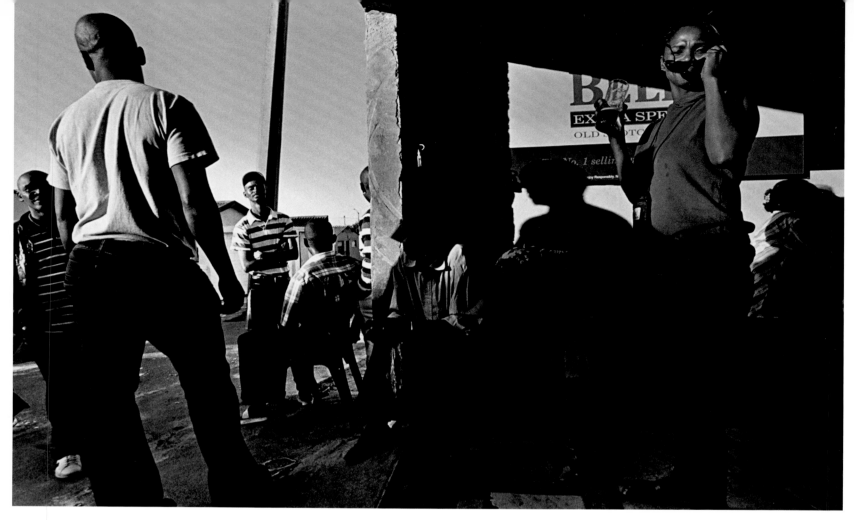

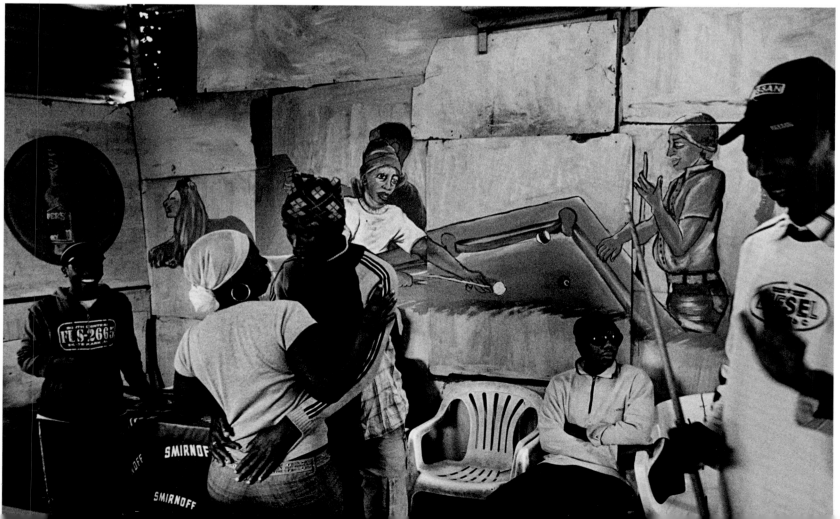

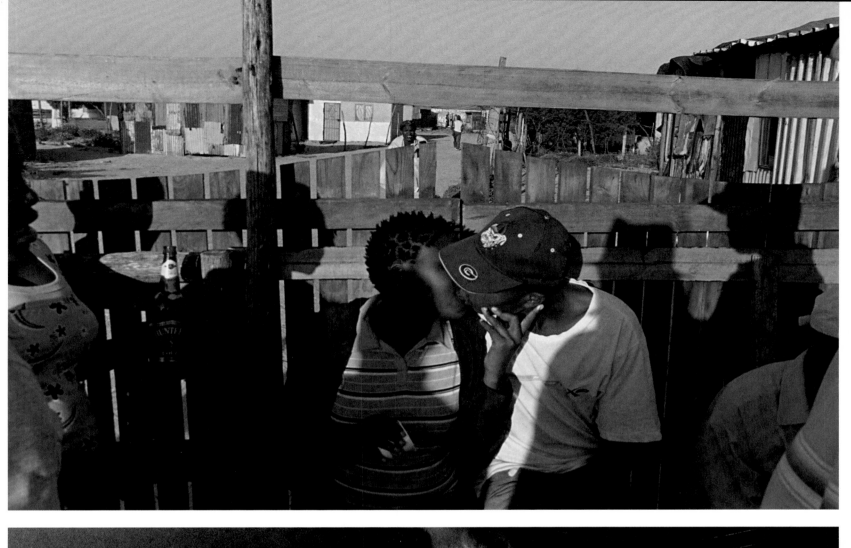
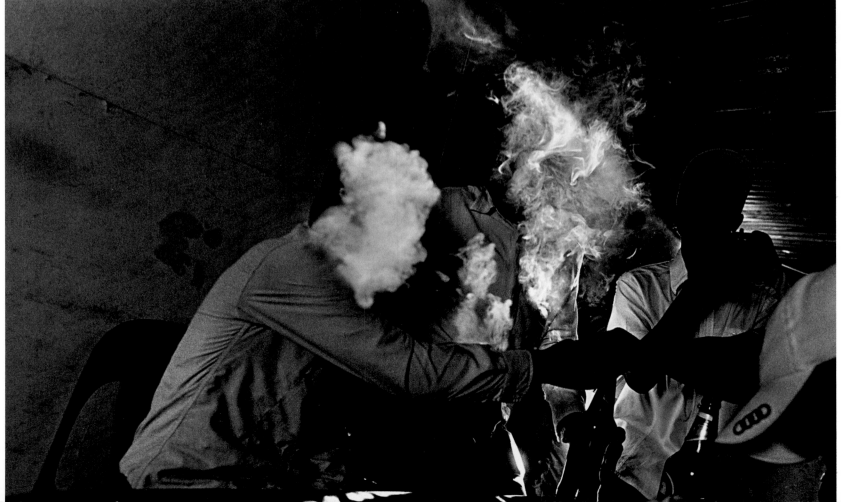

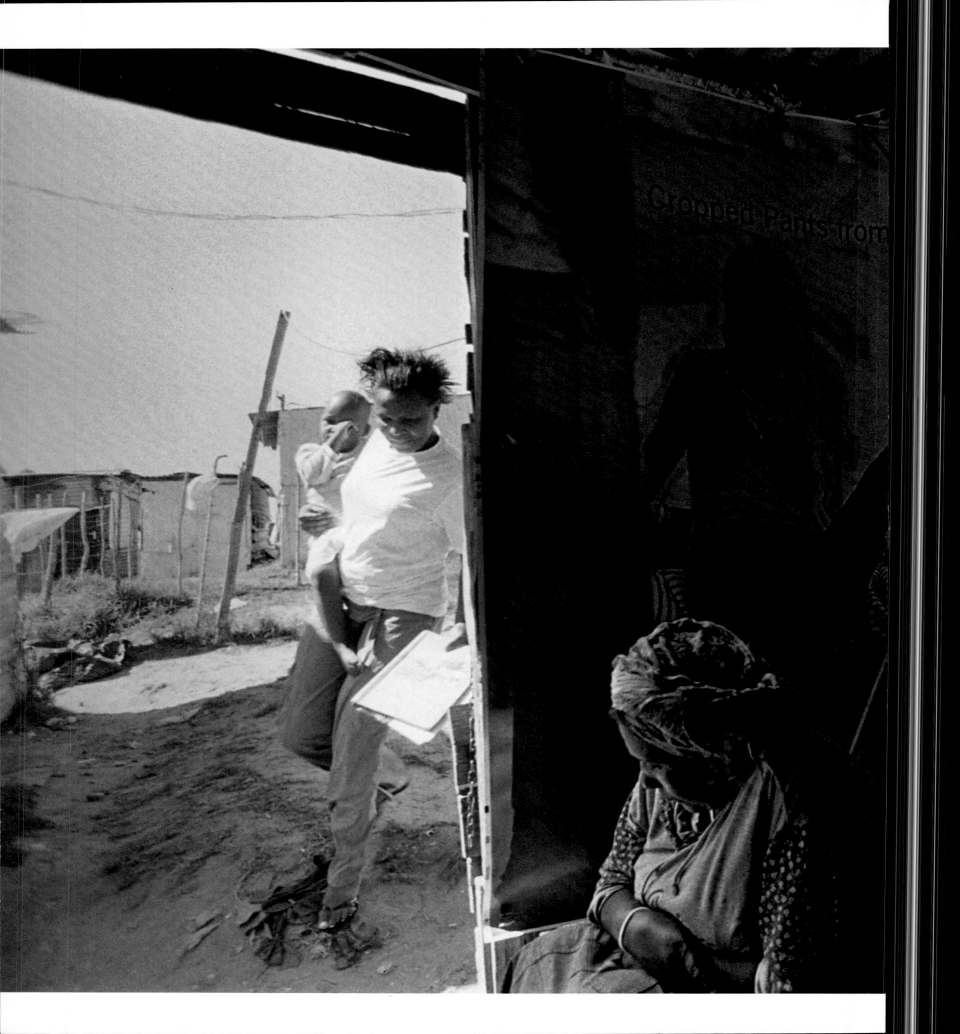

"I am confident that
the ARV treatment will
prolong my life. I encourage
the others and preach
that this is our lifetime
and if we're not
taking our medication,
we're going to die."

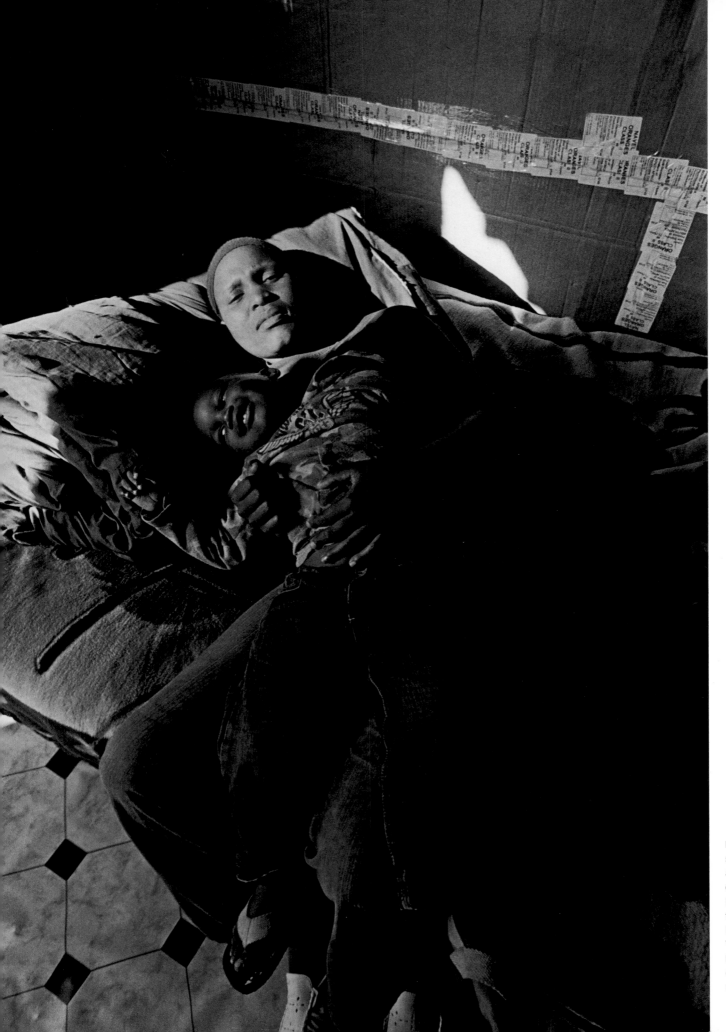

Bulelwa and her son, Lisakhanya, at home in the one-room, cardboard-lined tin shack that they occupied with Bulelwa's partner Thembisile when she began treatment. The double bed filled most of the space.

"My wish is to have a job and the first thing I'll do is to build a house for my children because I want my children to have a home of their own."

While Bulelwa and her family moved to a safer neighborhood in Gugulethu to be close to her boyfriend's sister and extended family *(pictured here)*, poverty remains the dominant note.

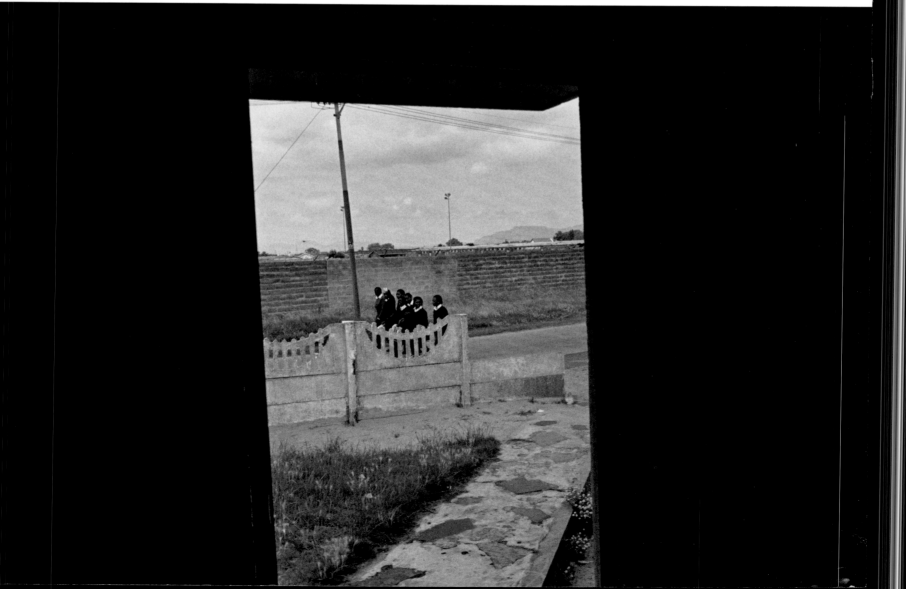

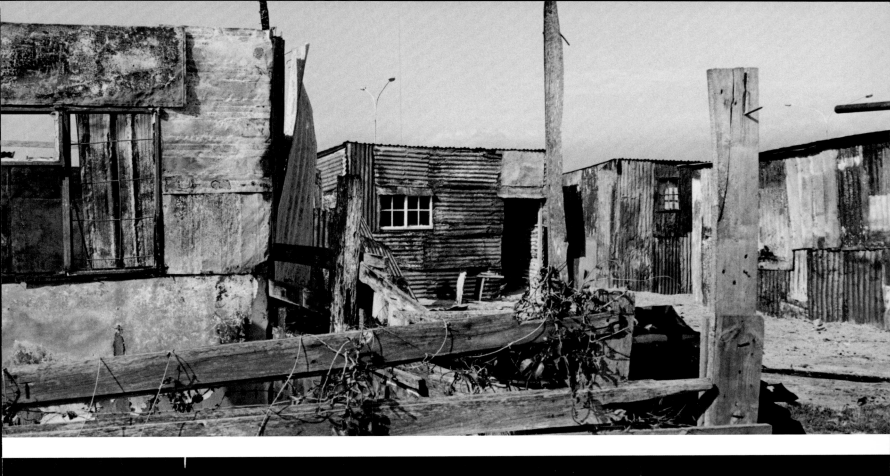
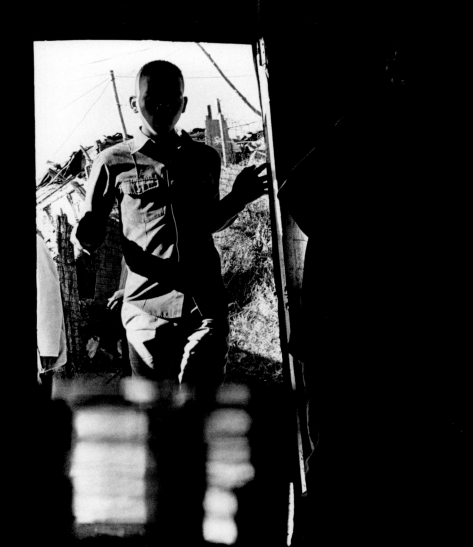

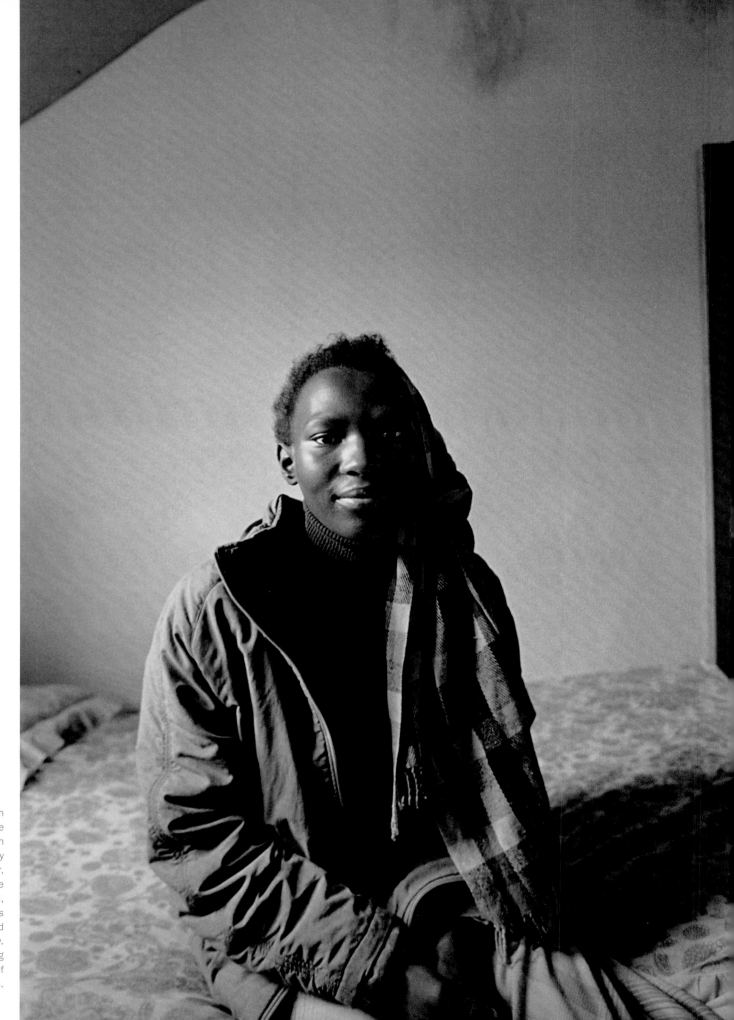

Although Ntombizandile has two children of her own, they live with her mother, far away on the Eastern Cape, while she stays with her cousin and her cousin's baby. "Nobody was going to take care of me," she says.

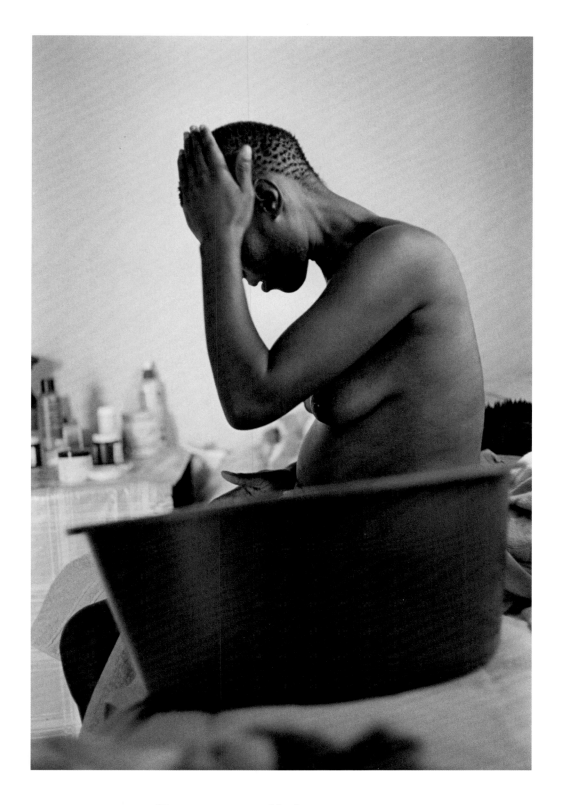

"I was very stressed before my treatment.
I had constant headaches.
Now, although they're still there,
I'm much better than I was."

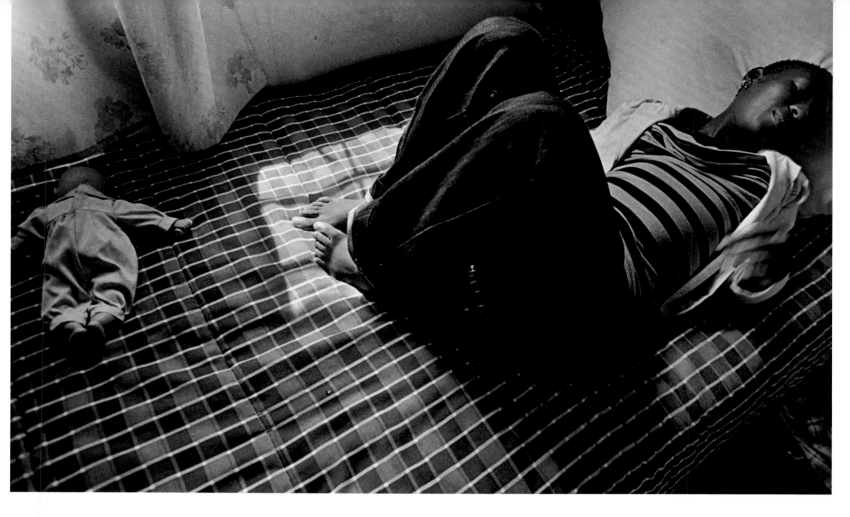

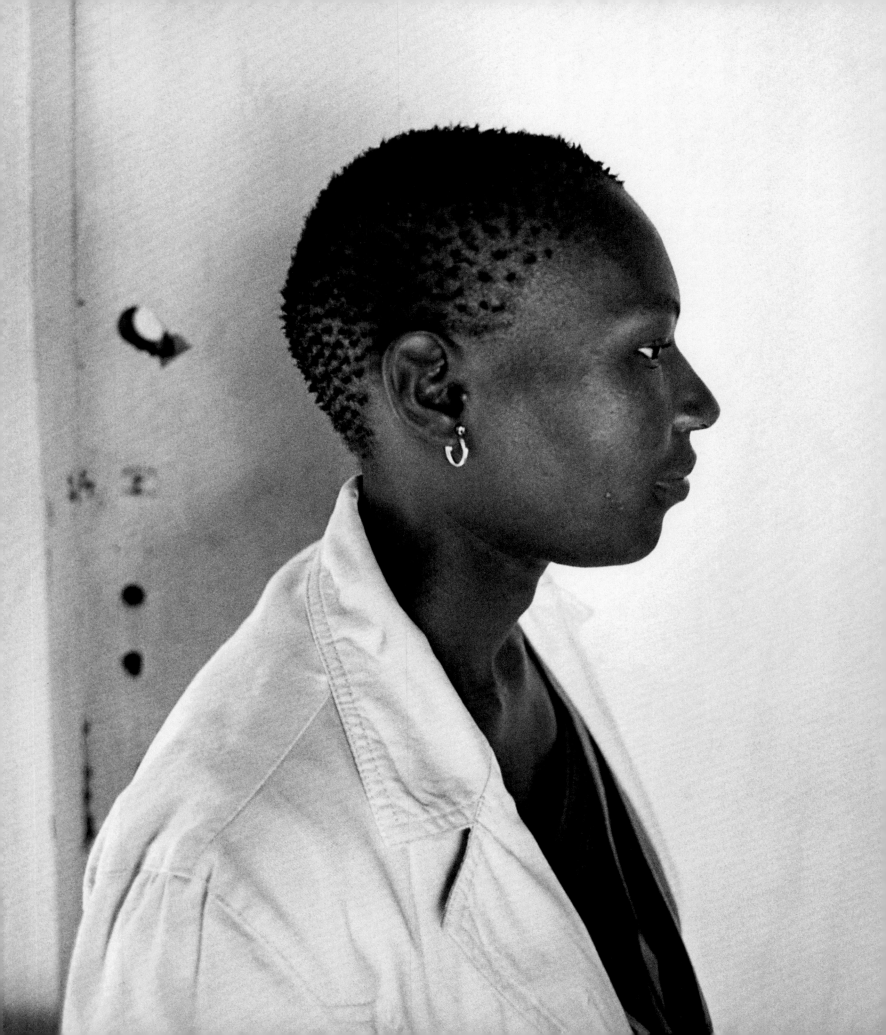

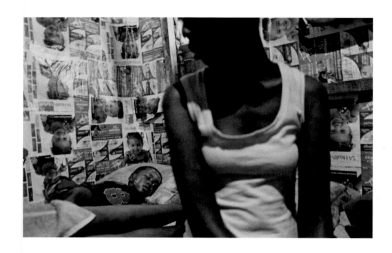

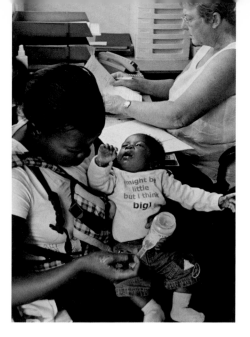

LITHO NYANDA, 19
OCCUPATION: Student

Litho Nyanda lives with both of her parents and her four siblings in Kanana, one of the poorest neighborhoods of the "informal settlement" of Gugulethu, near Cape Town, home to generations of migrants. "We've got nothing," says Litho's mother, Nokhuthulo. The family shares a two-room house made of corrugated iron and wallpapered with government health-care posters. Litho was a promising 10th-grade student—and a very religious Zionist Christian—before becoming too ill with tuberculosis and AIDS to stay in school.

"I thought I was bewitched," Litho recalls thinking when she was told the diagnosis, though she now understands that she was probably infected by a boyfriend whom she no longer sees. She became so thin that it was hard to tell if she was a young man or woman. In a wheelchair, too weak to stand and suffering from agonizing pain in her feet due to nerve damage, Litho was "fast-tracked" into treatment at the Hannan Crusaid Clinic in Gugulethu.

Initially, Litho's doctor thought her chances of survival were 50-50 at best. Four months later, however, Litho, while still thin, had regained her strength and resumed her role preparing her younger siblings for school, cleaning the house, and cooking. "I am really, really happy," says her mother, who has been Litho's staunchest supporter. Litho is in the unusual situation of living with both parents in a strongly supportive nuclear family and is open about her status. "My family helped me in the sense that they never judged me because of the disease," she says. "They encouraged me every day." Litho's older sister, Numelca, has also been diagnosed HIV-positive, and has TB. Litho's advice for their younger sister, Lumka: "That immediately when she starts to be sexually active, she must condomize."

AKHONA SAM, 28
OCCUPATION: Mother

Akhona Sam tested positive for HIV during a routine, government-mandated screening while in her eighth month of pregnancy. The diagnosis "came as a shock," she says. "The first thing that came to my mind was death." She was already living a life on the edge. Four months earlier, her baby's father had been killed—shot by police during an armed robbery. And her brother, the youngest of six siblings, had been stabbed to death.

Akhona and her boyfriend had been together for more than two years, but she lived with one of her five sisters and an uncle in what seems to have been a turbulent arrangement. Akhona also has a three-year-old daughter who lives with her previous boyfriend's family.

Though Akhona looked healthy when she began anti-retroviral treatment, HIV had already severely depressed her immune system beyond the optimal point where ARV prophylaxis could reduce the risk of transmitting the virus to her baby. Four months later, Akhona gave birth to Lutho, having done all she could to ensure he was negative, but she was "not yet ready" to have him tested. "I don't want my child to be on treatment," Akhona said. "I just want my child to be negative."

Still struggling to accept that she is HIV-positive, she is fearful of disclosing her status to anyone other than her cousin, Nokuzona (also positive, and thriving on ARV treatment since 2002). Akhona has little emotional support apart from Nokuzona and her clinic counselor. She survives financially on a government child-care grant, and in March 2007 had found a cleaning job—one step closer to her goal of making a home for her new baby.

BULELWA KOTA, AGE 24
OCCUPATION: Mother

When Bulelwa Kota and her partner, Thembisile Ketsiwe, moved to Cape Town from the Eastern Cape in June 2007, they followed the millions who for decades have streamed into South Africa's main cities, fleeing the arid poverty of rural areas. Before migrating, Bulelwa had tested positive for HIV during routine screening while pregnant with their son, Lisakhanya, now three. But she began ARV treatment only in November 2007, when she was referred to the Hannan Crusaid Clinic in Gugulethu.

The couple lived initially in a one-room cardboard shack in the Newrest area of Gugulethu, where alcohol flowed after sundown and Thembisile feared for the family's safety. Four months later, Thembisile found a new spot in Kanaan, another Gugulethu neighbourhood that is close to his sister and extended family. The new neighborhood is quieter and safer—a relief both to Bulelwa and Thembisile, who has found a full-time job in a glass factory, which means more income but long hours away when he works the night shift.

Bulelwa's confidence about her health has increased as the treatment proves effective. She was inspired by her counselor, she says: "The main thing he stressed was that if I didn't disclose [that I was HIV-positive], it will block my way of happiness. I mustn't 'protect' the people who love me. I must just tell them and take it from there, which is what I did." Still, Bulelwa is plagued by the fear that she will infect Thembisile, who is HIV-negative and refuses to use condoms—which, he says, would signal that he is not committed to her.

NTOMBIZANDILE MATI, 25
OCCUPATION: Mother, family helper

The township of Khayelitsha (Cape Town's biggest), where Ntombizandile Mati lives with a cousin and an uncle, is windy, sandy, and desperately poor—home to more than half a million people, most of them migrants from the impoverished Eastern Cape. Previously, Ntombizandile lived with her husband and their two children—her son, Athule, seven, and daughter, Simnkele, two—in Paarl, a wine region an hour away from Cape Town. But she left her husband's home there for reasons she keeps to herself. Her enigmatic story—ejection, or rejection, by her husband's family, who "couldn't take care of" her—is similar to that of thousands of township residents, driven by poverty (and stigma, in the presence of HIV) to the twinkling promise of Cape Town, only to find scant opportunity, insecurity, and poverty. Around 80 percent of Khayelitsha's adults are unemployed. In a further effect of displacement, Ntombizandile's children live not with her but with her mother in a region of South Africa formerly known as the Transkei "homeland," a 10-hour ride by rattling bus from Cape Town.

On the positive side, it is relatively easy to access antiretroviral treatment in Khayelitsha, which Ntombizandile began more than a year after discovering she was HIV-positive, while pregnant with Simnkele (who turned out to be HIV-negative). She had lost a lot of weight and was suffering with "a lot of pains in my body, so painful I couldn't sleep." But Ntombizandile progressed smoothly on treatment. She has gained weight and is now strong enough to assist her cousin, Miselwa, in running a "shebeen," or beer bar, and an informal beauty parlor in her living room. She doesn't have ambitions for herself, but her spirits have improved. "I see myself much healthier and I've gained weight and look beautiful," she says.

OVERALL POPULATION: 47.4 million

NUMBER OF PEOPLE LIVING WITH HIV AND AIDS: 5.5 million. South Africa has the highest incidence of the disease in the world. (Overall, Sub-Saharan Africa had more than two-thirds, or 68 percent, of the world's total number of people living with HIV, and more than three quarters, or 76 percent, of the world's AIDS-related deaths.)

HIV PREVALENCE AMONG ADULTS: 18.8 percent

NUMBER OF PEOPLE ON ANTIRETROVIRAL (ARV) TREATMENT: 428,951

NUMBER OF PEOPLE WHO NEED ARV TREATMENT: 1.7 million

NUMBER OF CHILDREN ORPHANED BY AIDS: 1.2 million

GROUPS MOST AFFECTED BY THE HIV EPIDEMIC IN SOUTH AFRICA: As in the rest of Sub-Saharan Africa, the majority of people living with HIV—61 percent—are women. While the HIV epidemic is of staggering proportions, adult HIV prevalence has started to decline (with some regional variation).

AVAILABLE TREATMENT FOR PEOPLE LIVING WITH HIV AND AIDS: While more than a million South Africans—many of them in rural areas—who are medically eligible do not yet have access to antiretroviral treatment, South Africa's public-health system has succeeded in treating the largest number of people of any country in the developing world.

HIV TREATMENT CHALLENGES: Since 1998, South Africa's president has denied the causal link between HIV and AIDS. Until 2006, this lack of political leadership slowed down the country's roll-out of care and treatment, and prevented millions of timely diagnoses. HIV stigma still occasionally prevents people from getting tested and seeking treatment, but the high prevalence rate and greatly improved accessibility of ARV treatment are making this less common.

IGOR

ALEXEY

russia

photographs by alex majoli

oksana

ASSIGNMENT: RUSSIA

Are the big challenges privileges for strong human beings? I would like to believe that, but it's not true. Both heroes and criminals have that imperturbability I saw in Igor, Alexey, and Oksana. It is not about courage or will, but simply about the tenacious attachment to ourselves: It's hard to die, until the end. Many times I tried to imagine what it means to die alone, as Alexey did. I tried during my visits at the hospital, where his life was ending. I tried after all the phone calls I had with my girlfriend and my daughter. I still have no idea how that must feel.

This is not the first time I've faced AIDS in my life, either professionally or personally. I've worked on the subject various times before, and I've shared many thoughts with close friends affected by the virus. "So why not Russia?" I asked myself when I saw the list of possible countries to work in. I thought of all that Russian literature, from Mikhail Bulgakov to Andrei Makine, the plague, the loneliness among the characters of those novels. The collapse of the Soviet Union has profoundly affected everyone's pride. And this extends to AIDS. They act like they know everything, when in fact they don't. What happens in this situation? The whole story is mainly about stigma, about pride, about the lack of information.

The stories of the people I met are so sad. Igor was really young when he went to prison and his wife was killed. Oksana had emotionally shut down. Alexey was in very bad condition—he had a hole in his hip; you could see the bones—but with the ARV treatment he was already improving. AIDS wasn't Alexey's real problem, however. It was like fighting against a dead man already, because of all his other issues.

By the time of my second trip, most of my subjects had died. I felt sad and angry. As Portuguese poet Fernando Pessoa once wrote, "The four walls of my squalid room are at once a cell and a wilderness, a bed and a coffin. My happiest moments are those when I think nothing, want nothing and dream nothing... I savor without bitterness this absurd awareness of being nothing, this foretaste of death and extinction." Maybe this is what Alexey felt when he died. **—Alex Majoli**

"He's calm—maybe *too* calm. I've told him many times, 'Hey man, move your ass, keep going, keep fighting, you have to survive, *do* something about your life. He's too calm for that."
—ALEXEY VASILYEV, friend of Alexey Smirnov

The Municipal AIDS Center in St. Petersburg *(previous pages)*; the AIDS Center in-patient facility *(above)*, St. Petersburg, November 2007; Alexey Smirnov, 26 *(opposite)*, at the AIDS Center in-patient facility

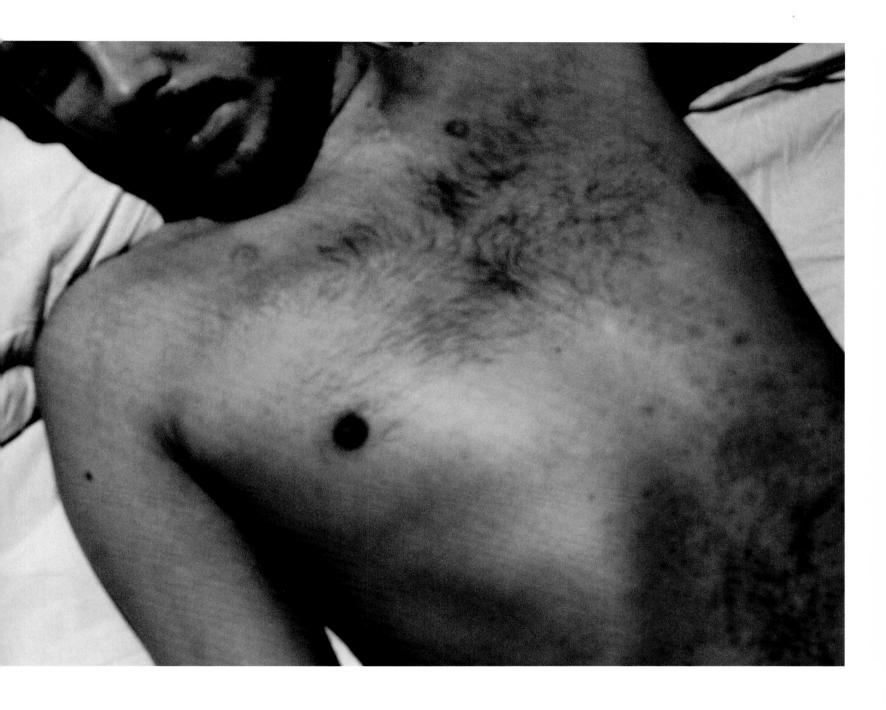

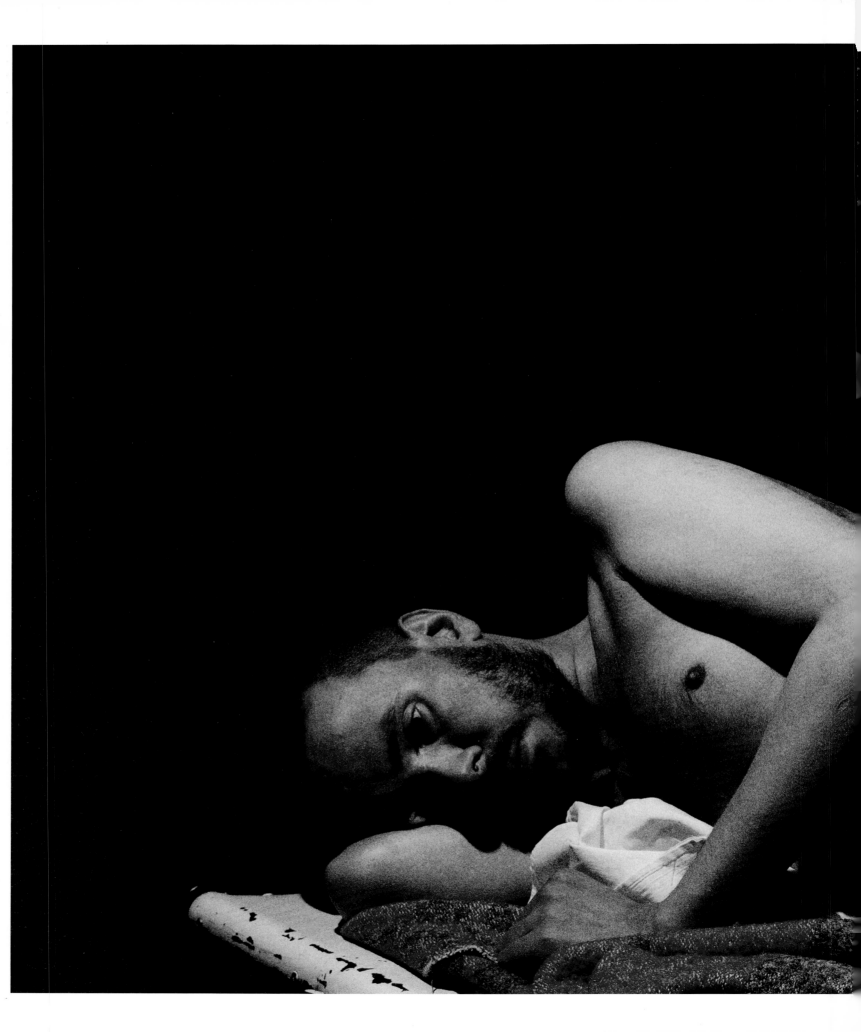

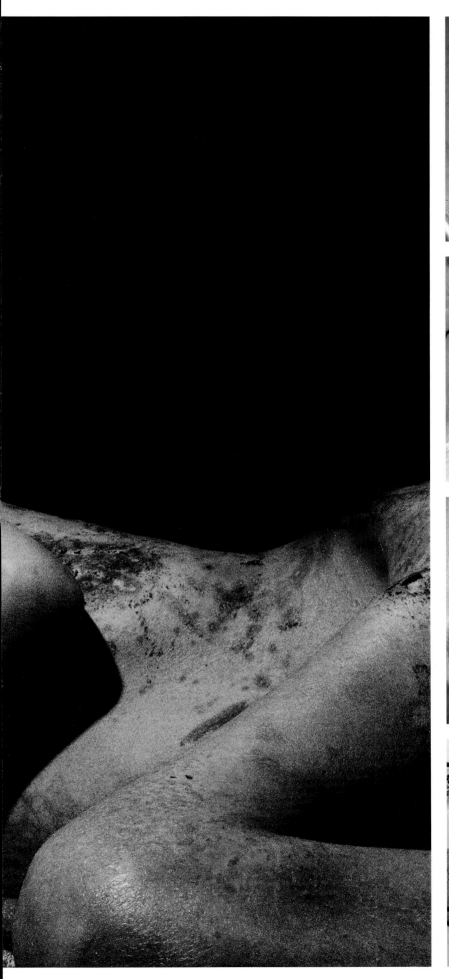

Alexey's ravaged body; in the AIDS ward, where he kept a photo of himself with his estranged wife, Marina *(above left)*, a rare reminder of his pre-AIDS life.

"His father had abandoned him—had refused him and denied him because of [the father's] new wife. So his father came here with the new wife—and, well, I don't know if I did the right thing, but I said everything I thought about his attitude toward his own son. I said, 'He was your boy. You had to be more merciful. You didn't do enough for him when he was alive. Maybe now that he's dead, you can at least bury him in a decent way, like a human being.' I know that he was buried and it was a decent funeral."

—DR. OLGA LEONOVA, *Alexey's attending physician*

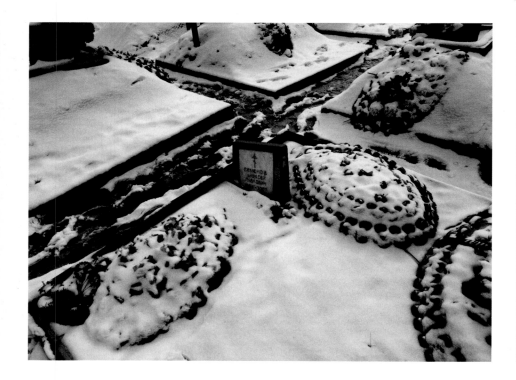

Alexey's snow-covered grave in St. Petersburg *(left)*. The red ribbons *(above)* are a memorial to those who died during the 900-day Siege of Leningrad, which lasted from 1941 to 1944.

"I was really upset about her condition, but it didn't change my attitude toward her in any way. No one is insured against HIV. If you have it, you have to move on, to just continue living. . . . Now that Oksana is taking those drugs, she feels so much better, so she can spend much more time with me and my child. Oksana is my child's godmother. Now we are sure Oksana will always be there to be with us. And that's great."

—VERA, Oksana's friend

Oksana at home with her 12-year-old son, Sergei.

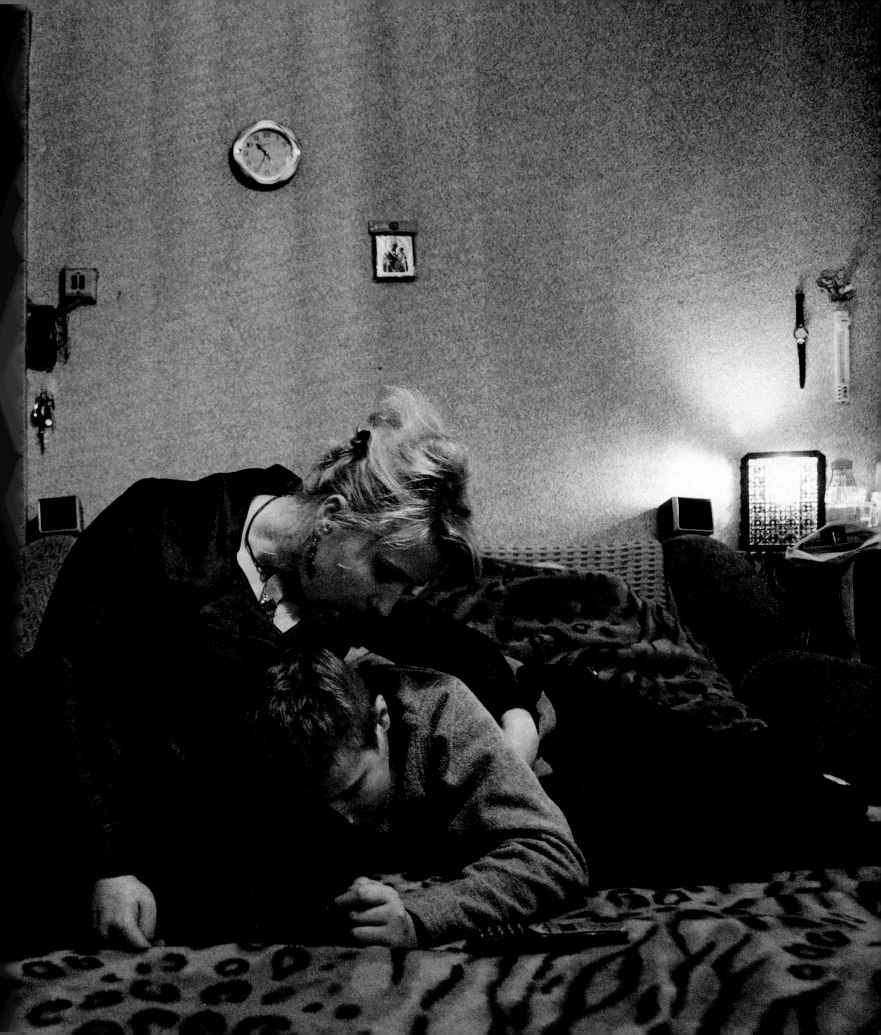

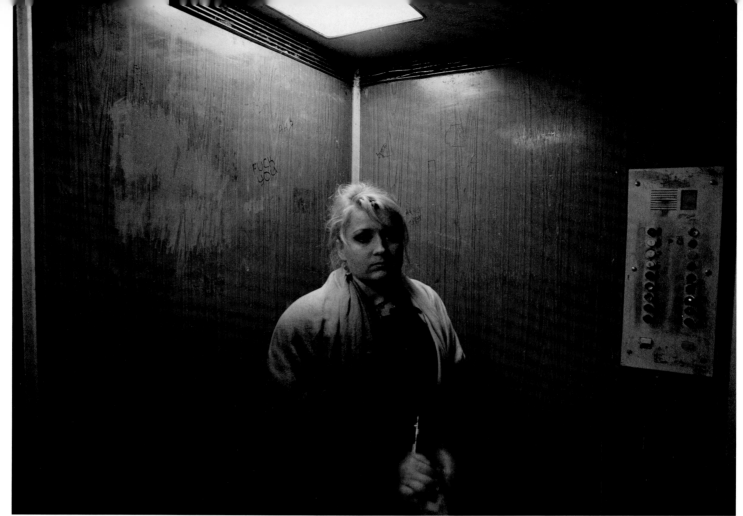

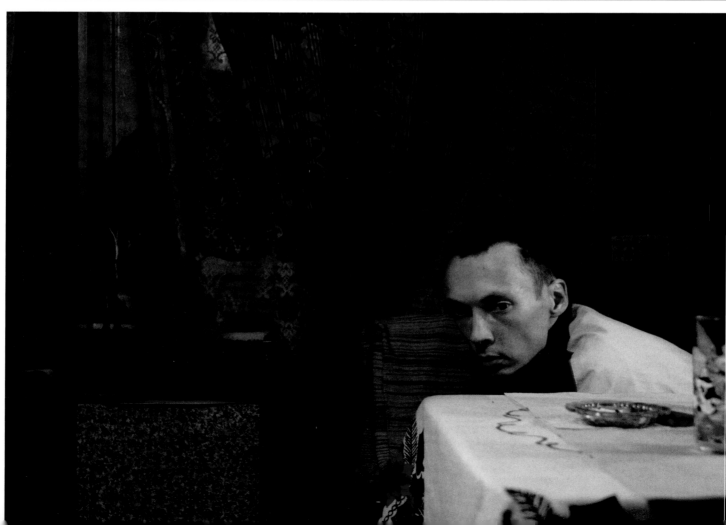

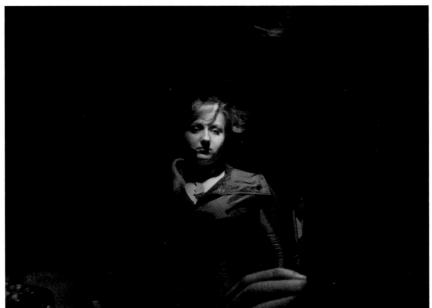

Oksana
(opposite, top)
and her fiancé,
ex-prisoner
German Kho-Shu-De
(opposite, bottom),
who is also on
antiretroviral
treatment.
Some of Oksana's
possessions (left)
at German's
apartment.

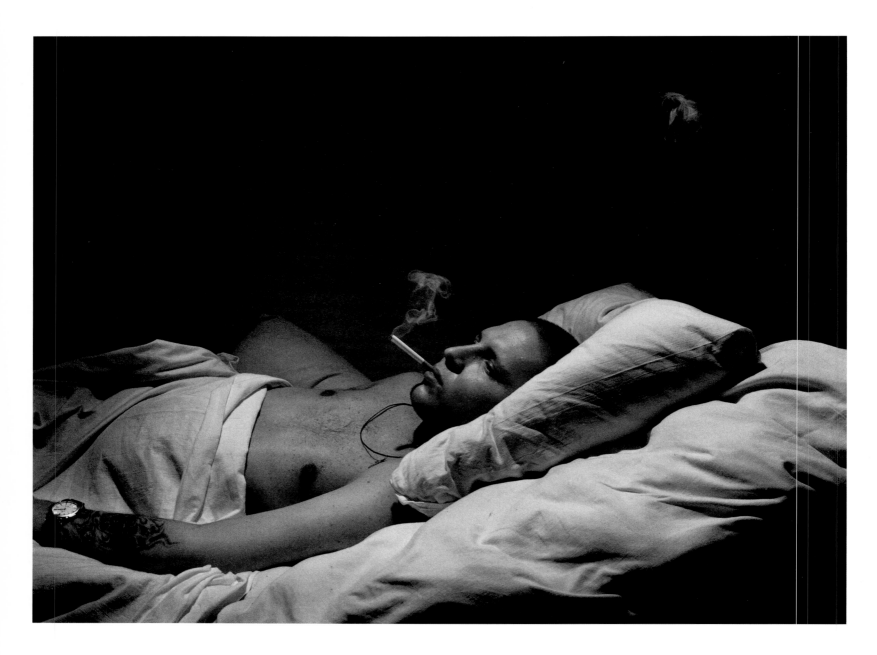

"People used to be afraid of AIDS because of the lack of information.
They used to think that HIV or AIDS was like a plague, so when you touched a person you got
infected right away. But the situation has changed since then."

—IGOR TERESHENKO,
who discovered that he was HIV-positive in 2003

Igor in Ward 3 at the St. Petersburg AIDS Center.

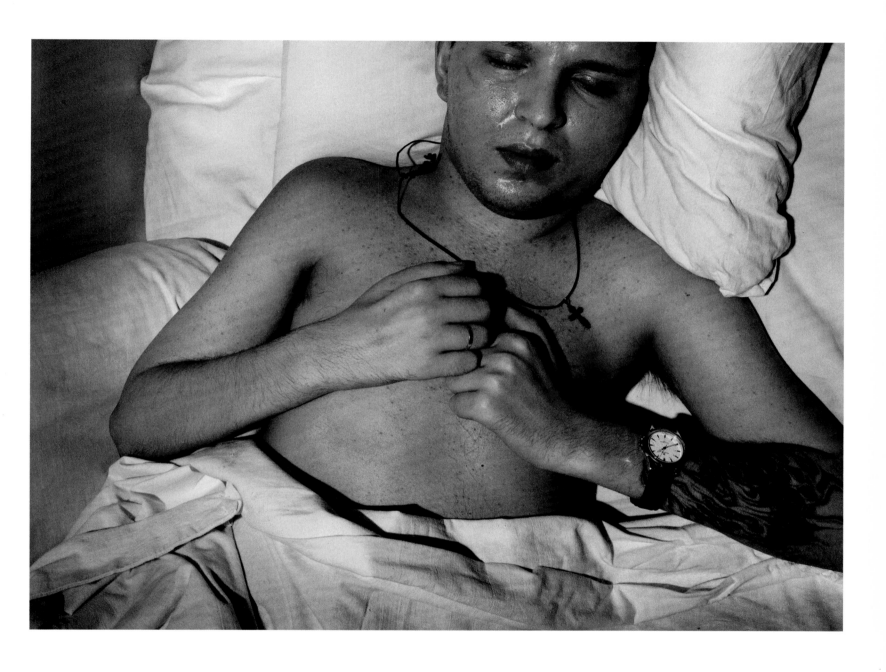

Igor's photo album: Happier days, pre-prison and pre-AIDS.
Igor had been sentenced to serve three years for stabbing one of two men who assaulted his wife.
In a tragic postscript, Igor's wife was murdered in her apartment the day before he was released from prison.

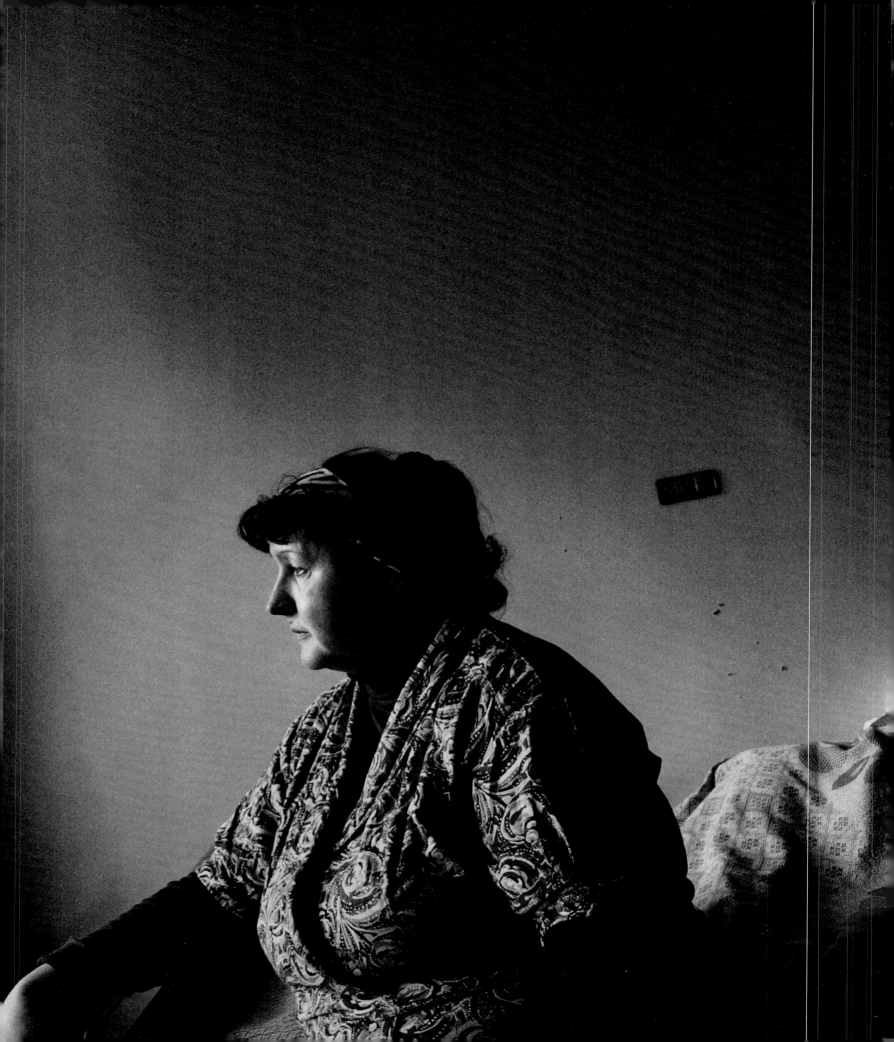

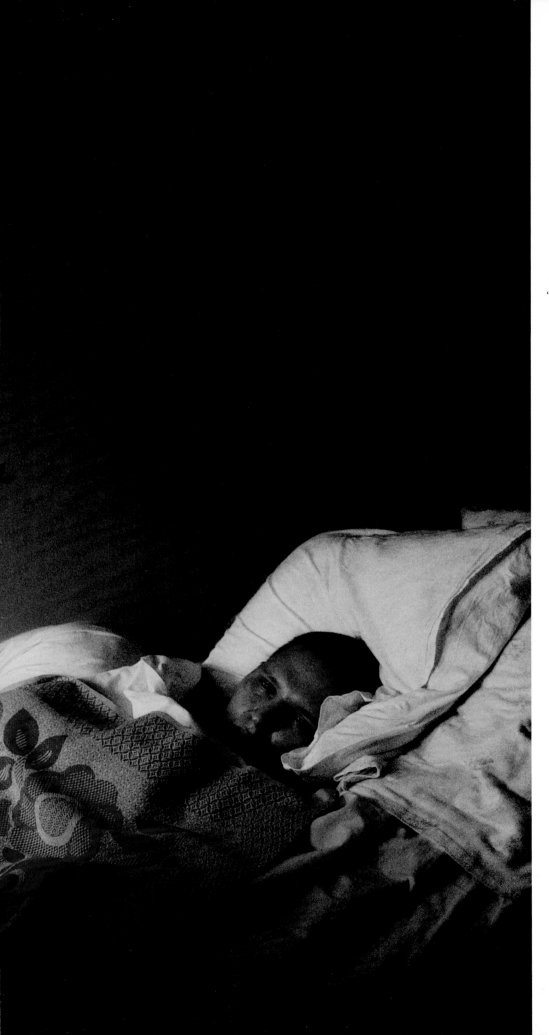

"I was hired by the hospital to work
as a sanitation woman. That allowed
me to spend as much time as I wanted
with my son, and to take good
care of him. But I can't stand it here
anymore. The atmosphere is so depressing,
and I'm so tired. It's just impossible
to see your own son in this condition."
—TAMARA VALENTINOVA TERESHENKO,
Igor's mother

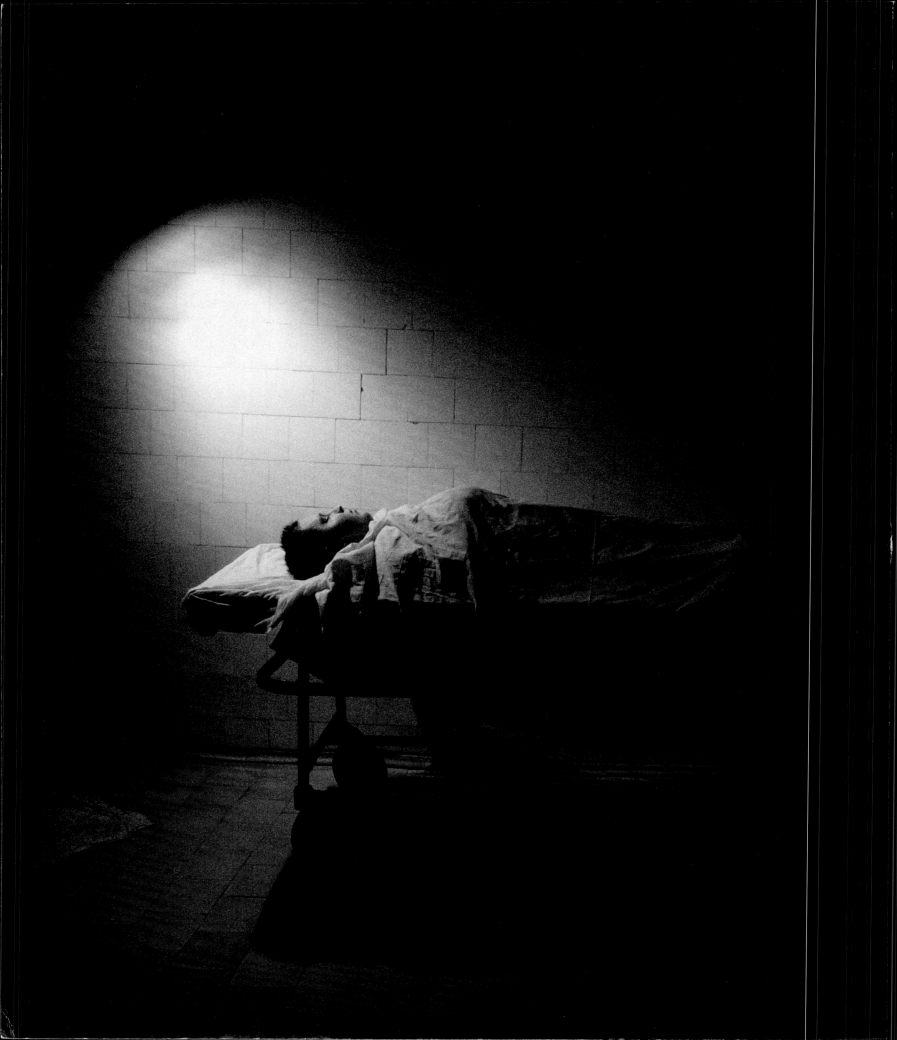

Igor's body at the morgue
in St. Petersburg, March 2008,
the night after he died.

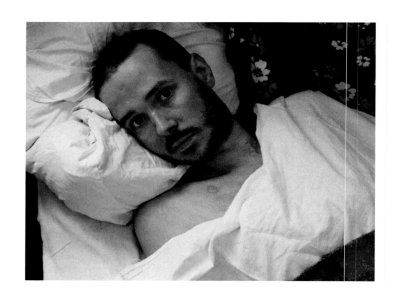

ALEXEY SMIRNOV, 26

OCCUPATION: Manager, print shop

The odds of surviving were always against Alexey. Like many AIDS patients, he suffered from multiple illnesses, many of them serious. He was first admitted in November 2007 as an in-patient at the St. Petersburg AIDS Center when his legs "stopped working." He had been in "a desperate state" when he was hospitalized, according to his doctor, after suffering from hepatitis for a year without medical attention. His lack of treatment underscored another huge problem in Alexey's life—that nobody seemed to care. "None of his relatives and friends tried to get him to a medical facility for help," his doctor said.

In fact, Alexey had been "scared, but not that scared" when he discovered in 2001 that he was HIV-positive. He thought he had been infected in 1999, through heroin injection, but began experiencing symptoms only in 2006. At that point, nobody stepped in to help him. Though married and jointly renting a room in an apartment shared with several other families, Alexey and his wife, Marina, were estranged, and their two children—one of whom, Nadia, Alexey spoke of often—live in Vladimir, a town near Moscow, with Marina's parents. Alexey's non-AIDS-related medical problems overwhelmed his system just six weeks after he began antiretroviral (ARV) treatment, and he died on December 29, 2007. (The official cause of death was alcohol intoxication.) "Nobody was interested in his life, his health, and his well-being," said his doctor. "I think Alexey died because he was too psychologically depressed. He had no life in his eyes. I think life had lost meaning for him."

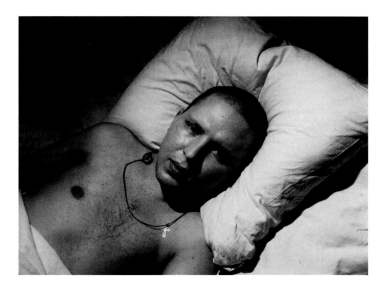

OKSANA NIKANDROVA, 29
OCCUPATION: Manager, food store

When Oksana found out she was HIV-positive in 2001, after being tested as an outpatient at the AIDS Center, she was "on the brink of committing suicide." She became seriously ill late in 2007 and was referred to a local hospital for antiretroviral treatment. She had learned of the treatment from a friend, German Kho-Shu-De, who has since become her fiancé. German had begun his own ARV treatment regimen the previous year.

Within one month of starting her ARV treatment in November 2007, Oksana, who had been constantly fatigued and susceptible to colds, noticed a "dramatic difference" in how she felt: "The effects were especially obvious when the lab results came in for my CD4 count [measure of immunity]. That made the therapy really tangible and visible," she remembers.

Though Oksana's treatment experience has been easy, she remains wary in the face of the ongoing stigma in Russia against people who have AIDS. She lives with her 12-year-old son, Sergei, and her mother. Her sister is aware of her medical status, Oksana says, but "doesn't realize what it means." Oksana continues to manage a small food store but is reluctant to disclose her status there: "You never know how people will react. I don't want anyone at my work to know I'm HIV-infected. I don't want this unnecessary compassion, either."

She is heartened by her friends' casual approach to the subject of HIV: "They treat me like a normal person. They try not to remind me that I'm ill, and that's their best support."

IGOR TERESHENKO, 24
OCCUPATION: Construction worker

Like many among the "lost generation" of young Russians cast adrift into an insecure future after the collapse of the Soviet Union, Igor, a former construction worker, was a heroin addict. He knew he had been infected by a dirty needle, but wasn't sure when, and found out that he was HIV-positive in 2003, while in prison serving a three-year term for stabbing one of two men who had attacked his wife on the street. (In a sad postscript, his wife was murdered the day before Igor was released from prison.) Igor remained healthy for years after his diagnosis but contracted pneumonia in early 2007. Then, in the summer of 2007, he became paralyzed from the waist down after injecting heroin. At the St. Petersburg Municipal AIDS Center, doctors told him he had suffered a spinal injury of some sort (Igor claimed the ambulance team had beaten him up). The condition forced him to lie motionless, leading to the development of massive bed sores. In fact, doctors discovered he was suffering from a cancerous tumor. Igor's parents were both strongly supportive. His mother became a cleaner at the hospital, which enabled her to sleep in his room at night and provide constant care.

Igor had begun antiretroviral therapy four months before his death on March 18, 2008, from cancer. Although he had made excellent progress with a relatively high CD4 count (his immune system had strengthened) and an undetectable viral load, his doctors decided to discontinue his ARV treatment when they realized that he would soon die from his inoperable spinal tumor.

OVERALL POPULATION: 143.2 million

NUMBER OF PEOPLE LIVING WITH HIV AND AIDS: Approximately 940,000 people are infected nationwide; in St. Petersburg, the number as of 2008 was estimated at 60,000 to 90,000. The Russian Federation has the biggest AIDS epidemic in Europe.

HIV PREVALENCE AMONG ADULTS: 1.1 percent

NUMBER OF PEOPLE ON ANTIRETROVIRAL (ARV) TREATMENT: 31,094

NUMBER OF PEOPLE WHO NEED ARV TREATMENT: 190,000

GROUPS MOST AFFECTED BY THE HIV EPIDEMIC IN RUSSIA: Injecting drug users, commercial sex workers, men who have sex with other men, and prisoners have the highest infection rates. Heterosexual transmission is on the increase.

RUSSIAN SOCIAL ATTITUDES TOWARD HIV: There is a huge social stigma against the disease, prompting considerable discrimination in the workplace against people known to be HIV-positive. Health-care providers are themselves often stigmatized.

AVAILABLE TREATMENT FOR PEOPLE LIVING WITH HIV AND AIDS: A national governmental commission on AIDS was established in October 2006; a new Federal AIDS program for 2007–2011 has been adopted. ARV treatment became more widely available in 2005 through the Global Fund.

HIV TREATMENT CHALLENGES: The size of the country and the autonomy of the various regions make it difficult to coordinate treatment activities. Lack of comprehensive sex- and drug-education programs in schools hampers effective prevention work among young people. A rise in the incidence of tuberculosis among patients with HIV or AIDS is a serious and growing concern.

BIGGEST PROBLEM: Since the majority of people who seek HIV-related care are already critically ill by the time they enter the healthcare system, it is sometimes too late for ARV treatment to work.

TOBHA

zweli

swaziland

siphiwe

photographs by larry towell

khaya & tenele

ASSIGNMENT: SWAZILAND

If a journalist's job is to monitor power, one way of doing so is to spend time with the powerless. The patients I photographed in Swaziland were mostly women who'd been infected by their husbands and who then passed on the virus to their children at birth, through their blood.

Tobha (Nzima), one of my favorite patients, had two partners and a child who had died of AIDS. She currently has one child who is HIV-positive and one who is not. She also has a 32-year-old brother and two sisters who are infected. This is a normal nuclear family in Swaziland, where 1 person in 4, or 1 woman in 3, is HIV-positive.

Tobha lived on top of a hill overlooking a small lake, fields, and livestock. She went to sleep at night in the same bed as her children. She rose at dawn, prepared them for school, fed the chickens, and walked down the road to clean someone else's house and take care of someone else's family. Then, when the sun was low, she returned home to cook supper on an open fire. She gathered the eggs and fed corn and oats to the chickens again. She looked down from her little hilltop world and saw only hopeful things around her—her mother, her garden, her children, her neighbor's children—all her reasons for living. She felt blessed. She seemed cursed, but she felt blessed. **—Larry Towell**

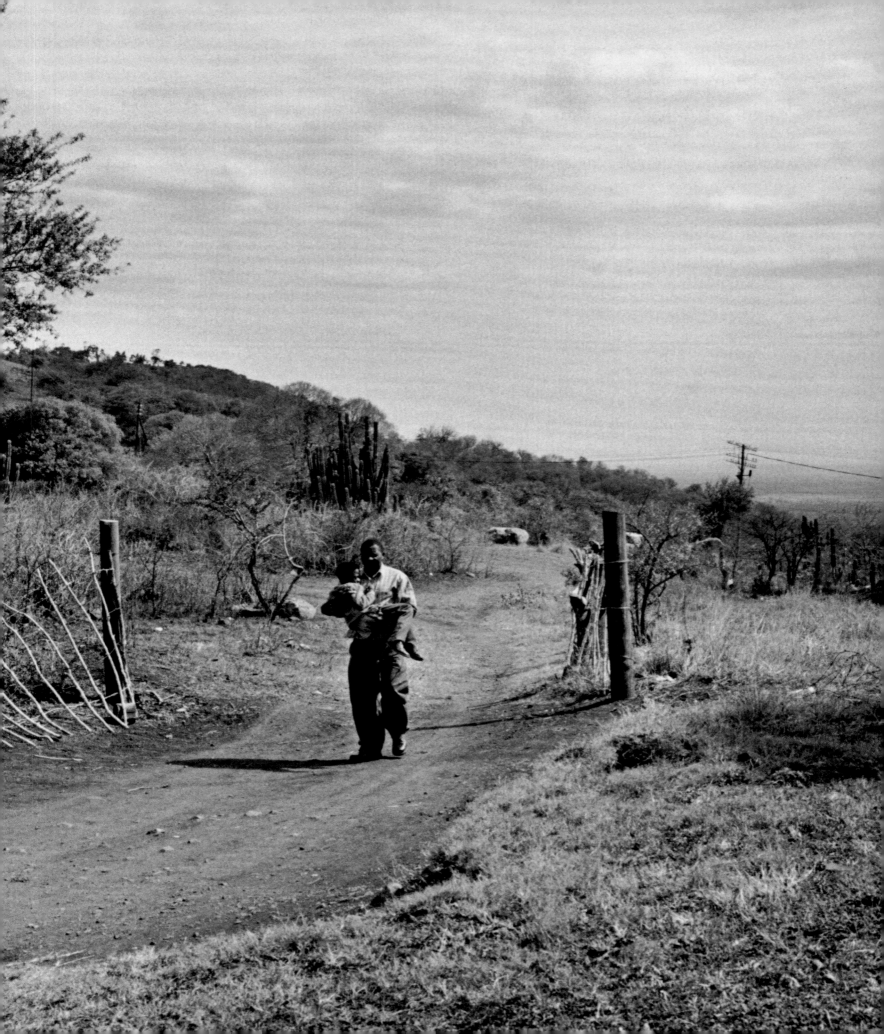

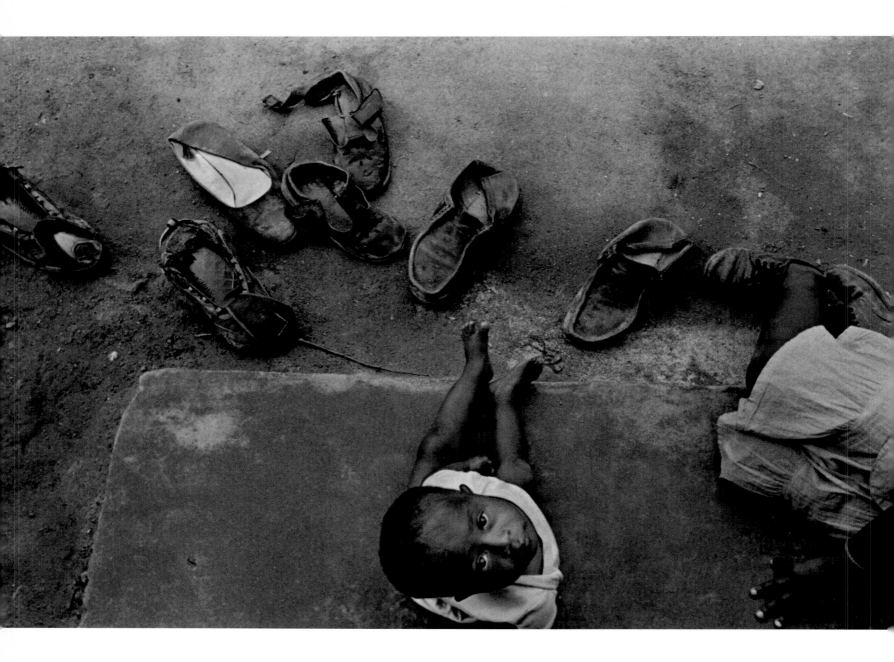

"I tried to take my children to traditional healers, but they couldn't get well.

Tenele *{above}* was so sick that she couldn't walk or crawl or sit.

But now she's walking—she's running! I'm going to tell my children that being HIV-positive doesn't

mean you're going to die. It's the other way around: You'll live, like Tenele."

—SIPHIWE TFUMBATSI, Tenele's mother

Siphiwe *(opposite)* with her new infant daughter, Nozwelethu, also known as "Mazwi," who is HIV-negative.

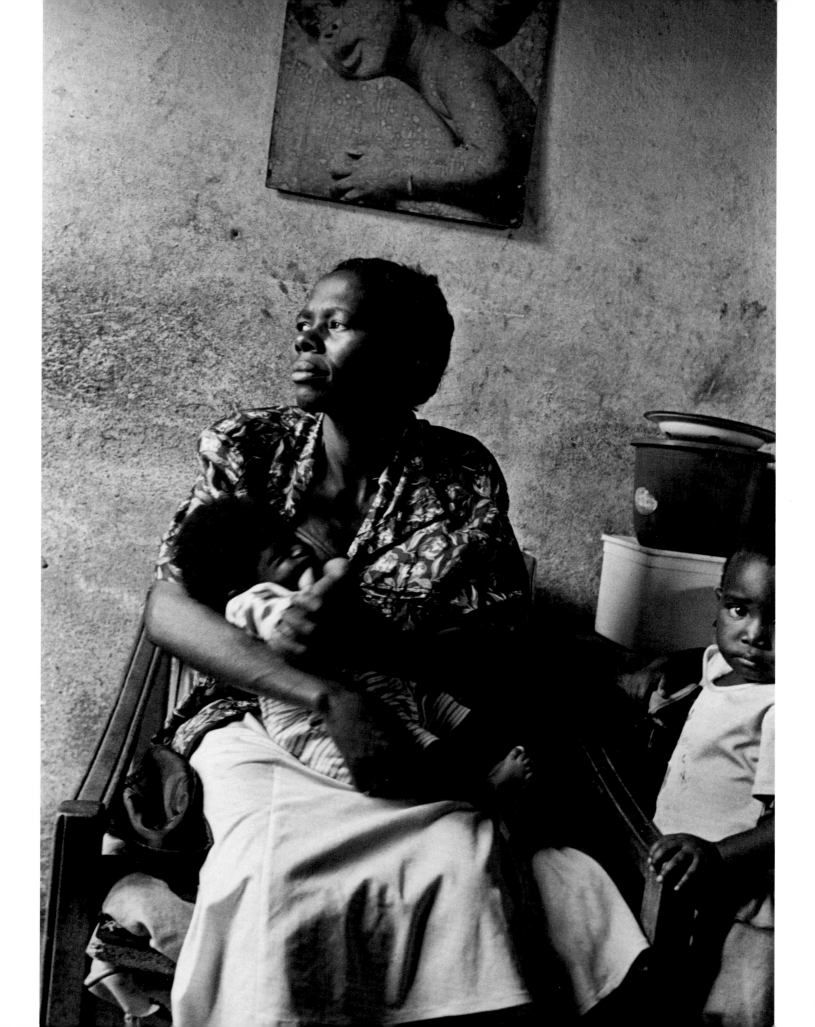

Siphiwe's home in Mbabane: Tenele *(lower left)* has been on ARV treatment for a year, while her four-year-old brother, Khaya *(opposite)* started treatment in October 2007.

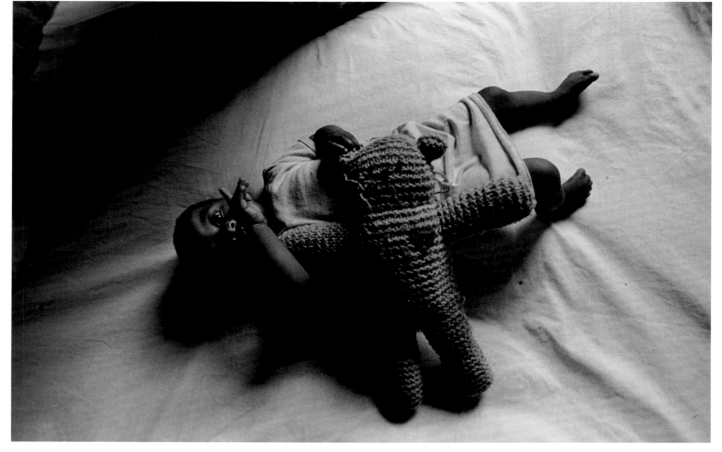

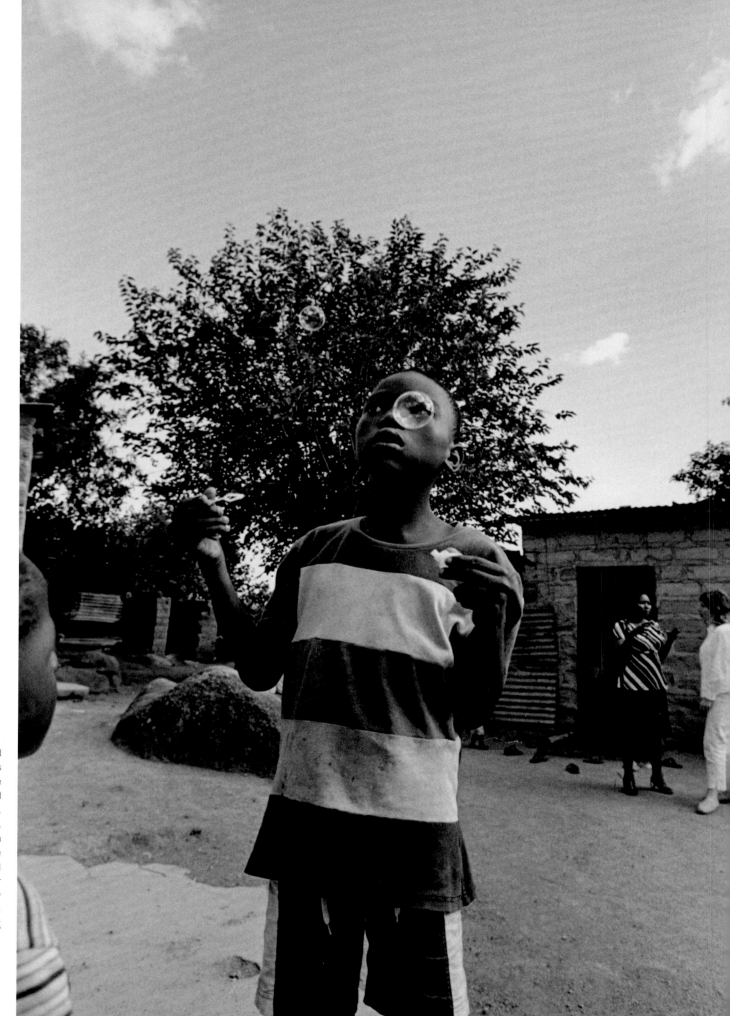

Neighborhood children are always playing in Siphiwe and her husband Themba's front yard. Like many Swazis, Siphiwe and Themba both came to the capital from a rural area to look for work. Siphiwe now sells snacks from a stand bordering this yard.

"You see, men in Swaziland, they don't want to have *one* partner. They take it as Swazi custom to have many partners. Whereas the mother, the wife, or the girlfriend, you find that they stick to him alone. So I can say to you that when you get that disease, it's just from the men. I don't know how you cope with this, especially when it's your husband. There's nothing you can do. You just stay with those problems you are facing."

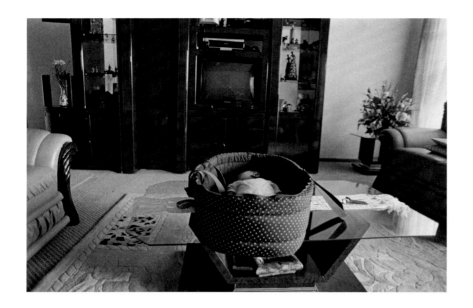

"I feel that now that I'm strong,
I am able to do every job that I'm supposed to do.
I'm proud of myself, in everything."
—TOBHA NZIMA

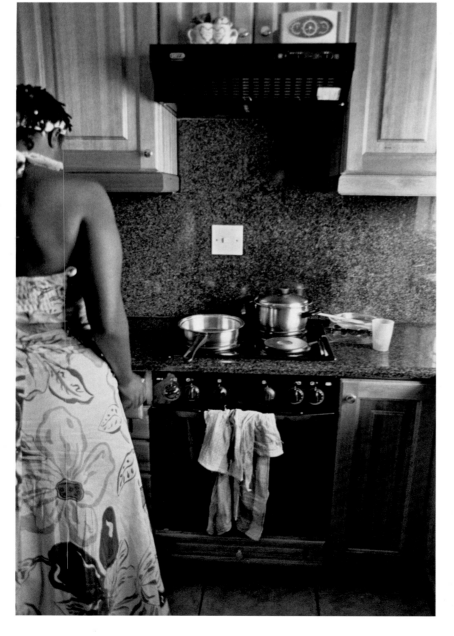

At the
Baylor Clinic
in Mbabane *(left)*:
Tobha was infected
by one of her
two previous
partners, both
of whom died.
Tobha *(opposite)*
at work in the
home of her
employers, a
wealthy Swazi
family, whose new
baby, Smekatle
(opposite, top),
Tobha looks after.

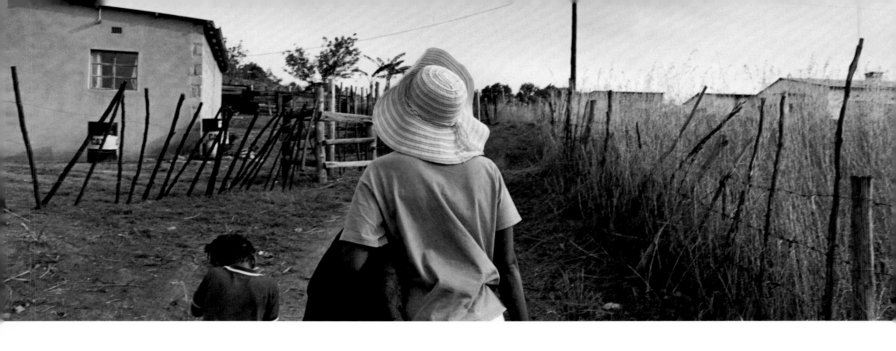

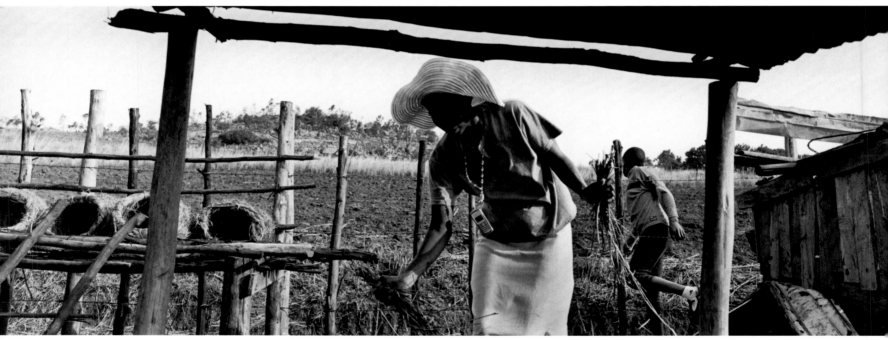

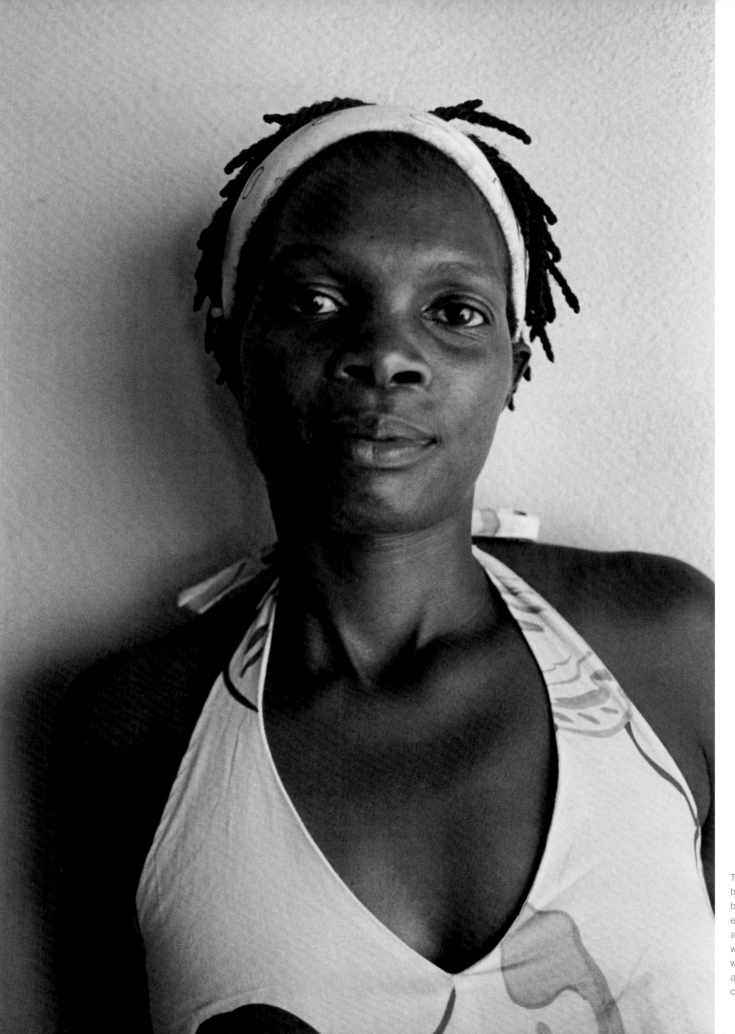

Tobha shuttles back and forth between her employers' house and her family's working farm, with its chickens and communally cultivated fields.

ZWELI SIHLONGONYANE, SIPHOFANENI

"In this community they don't
know about HIV, don't know how to
handle it. They are harassing each
other about it."
—ZWELI SIHLONGONYANE

Zweli lives with his family in the poor, desolate hamlet of Siphofaneni,
about an hour from the capital of Mbabane. His own brother, Kwanele, 22,
finds it too painful to talk about Zweli's disease: "I have nothing to say."

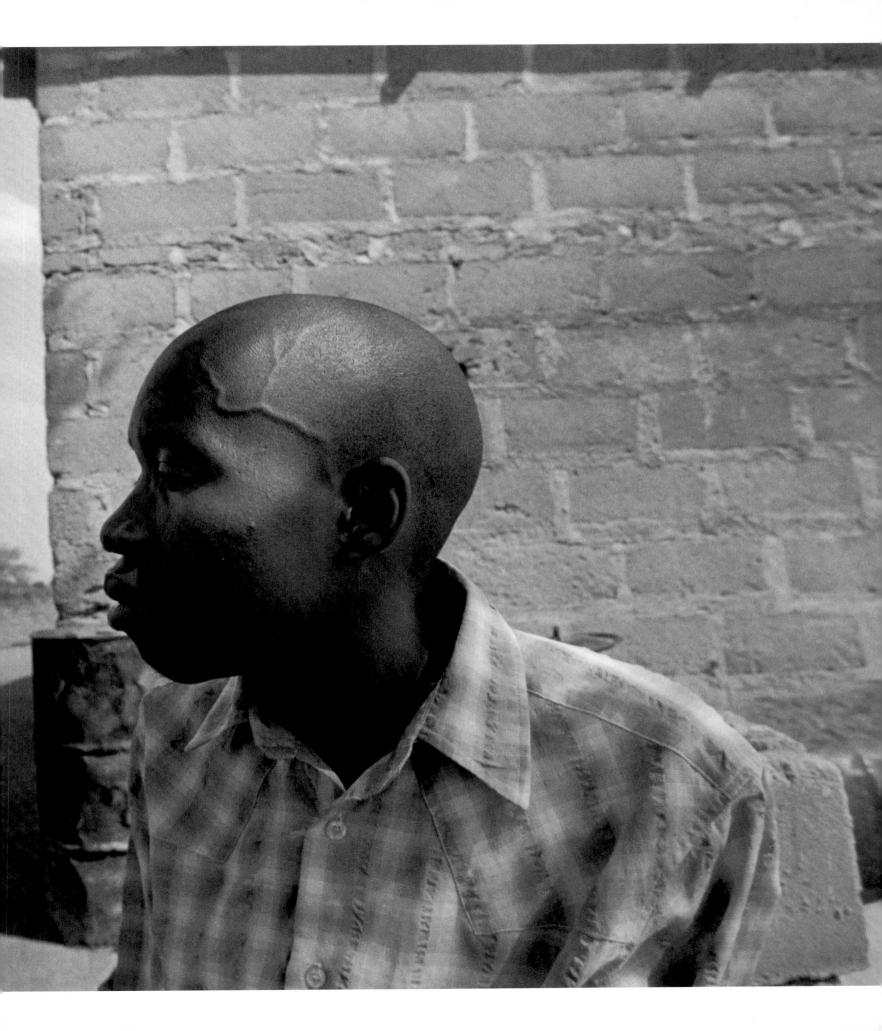

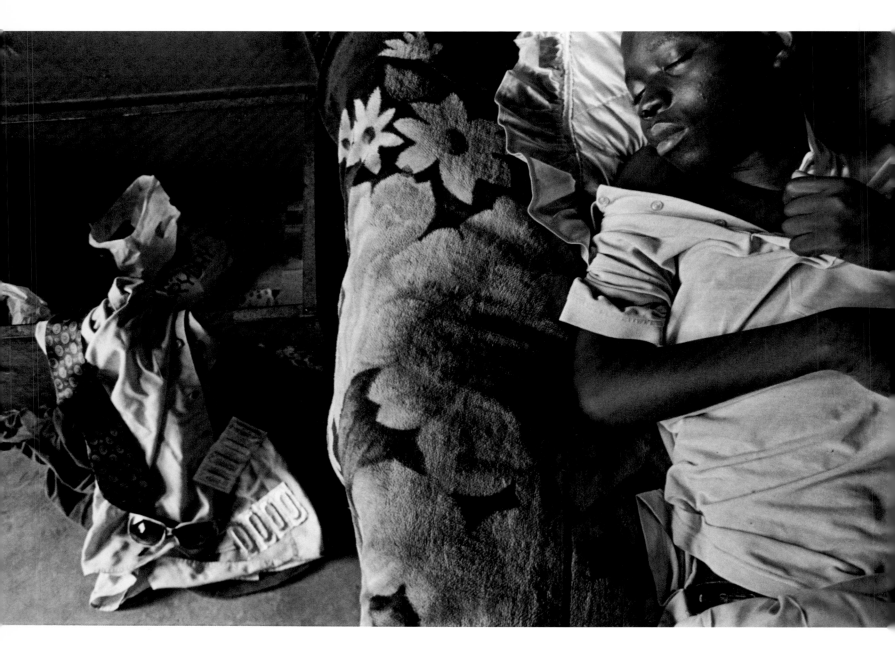

"Even now I can't accept that Zweli is positive… I would like to urge all people to get tested.

Knowing your status is the only way to live. People with HIV are not prostitutes.

You can get it many different ways. Don't blame anyone. You don't need to know where you got it.

Know your CD4 count, accept your status, live longer, go ahead with life."

—VUKILE
Zweli's sister, 21, who is also HIV-positive

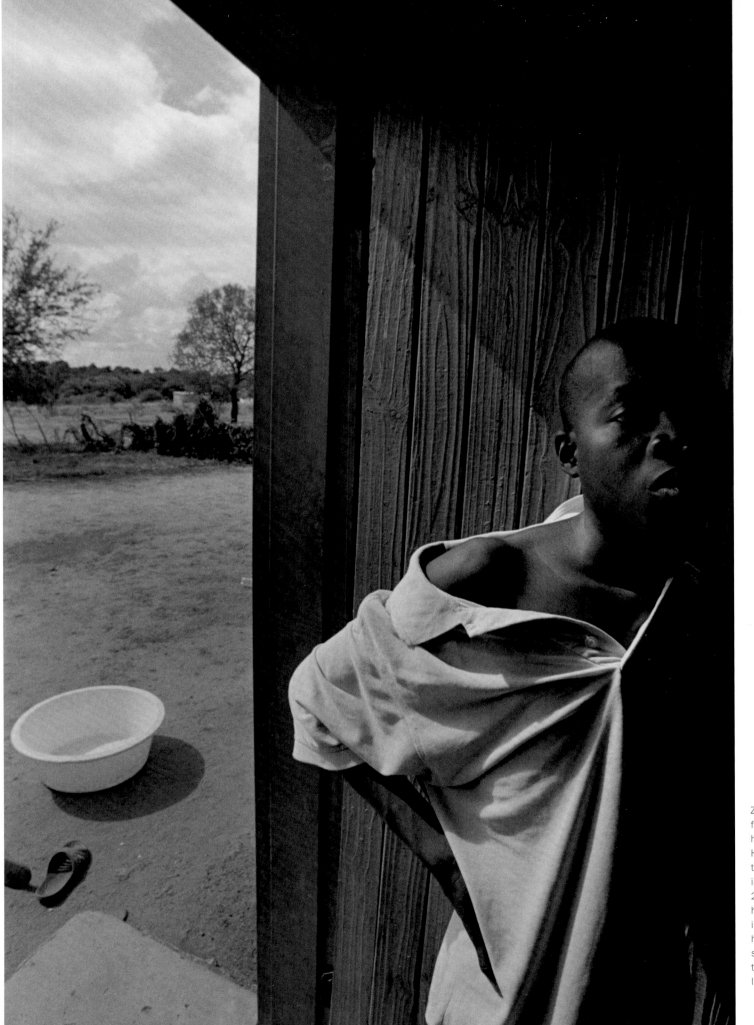

Zweli at his family's homestead. He began ARV treatment in October 2007, and his health has improved. But he is not yet strong enough to work a manual-labor job.

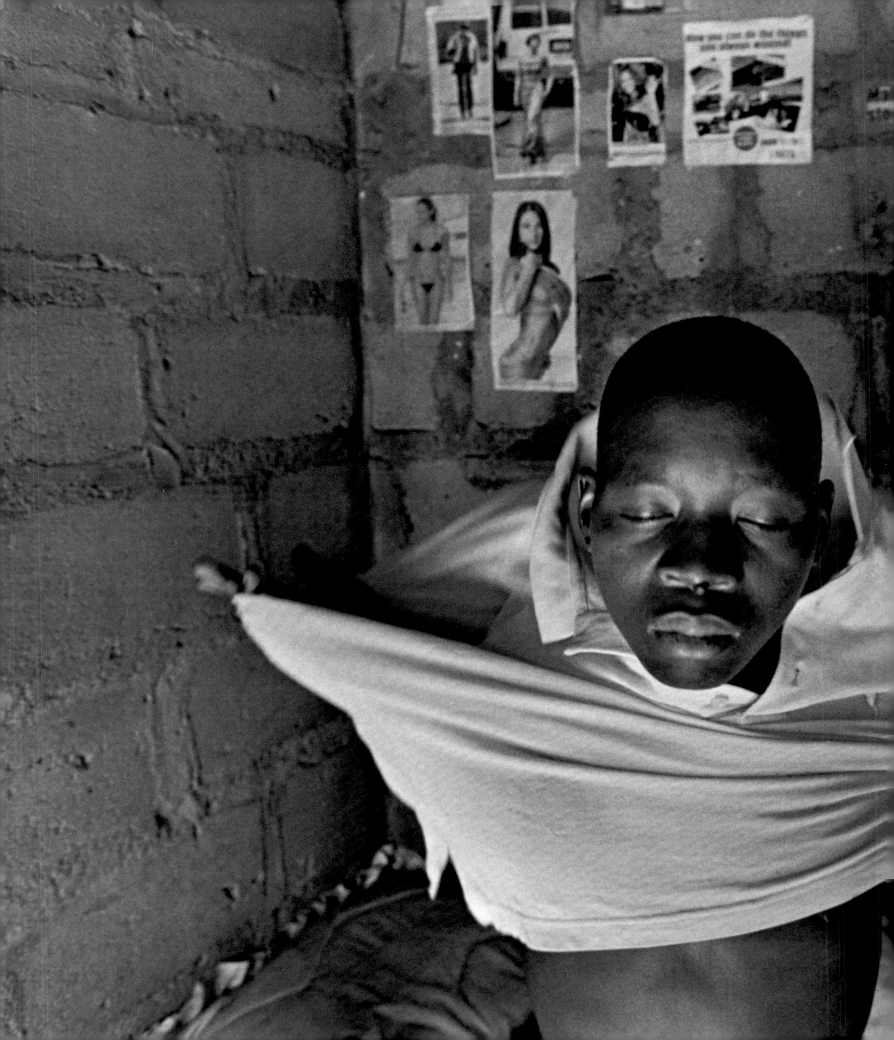

"It's much better; it's not like before," says Zweli, who before ARV treatment suffered from sexually transmitted infections and chronic diarrhea. He continues to suffer from Kaposi's sarcoma, an HIV-related skin cancer. ARV medicines can help in treating Kaposi's sarcoma. Zweli is receiving chemotherapy as well.

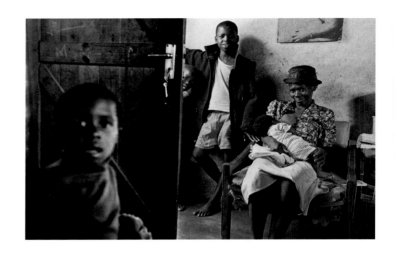

SIPHIWE TFUMBATSI, 35
KHAYA MATABELA, 4, TENELE MATABELA, 2
OCCUPATION: Mother, part-time snack seller

The Matabelas are suffering more than most families in Swaziland (a poor, postage-stamp-sized country surrounded by South Africa and Mozambique), which has the highest rate of HIV infection in the world (1 in 4 adults between the ages of 15 and 49). Siphiwe is HIV-positive and so is her husband, Themba. So, too, are two of Siphiwe's five children—Khaya, age 4, and Tenele, age 2. Nozwelethu ("Mazwi"), born in January 2008, was HIV-negative when tested at six weeks, but the couple has decided not to have any more children. "If you have this disease," says Themba, who works as a gardener, "it's not good to have kids."

Siphiwe is not sure how she became infected. She came to Mbabane, the country's capital city, from a rural area looking for a job as a domestic worker. She met and married Themba, 38, who was working next door as a gardener. They now live in a two-room, cinder-block house on a small, boulder-strewn plot of land that was once part of a much larger family homestead. Themba cuts grass when he can afford to rent the equipment. Siphiwe sells snacks at a stand bordering their yard and looks after their own as well as some neighbors' children. Tiny Tenele was the first in the family to begin treatment, in 2006; Siphiwe was diagnosed as HIV-positive at the same time as Tenele. All four HIV-positive family members are now in treatment.

Buoyed by Themba's Zionist Christian faith and the couple's steadfast support for each other, the Matabelas are optimistic about their family's future. Still, Siphiwe remains reluctant to talk about her treatment. She's scared that people will have a negative attitude toward her and think that "she's not supposed to live."

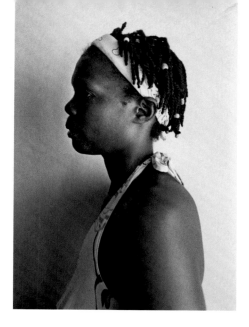

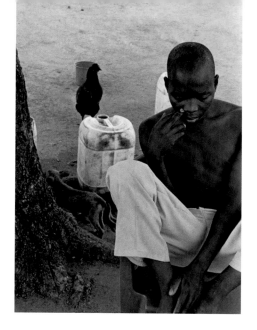

TOBHA NZIMA, 35

OCCUPATION: Domestic worker

For over a decade, Tobha's life has been profoundly—and negatively—shaped by desperate encounters with AIDS.

In 1999, she lost her first partner to AIDS. Two years later, their eight-year-old son, Sakhile, suddenly succumbed to the disease, just a week after starting antiretroviral (ARV) treatment. The only daughter of that union, Nokwanda Masuko, now 16, is also HIV-positive.

Then in 2004, when Tobha was three months pregnant with Ndududzo (now five) by her new partner, the father of the yet-to-be-born child died of the disease. And Tobha herself, who is a domestic worker for a wealthy Swazi family near her family homestead, is also HIV-positive, infected by one of her two previous partners.

One of Tobha's more difficult recent challenges has been convincing her teenage daughter (who, with Ndududzo, lives with their grandmother while Tobha works) of the importance of continuing to take her ARVs. Baffled by why she is HIV-positive in the first place, Nokwanda has insistently told her mother that she hasn't "slept with a boy"—classmates had told her that having sex led to HIV. Nokwanda, who began treatment in October 2007, had a lapse in taking her medicine. But with the help of local health workers, Tobha—a practicing Seventh-Day Adventist and relentless optimist—has explained to Nokwanda that she contracted HIV from her mother. "I had to sit down and tell her everything," Tobha reports. "This is your life and you have to take this for the rest of your life. There is nothing else we can do... I wish for Nokwanda a brighter future." As for herself, Tobha adds, "since I started treatment, I already see my future coming bright."

ZWELI SIHLONGONYANE, 18

OCCUPATION: none

Drive through the green hills of Swaziland and about an hour from Mbabane, the capital city, you will come upon the poor, dry town of Siphofaneni. Zweli lives in a nearby hamlet, in a tiny, two-room cinder-block house with his sister and two younger brothers. His older half-brother and mother live in the same compound. There is no running water or electricity, and only a few neighbors' homesteads are nearby. The town's dusty main street, 100 meters long, has just a few market stalls; Zweli's mother sells fruit in one. She is the family's sole breadwinner. Zweli had to drop out of high school because his family could no longer afford the fees. Days are spent in an outside kitchen and communal space under an old tree, where the family often sits listening to the radio for entertainment.

Zweli suspects he contracted HIV from a sexual encounter "a long time ago," probably when he was 15 or 16 (he says he hasn't had sex since). Chronic diarrhea, nausea, and loss of appetite drove him to a clinic to get tested and treated in early 2006. He initially resisted ARV treatment until his peers at an adolescent HIV support group persuaded him to start.

Even so, Zweli's future doesn't inspire much confidence. While his family—including his sister, Vukile, 21 (who is also HIV-positive)—form a solid support network, Zweli is unemployed, and not strong enough to undertake manual labor. Finding bus fare to get to Mbabane for HIV check-ups and for chemotherapy to treat his Kaposi's sarcoma, an HIV-related skin cancer, is a constant challenge. His spirit, however, remains strong. Though he knows it's unrealistic, Zweli nurtures dreams of becoming an R&B artist. "I know that life goes on even though I am HIV-positive," he says.

OVERALL POPULATION: 1 million

NUMBER OF PEOPLE LIVING WITH HIV AND AIDS: 220,000. Southern Africa is considered the epicenter of the AIDS pandemic, accounting for more than one-third of all people worldwide living with HIV.

HIV PREVALENCE AMONG ADULTS: 25.9% (31% among pregnant women). The extremely high prevalence is influenced by the ongoing practice of "multiple concurrent partners," the economic disempowerment of women, and migrant labor.

NUMBER OF PEOPLE ON ANTIRETROVIRAL (ARV) TREATMENT: 24,535

NUMBER OF PEOPLE WHO NEED ARV TREATMENT: 59,000

NUMBER OF CHILDREN ORPHANED BY AIDS: 110,000

SWAZI SOCIAL ATTITUDES TOWARD HIV AND AIDS: There is a powerful stigma attached to being HIV-positive, and open discussion about it is still inhibited, despite the high prevalence and widespread awareness campaigns. Swazi men in particular are often unwilling to discuss HIV or to practice safe sex, and sexual behavior has not changed appreciably as a result.

AVAILABLE TREATMENT FOR PEOPLE LIVING WITH HIV AND AIDS: All government hospitals and primary health-care clinics are equipped to manage HIV, either offering treatment directly or providing counseling and testing, with referrals to treatment centers. Several Global Fund-supported national programs since 2003 have enabled the Swazi government to provide free antiretroviral treatment countrywide.

HIV TREATMENT CHALLENGES: Many of those infected with HIV live in isolated areas (most of the population is rural) and can't afford to travel to get treatment, even though such treatment is free. Because of the social stigma attached to the disease, many avoid testing or begin treatment too late, when they are already extremely ill. Many don't want to seek treatment close to home for fear of being identified as HIV-positive.

NGUYEN

DUONG

vietnam

photographs by steve mc curry

nguyen

I had photographed AIDS patients before, but this assignment was different. It offered me the chance to see the positive results of the new AIDS treatments. The plan was that I was to meet people who, thanks to outside funding, were being given free treatment that would keep them alive. The majority of people who get treatment, I was told, can return to normal lives. So I began the assignment thinking I'd start with people who were very sick but who would then have some dramatic turnaround. It didn't turn out that way.

Luong was a young woman who had just married at 19, had a small child, and expected to live a typical farmer's life in the countryside. Out of the blue, she learned that her husband was dying from AIDS—and that she too had been infected with the virus. Knowing free treatment was available was the one thing that gave her a little bit of breathing room.

Luoc said he and his brother had shared a needle to inject vitamins, but his brother was infected with AIDS at the time. Why hadn't he known better? It's hard to know whether he had ever received information about the ways that HIV is spread, or if he just hoped it wouldn't happen to him.

The third person I photographed was Tiep. She had a breakfast stall in the market that was her family's main source of income. But once people learned that her husband, Khanh, had AIDS, many of them stopped buying food from her. Yet Khanh represents the positive side of the AIDS story; he's now recovering and knows it wouldn't have turned out this way had he not received free treatment.

Many of us are in a position to help others, but few of us are aware of what we can do—or what a difference our contribution can make. I hope my photographs help people become more informed and find a way to contribute. **—Steve McCurry**

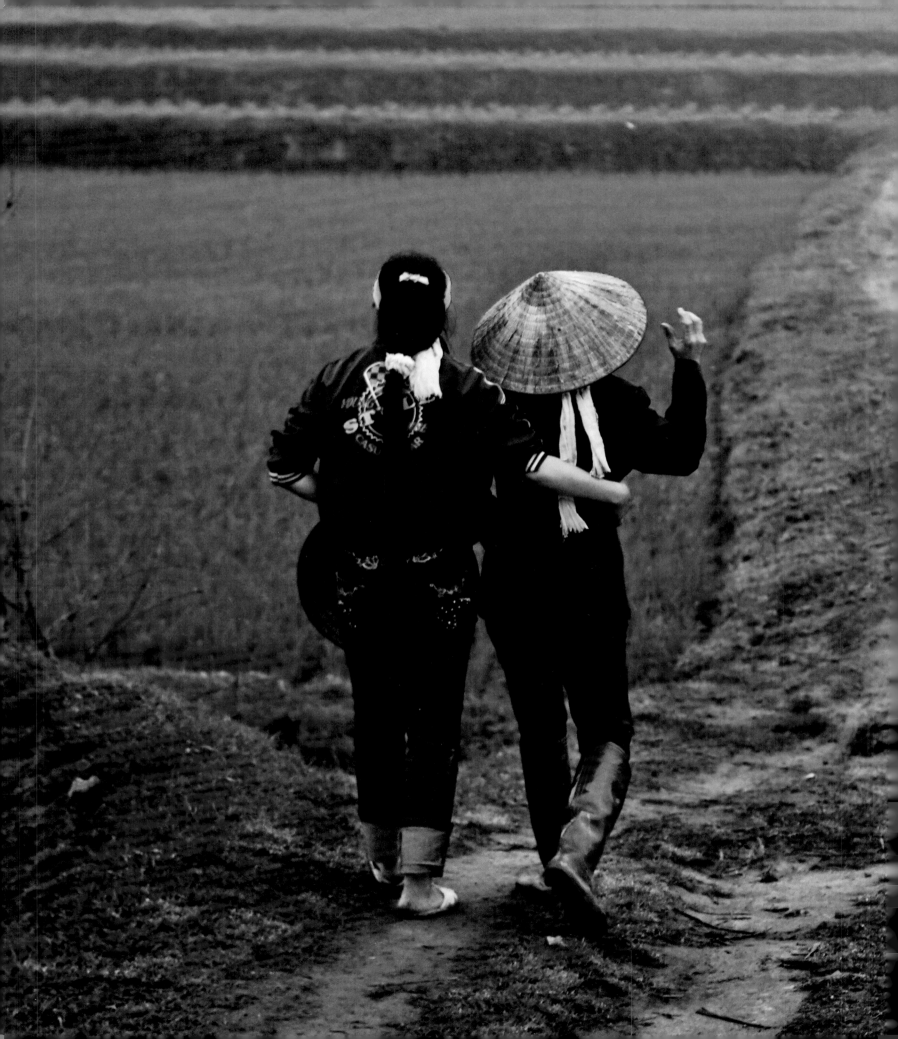

NGUYEN QUOC KHANH
PHU THO PROVINCE

"When you're between death and life and you come back, your health becomes most precious. Before, I had to stay in bed and take support from my wife, son, and daughter for personal things. But now I can do them by myself. And my spiritual health is very much improved now. If I can live three to four years, maybe they can find the drugs to cure the disease."

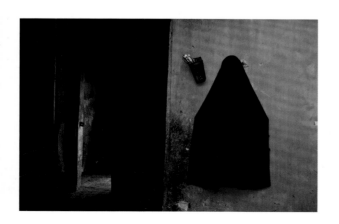

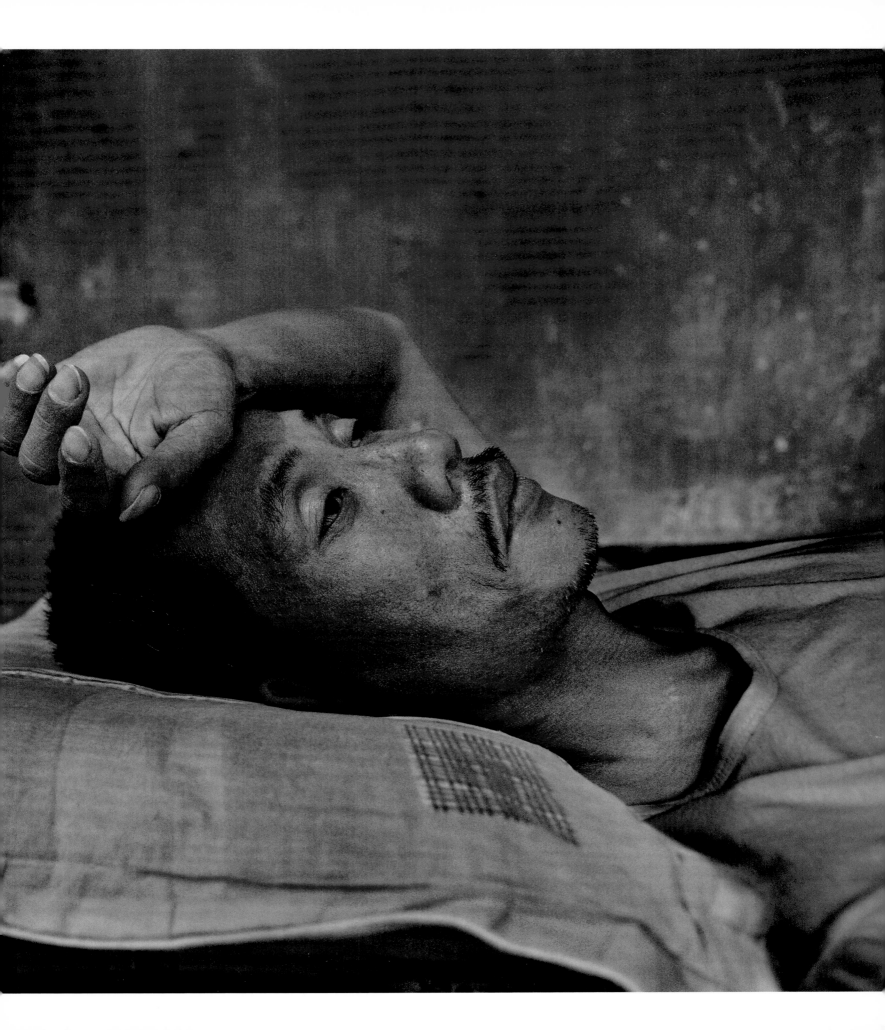

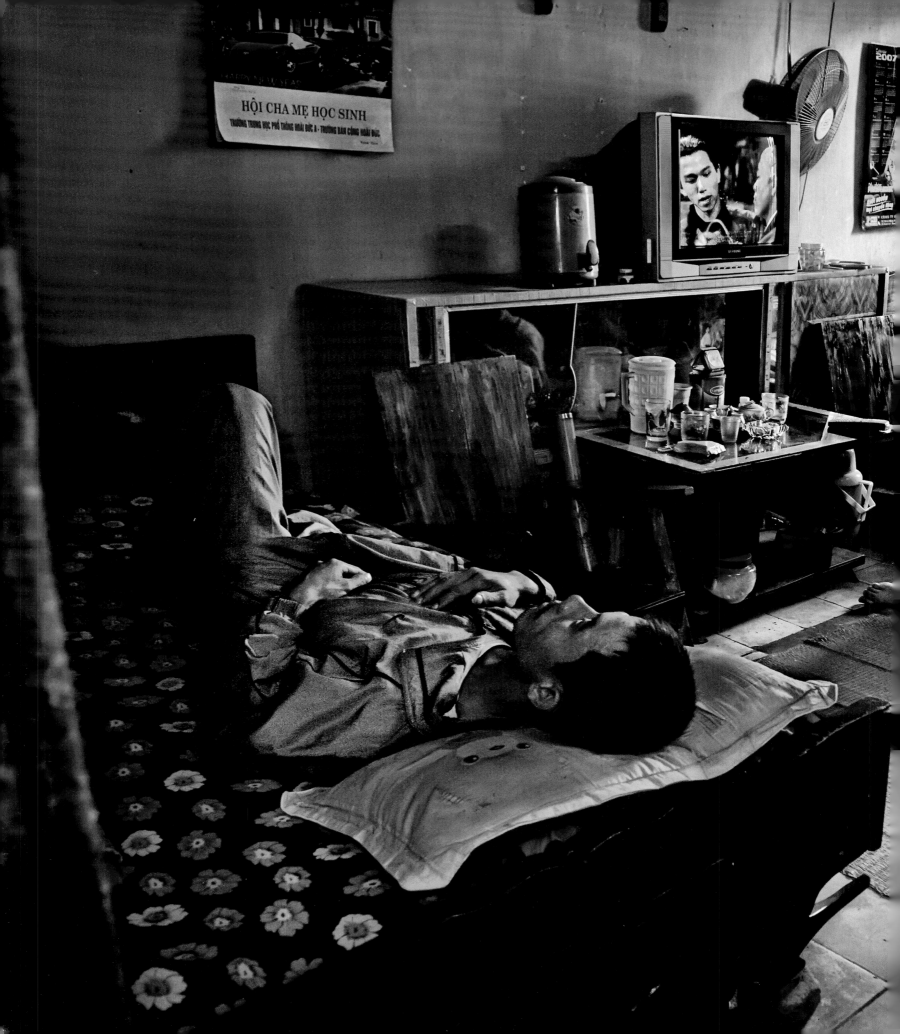

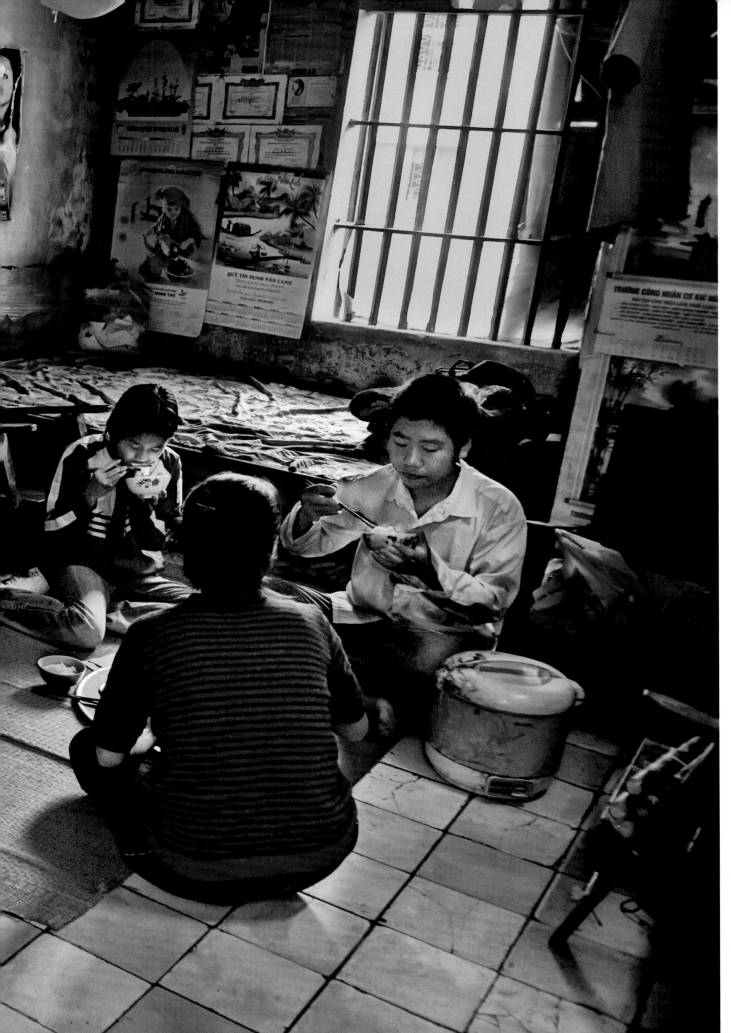

Khanh rests
on a bed in his
two-room apartment
in December 2007
as his family
shares a meal
nearby. From left
to right they are
his daughter, Binh,
his wife, Tiep, and
their son, Thanh.

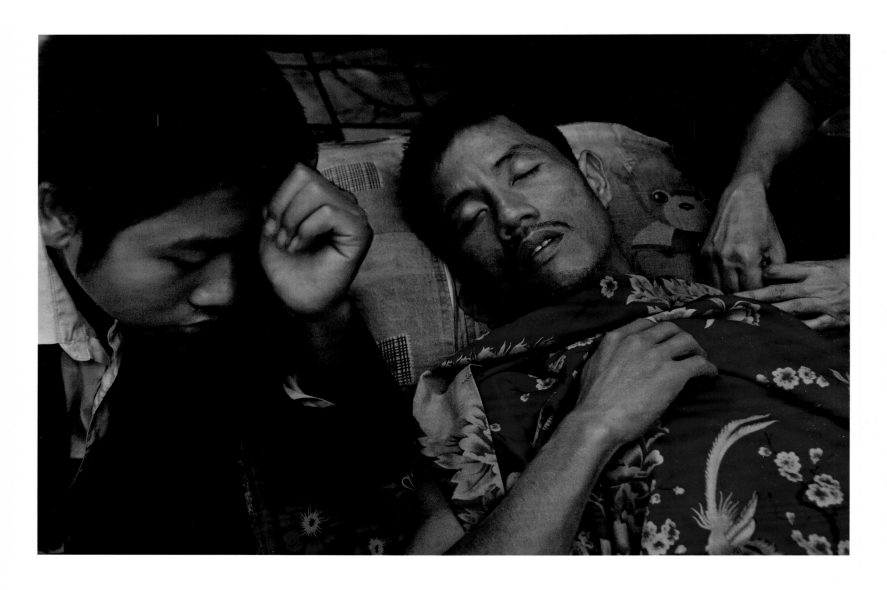

"During his illness, I realized that my father is a brave and optimistic man.
In the beginning, he said a few times, 'I am going to die,'
but only a few times. After my mother encouraged him,
he never said that again."

—BINH, Khanh's daughter, age 13

Taking care of the patient: Khanh with his son *(above)* and his wife *(opposite, top)* at home.

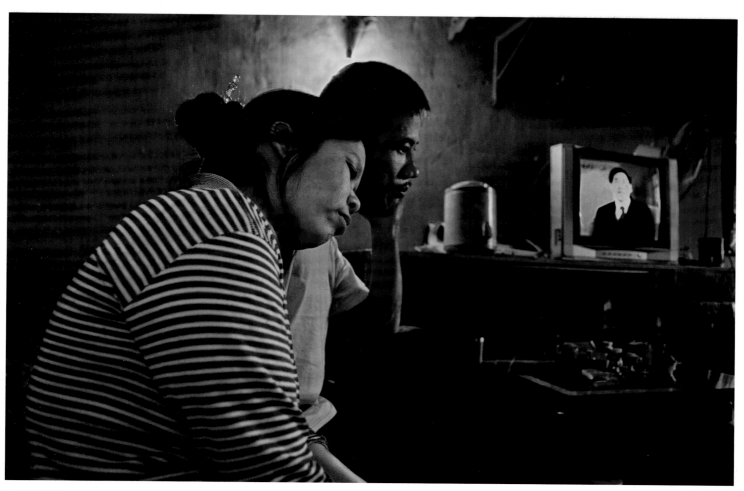

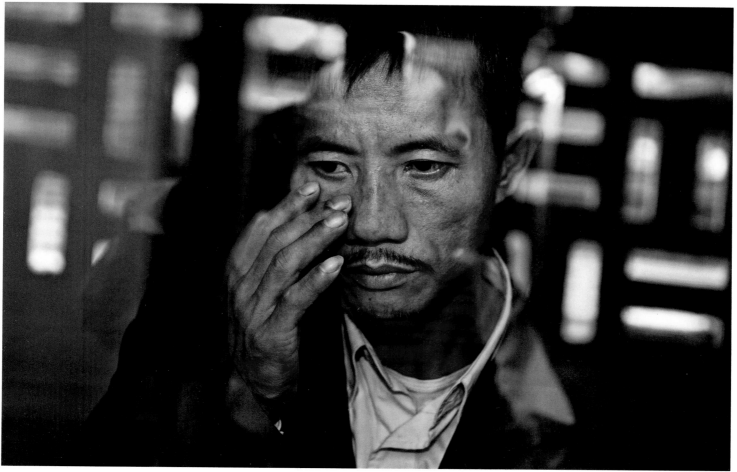

Khanh in the stairwell of his apartment building *(below and opposite)*; a time-worn AIDS prevention poster *(below)*.

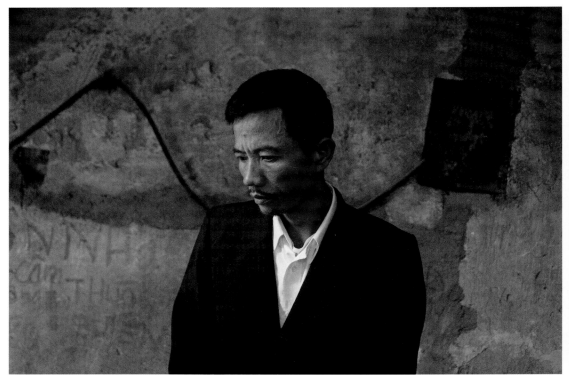

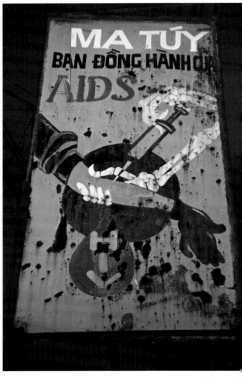

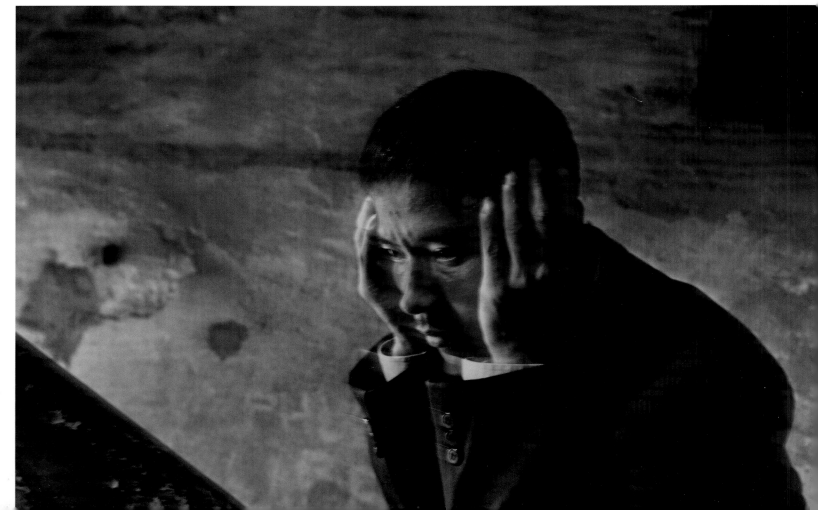

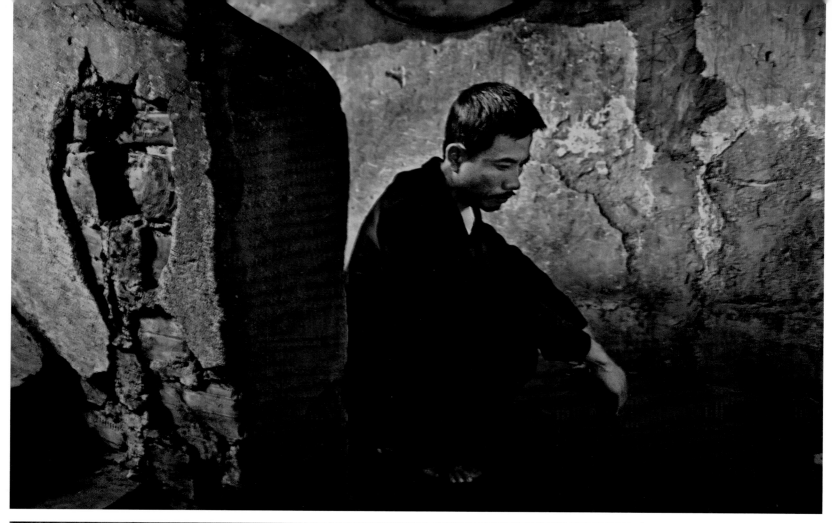

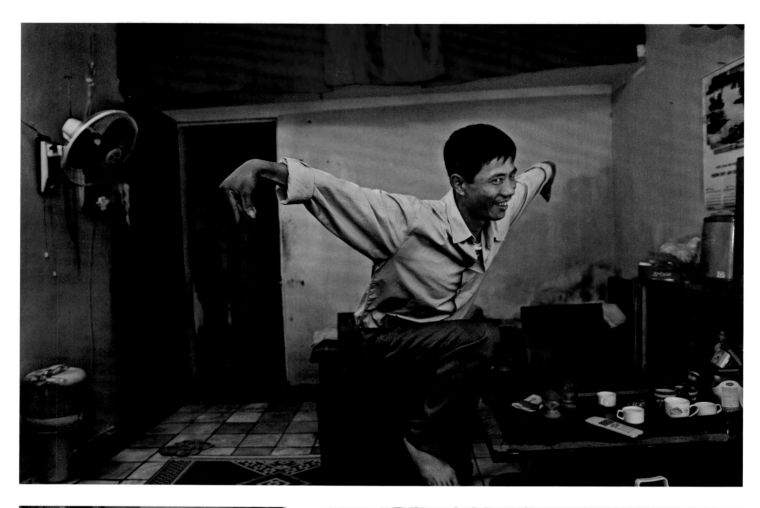

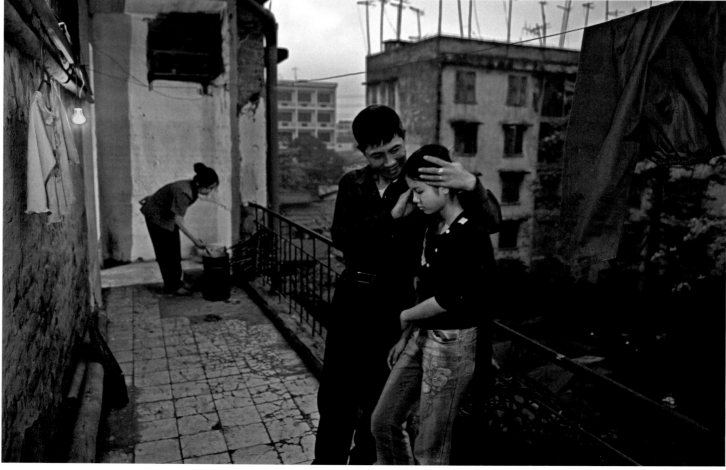

In April 2008, five months after starting antiretroviral treatment, Khahn felt well enough to do odd jobs around his house.

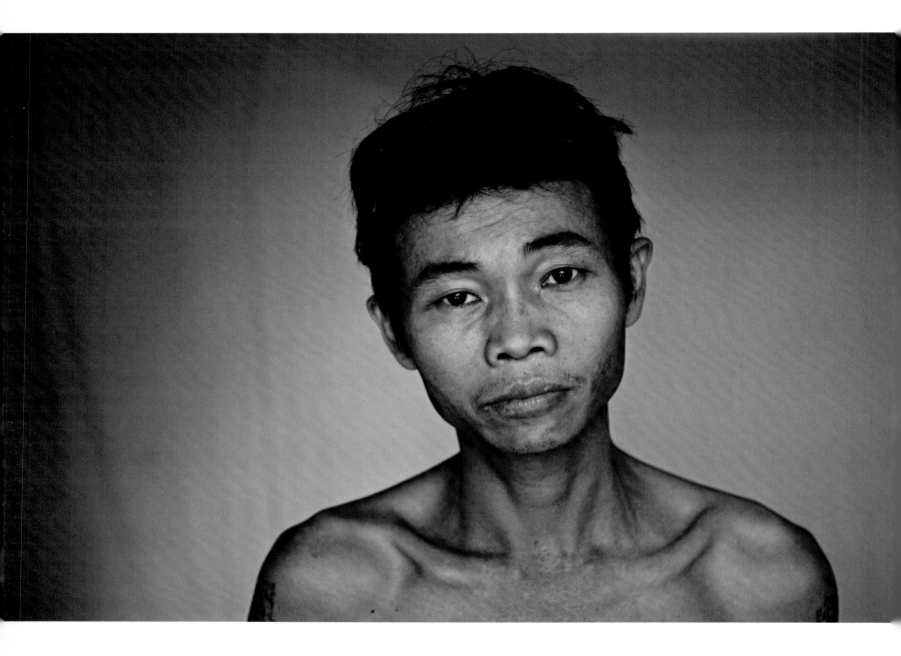

"I'm not afraid of death.
At the beginning, I was upset and disappointed and lost hope.
Knowing that there is treatment to maintain my status,
I feel more stable, not scared."

Luoc *(above)* contracted the virus by sharing a vitamin injection with his HIV-infected brother.
His wife *(opposite, bottom right)* and aunt *(opposite, top and bottom left)* take care of him.

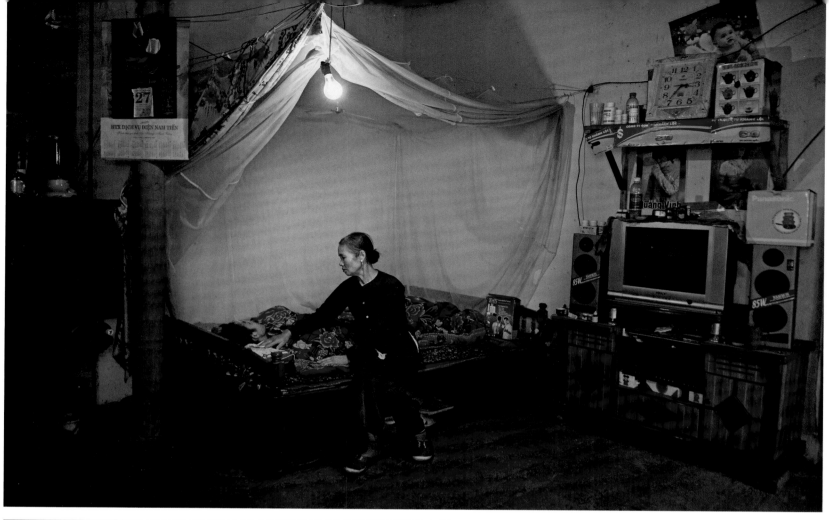
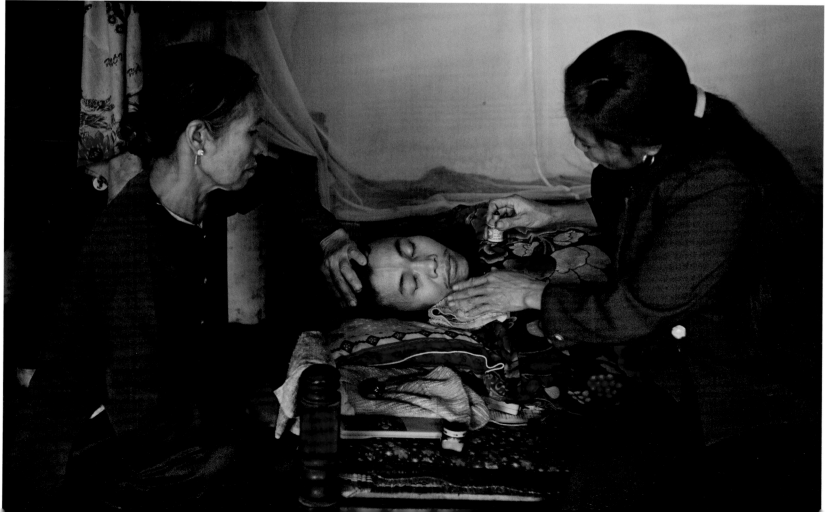

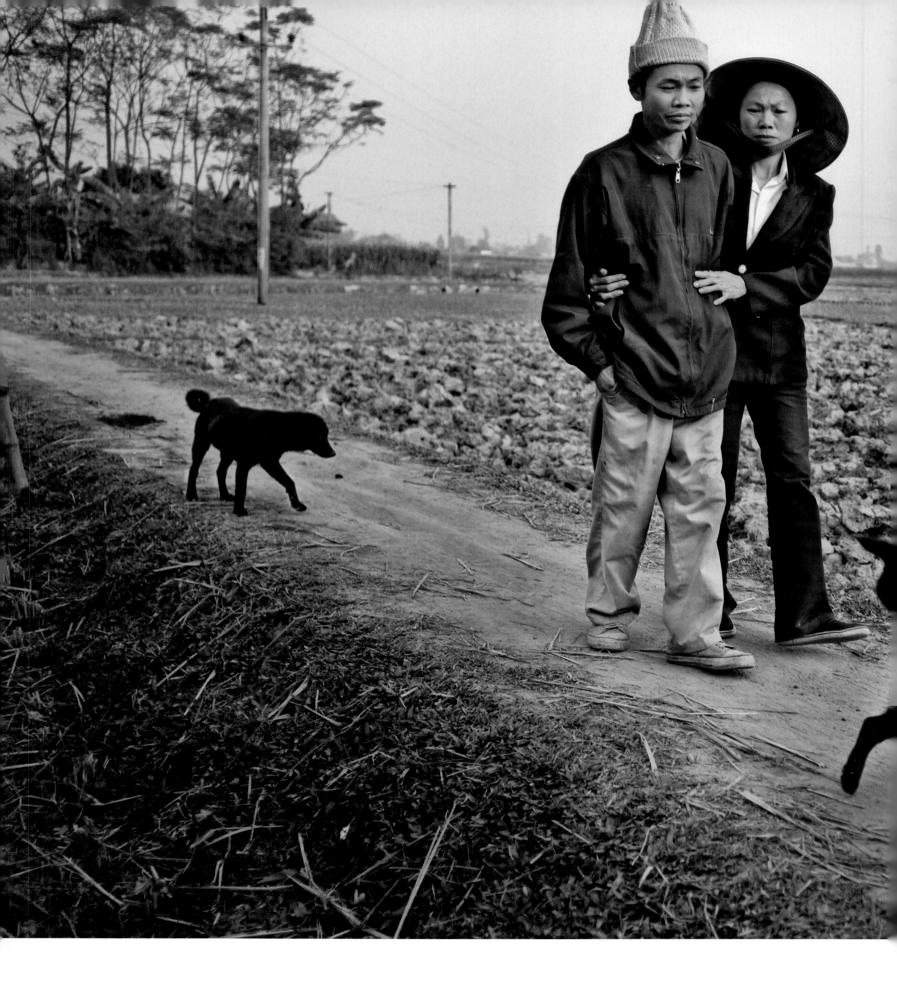

Luoc with his wife, Luan, near their farmhouse and at home *(opposite page)* in Thai Nguyen province, December 2007.

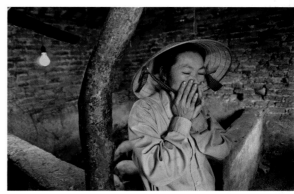

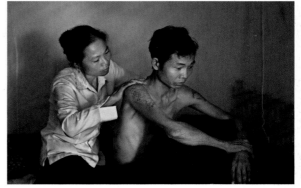

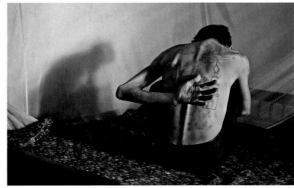

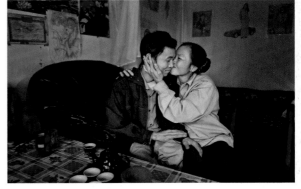

"I lived all my life bearing the bitterness of waiting for my husband to return and waiting to have a second of care from him."

—LUAN, Luoc's wife

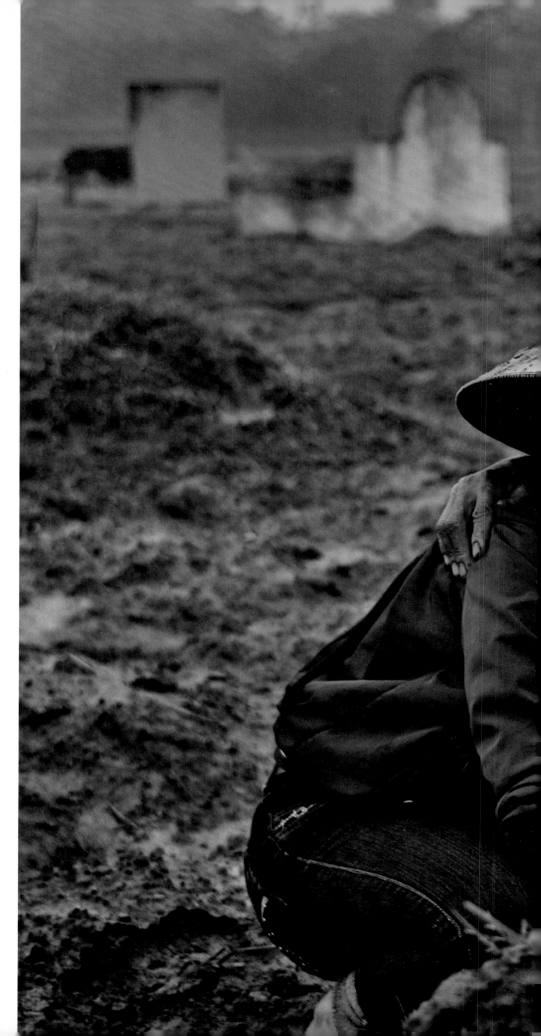

"I will remember the way he
treated me and his family—so sweet.
The way he called me 'Honey.'
Actually, I miss a lot about him.
The mistake that put him into prison
emerged from the wish that he could
earn more money for the family.
But he was never a thief."

—LUAN, Luoc's wife, speaking in March 2008,
shortly after Luoc died

Luoc's daughter, Loan, and his wife, Luan,
mourn at his graveside, April 2008.

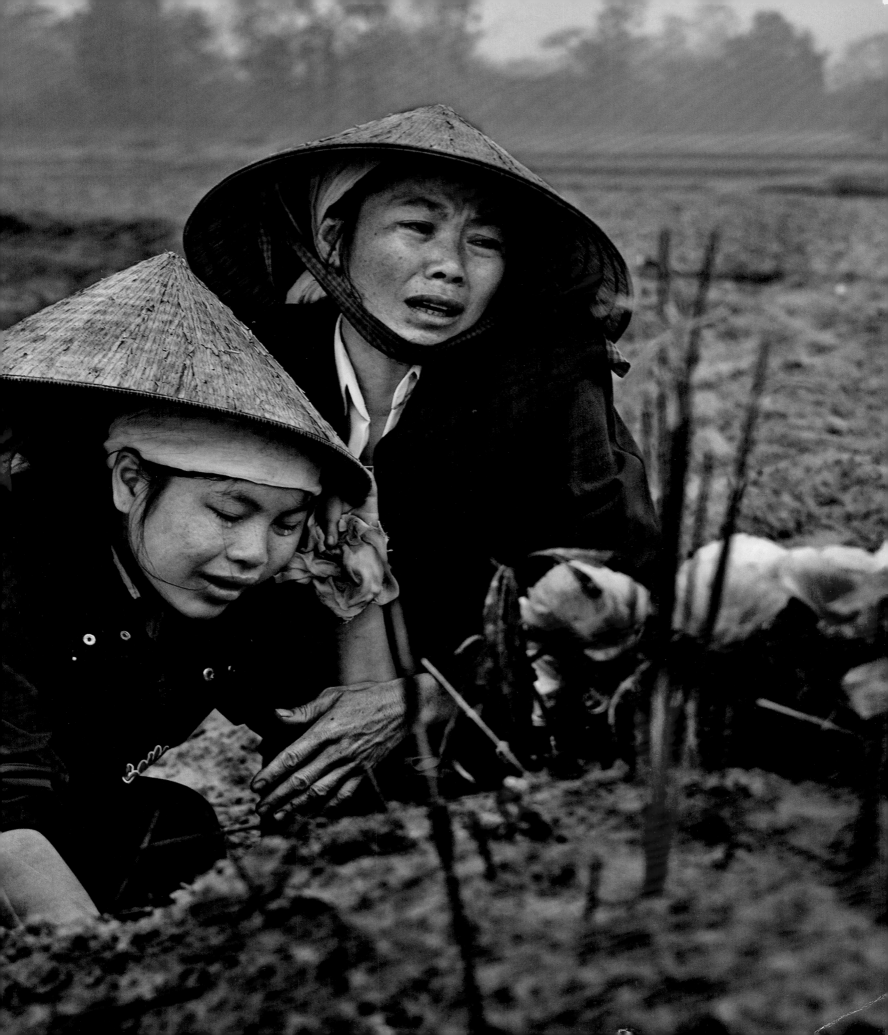

"At first I thought, 'That's it—
now I will die from this.' After
that, many people encouraged
me to go get medications to take.
With health, I can still help
my wife and son. I can still live
with my wife and my son
and my parents. But if I die,
I don't know what my wife and
child will do. How will they live?
If they are infected, they won't
know how to get the medications
and take them. They'll die
just like me. So I try to live."

—TUYEN, shortly before he died
in December 2007.

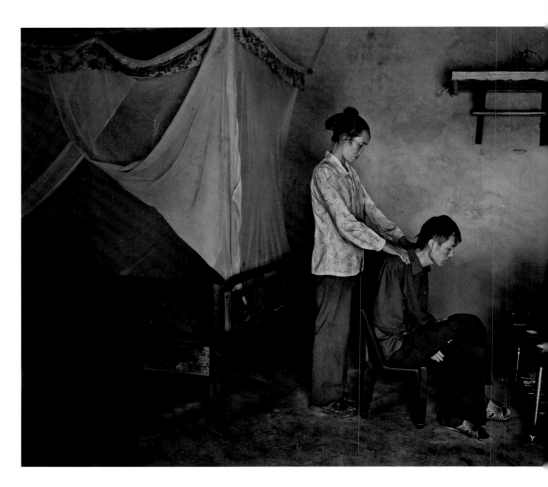

"I don't know when he got his disease. Before getting married, he seemed a good man and good-tempered. I don't know anything about when he got infected. If you talk about me placing blame, then I don't. I don't place blame on anybody, because it's this disease. It's heartless—and it's easy to transmit."

—LUONG, Tuyen's widow

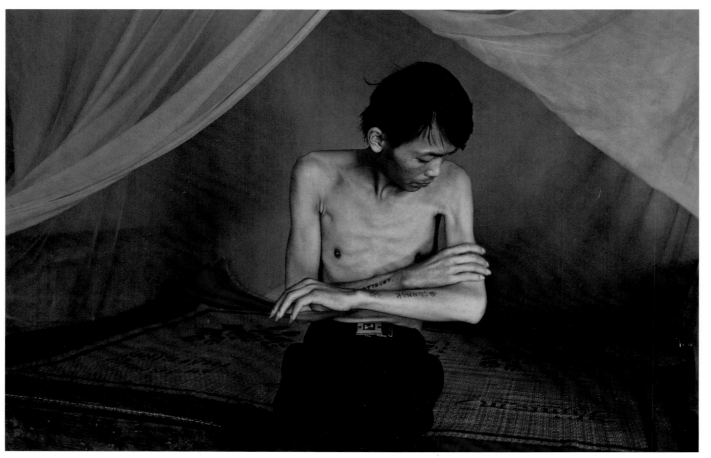

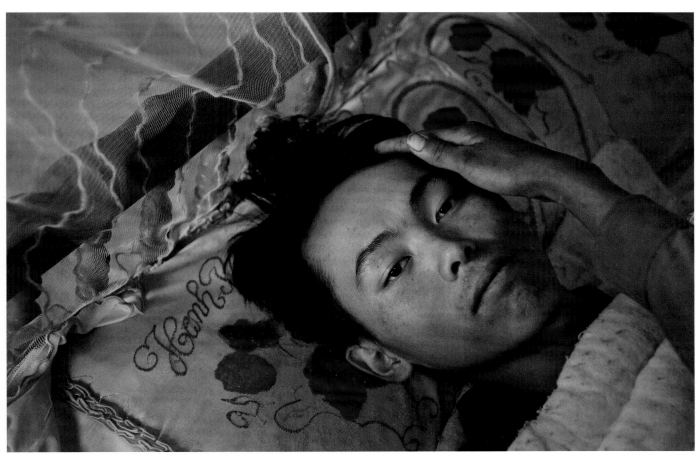
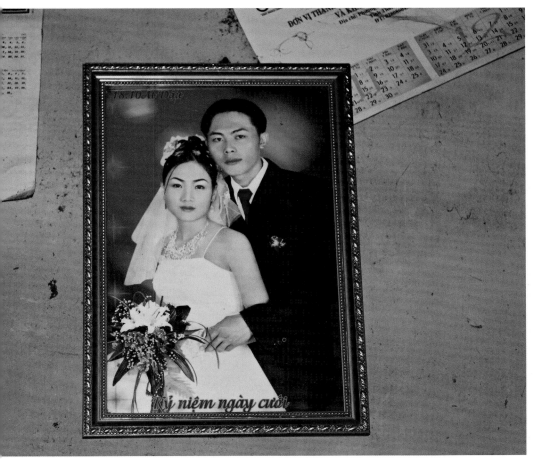
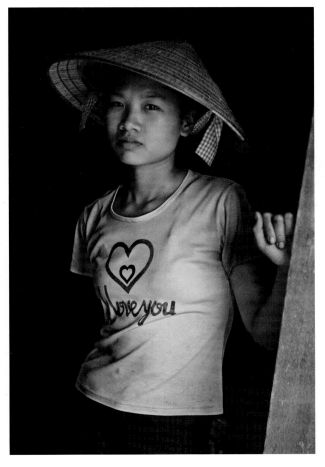

Portraits of a marriage: Tuyen and Luong at their Binh village home, where their wedding portrait is among the few wall hangings.

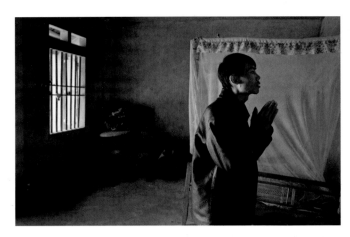

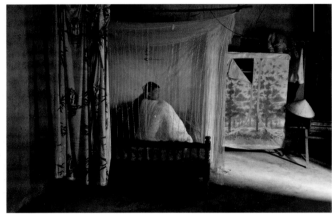

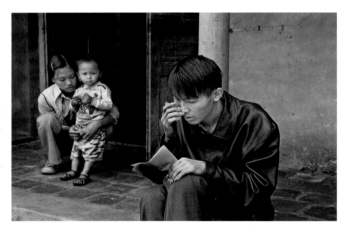

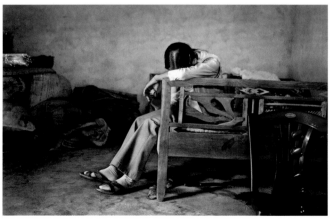

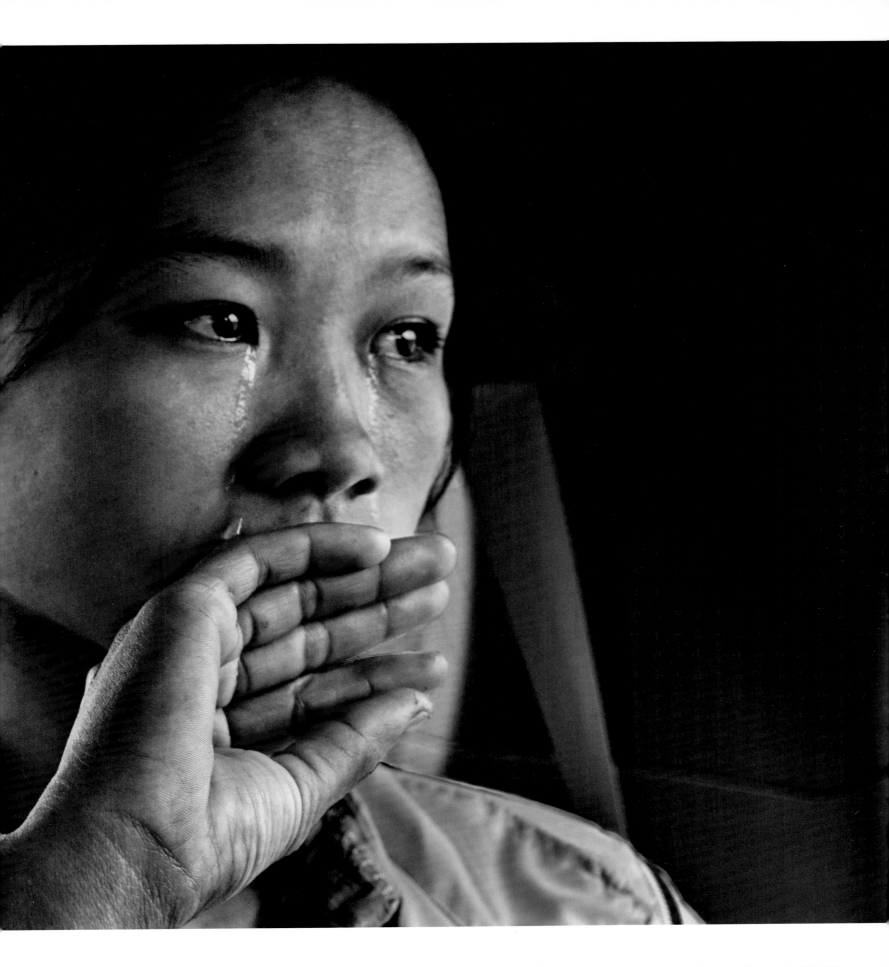

(Above) Luong reacts emotionally to discovering in December 2007 that she too is HIV-positive. Although their marriage became rocky once Tuyen was diagnosed with AIDS, Luong was resigned to her fate. *(Opposite page)*: The caregiver's burden is obvious as Luong tries to care for the couple's two-year-old son, Toan.

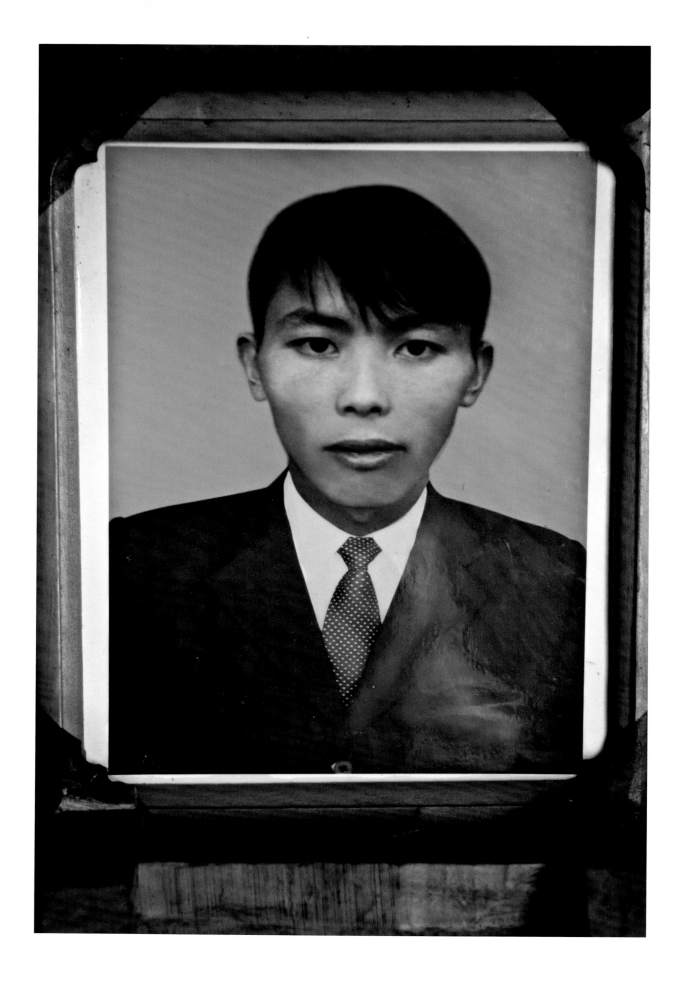

Tuyen's face superimposed atop a stock photo *(above)*. Opposite, Luong visits Tuyen's grave *(top)* and consoles Toan at home *(bottom)* in April 2008.

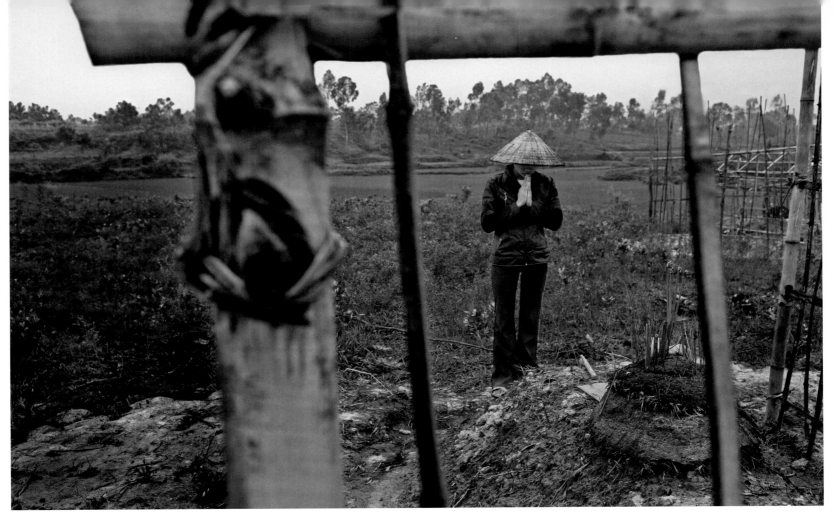
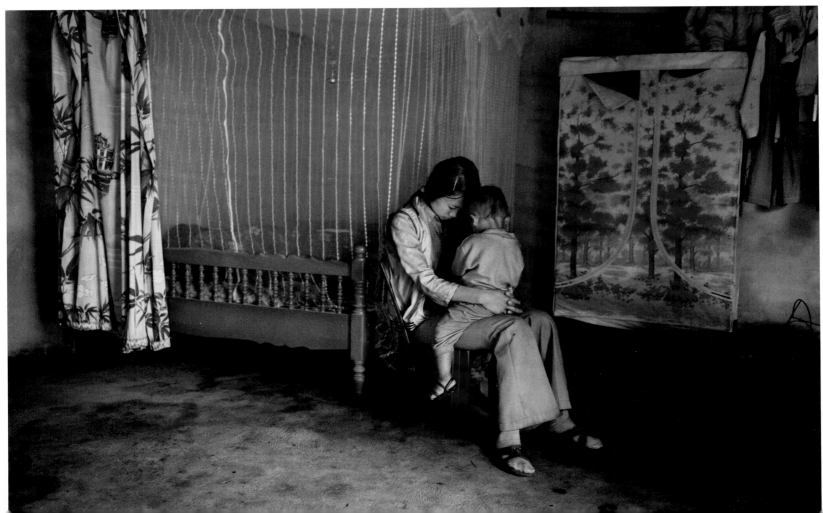

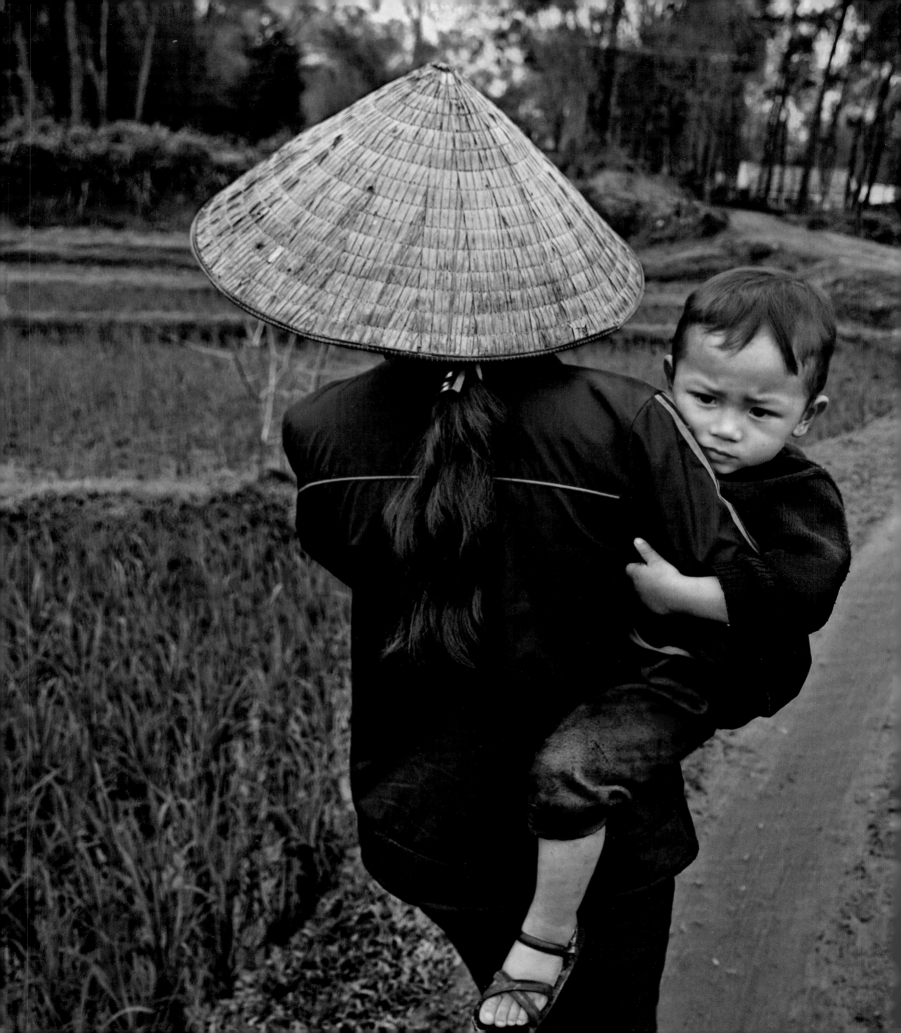

"Now I too am infected by the disease. I'm just 21 years old. It is possible that my son is also infected [he has since tested negative]. I thought a lot about that. I was very depressed. I wanted to die. For three days after getting my results, I thought a lot about everything. But I would still get up when I had to prepare lunch or dinner for my son."

—LUONG, Tuyen's widow

Luong and Toan take a walk in the fields beyond their village, April 2008.

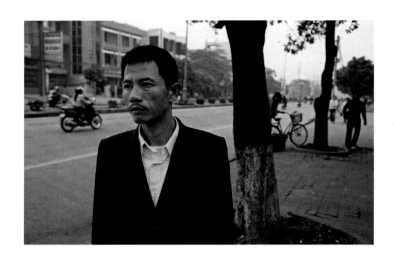

NGUYEN QUOC KHANH, 44

OCCUPATION: Day laborer

Khanh began using opium when working in a remote gold mine a year after he was married in 1989. Local tribespeople told him and other miners that the drug would protect them from malaria. Then, when opium sellers switched to heroin around 1995, Khanh did too—and quickly became an addict. He tried to quit, submitting to a three-month stint in a government rehab center, but heroin was available there and the temptation proved irresistible. Up to 20 people shared a needle. It is likely he was infected with HIV then.

Though Khanh first fell ill in 2002 with a bout of severe diarrhea, he only learned that he was HIV-positive five years later. Weakened by his illness, he spent most of his time in bed. Khanh's wife, Tiep, supported the family by selling porridge and rice cakes every morning at an open-air market stall downstairs from their fourth-floor, one-room apartment, but her business suffered once Khanh's illness became known. "People now know about my disease and don't want to eat there," says Khanh, who estimates that the food stall's income has dropped by about a third in the past year.

Two months after starting his ARV treatment in 2007, Khanh felt so much better that he jumped at the chance to help with a house-painting job. He bought the leftover paint cheaply and used it to brighten up his own home. The improvement in Khanh's health has cheered up the family. Tiep feels that ARV treatment has brought back dignity to the family. Son Thanh, 16, describes his father as "humorous, helpful, skillful, and talkative." Khanh himself is still remorseful about his life. "I regret what I've done, though it may be too late for regrets," he says. "I don't know how much time is left for me to be a good father and a better husband."

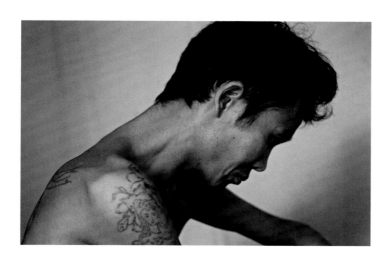

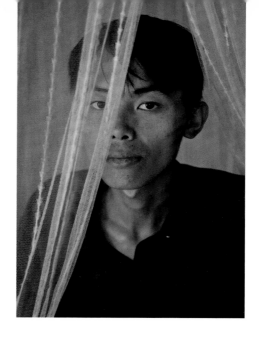

NGUYEN VAN LUOC, 42

OCCUPATION: Farmer, metal shop worker

Luoc's life was full of contradictions. He probably contracted HIV in prison or by sharing a needle with his HIV-infected brother in 2006. Luoc says he wasn't taking drugs at the time, but injecting vitamins—a common practice in Vietnam.

There were other mysteries as well. Luoc was in prison for three years, charged with smuggling explosives from China, but he claims he thought he was smuggling beer. He seems to have been in prison two other times as well—though he rarely, if ever, spoke about those. According to his wife, he was once imprisoned for helping a girl run away to China.

Luoc's last years, however, belied his complicated past. He and his wife, Luan, lived on a small farm along a narrow, winding road in a bucolic setting: verdant fields separated by raised paths against a mountainous backdrop. Rice, corn, cassava, and sweet potato (depending on the season) grew abundantly. They had two children—a 22-year-old son and a 13-year-old daughter. The family raised pigs, chickens, and vegetables to sell in the local market. Many neighbors remarked on Luoc and Luan's close and tender relationship.

Already ill with tuberculosis, Luoc was diagnosed as HIV-positive in the summer of 2007. He was the most conscientious of patients. Worried that he might infect others with TB, he wore a mask and rubber surgical gloves in public. He insisted that his children continue their education. And he made plans to install a water tank at home to spare Luan from carrying water up the hill. He was also optimistic about his antiretroviral (ARV) treatment until the very end. Luoc died of TB in early 2008.

DUONG VAN TUYEN, 26

OCCUPATION: Farmer

Tuyen married Luong, barely out of her teens, after a seven-month courtship. In Binh Tri, a rural district northwest of Hanoi where he lived at the time, Tuyen was considered quite a catch. The young couple soon had a son, Toan, now two years old. They lived in a two-room house and farmed the small rice field Tuyen's father had given them and raised a few pigs and chickens, while Tuyen also worked as a day laborer. Though poor, they were happy.

But when Tuyen was admitted to the hospital in mid-2007 and found to be HIV-positive—most likely from trying heroin with a shared needle before he married—he became, according to Luong, difficult and "more hot-tempered." Nonetheless, she remained stalwart in support of her new husband. "When my wife knew that I had the disease, she said, 'You scream at the heavens in despair—just go get the medications,'" Tuyen recalled shortly before he died. Nevertheless, he was reluctant to follow his wife's advice. Money was tight and they were already in debt from his first hospital stay.

Tuyen eventually started treatment, but it was too late. He survived for only 17 days, dying in December 2007. As Tuyen began his ARV regime, Luong also tested positive for the HIV virus. The news devastated Tuyen. Knowing that he had infected his wife and possibly their son—although Toan has since tested negative—was too much for him to stand. Now Luong struggles alone. She fears that Tuyen's father will take away her field, her house, perhaps even her son. To cope and earn some money, she makes hairpieces and would like to attend school. But she's worried about the future, haunted by fear, insecurity, debt, and loneliness.

SNAPSHOT: HIV AND AIDS IN VIETNAM

OVERALL POPULATION: 84.2 million

NUMBER OF PEOPLE LIVING WITH HIV AND AIDS: 132,628

HIV PREVALENCE AMONG ADULTS: 0.5 percent. Although the percentage of Vietnam's population infected with HIV is relatively low, the number of people infected has more than doubled in the past six years.

NUMBER OF PEOPLE ON ANTIRETROVIRAL (ARV) TREATMENT: 14,969

NUMBER OF PEOPLE WHO NEED ARV TREATMENT: 67,000

GROUPS MOST AFFECTED BY THE HIV EPIDEMIC IN VIETNAM: Injecting drug users (about one-third of injecting drug users—who are mostly men—are HIV-positive), their partners and children.

VIETNAMESE SOCIAL ATTITUDES TOWARD HIV AND AIDS: There are widespread misconceptions and stigmas about how the virus is transmitted. Discrimination against HIV-positive people, socially and in the workplace, is common.

AVAILABLE TREATMENT FOR PEOPLE LIVING WITH HIV AND AIDS: In 2008, Vietnam expanded its HIV treatment program in the 20 provinces where 65 percent of people living with HIV reside—and where the Global Fund has been active since 2004. The program includes counseling and testing, ARV treatment, prevention activities (including prevention of mother-to-child transmission), and community-based services.

HIV TREATMENT CHALLENGES: Injectable drugs such as heroin are cheap, and casual use of these drugs, often with shared needles, is more common than in most other countries. HIV is easily spread via sex between drug users and their partners.

OLIVE

MARCELLINE

rwanda

eliyeri

photographs by gilles peress

Goreti&Chantale

ASSIGNMENT: RWANDA

I had not been back to Rwanda since 1994. The experience of traveling there during a genocide—from concentration camps to massacre sites, with their everlasting smell of death and the absence of any noise—left me numb and in a no-man's-land of humanity. There was the silence, too, of an international community that did nothing to stop this genocide. So it was with some trepidation that I prepared to return.

To my surprise, I found the country so changed that I could not associate it with those tragic moments in 1994. Rwanda is clean, the roads are good. The wings of the angel of death no longer cast a shadow over the land.

This time I was there to try to understand another tragedy. As Kofi Annan once stated, AIDS has killed more Africans than all the continent's wars since decolonization. Each of the individuals and families I met had their own narratives and problems. There is Marcelline, who has lost more siblings to AIDS than to genocide, but whose wonderful brother truly was "his sister's keeper." There is Eliel, who admits to committing adultery but who is above all a great parent. So is Goreti, who focuses fiercely on the health and education of her daughter, Chantale.

All these patients showed an incredible openness and honesty. But beyond the miracle of ARV treatment (whose success rate is higher than in some parts of the "developed world"), troubling patterns remain. In Africa, the economic context is key to understanding most situations—from simple political crises to outright war. It also has a huge impact on the spread of AIDS as well as on the factors for the recovery of individual patients. If a patient is homeless, with no access to the special diet necessary for recovery, how will that patient get better? How will even the most fortunate rebuild their lives after treatment when the economic realities surrounding them are so bleak?

Alone in my studio, writing these words while my children play in the garden, I keep wondering about "my patients" and how each one is doing. Are they smiling? —***Gilles Peress***

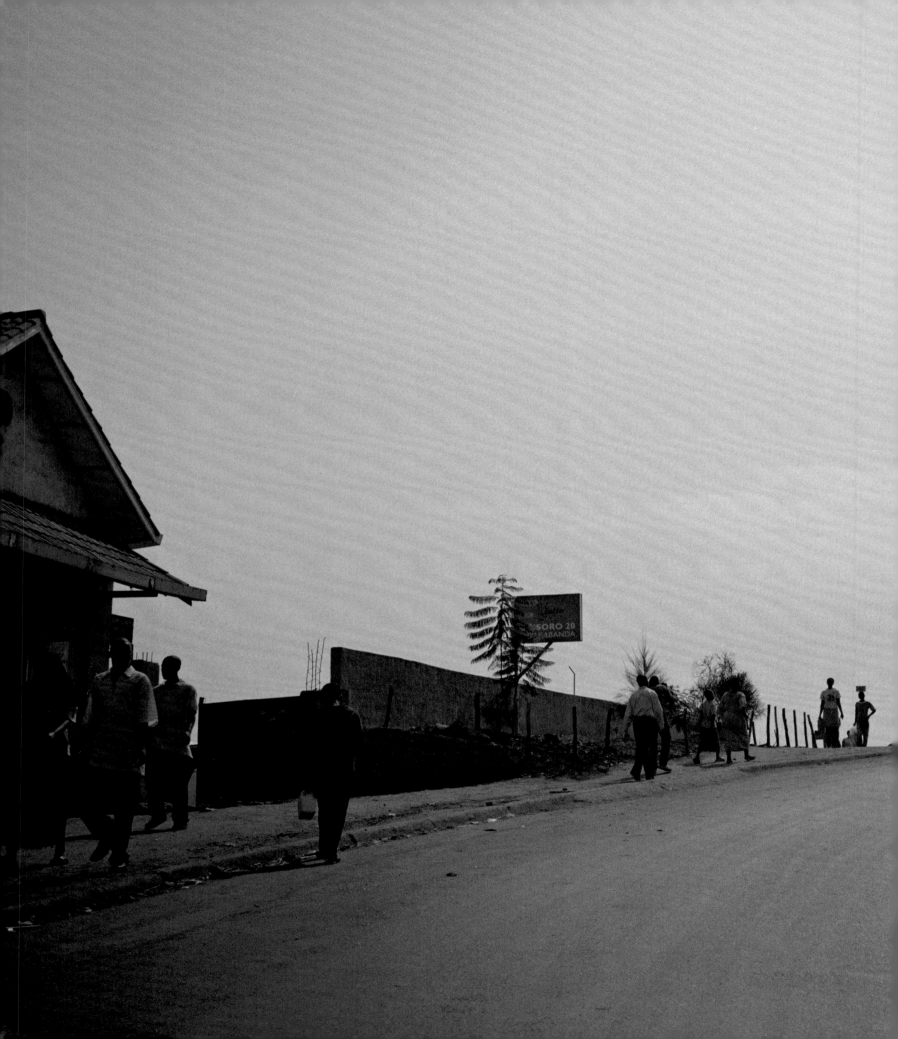

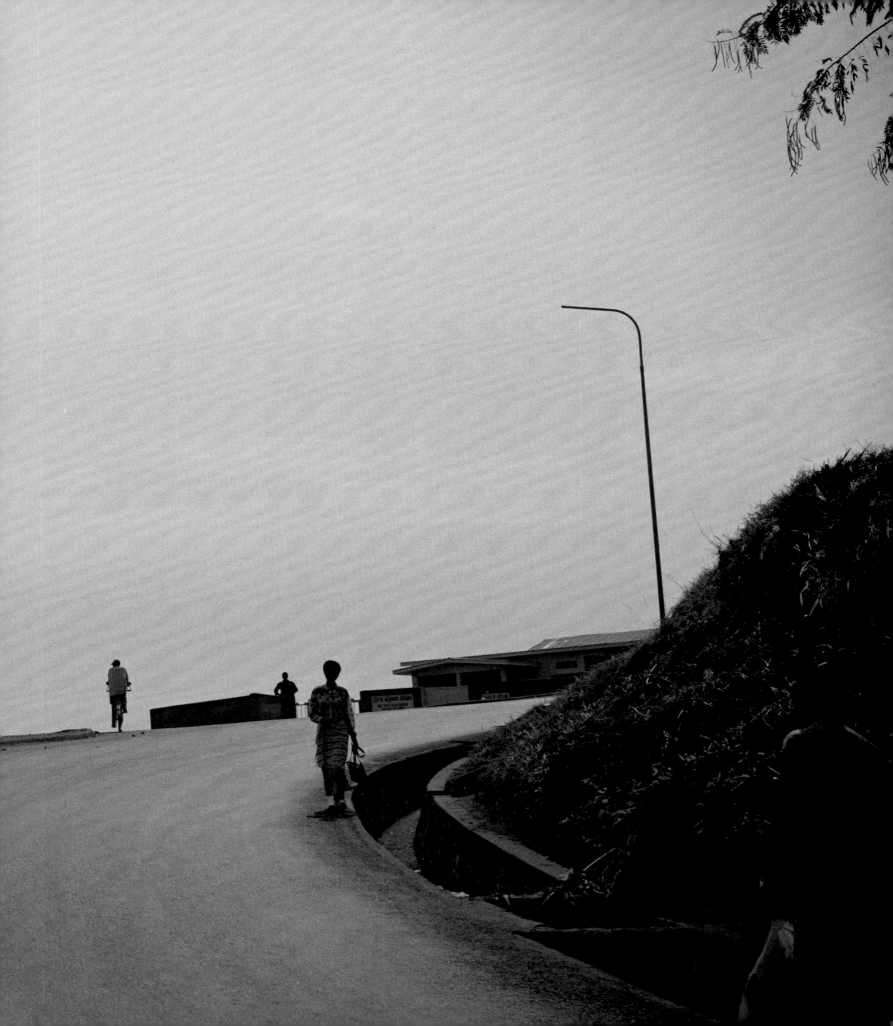

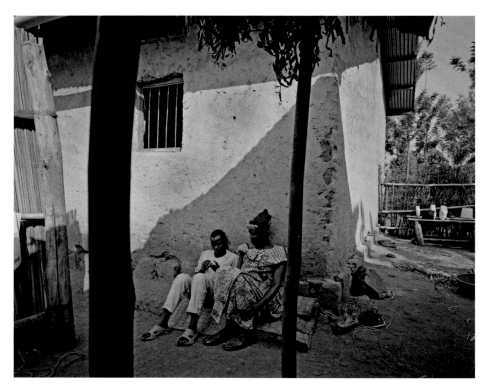

"Life became difficult when I contracted this disease. This house that you see here, I built it myself. My husband had become disabled. I thought that I was going to die and my children did not have a home of their own. I had several head of cattle that I had brought back from Uganda. So I began selling them, and I purchased wood and began to build the frame. I had just started to put the roof on when the disease became stronger and stronger."

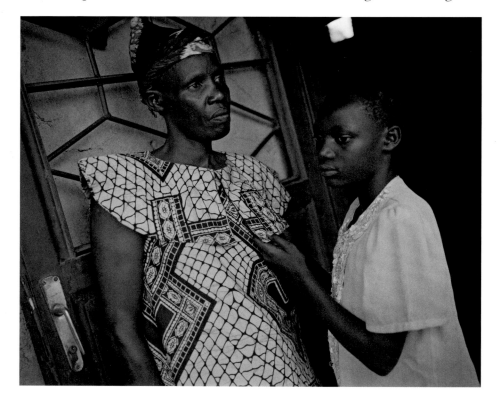

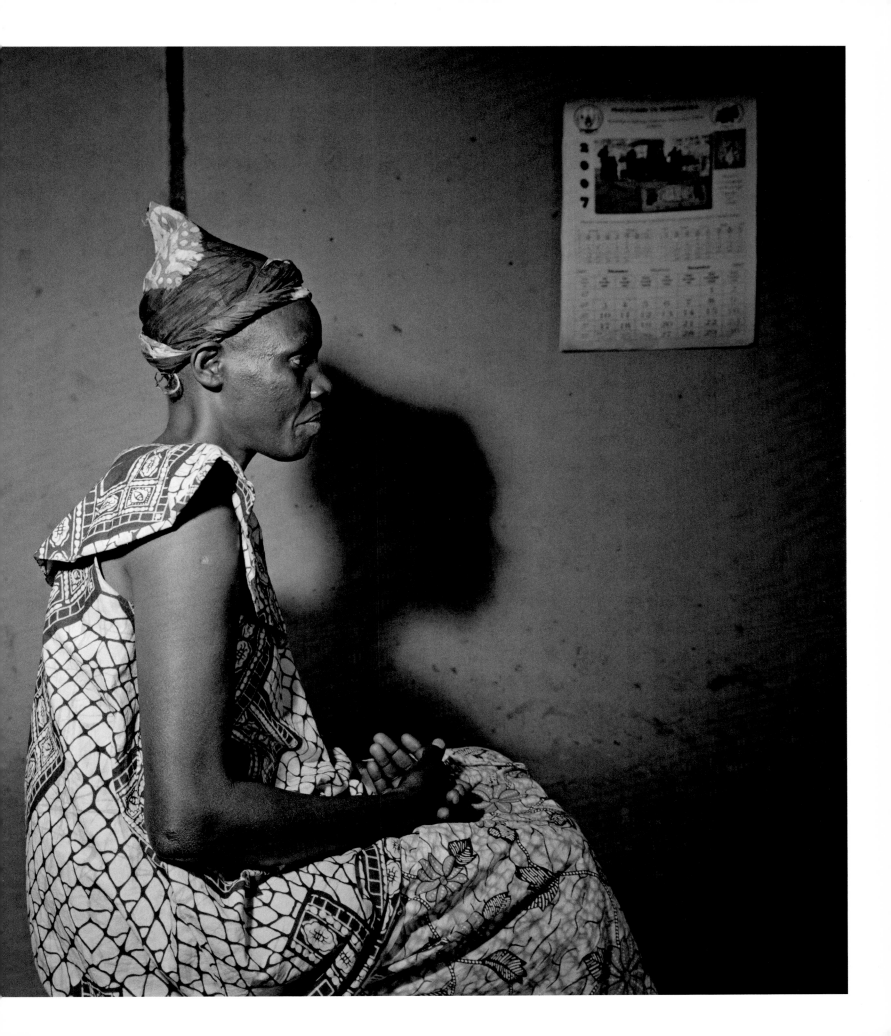

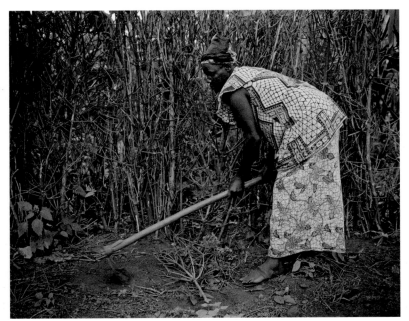

For Goreti and Chantale, 13 *(opposite)* ARV treatment has meant a new life. Goreti has the energy to work in the fields, and Chantale is a star student. Chantale wants to become a doctor. "I want to treat people so they can have a better life," she says.

Following pages: Vestiges of the disease linger in Goreti's skin ailments; Goreti's husband and Chantale's father, Cyril, lower left. A trucking accident during the war left him disabled.

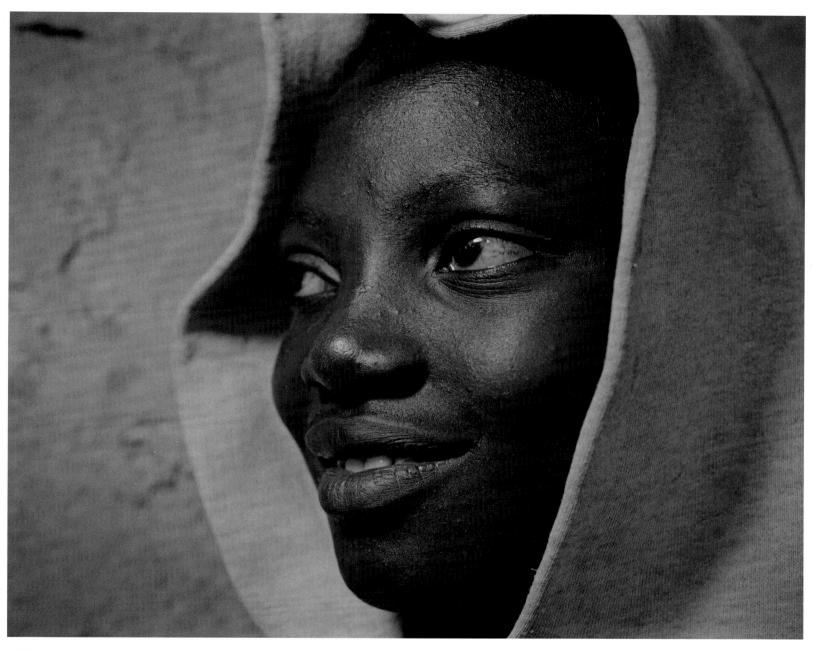

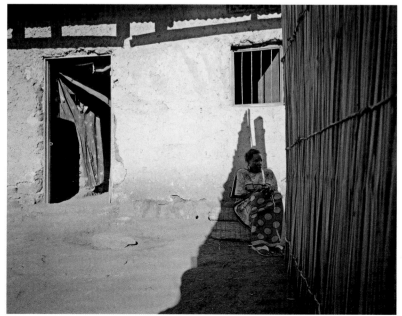

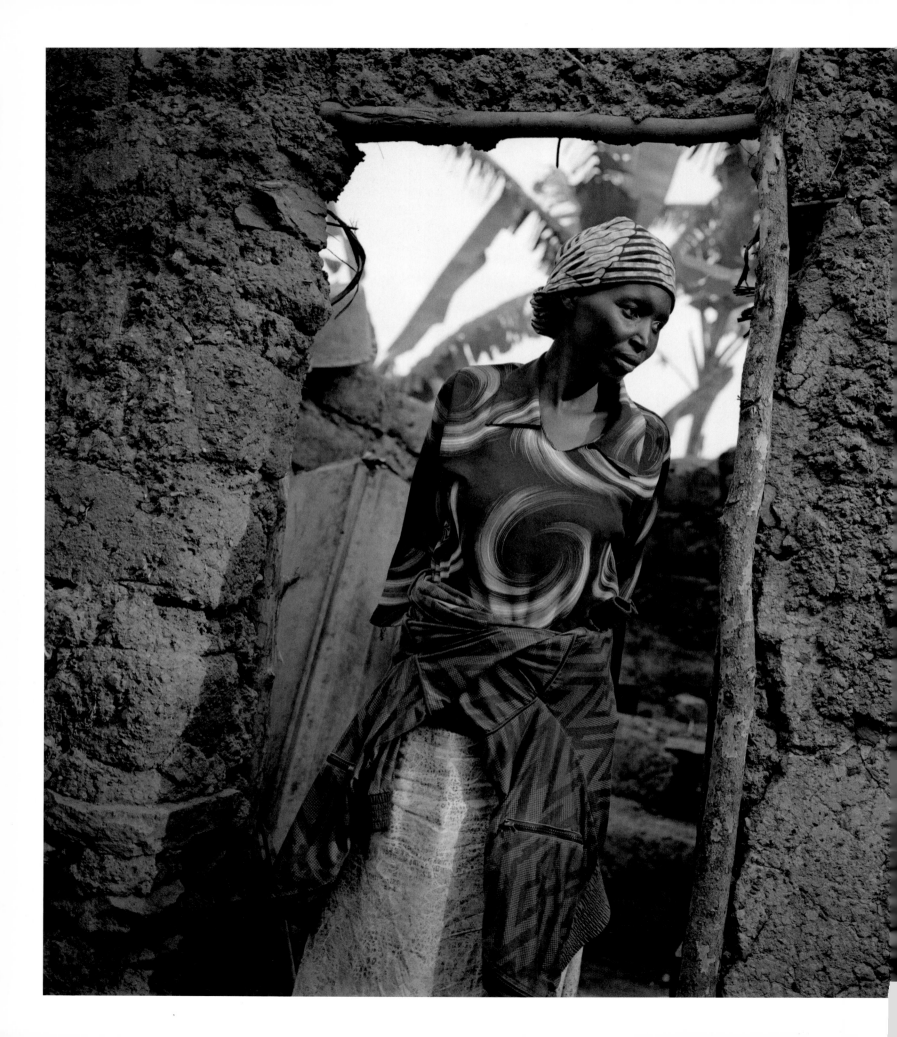

"I believe that the war worsened the problem of HIV in Rwanda. The war itself contributed because there were many women who were raped by Interahamwe militias and became infected. But even then, the virus didn't spread much. It was only after the war, when people returned home from different places, that the influx led to a rise of HIV."

Marcelline at her parents' home in Ruhama, where she returned after leaving her husband. She has two children— Solange, 11, and Richard, 9— and is extremely close to her brother, Jean-Marie, who helped her survive the war and is still her main caregiver.

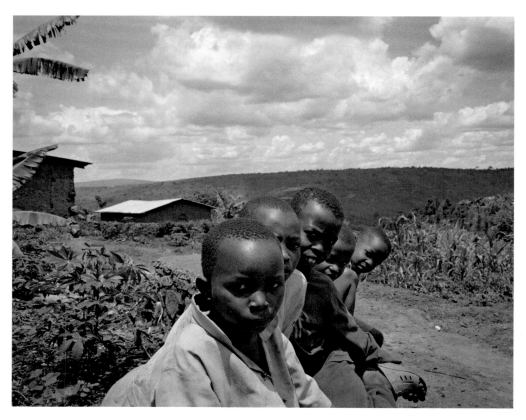

"My husband was promiscuous and a drunkard. It was very disturbing for me and I decided to leave him. I used to tell him that we were running the risk of getting infected because of his habits of sleeping around. Some of the women he slept with have died, and many are infected. Some have joined the association of HIV-infected women. That is how I found out who they were."

—MARCELLINE UWIMBAZI

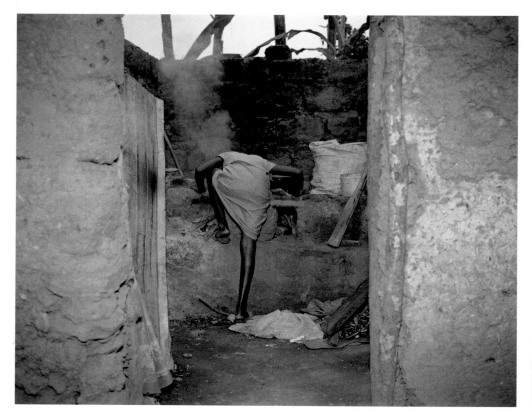

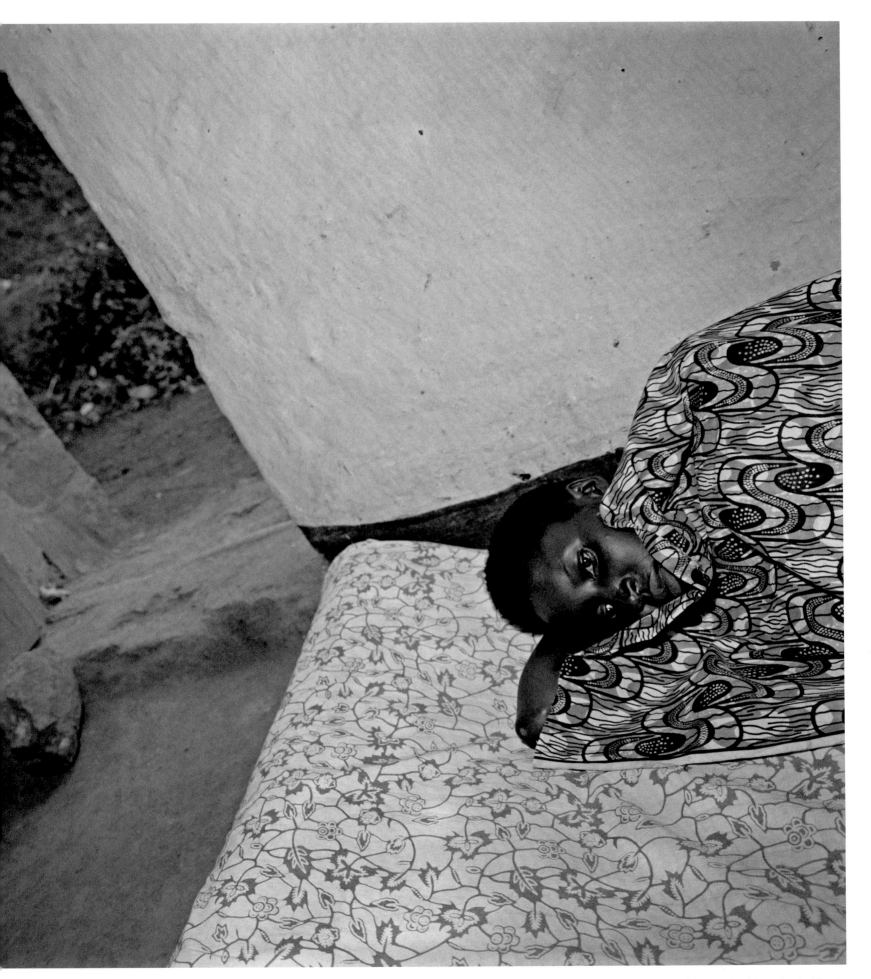

Marcelline resting at home. She plants crops on her parents' farm to feed the extended family.

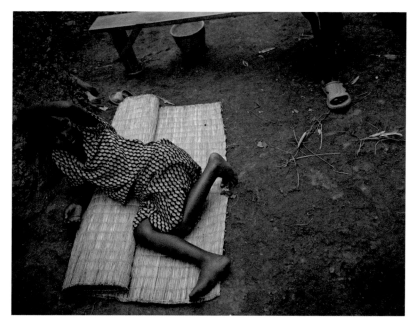

170

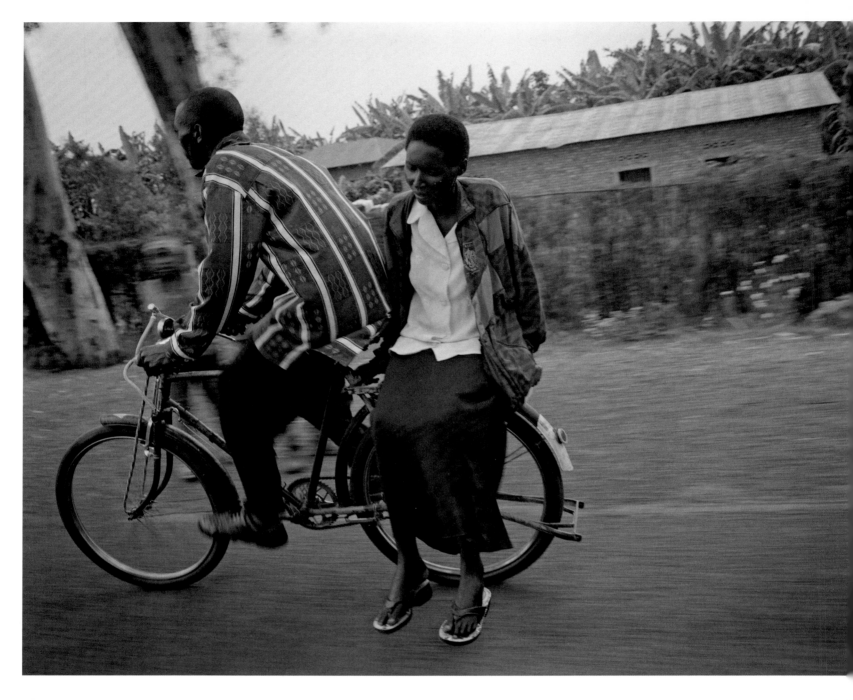

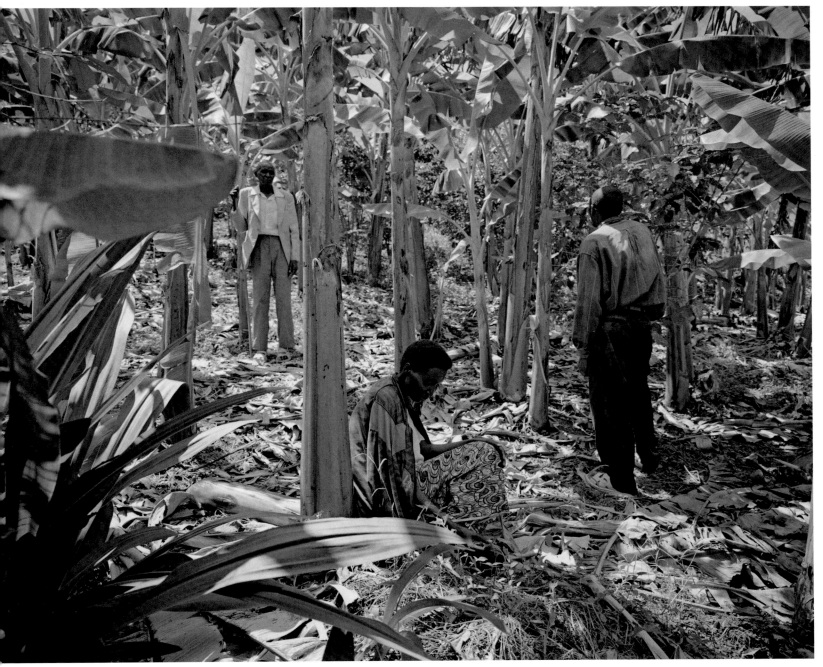

Marcelline celebrates her new life: "I told myself, 'Now that I am able to eat cassava and sweet potatoes, that's it. I have recovered completely.'"

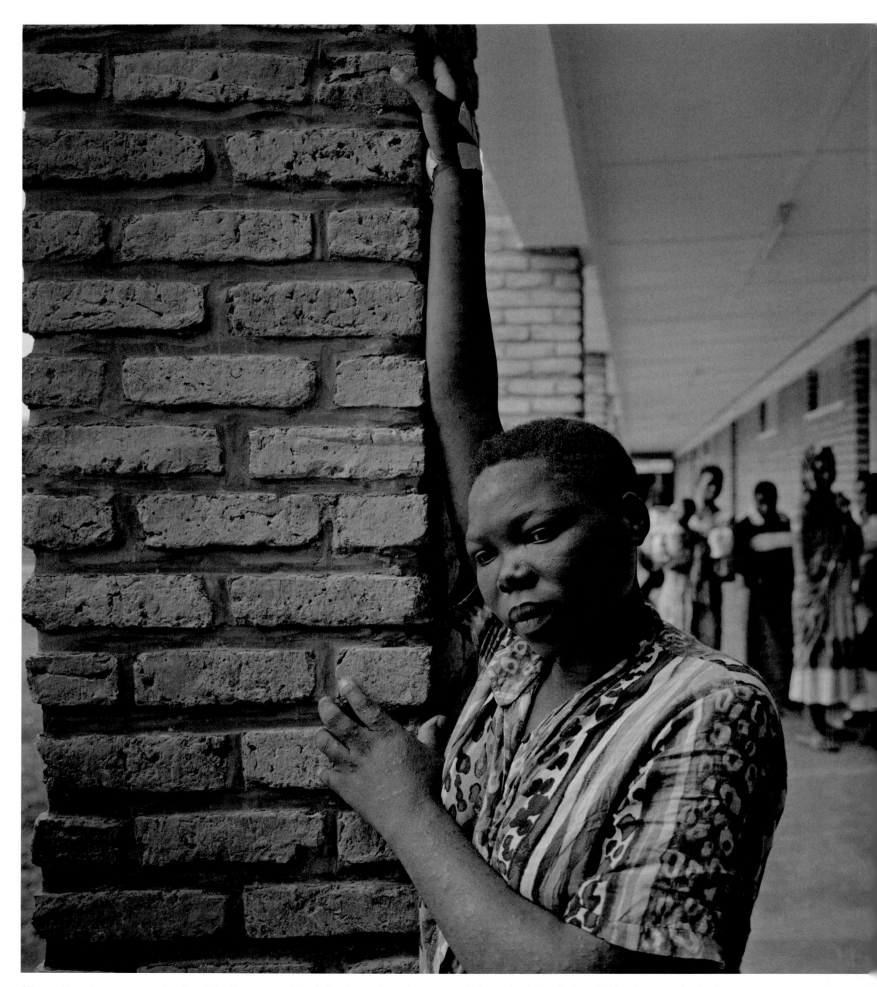

Olive and her six-year-old son, Janvier, at the Rwamagana Hospital—where, when she was very ill *(opposite, bottom)*, she told him she was going to die.

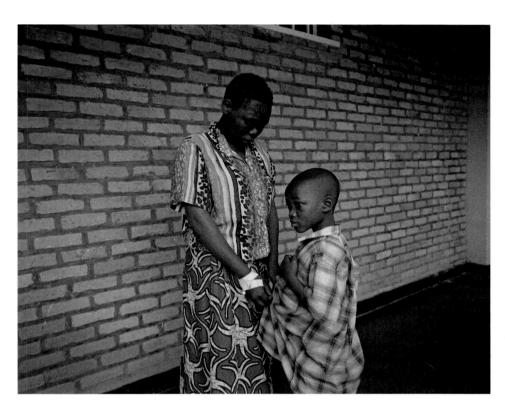

"Things changed as I got sicker and sicker. Before, I could socialize with everybody and they would even invite me to share their meal. But when they started saying that I had HIV, nobody would even give me drinking water from their cup. I then lost all hope in life."

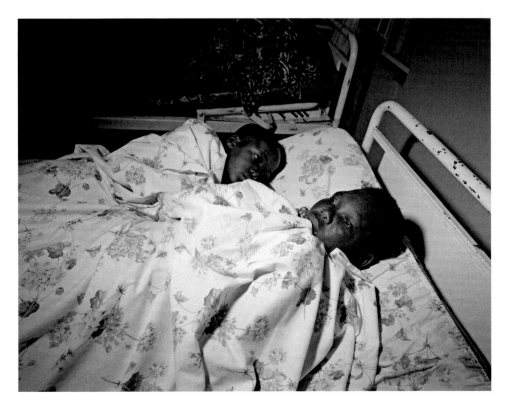

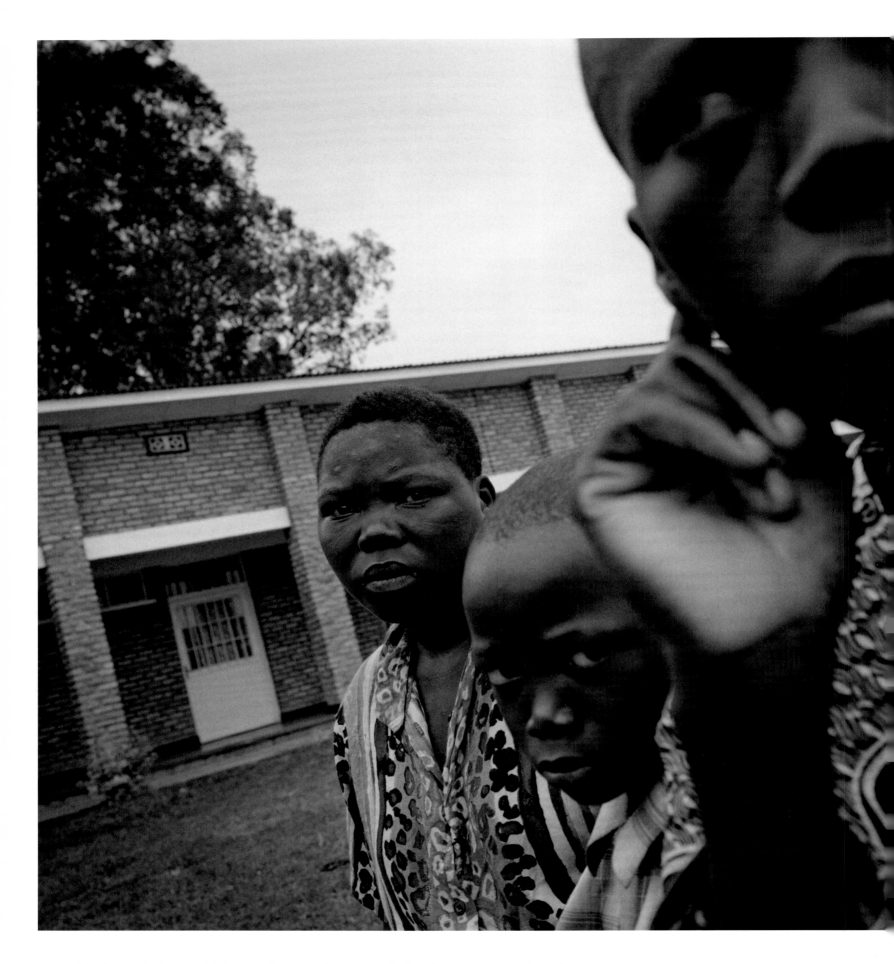

Olive and Janvier with Fred *(above, right)* who got them to the hospital after finding Olive unconscious by the roadside.
(Following spread) Olive and Janiver with Olive's partner, Éduard *(in background)*, who has accepted her AIDS diagnosis.

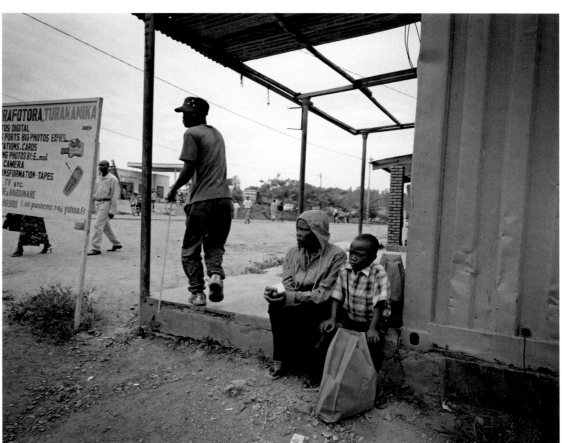
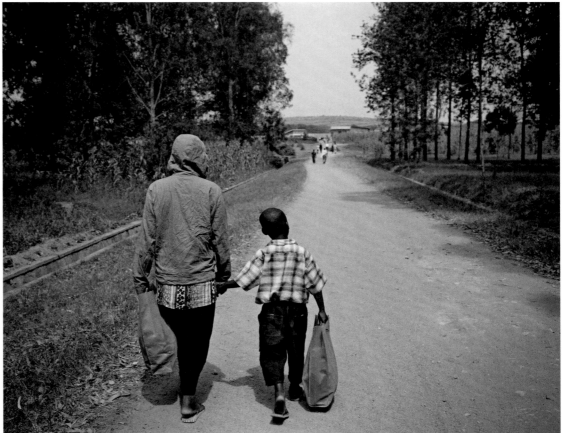

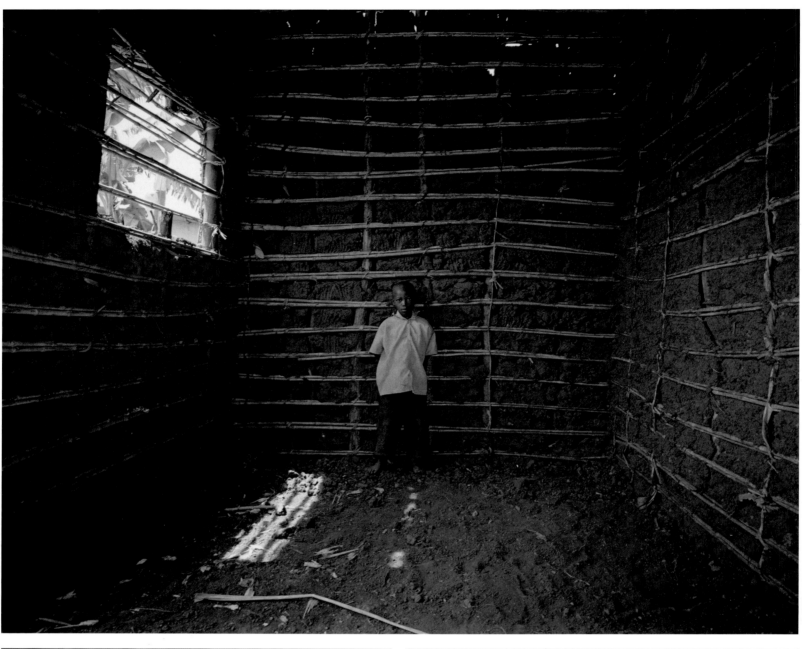
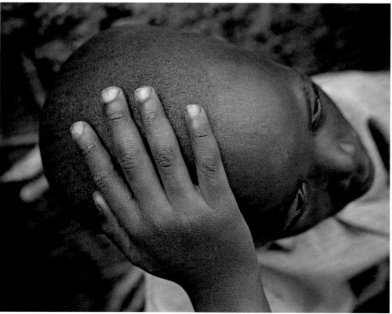

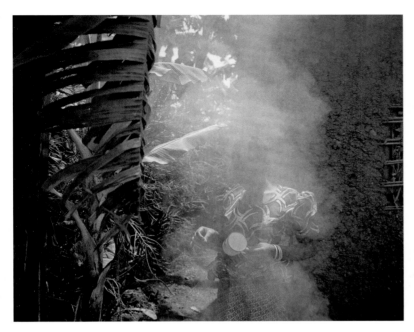

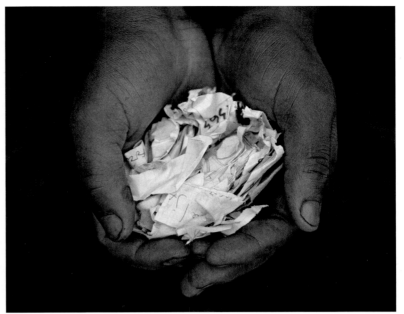

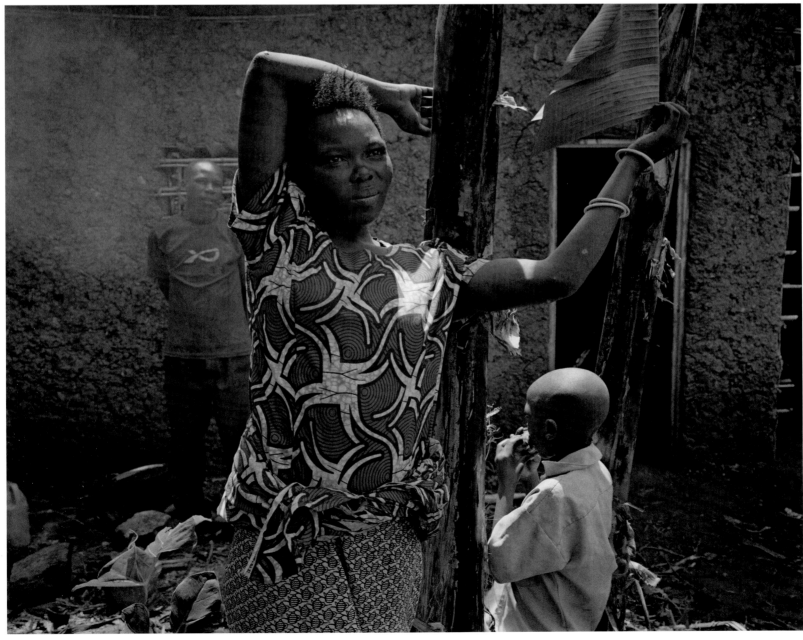

"This disease has impacted my family because I am unable to work as much {as a motor scooter cabbie}. Consequently, I don't make as much as I used to. So sometimes my family doesn't eat well. Riding people around in Kigali is a very tough job. It demands a great deal of patience and mental toughness. You can't do it without good health."

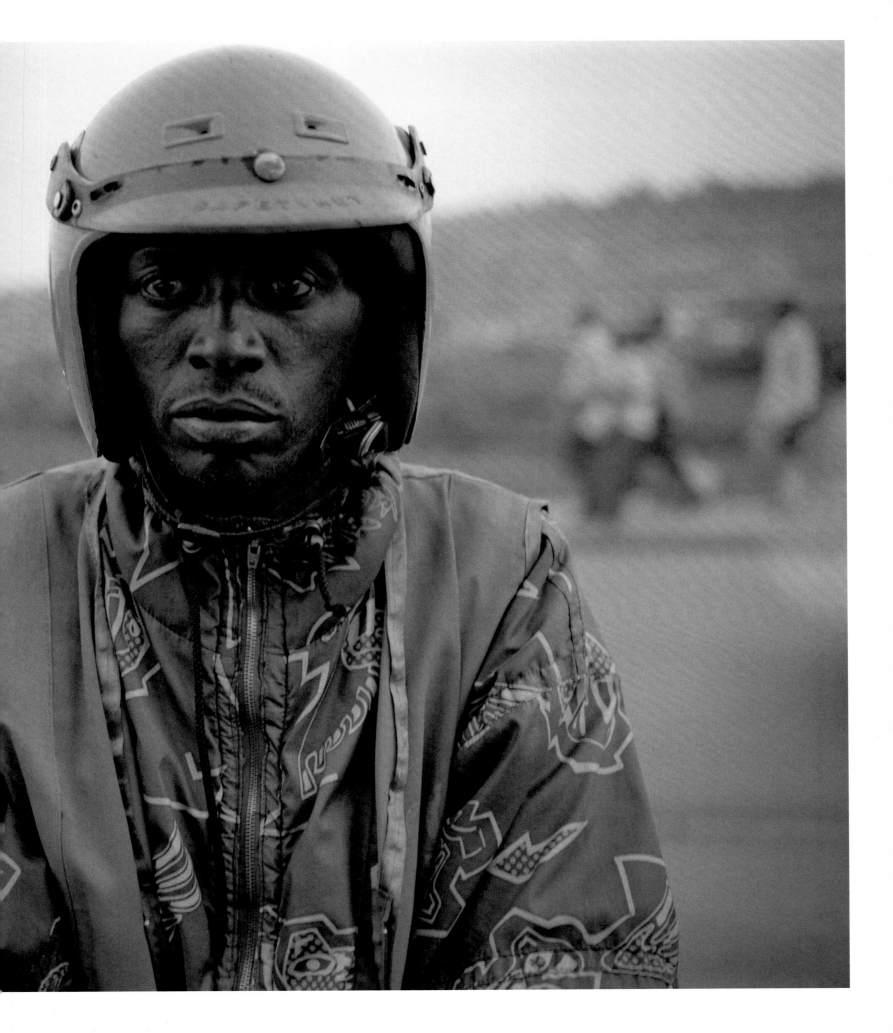

Eliyeri's prize
possession is his
motorbike
(opposite), which
his children have
nicknamed "the
old woman." It is
brought inside
at night for
safekeeping.
An avid soccer
player before
becoming too sick
to play, Eliyeri
dotes on his and
his wife Juliette's
four children,
who range in age
from 14 to 5.

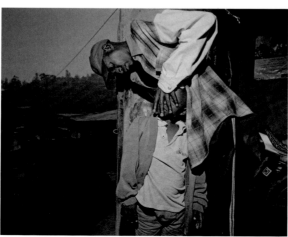

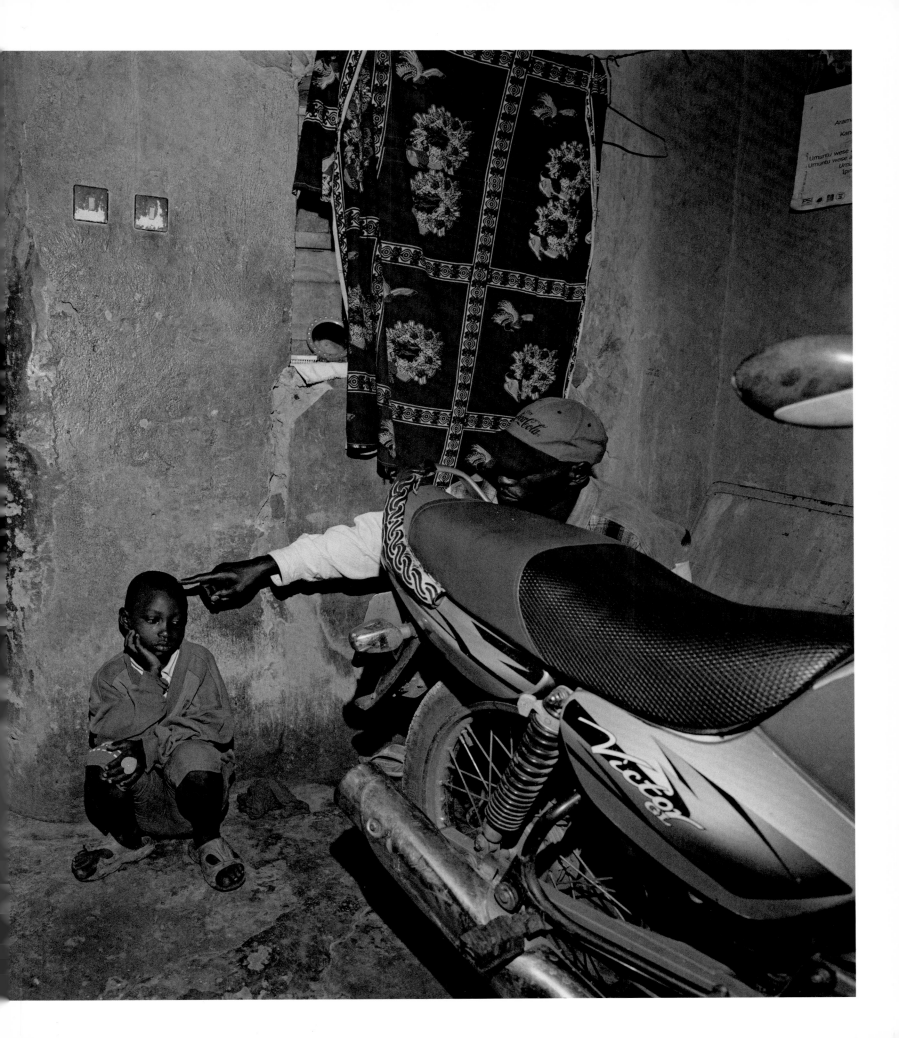

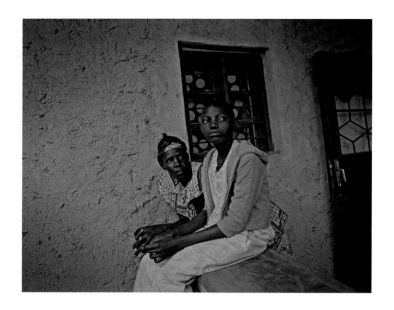

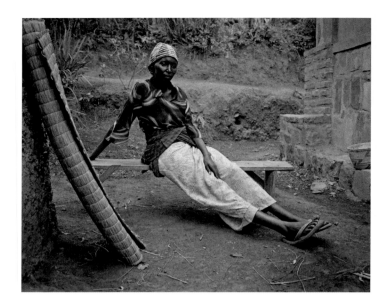

GORETI MURIKITISONI, 42, AND CHANTALE BATAMULIZA, 13
OCCUPATIONS: Farmer, student

Goreti Murikitisoni's life, like that of most Rwandans, has been irreparably shaped by war and genocide. Goreti and her husband, Cyril, grew up in Uganda, the children of Rwandan refugees from the 1950s. They had a good life there. The family owned 18 cows, and Cyril worked as a long-distance trucker. But in 1994, while driving over the Rwandan border during the fighting, Cyril was shot at by Interahamwe militias, his truck overturned, and he was left permanently disabled. Goreti, the mother of four boys, was pregnant at the time with her daughter, Chantale.

Two years later, part of a wave of returnees with high hopes, they moved back to Rwanda. But soon there were new worries. In 2001, Goreti was diagnosed as HIV-positive while hospitalized with TB. She felt distraught to the point of being suicidal, she said, and concerned about the children's welfare. For years she was in and out of the hospital.

Worse was to come. During one of her mother's hospital stays, Chantale, then nine, was rounding up the family's cows when she was raped by an older man. Chantale and her attacker were tested for HIV, and both were found positive. (The rapist is in prison.) Finding out that her "first and only daughter"—sickly since age three—was HIV-positive was "extremely painful," Goreti says. She believes that both she and Chantale were infected during the child's birth, by blood on the delivery table.

When she heard about antiretroviral treatment on the radio, Goreti was "so overjoyed, I could hardly contain myself." But the drugs were not yet locally available, and Goreti lobbied hard to get them. Goreti began treatment in 2005, Chantale at the end of 2007. Now 13, Chantale is the top student in her class. She likes French, science, and mathematics, and wants to be a doctor "so that I can treat people."

MARCELLINE UWIMBAZI, 31
OCCUPATION: Farmer and mother

Marcelline, the youngest of six children, grew up in Ruhama, in the southeast part of Rwanda, where her family lived off the land, farming cassava, sweet potatoes and beans. Despite her father being "very strict," she was spoiled as the youngest and, though she was a "strong girl," didn't have to do any chores. She never went to school, but learned to read and write through adult-education programs. Marcelline got married at 18—young by Rwandan standards—to a man 14 years older. They had three children—Solange, now 11, a baby boy who died, and then Richard, 9. Marcelline soon learned that her husband was a womanizer and an alcoholic. Humiliated by his affairs and abuse, she left. Soon after, he grew ill and died; some said he died of AIDS.

Back in Ruhama, Marcelline farmed her elderly parents' land and took care of them and her children. In late 2007, she thought she had malaria—she was too weak to plant and the family had no spring crop. When she found out she was HIV-positive, she cried. Her first thoughts were of her late husband's cause of death. (She took Solange and Richard for a test; they are HIV-negative.) Three of her sisters have already died of AIDS, and one brother is HIV-positive as well. Jean-Marie, her closest brother, cares for her, just as he did during the 1994 war, when they traveled and hid together. When Marcelline needs medical attention, he takes her to the hospital on his bicycle. To help her earn again, he cycles almost to the Tanzanian border to buy bunches of onions, which Marcelline sells the next day at the local market, earning a total of about two dollars.

Marcelline says she now feels like the "strong girl" she was. Were it not for the ARV treatment she takes every day, she "would forget that I have AIDS."

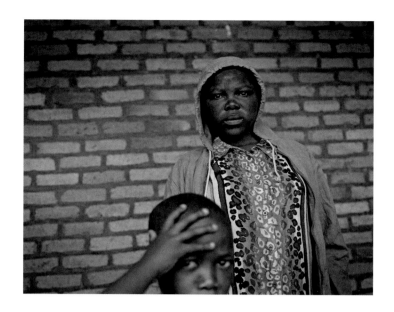

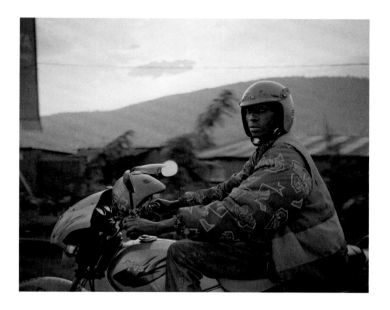

OLIVE UKWIZABIGIRA, 20

OCCUPATION: Refugee, mother

Although she is just 20, Olive has already had a lifetime's worth of tragedy. During a Rwandan Patriotic Front attack in 1994 near the farm where Olive and her mother lived, they were separated; her mother was killed by a stray bullet. Olive, only six, remained alone, living in abandoned buildings, doing farm work, and working as a maid. At 13, she was raped by her employer and became pregnant. It was then, Olive believes, that she was infected with HIV. At 14, she had her son, Janvier. "I sometimes ask God why he tried me this hard," Olive says.

Olive developed severe skin rashes and was cast out by her community—many believing she had been cursed for using her dead mother's unexorcised belongings. She consulted a witch doctor but ran out of money. By late 2007, Olive's face was so swollen that she could hardly see. A pastor found her unconscious by the roadside and took her to the Rwamagana Hospital east of Kigali, where she was immediately put on ARV therapy. Desperately worried about her abandoned son, however, she fled from the hospital soon after. She found Janvier but, without her ARV drugs, lapsed into a coma.

Found by a policeman, and returned to hospital treatment, Olive improved enough to leave the hospital and begin earning a living by selling potatoes at the market. There she met Éduard Nshimiyimana, 27, a day laborer from the north. She hid her HIV status from Éduard—and hid Éduard from her HIV counselor. Her guilt grew and she decided to flee again. Robbed on the road, she and Janvier were left penniless; Olive begged for bus fare and returned to Éduard, who told her, "You are my wife now, till death do us part." Having interrupted the ARV treatment several times, Olive's health remains fragile, and so does her belief that she will survive; but with the support of Éduard, she is slowly getting better.

ELIYERI (ELIEL) RURANGAWA, 48

OCCUPATION: Motorbike taxi driver

Eliel met his wife, Juliette, when she was still in high school. She was from a well-to-do family in Kigali and defied them by falling for Eliel, an older boy from the poor section of town. "When God chooses you to love someone, that is it," Juliette says. In the beginning of their relationship, however, Eliel was unfaithful to Juliette. He now regrets that he hurt her in this way—that he might have been infected with HIV then, from unprotected sex.

The 1994 war was devastating for the couple. They fled to Gikongoro, where they found that their parents had been killed. They then went on the run, moving between different relatives before ending up in a refugee camp where Clarisse, their eldest daughter, was born. After the war they returned to Kigali. Eliel and Juilette now live in a neighborhood called Cyahafi, formerly known as Gakinjiro—"the slaughter place"—because of the killings there. "We lived with such fear of being hacked to death," Eliel says. "The war has changed us. Even if life in Kigali is difficult, at least it's secure." Still, he fears being ostracized if the community finds out about his HIV status.

Eliel, a motorbike taxi driver, believes that the number of HIV-positive people increased when the war finally ended because people felt invincible, he says, and gave little thought to sexually transmitted infections. His main AIDS-related symptoms at the end of 2007 were a 20-pound weight loss and a painful, peeling skin rash, which made it too uncomfortable for him to sit on his bike and drive customers. After three months on antiretrovirals, however, his strength began to return and his skin rash cleared up. A devoted father to his and Juilette's four children, Eliel can finally support his family again.

SNAPSHOT: HIV AND AIDS IN RWANDA

OVERALL POPULATION: 9.2 million

NUMBER OF PEOPLE LIVING WITH HIV AND AIDS: 150,300

HIV PREVALENCE AMONG ADULTS: 3 percent (4 percent among pregnant women)

NUMBER OF PEOPLE ON ANTIRETROVIRAL (ARV) TREATMENT: 48,569

NUMBER OF PEOPLE WHO NEED ARV TREATMENT: 68,000

NUMBER OF CHILDREN LEFT ORPHANED BY AIDS: 224,000

GROUPS MOST AFFECTED BY THE HIV EPIDEMIC IN RWANDA: All demographic groups are affected, with rape survivors and orphans of the 1994 genocide disproportionately affected.

RWANDAN SOCIAL ATTITUDES TOWARD HIV AND AIDS: The disease is stigmatized in some rural areas, but it is increasingly accepted in areas where treatment is available.

AVAILABILITY OF TREATMENT: ARV is available throughout the country; services aimed at preventing mother-to-child transmission now exist in more than half the country.

HIV TREATMENT CHALLENGES: The population is predominantly rural and very poor (83% of people live on less than $2 a day), which makes getting regular treatment difficult.

TREATMENT SUCCESSES: Rwanda is reaching two-thirds of all people who need ARV treatment, and the country is on course to reach universal access to treatment by 2010. Some rural and urban areas have seen substantial declines in HIV prevalence, while infection levels overall appear to have stabilized.

ana marìa

Mateo Joaquin

peru

JUAN CARLOS

photographs by eli reed

josé luis

In the 1980s, while I was in San Francisco working for a newspaper, I was assigned to an AIDS-related project. If you lived in San Francisco there was no way, at that time particularly, that you could not see what was going on. The AIDS epidemic was developing very fast. Still, people didn't understand at the time the importance of what was going on.

People trying to understand what's happening, people shunning other people because they don't really understand what it's about: All that's been going on for such a long time.

I had been in Peru once before, in the 1990s. I was struck then by how people embraced each other when they met, how tight families were. I didn't know whether HIV would change that. It's such a terrible thing to happen—how are they going to get through this? It's such a heavy weight to bear. For most of the subjects, their HIV status was not something they could reasonably share with anybody, except maybe their closest friends. Sharing with their families was always an issue—not being able to tell your family that you have this, in a place where family is so important, only adds to the tragedy.

I didn't know what to expect. I was hoping for the best—hoping that this treatment would work for these people and that they would get better. We got to them early enough so that the possibility of things getting better was strong—and that's what I saw. Coming back was like light at the end of the tunnel. Seeing how people actually improved was the high point: "Break on through to the other side," this thing works! For them this was a godsend, you know.

Every time you go in to work with stories such as this and projects such as this, you carry them with you when you leave. There isn't a clear-cut choice. It's the same thing as when you cover a conflict. It sleeps within you for the rest of your life. I'd rather do work that has a long-lasting effect, to render help where help can be rendered. That's the adventure of life. **—Eli Reed**

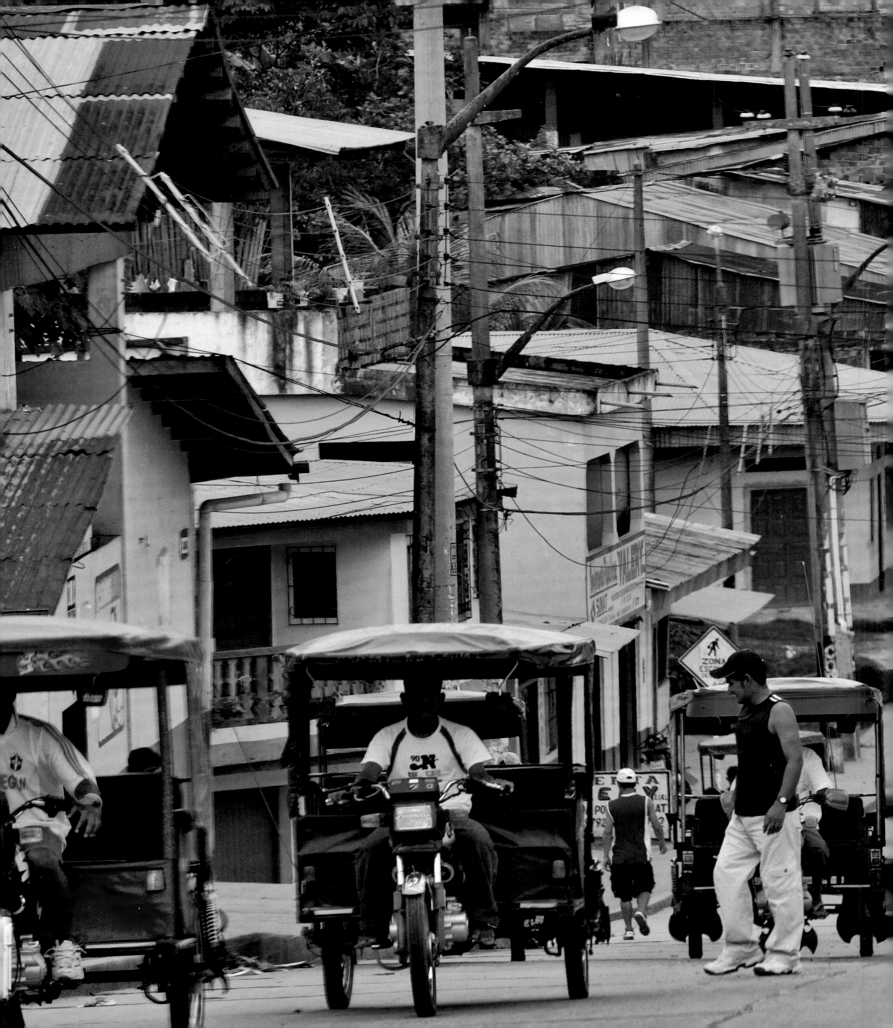

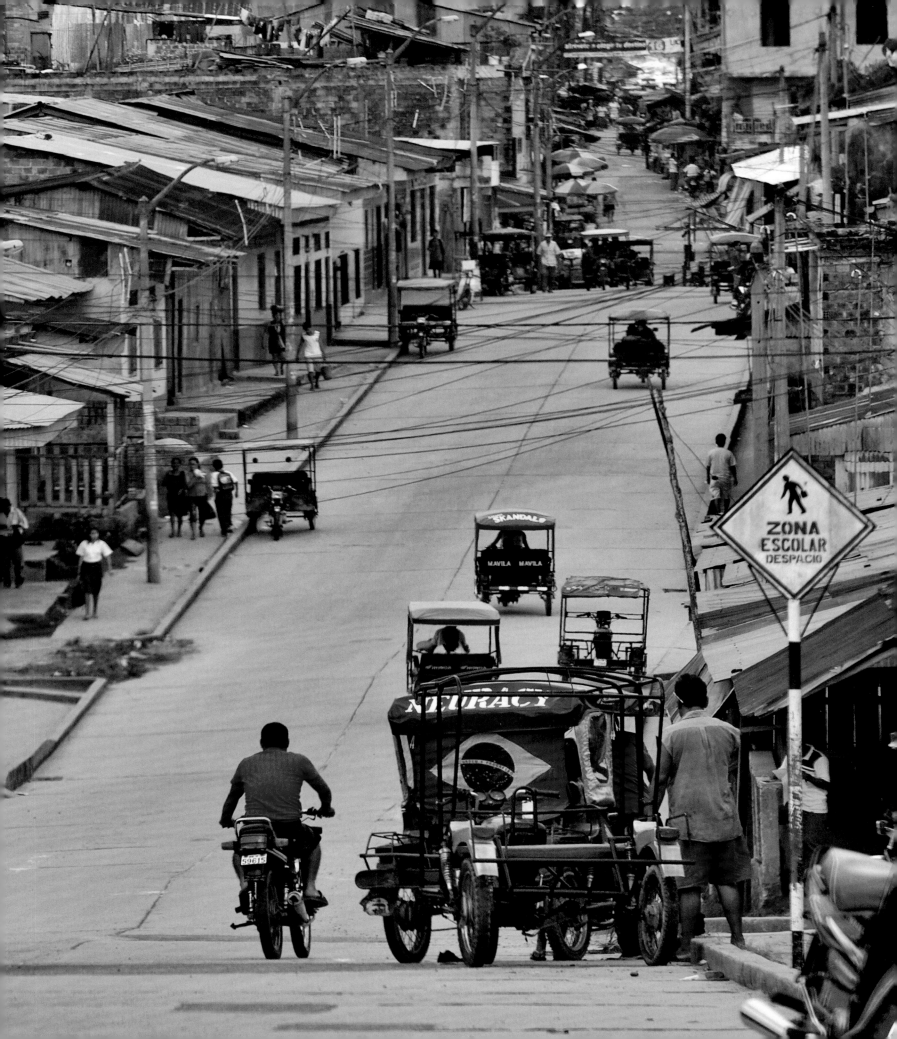

"I felt like a woman when I was growing up. My mother knew that I was like I am now. She loved me. The problem was with my brothers and sisters. When I left the house, they insulted me. We fought. So I went to Iquitos when I was 12 and rented a room. I grew up there… I don't want to be whoring again. When you're a prostitute you need to be very bold, to fight, to rob—and sometimes you don't eat."

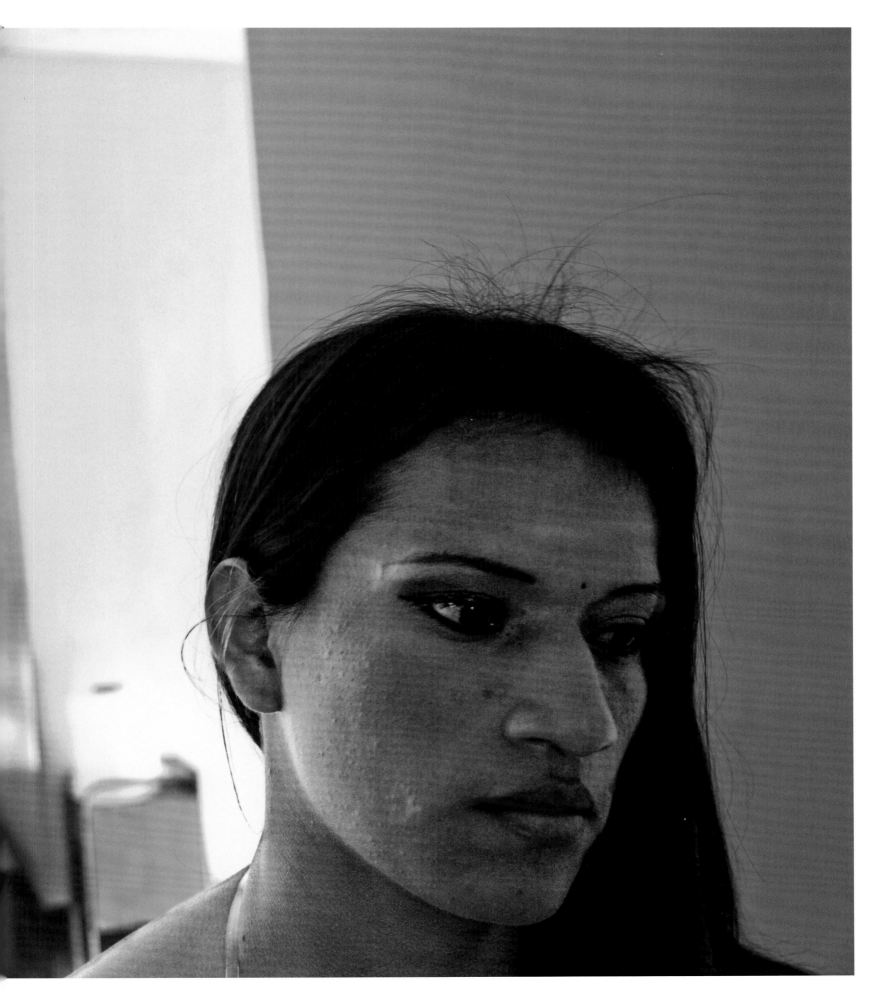

*Because of the powerful stigma against HIV and AIDS in Peru, the names of all people and places in this section have been changed to protect the privacy of the individuals. All other facts and details are true.

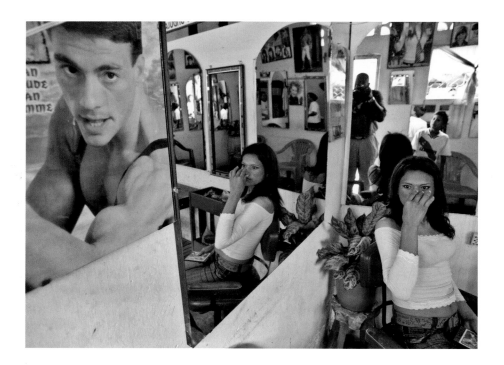

"The HIV epidemic is getting worse. More and more people are getting HIV because they have sex without condoms. When they told me that I had this illness I was having sex without a condom, passing it on to other people. For a month I did this. I *wanted* to give HIV to others. Men would do it with me without a condom and then they have their woman and they would have sex without condoms and pass it on to others. The men do this and that's how HIV increases."

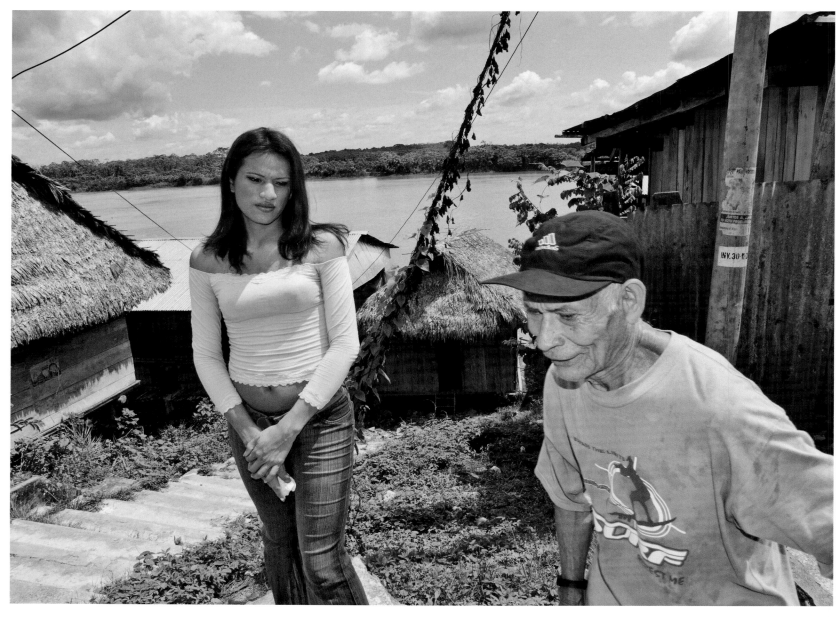

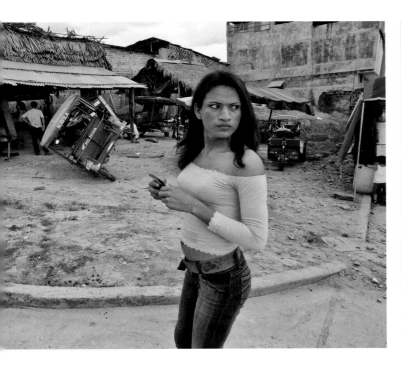
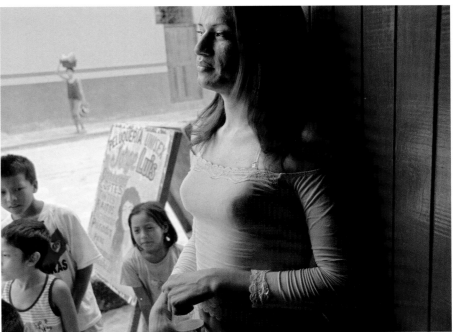
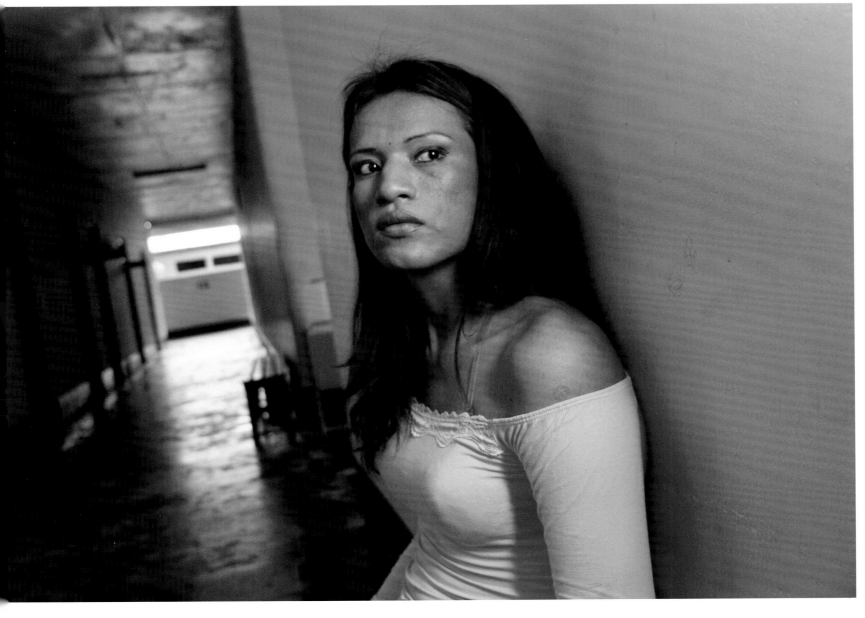

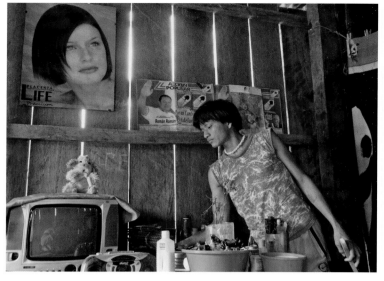

In January 2008, Juan Carlos fulfilled a lifelong dream, opening his own hair salon. "I get up at 6:30, sweep the room, wash the toilets, clean the armchairs… I am feeling fairly normal. I also feel now that my family loves me. Before they did not love me. But I haven't told my family yet about my HIV. When I've told other people, they have not wanted to be with me, they have pushed me away. That's why I'm afraid."

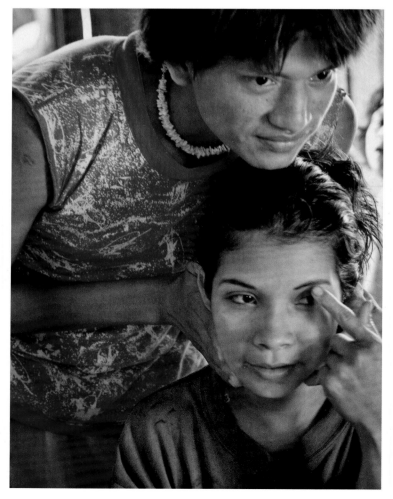

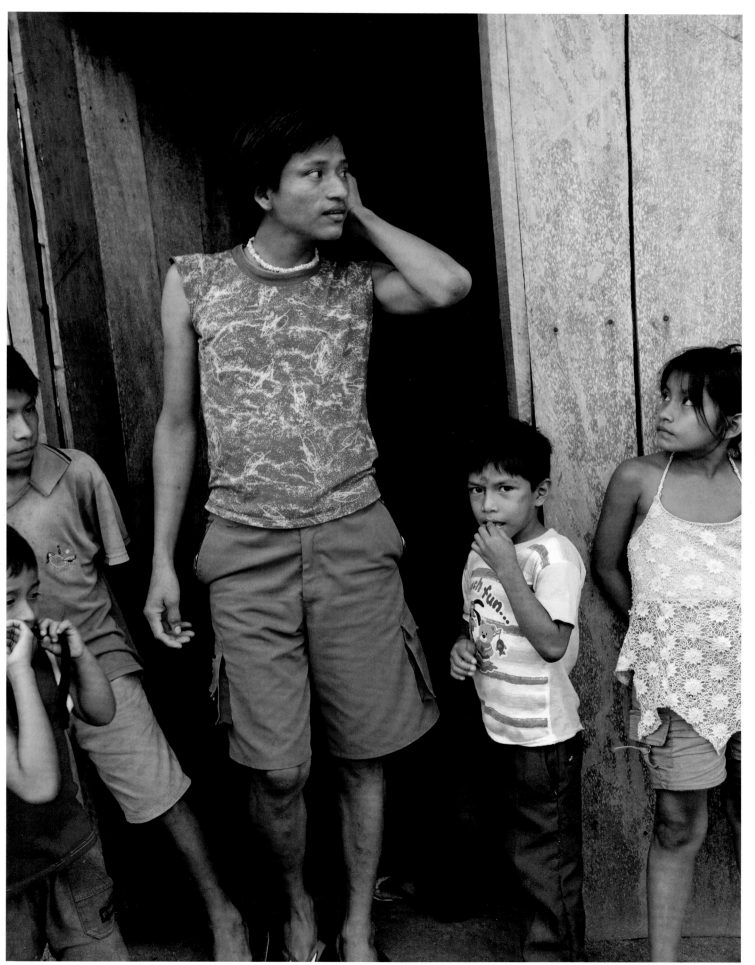

Juan Carlos at his beauty shop *(opposite page)*, cutting hair, talking to clients, and sweeping up. And with local children outside the salon *(this page)*.

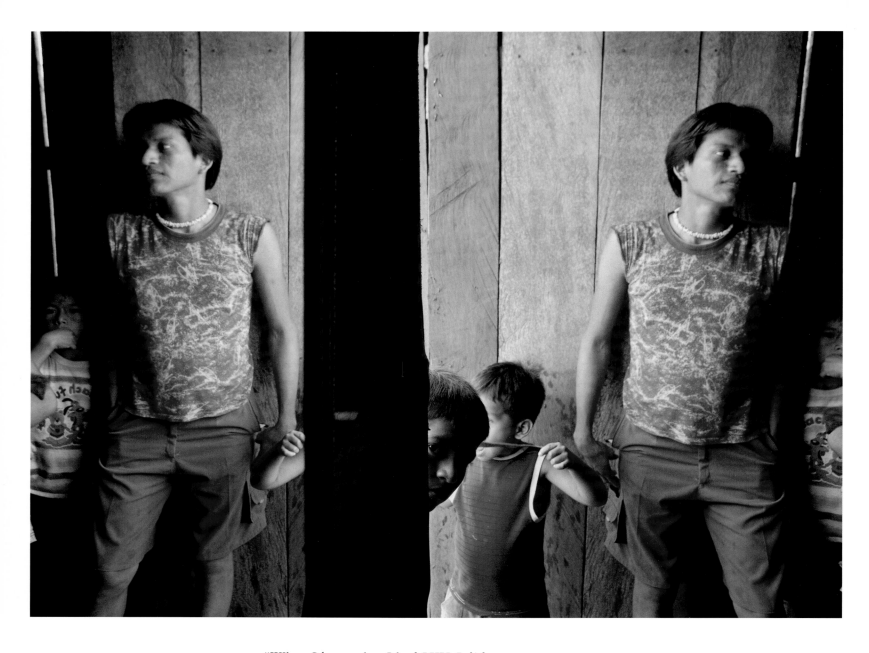

"When I knew that I had HIV, I did not want to go out.

Pain, sadness, sleepiness was all there was. For weeks, I wanted to sleep. I felt as if I had been beaten up.

I was worried. I didn't want to eat. I felt anger and pain. I didn't value myself at all and I wanted to end my life.

But little by little, from my friendships in the barrio, I began to feel happier.

Little by little, I have changed."

A former transvestite, Juan Carlos *(above and in previous spread)* decided to cut his hair and appear less feminine.

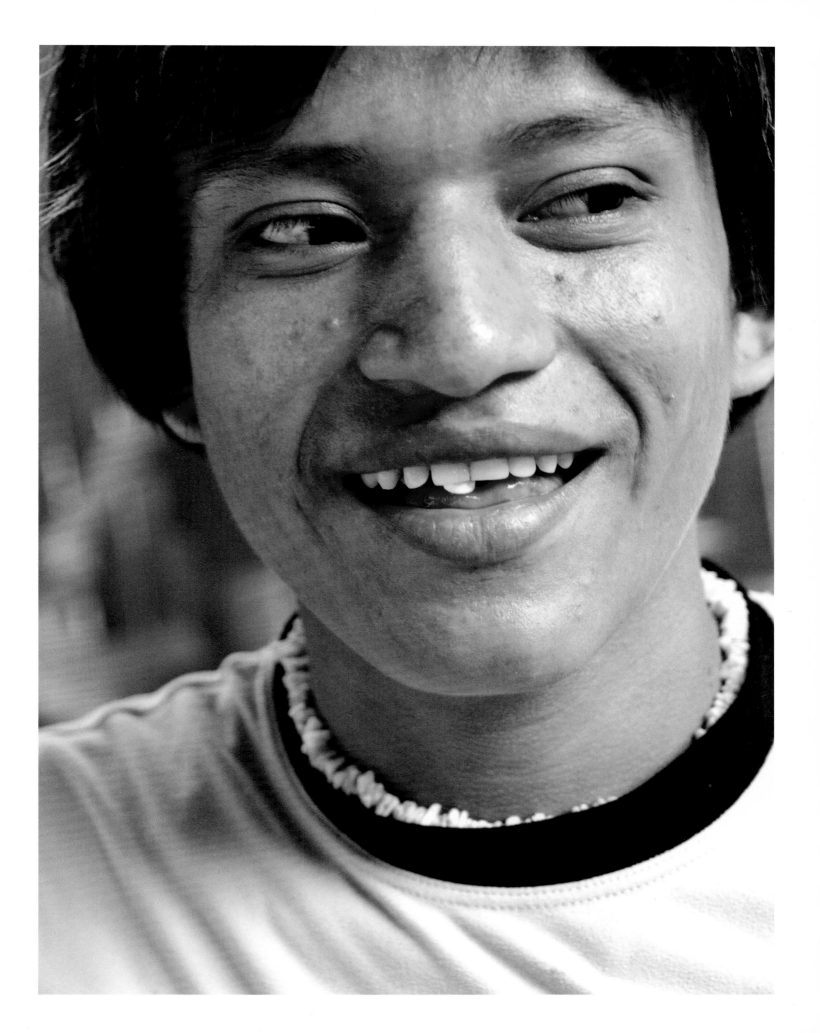

"It's not so easy to be a transvestite," says Ana Marìa. "Yes, for me {being HIV-positive} is very difficult. Somtimes I think of returning to my land, but I cannot. If my mother and father find out, they will never love me. They will never let me in their house. Rejection is what worries me most."

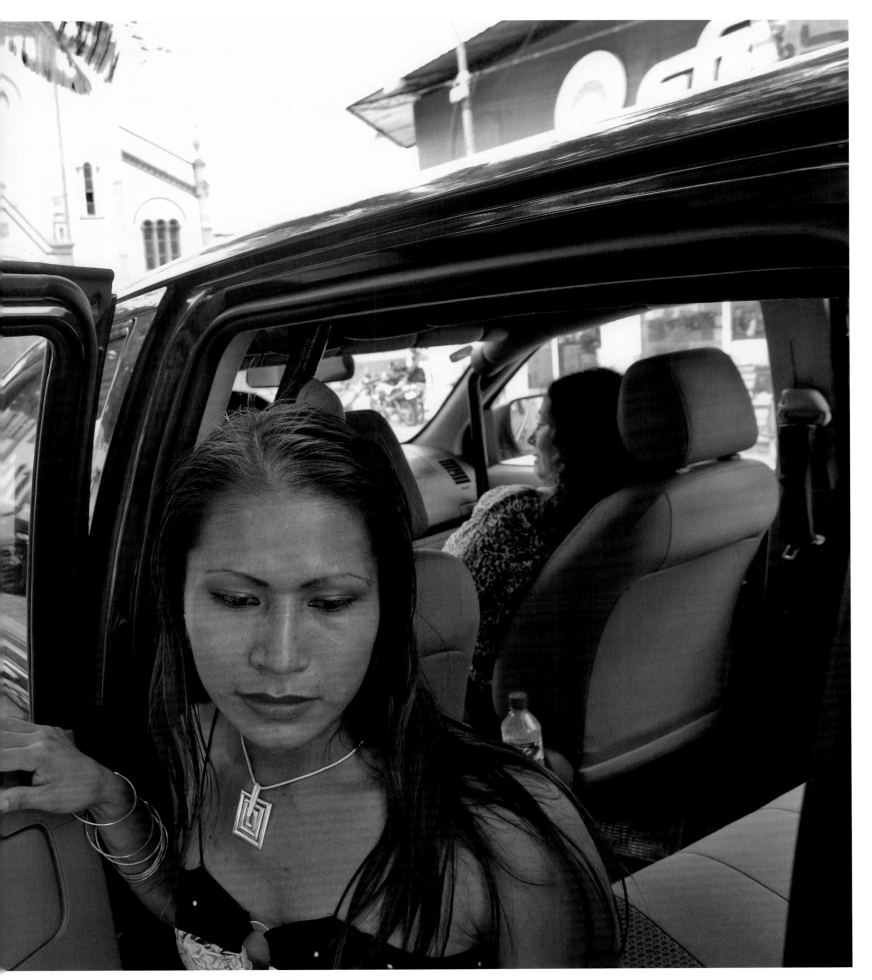

Ana María around town and at the volleyball field *(opposite page, top)* where she and her friends gather most nights, December 2007.

"The first day I got out of the hospital, my employer told me, 'Sit down, I want to talk with you because now, as of this moment, you are not going to work in my house.' I said, 'Why, ma'am?' 'Because,' she told me, 'someone with HIV cannot work in the kitchen because it is dangerous. You can infect other people.' Oh gracious, the things she said to me!"

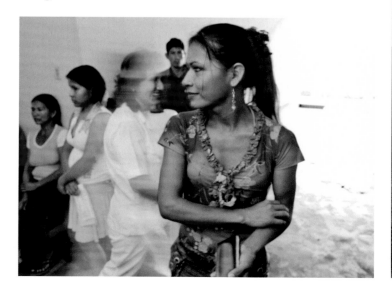

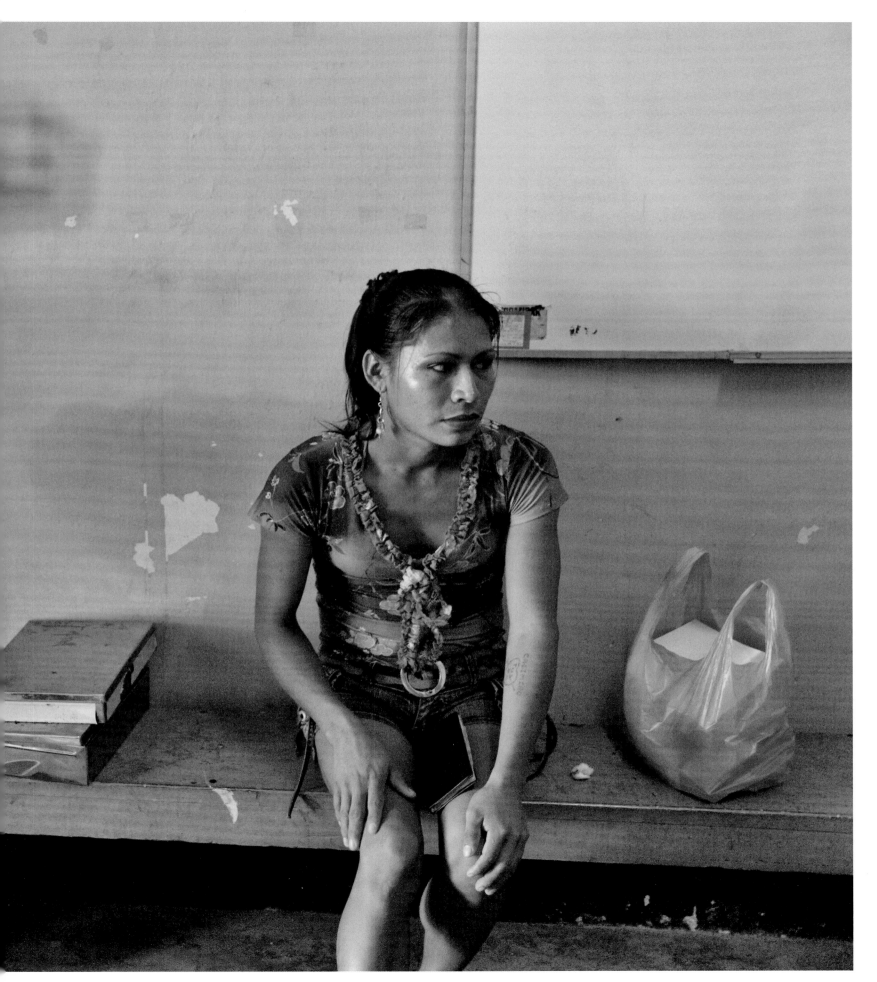

Two months after being diagnosed as HIV-positive, Ana Maria waits to be treated at the local clinic, December 2007.

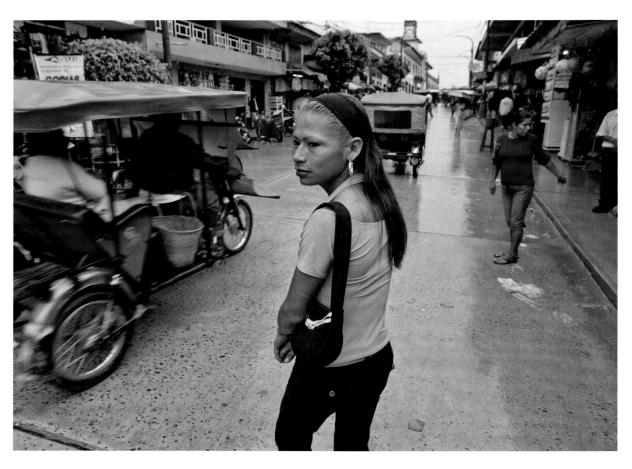

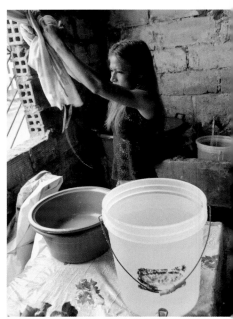

"When they told me I was infected, I wanted to end my life. But when I began the [antiretroviral] treatment, I felt like I was 14 or 15 again. I felt very happy."

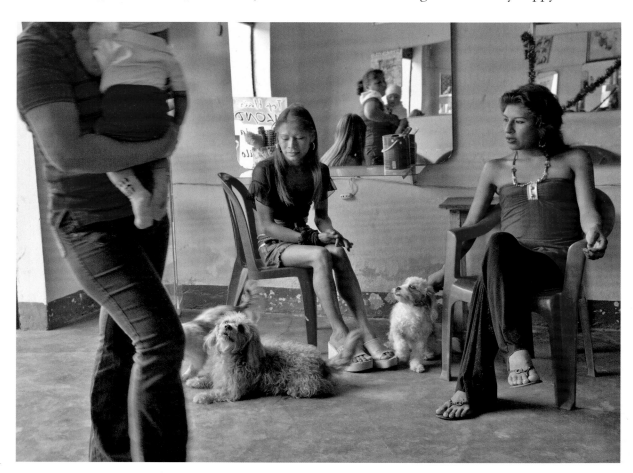

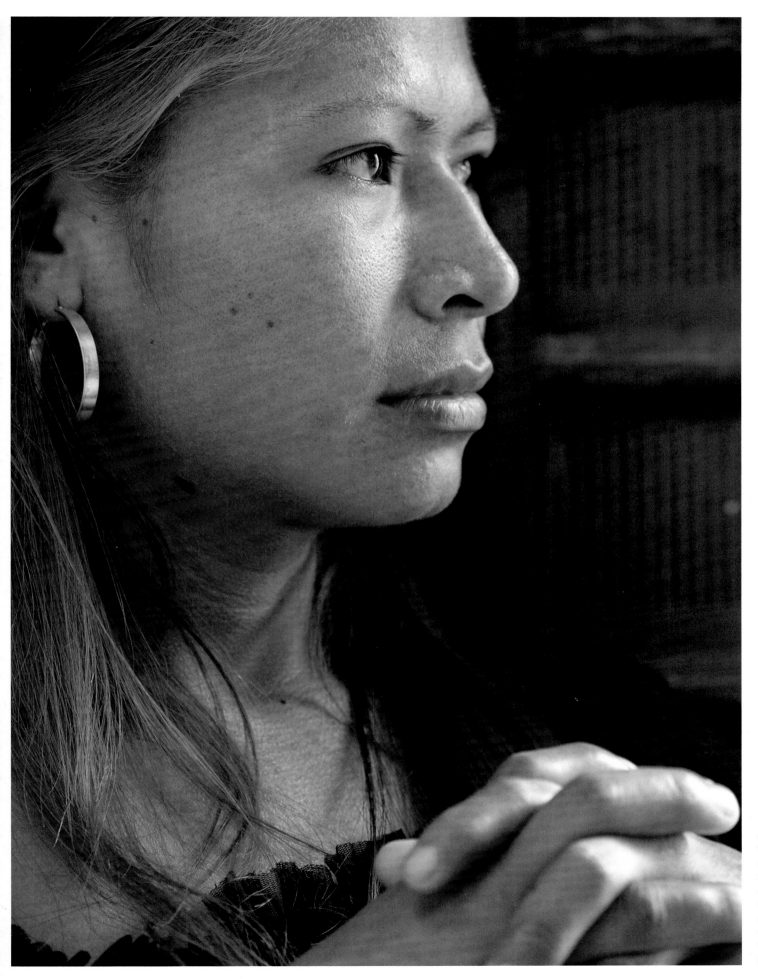

Ana Marìa on the street *(opposite, top)* and with friends *opposite, bottom)*. She cooks and does the laundry for her employer. The doll hangs in her living room.

MATEO JOAQUIN BALDIVIA, LIMA

"I left my home and came to Lima. I thought I would be able to study, but I couldn't. I had to work—nothing else. I would go out alone to parties and that's where it happened. Now I'm better informed and would not do that, but I learned too late."

—MATEO JOAQUIN BALDIVIA

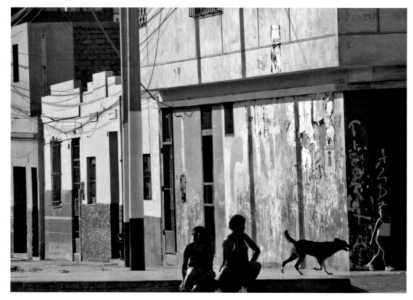

"Thank God that we now have treatment, because before people with this illness were dying. And thank God that those from other countries are receiving help. That is very good. It also seems very good that people are being informed about HIV on TV and in the arts and media. This helps a lot."

–MONICA MARIA, Mateo's good friend and supporter

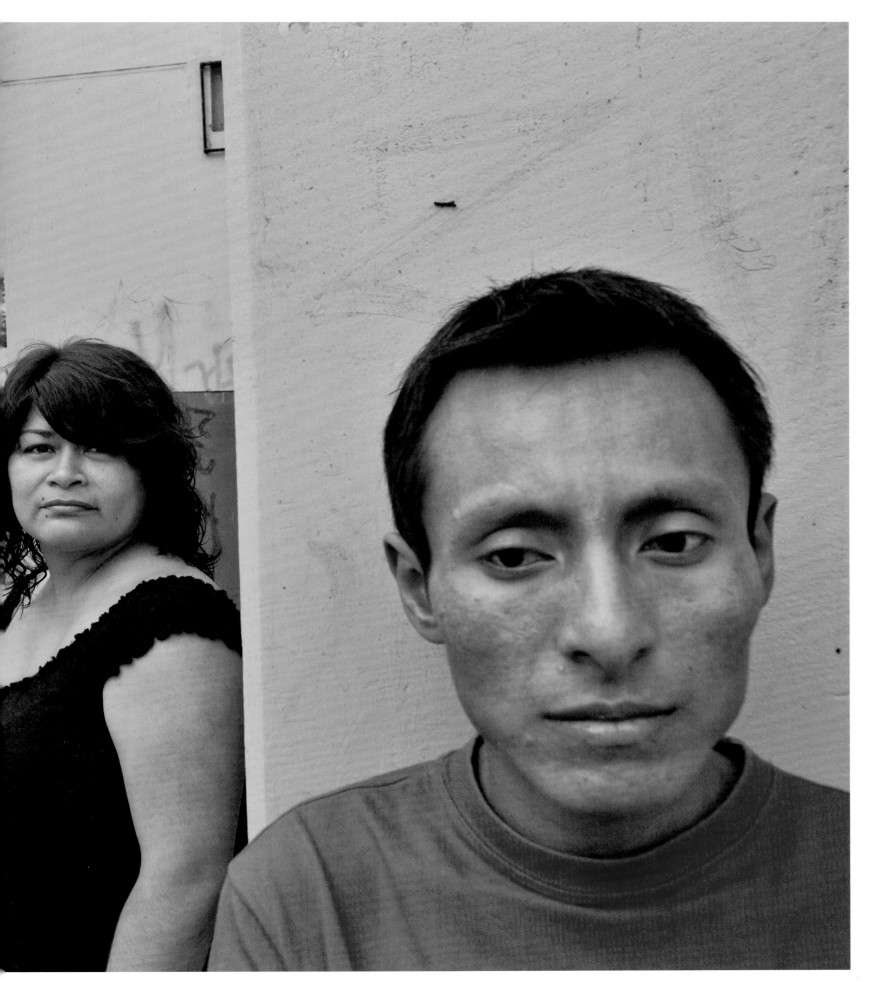

Mateo with his close friend, Monica Maria.

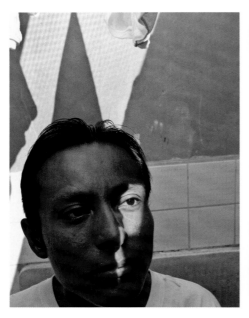
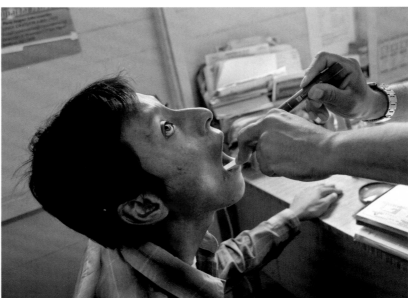

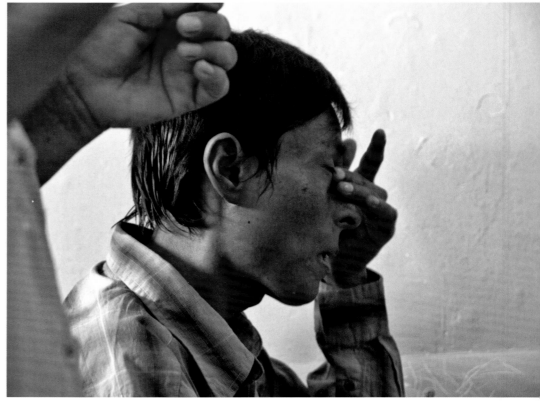

Mateo at the clinic in San José with his doctor *(top row)*. At his Christian evangelical church *(bottom left)* and hugging a friend *(righthand page, bottom)*.

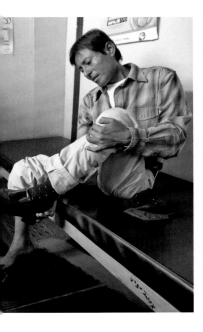
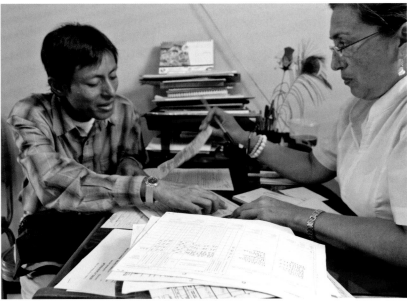
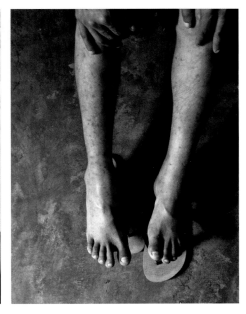

"Now, I am going to church and a Brother is giving me vitamins to take.

And this is giving me a big appetite, along with the antiretrovirals.

I know that God is going to help me a lot and I'm going to come out ahead. The dear Lord is helping me.

I know he is helping me, isn't he?"

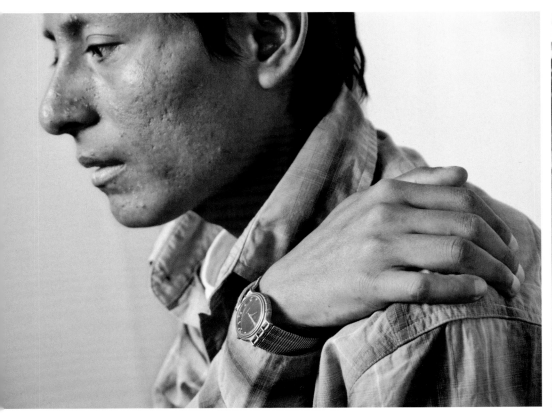
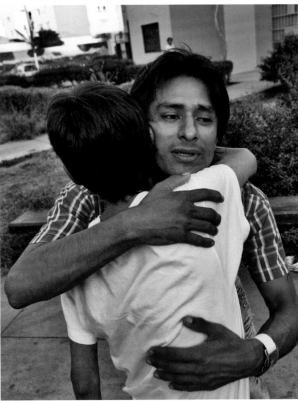

"When I was first told I was HIV-positive, I had a bad reaction. I cried a lot. But soon the doctor told me that nothing would change: I could eat, drink, sleep, cook, do all sorts of work. My illness would affect only my sex life. I could accept that. Still, I don't go out anywhere. It's worse now that I'm so skinny. Sometimes I feel ashamed. If only I were fatter!"

December 2007: After waking at 5 a.m., José Luis, 60, often spends much of the day in bed.

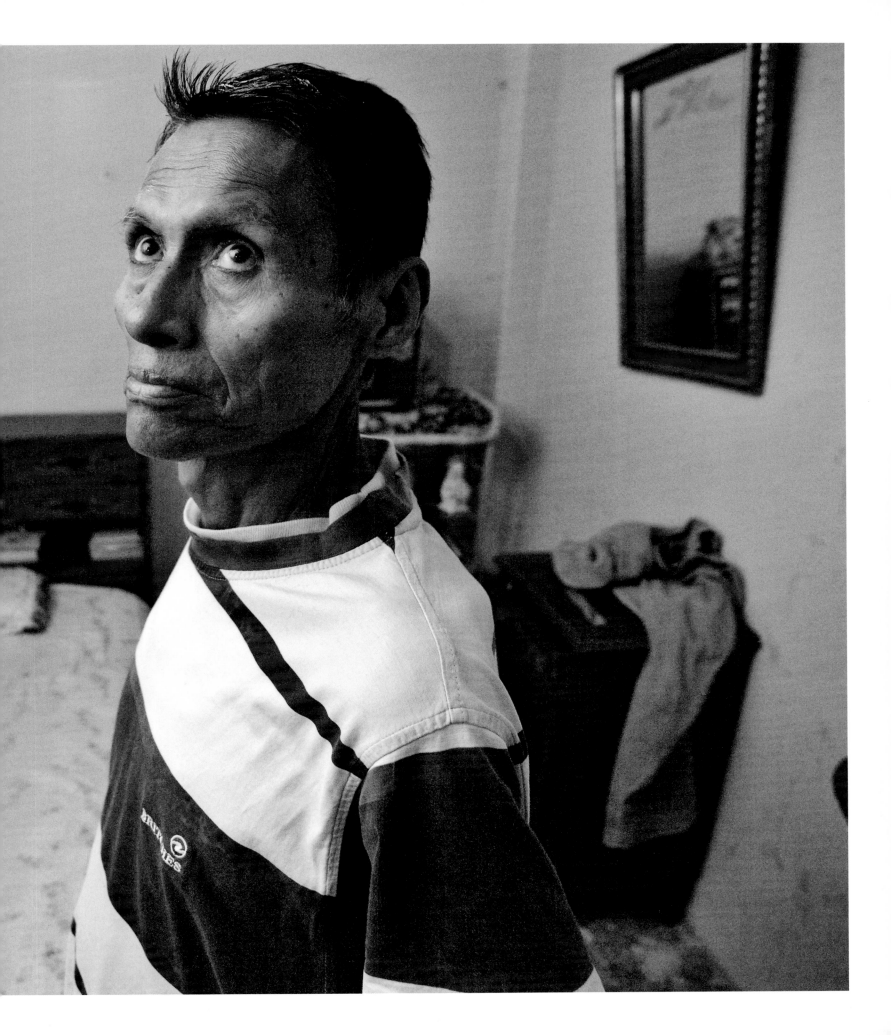

José Luis abandoned his first round of treatment after two weeks because
of shivering, insomnia, and loss of appetite. But his second round of
treatment has him "feeling almost normal." He says: "The people who are meeting me now
that I am recovering are asking me about going to work…
Suddenly, I'm going to have a good salary."

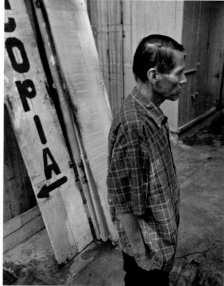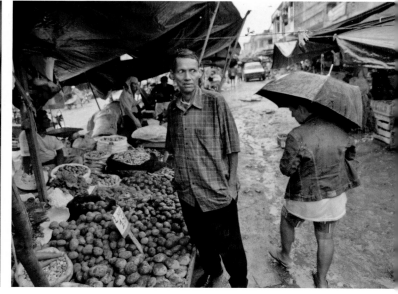

When he can, José Luis goes to the market *(above)* every morning to shop for his cooking. With his daily antiretroviral medications *(opposite page)*.

212

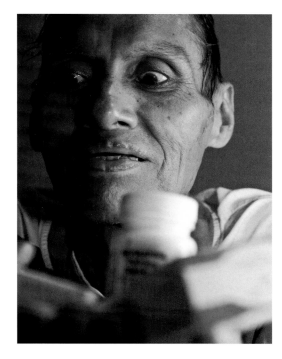

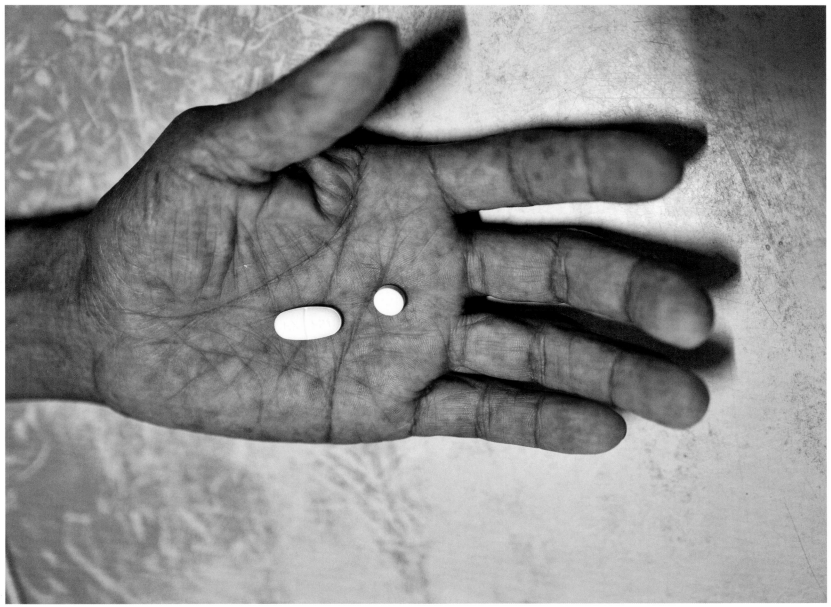

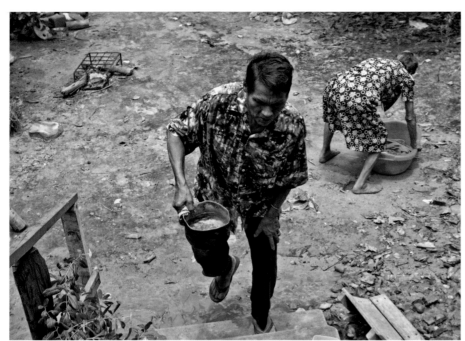
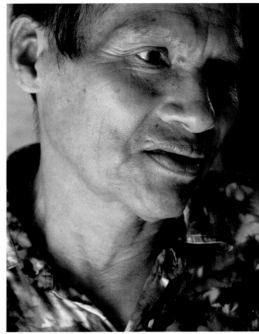
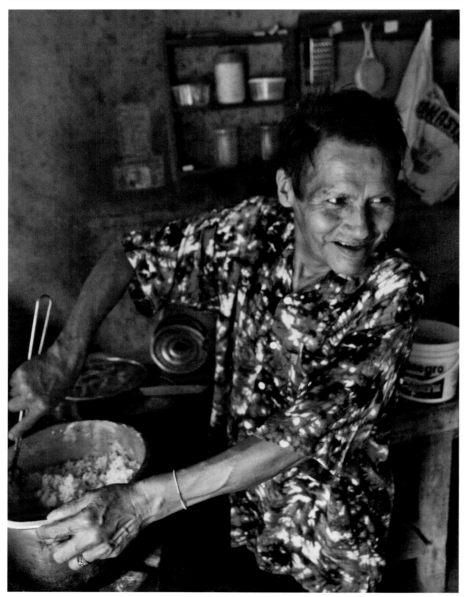
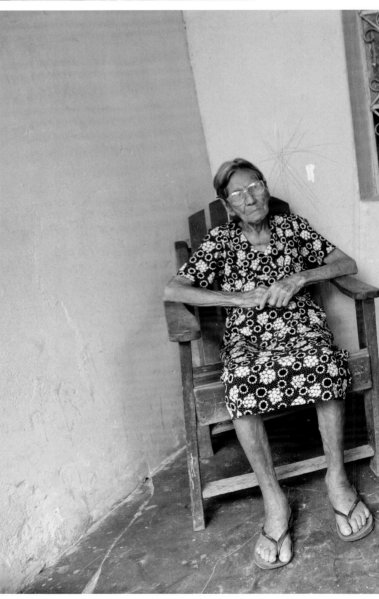

José Luis lives with his 94-year old mother, who helps out with the cooking when she can.

"When José Luis was a young man, he worked very hard in different places with different types of people. No barrier would get in his way. He was cooking in the 1970s, working for the gringos in transportation when they were building the highway toward Lima. He paid our debts because we were poor people. As a result, he paid for the construction of this house and our houses next door. We brothers paid too, but José Luis covered much of it."

—WINSTON TOMAJANBO, 58, José Luis' younger brother

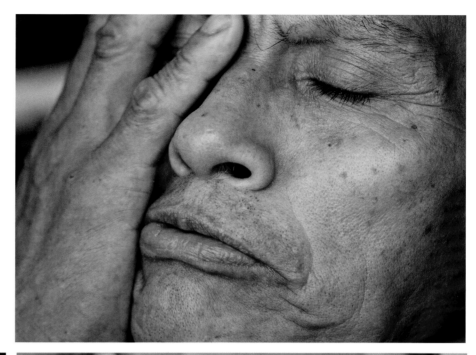

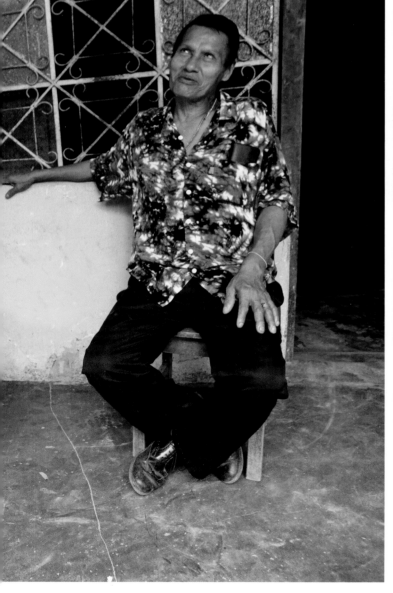

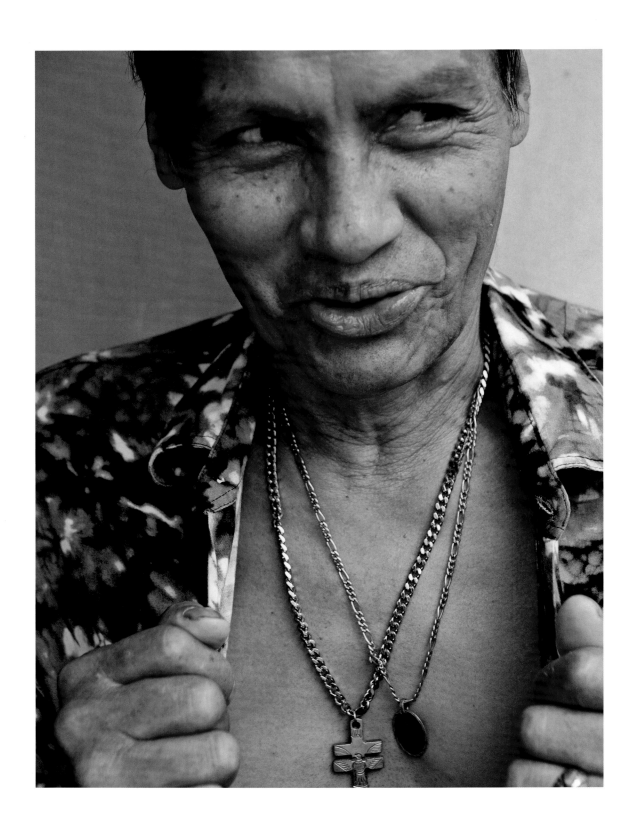

March 2008: José Luis proudly displays the evidence that he is finally gaining weight after starting his HIV treatment.

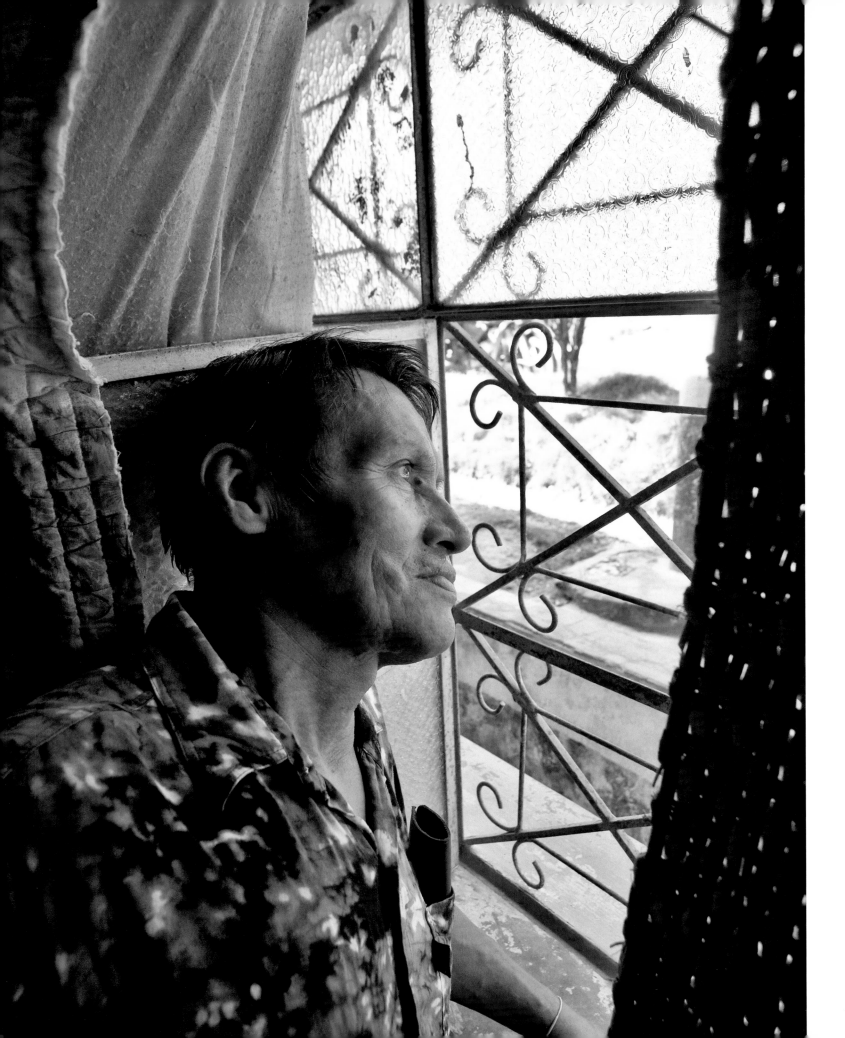

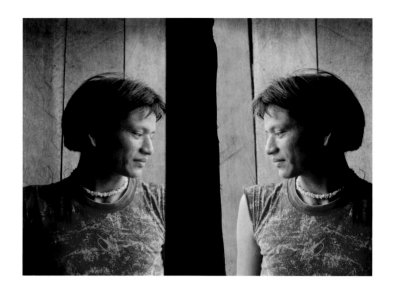

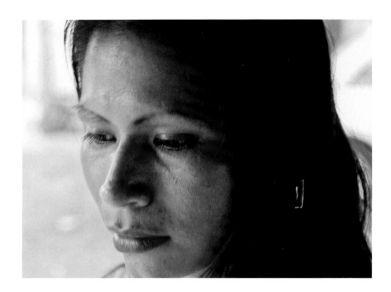

JUAN CARLOS HUAMAN, 20
OCCUPATION: Hair salon owner

A former transvestite, Juan Carlos is the fifth of six children, born into a family of small crop farmers in Peru's northern Amazonian lowlands. He left home at 12 to escape emotional abuse from his siblings, who taunted him because of his emerging sexual orientation. But leaving home also meant leaving school, and Juan Carlos was forced into menial jobs in Iquitos, a small town in a rich valley in the northern Andes, including being paid for sex from age 15 on. He thinks he was infected with HIV when he was 18 by one of his male clients.

Two years later, suffering from abdominal pain and fatigue, Juan Carlos was diagnosed as HIV-positive. Soon after he began antiretroviral (ARV) treatment. His first two treatment attempts were quickly aborted, each amounting to less than two weeks, because the irregular hours of sex work interfered with his treatment regimen. Then, after starting on the medication again, he moved to another town where it wasn't available. His third regimen, however, which began in December 2007, has been a success. Juan Carlos now says that "treatment is easy."

Other aspects of his life have also taken a turn for the better. Using $125 in savings from haircutting and sex work (which he has now given up) he has fulfilled his dream of opening his own hair salon, using a sectioned-off portion of his mother's living room. Still, he has not disclosed his status to his family—not even to his mother, whom he now considers his closest companion. He no longer smokes or drinks, and he says he would like to finish high school and go to church again. Most important, he has grown more optimistic about his future. "I don't want to be my past self," he says. "I see myself differently. Now everything has changed. I used to think, 'I am going to die.' But now, no more. The idea came to me in a moment when I was taking my treatment that I am going to live."

ANA MARÌA QUISPÉ, 22
OCCUPATION: Domestic worker

For as long as Ana Marìa can remember, she felt more like a girl than a boy. She grew up in an isolated community near the Ecuadoran border, one of ten children. Her parents farmed community land. But among the Shawi indigenous people, "behaving like a woman" when you are a man was deemed unacceptable, and Ana Marìa's parents forced her to leave home at an early age.

She became a domestic servant in Pucallpa, a larger town in the northeast, working for a woman who allowed her to continue school. At 17, with the help of a former school teacher, Ana Marìa began studies as a cosmetologist while continuing her domestic work, now for the teacher's family. But the job was virtually around-the-clock, and she was mistreated. After being beaten up and thrown down a flight of stairs, which left her unconscious, Ana Marìa was thrown out—again.

Ana Marìa discovered she was HIV-positive in September 2007, after being hospitalized because of a fever and loss of appetite. Upon hearing the news, she became suicidal. "I thought that was it. I wanted to take something so I could end my life... but I began to feel better when I realized that there was support for me."

Now in another housekeeping job, Ana Marìa lives in her employer's house with 11 others, sharing a bedroom with five of them. She's confident that her antiretroviral (ARV) treatment is working. "Now I am well, I have changed my life... I feel good," she says. She worries, however, that news of her HIV status could travel back to her home town, ruining her hopes of reconnecting with her family. "I want to return to the house of my mother and her family," she says. "If they accept me, I might tell them about my illness. I would like to hug them."

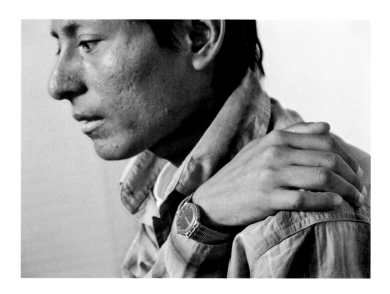

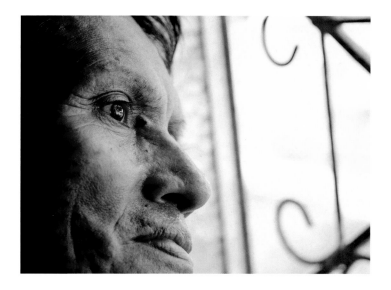

MATEO JOAQUIN BALDIVIA, 28
OCCUPATION: Restaurant server and office cleaner

When Mateo arrived in Lima at 19 from the northern coastal region of Piura, he dreamed of studying, making a good living, and being liberated from the conservative moral restrictions of his native area. But things didn't work out quite that way. He found work, but only in poorly paid menial jobs. And while he says he "lived a very accelerated life," it took its toll. Though Mateo says he didn't have many homosexual lovers, "sometimes I protected myself, sometimes no. Now I am better informed. But I learned too late."

Mateo first fell sick at the end of 2006 with diarrhea, stomach problems, night sweats, and interrupted sleep. But he was afraid to take an HIV test until the mother of his best friend convinced him that he should. His reaction to the positive result was relief rather than shock: "I suspected I had this," he said. For two months he continued to work, waiting tables during the day and cleaning offices on the weekends, but soon he was too ill to carry on. He began antiretroviral (ARV) treatment but again contracted secondary illnesses—gastritis, conjunctivitis, herpes, diarrhea—he had had before starting treatment (their reappearance, as the immune system begins to rally, is a common syndrome).

These days, Mateo is cared for and supported by a loving extended family. While his mother is at work in Brazil, he lives with an elderly aunt. A younger aunt and her husband feed and look after him. Though Mateo remains guarded about his homosexuality, more family members now know he is HIV-positive. Those family members who know about his sexual orientation and illness have become more, rather than less, supportive. "You just have to hope that your family will offer you moral support," Mateo says. "I already feel in good spirits."

JOSÉ LUIS TOMAJANBO, 60
OCCUPATION: Cook

José Luis was born in the "eyebrow of the jungle," in the northern Andes near where he now lives. His parents were *chacreros*, farmers of a small plot, and José Luis, the seventh of 11 children, helped in the fields after school and on weekends. He began working full time at 16, first as a *machetero*, harvesting sugar cane and other crops, then as a warehouse janitor, and subsequently in the kitchen of an American company involved in the building of the Marginal Highway linking Lima and the northern Amazon. It was there, in the rough and tumble of the traveling company's mess, that he learned to cook. Ever since, cooking has become José Luis' beloved "art" and established him as "the motor of the family."

When José Luis fell ill in May 2007, he thought it was the result of diabetes, a disease he had been diagnosed with 11 years before. He suffered from diarrhea and colic, and lost 10kg in eight days. It was only after his family sent him to Lima, where he underwent a battery of blood tests, that he learned he was HIV-positive, though it is still unclear how he contracted the disease. (José Luis says he did not know about the importance of using condoms when he was sexually active in the 1980s and 1990s.) Surprised and terrified by his diagnosis, he was convinced that he was going to die. "More than anything, it was the fear," he recalls. "The greatest despair was thinking that I wouldn't be able to work again."

Though José Luis began ARV treatment almost immediately after being diagnosed, side effects (shivering, tiredness, loss of appetite) made him abandon it after two weeks. But a month later he started again. Now, he says, he feels, "almost normal," sleeps better, has gained 20kg (from a low of 49kg), and is back in the kitchen, living with his 94-year-old mother so he can save money to open his own restaurant stand.

SNAPSHOT: HIV AND AIDS IN PERU

OVERALL POPULATION: 27.9 million

NUMBER OF PEOPLE LIVING WITH HIV AND AIDS: 93,000. In Latin America as a whole, about 1.6 million people have the virus. There were 100,000 new cases in Latin America in 2007.

HIV PREVALENCE IN THE ADULT POPULATION: 0.6%

NUMBER OF PEOPLE ON ANTIRETROVIRAL (ARV) TREATMENT: 10,860

NUMBER OF PEOPLE WHO NEED ARV TREATMENT: 23,000

GROUPS MOST AFFECTED BY THE HIV EPIDEMIC: In Peru, HIV infections remain concentrated among men who have sex with men and sex workers. About 10% of men who have sex with men are HIV-positive. (The country has a significant number of "heteroflexibles," men who have sex with both men and women.)

PERUVIAN SOCIAL ATTITUDES TOWARD AIDS: Widespread social stigma and discrimination hamper efforts to achieve universal access to HIV prevention, treatment, care and support.

AVAILABLE TREATMENT FOR PEOPLE LIVING WITH HIV AND AIDS: The Peruvian military began providing ARV treatment to its members in 1996; the Ministry of Health began providing ARV treatment in 2004 to anyone in need who could sustain treatment, after receiving support from the Global Fund.

HIV TREATMENT CHALLENGES: People living in underserviced areas often can't afford the travel required to access care and support. A lack of AIDS education and information means that many people do not understand what HIV is, how it is transmitted, or that treatment is available, so they live in fear of learning their status. Businesses often require that applicants undergo blood tests and have been known to reject those with HIV, so disclosing one's status remains risky.

massaman & fatoumata

kassi

Mariam

mali

FATOUMATA

photographs by paolo pellegrin

ousmane

I wanted to be part of a Magnum collective project, and this is one I felt particularly close to, having initiated my own journey into photography with a story on AIDS in Uganda in the early '90s.

My generation was coming of age when HIV/AIDS exploded into a global epidemic. When I first started documenting AIDS, there was no cure, no hope. A positive diagnosis was equivalent to death. What I have seen in Mali is a giant leap forward, something that only a few years ago was unthinkable—a scenario that literally gives a population "access to life." I wanted the opportunity to re-engage with this issue now that treatment is available.

The social stigma against AIDS remains in every part of the world. The people we met in Mali were reluctant to be interviewed, photographed, or even to be seen with us. Instead, they requested that we meet in their homes, their private sphere, away from public view. Those spaces—the colors, the cracks in the walls, the pictures clinging to them—became an extension of the portraits I was trying to take, a testament to lives that had been forever altered. And in some way those dark interiors became a metaphor for the alienating force of the disease.

Only four months later, I returned to the same homes. Two of the people I had photographed had not survived, as their treatment probably started too late and their basic life necessities were not met. But for the other six, a new chance at life was under way. They had once again become active members of their communities.

For me this project is ultimately about the strength and resilience of the human spirit—the desire to overcome even the most difficult circumstances and to embrace life, and a future, again. —**Paolo Pellegrin**

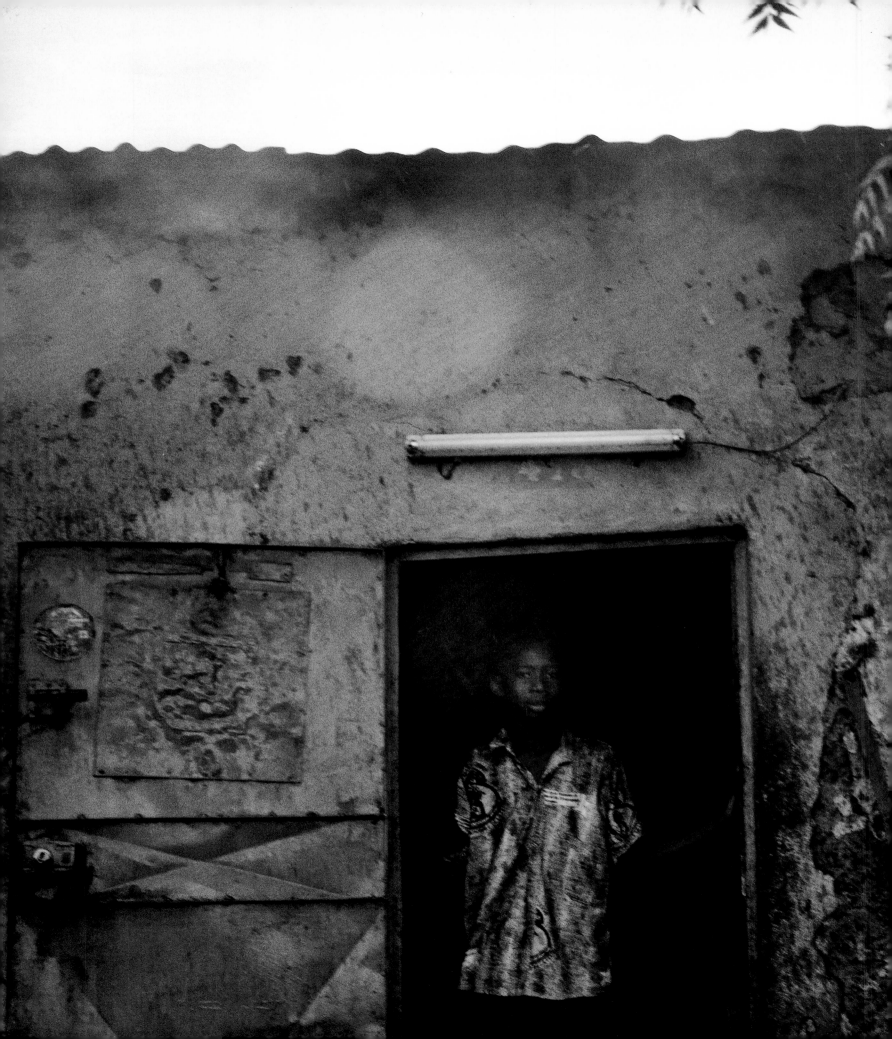

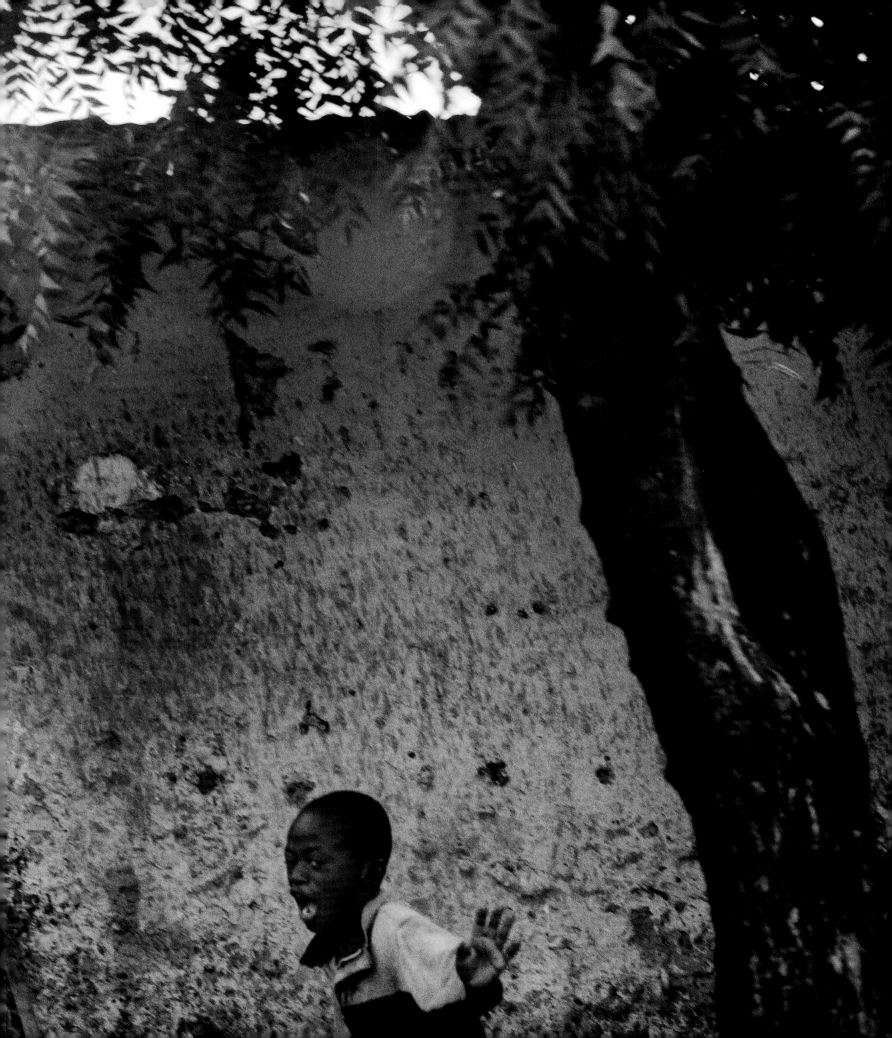

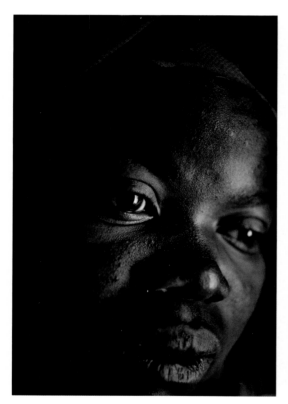 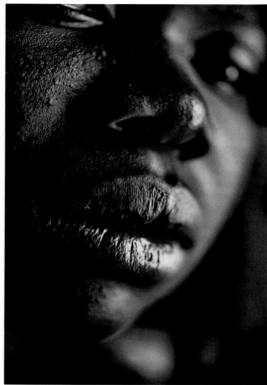 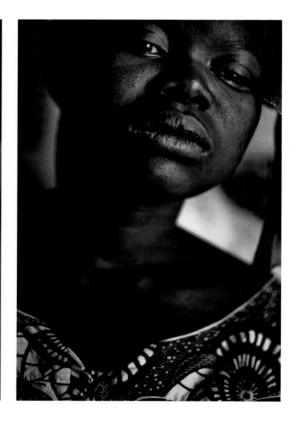

"Fatoumata was scared to disclose to her husband
that she was HIV-positive. I advised her to do it. I came; I met her husband
in his home. He is a fervent religious believer. I asked him what
will be the relationship with your wife. He promised me that
he would not leave her. He still loves her. They will carry on together."
—MOUSSA DIABATÉ, psychological counselor,
USAC treatment center, Bamako

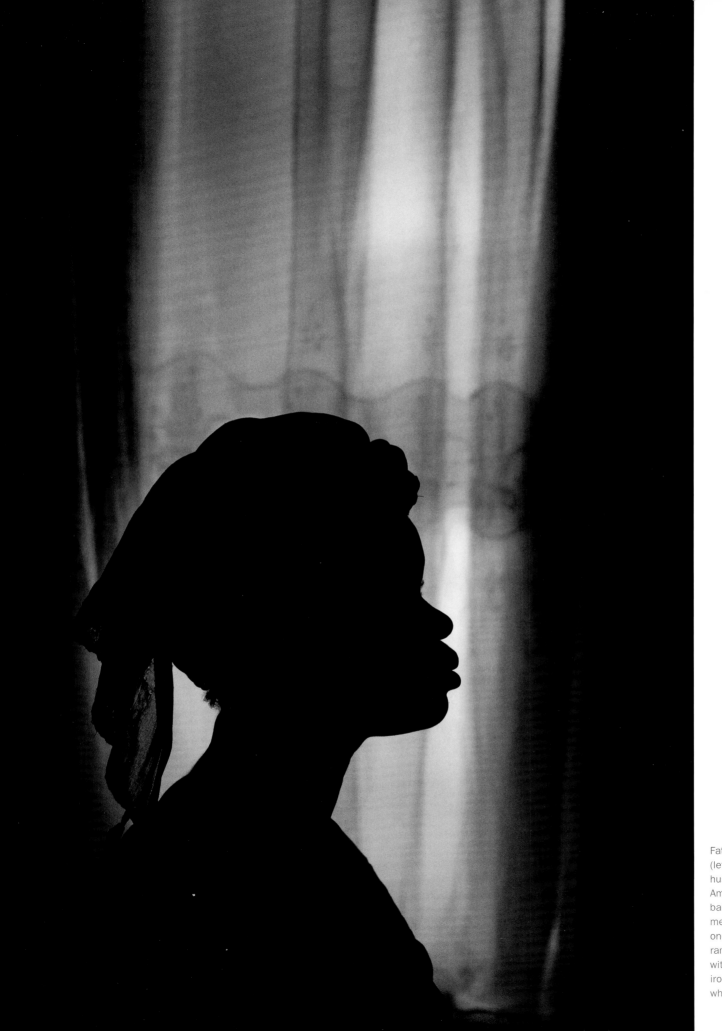

Fatoumata Yébessé (left) and her mason husband, Ibrahim Ambaïguéré Djiguiba, barely make ends meet. They live in one rented room in a ramshackle building with a corrugated iron roof that leaks when it rains.

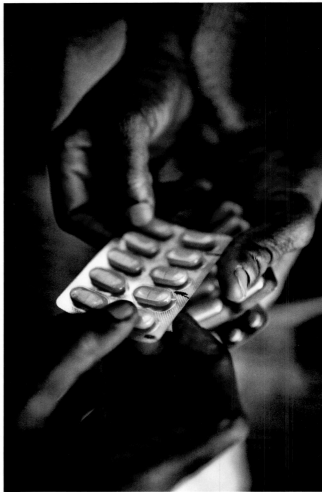

"This is a polygamous family and people do not see everything in the same way. I've very much understood the illness because Fatoumata is my lineal sister. We shared our mother's milk, and I cannot reject her. But the co-wives can reject her. Polygamous families are riddled with problems."
—DJÉNÉBA YÉBESSÉ, Fatoumata's sister

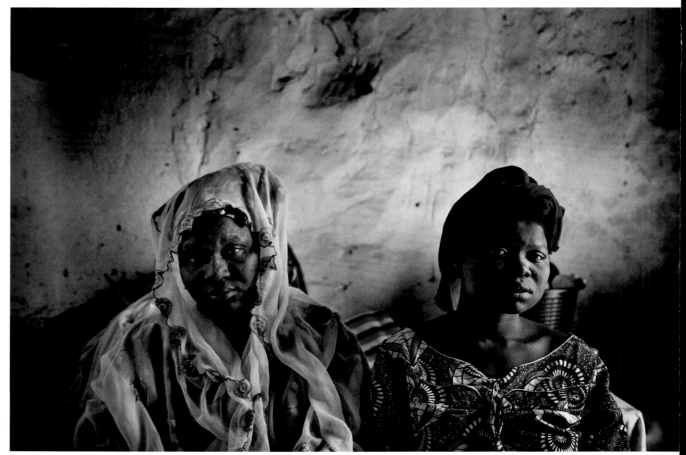

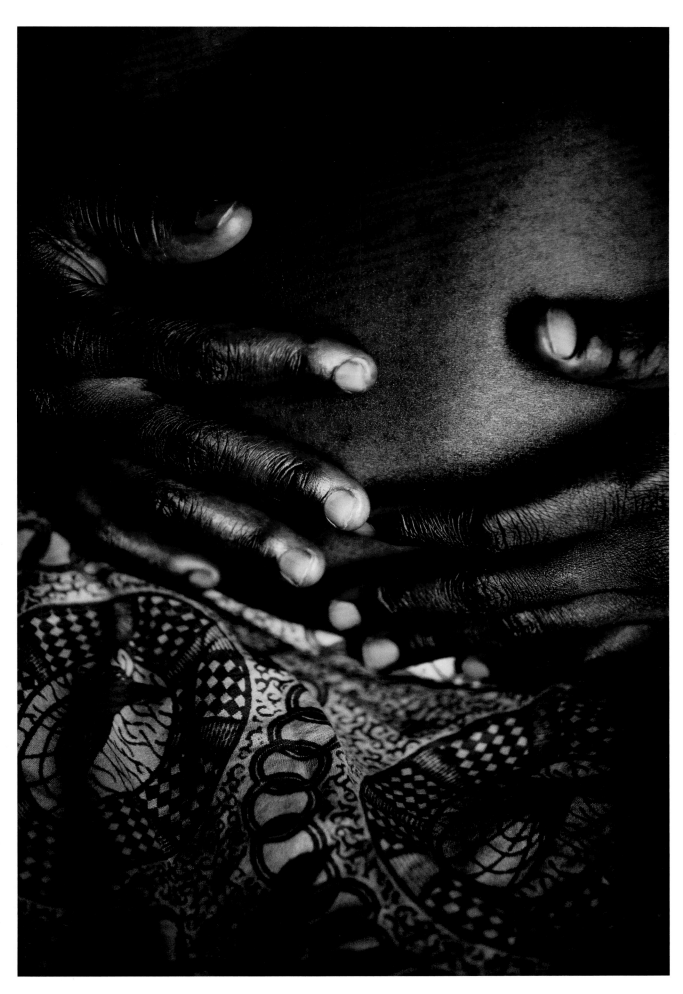

Fatoumata's biggest concern before giving birth was whether the baby would be HIV-positive: "I took drugs before the delivery," Fatoumata said. "The baby was also given drugs."

227

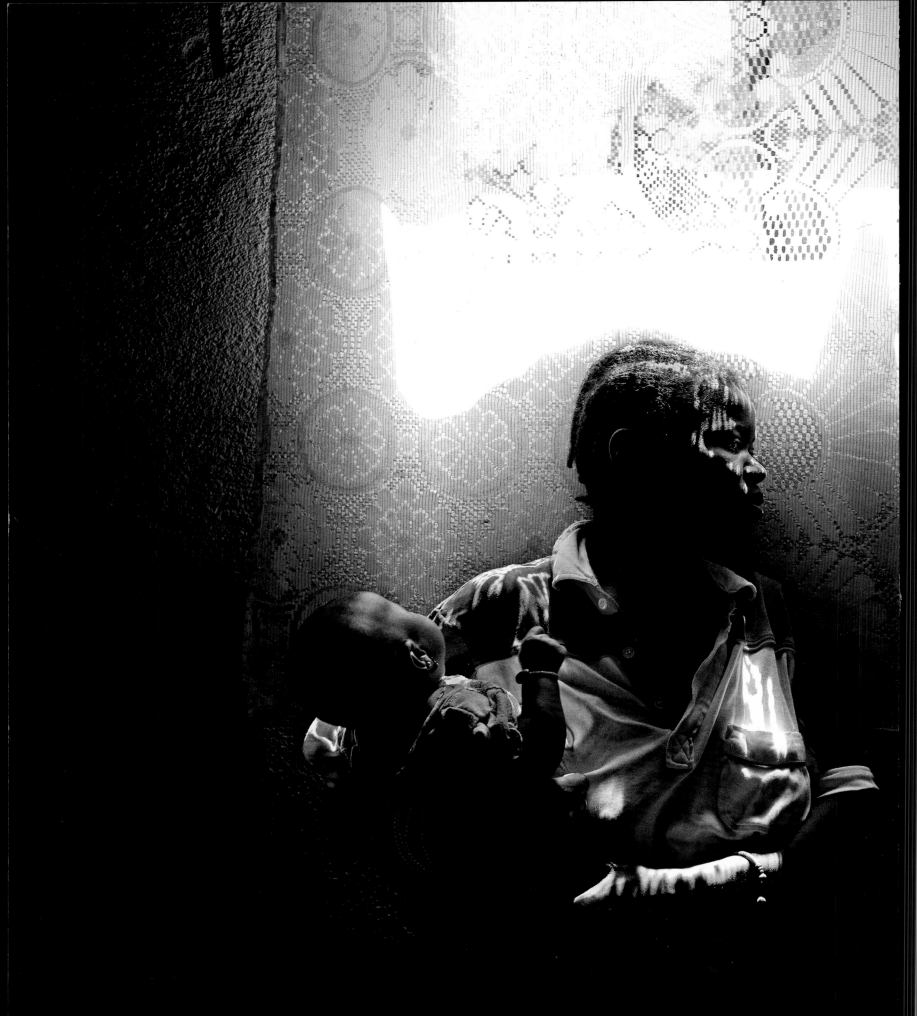

Fatoumata's baby
was born on January 5, 2008.
Her husband, Ibrahim,
named her Ambaga, which
means "God is great"
in the Dogon language.
"The child is among us and
I hope that she is not
HIV-positive," says Ibrahim.
"This is why I chose
that name."

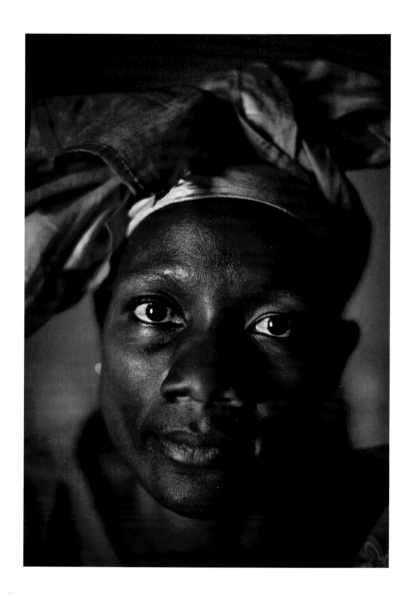

"Before, I was very scared about catching the illness. They were telling us that there weren't any drugs to treat it. I don't know how I caught it. If we could have a drug that would make it all go away, then we'd be happy."

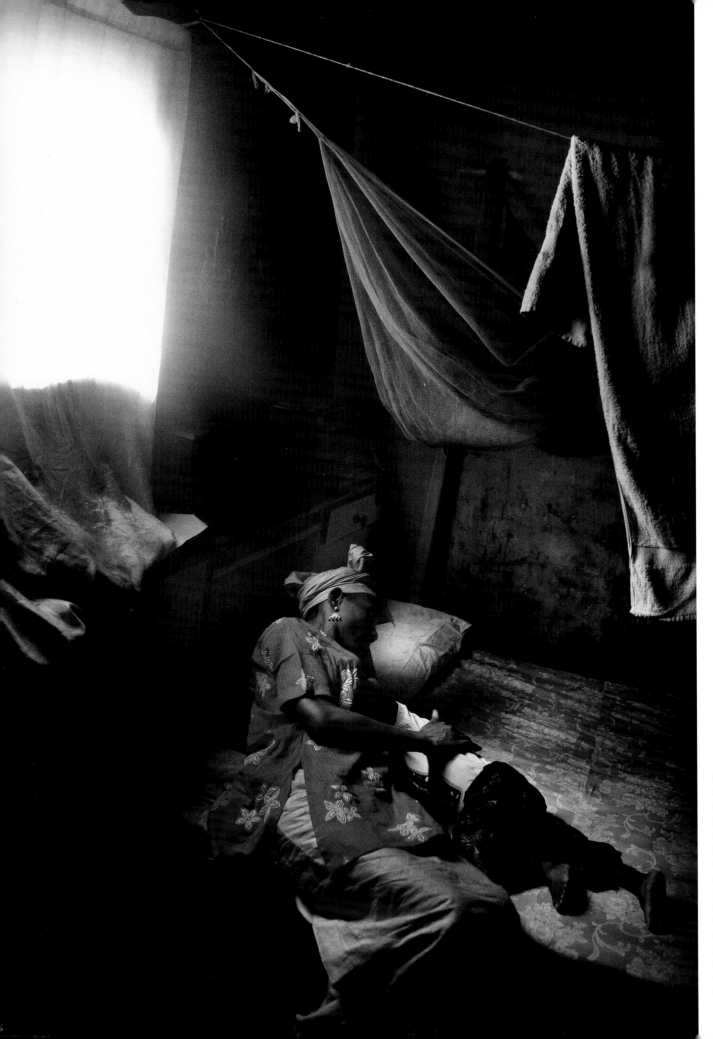

Mariam with son Kassi Keïta *(left)*. Mariam fell seriously ill in June 2007. She was diagnosed as HIV-positive, and hospitalized for five months for treatment. Kassi is also HIV-positive. Mariam, her husband, and their three children live with her husband's family. The family does not know of their diagnosis.

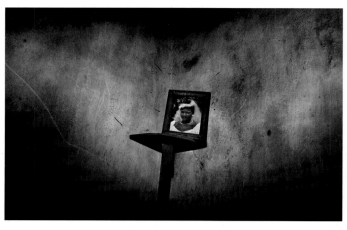

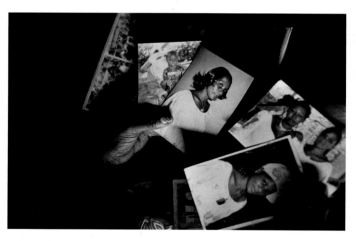

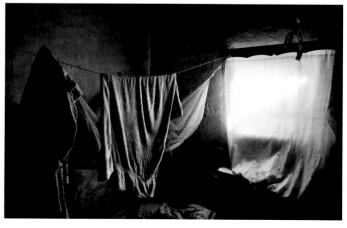

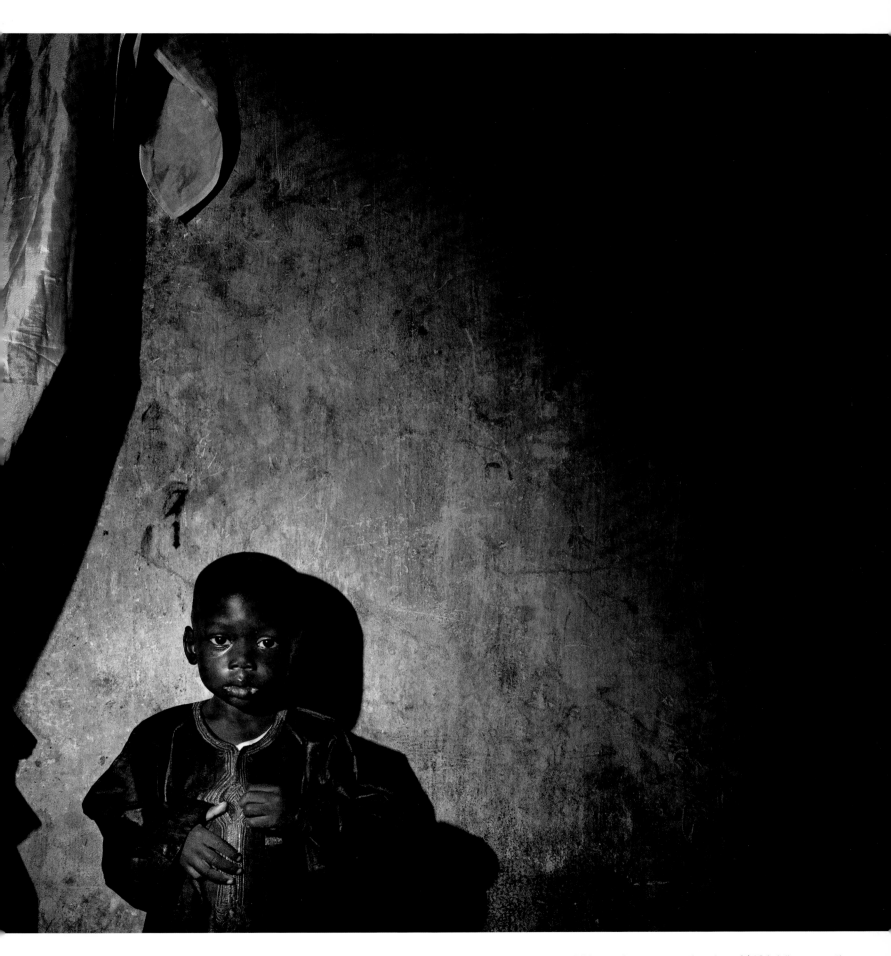

Mariam spent her life's savings ($4,850) to cover hospital costs. She finds it hard to support Kassi and her other two children on her accountant's salary of $194 dollars a month.

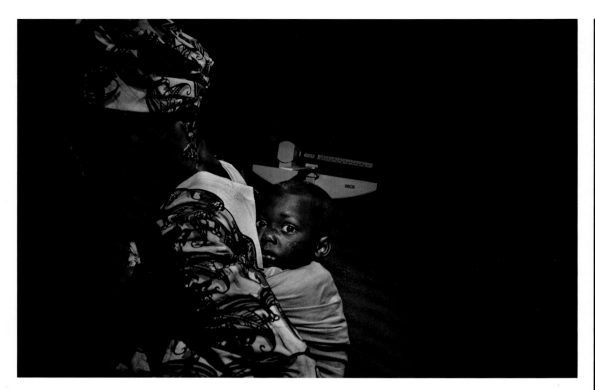

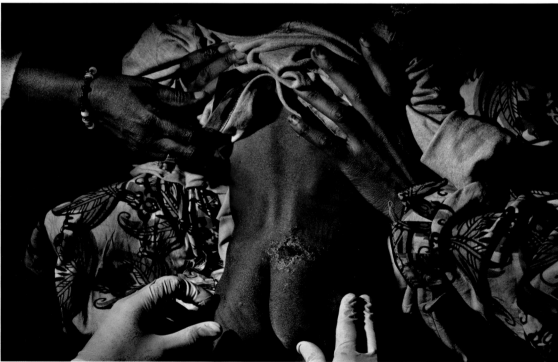

"He's never been to school.

I wanted him to go this year, but he fell ill and couldn't.

If he's better, he'll be going to school. That would make me happy."

—MARIAM of her son, Kassi

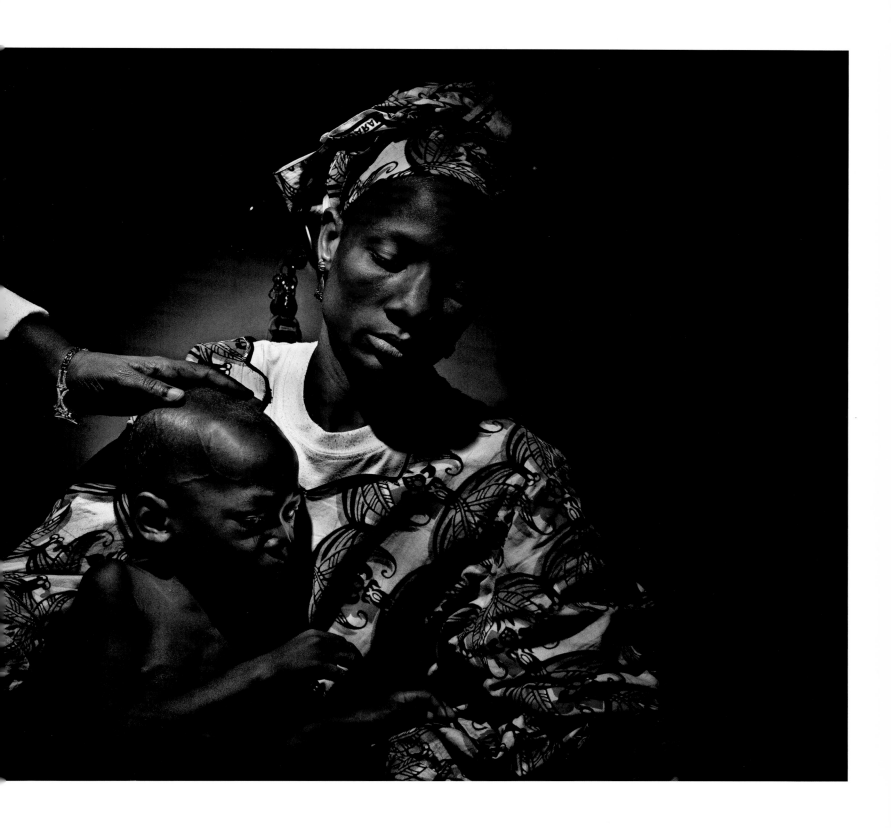

Kassi began treatment in November 2007. During the previous 18 months he had suffered from lip sores, a distended stomach, fever, and diarrhea.

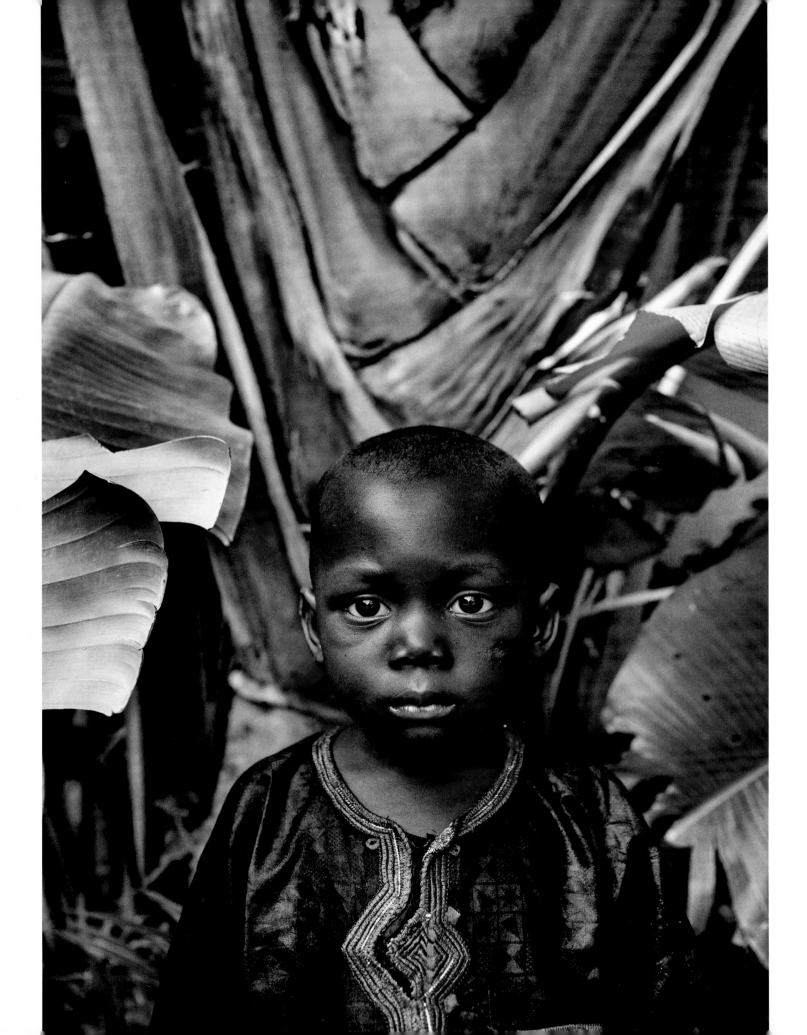

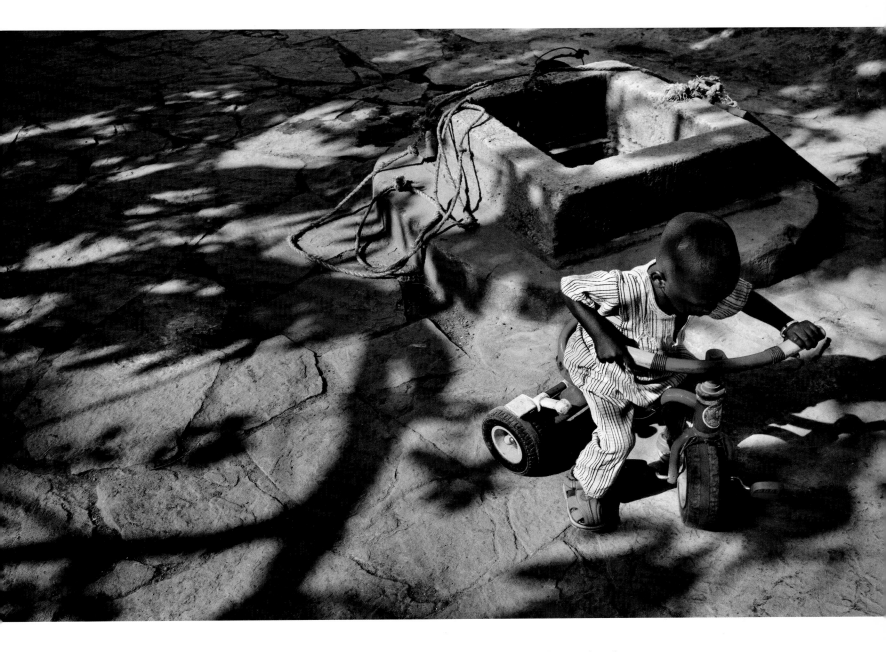

"I ask the Good Lord to grant Kassi better health, so that he

can do everything he wants until the day that this illness can really be cured and

completely disappears. Now, I can say that there is hope."

—MARIAM

Kassi riding his tricycle: "Before, Kassi was ill and didn't want to play with us," says his brother, Souleymane Keïta, 8. "I'm really happy that my little brother is better."

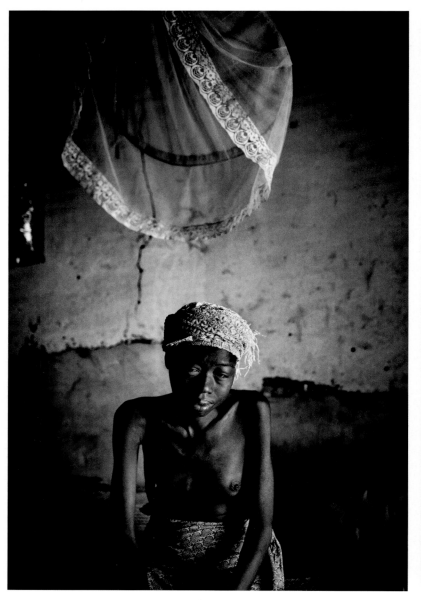 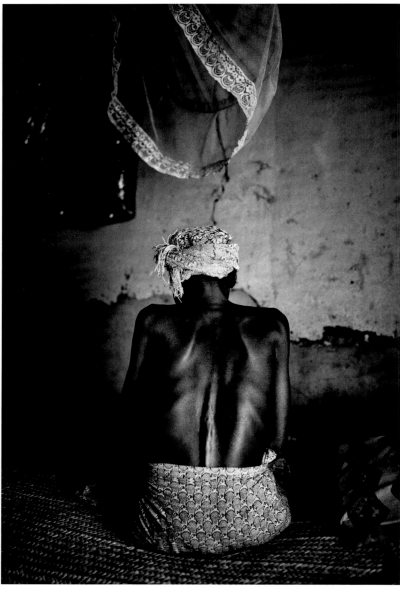

"People do not understand. When I came to CESAC [the AIDS clinic] I learned that there are three ways AIDS can be transmitted—through sexual contamination, blood contamination, or mother-to-child transmission. But in my village, when there is word that someone has AIDS, people say that it is because that person is a prostitute or because they do not have good sexual behavior. They are not aware of the other modes of transmission."—MASSAMAN KEÏTA, husband of Fatoumata Camara

Fatoumata stopped working three years ago, and her husband, Massaman, a year ago, because of their illness. They sold the few oxen they owned in order to survive.

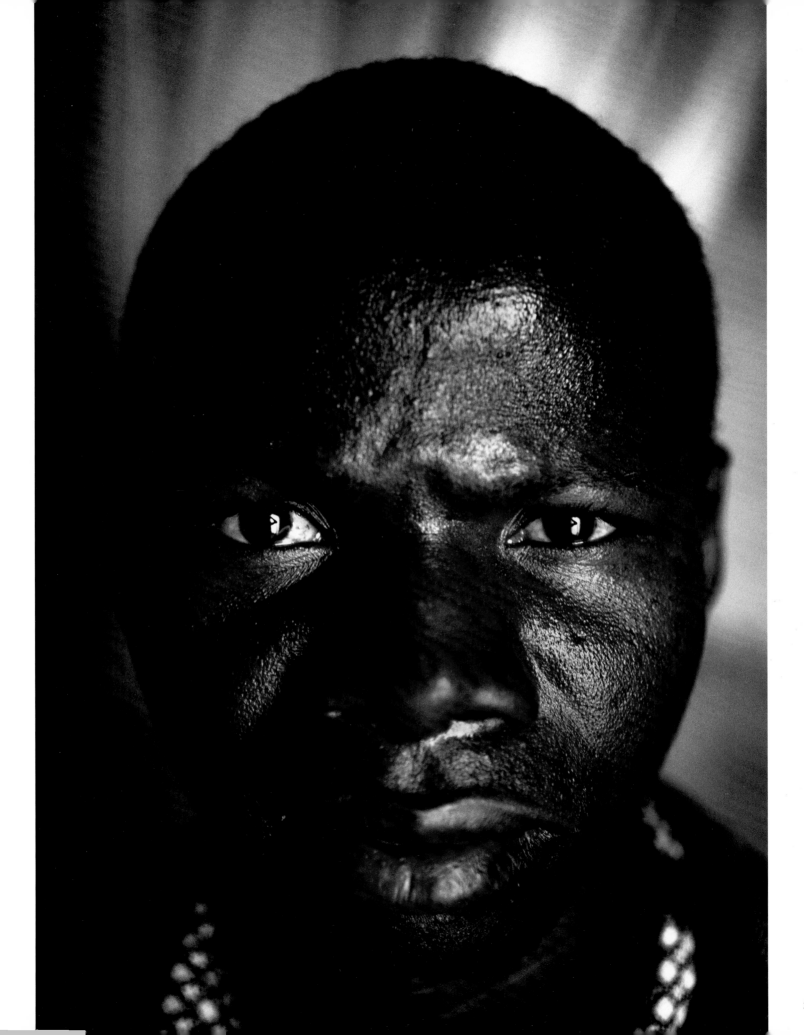

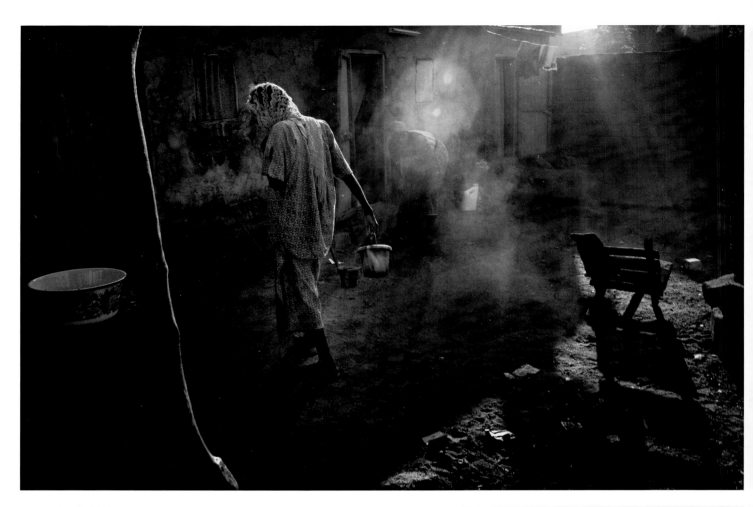

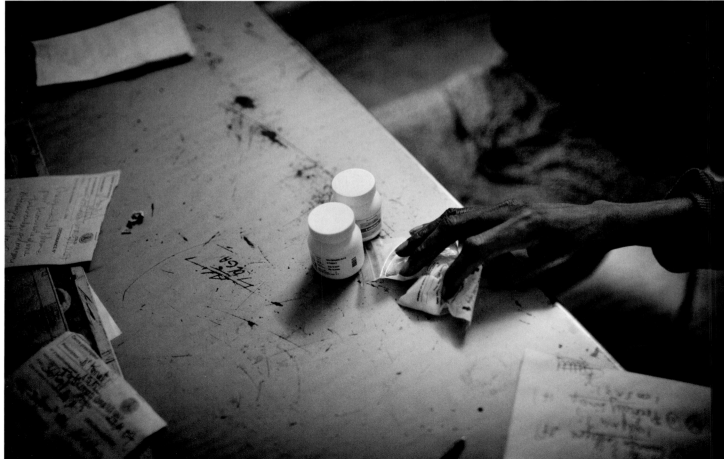

Taking the medication is key: "These drugs are quite strong; they can boost your appetite and can make you shiver," says Massaman.

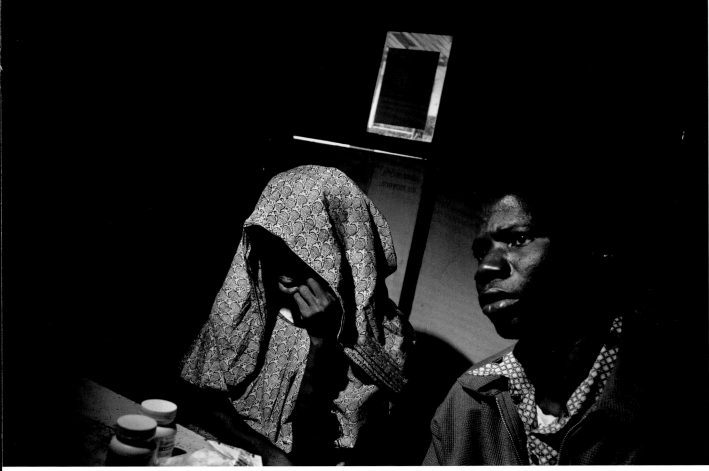

At the CESAC clinic: The first time, the couple went together to the clinic to have Fatoumata tested. Massaman was told that he, too, should be tested. Both proved HIV-positive.

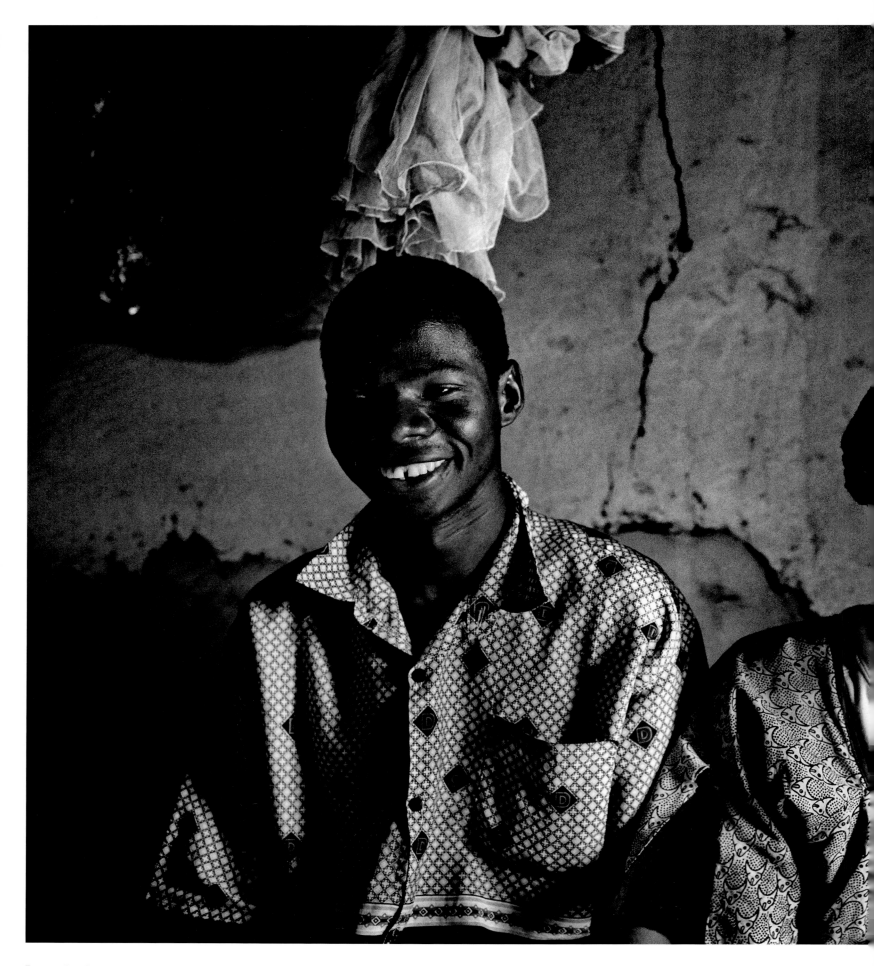

Two weeks after treatment began, Massaman was already feeling better. Fatoumata was still weak but had regained a little weight. "Before coming here, all I could see behind

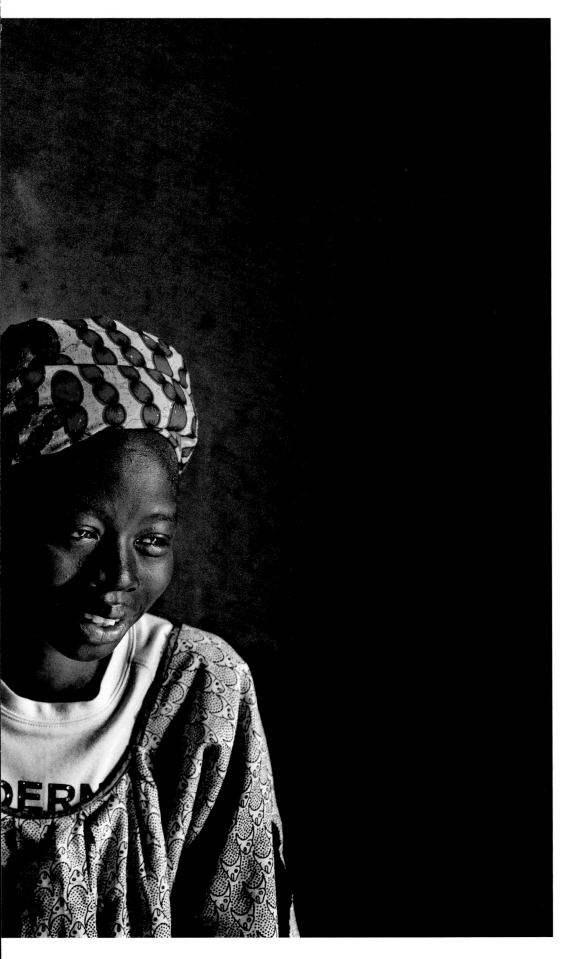

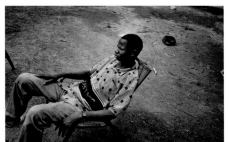

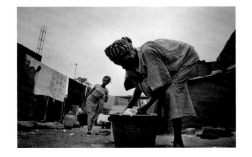

HIV was death," says Massaman. "But with the explanation that has been given to me, I now know that drugs can ensure we go on living. There is therefore hope."

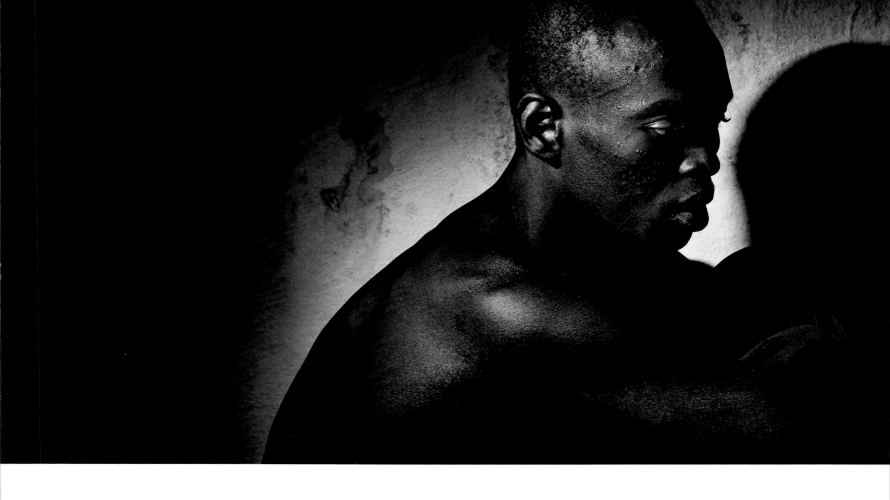

Ousmane began treatment only after four months of sickness, with symptoms including numerous marks and spots on his body *(opposite)*.
The treatment did not agree with him: "Each time you take the tablets, you can't eat," he said.

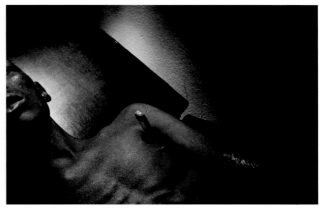

"When I fell ill, HIV didn't cross my mind. I thought it was malaria. I started being sick. I had diarrhea and I couldn't eat. It's the diarrhea that made me weak… Seeing people now with AIDS, I'm aware that the illness is there, that it exists. But how it came to exist in my body, I can't figure it out."

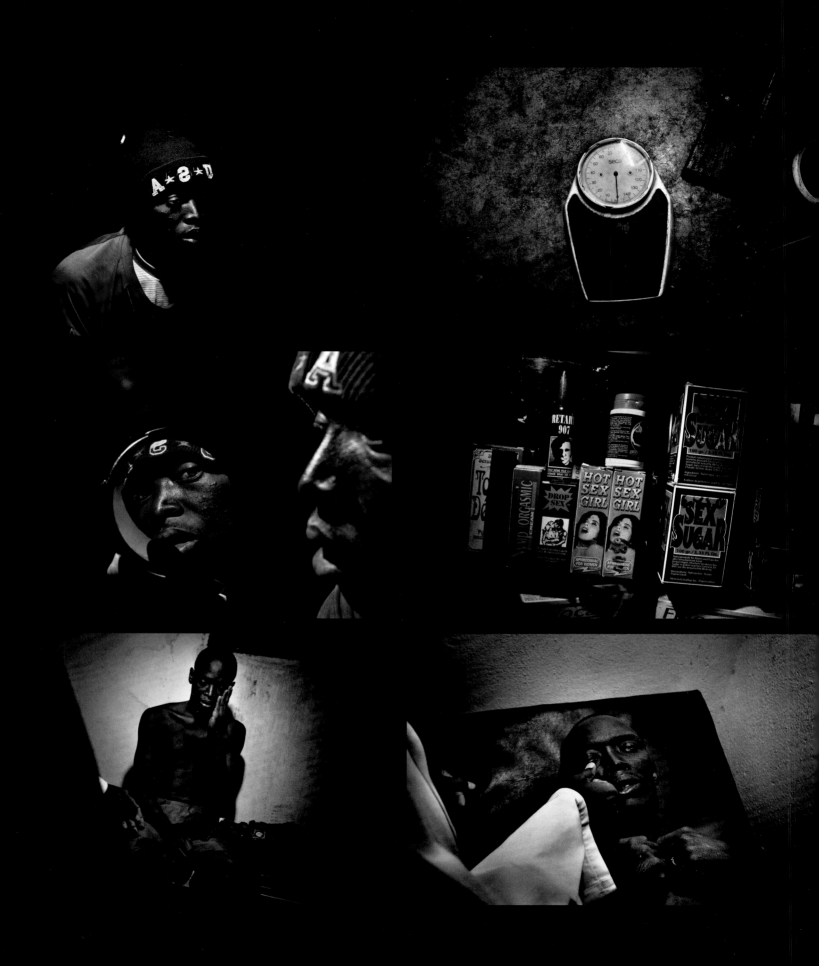

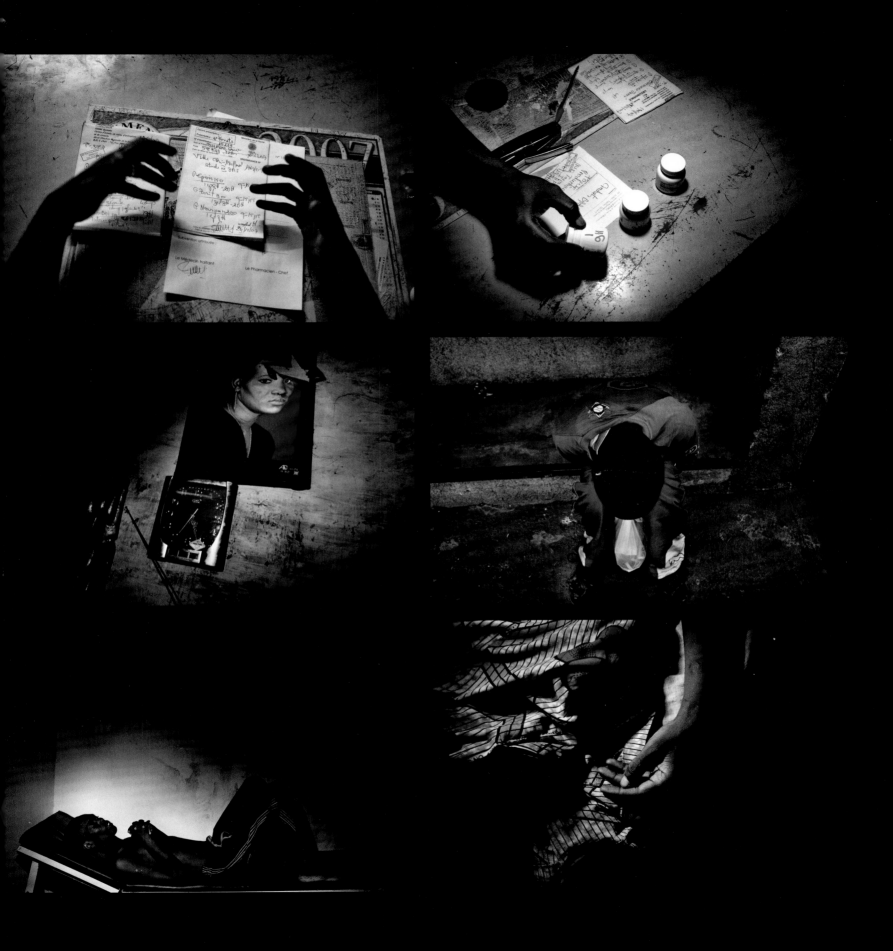

refused to seek his help, he could not afford regular meals or the other drugs prescribed to treat opportunistic infections, and he became became increasingly helpless.

"If God took him away from me, that was his destiny. It is my destiny also," says Ousmane's mother, Kadiatou. Despite postponing treatment because he refused to accept that he was HIV-positive, Ousmane himself thought that he would live. "Ousmane thought he was going to get better because they gave him an intense treatment with numerous serums and pills," says Dacoro Mariko, who worked at the hospital where Ousmane died. "Sunday morning [January 20, 2008] his condition took a turn for the worse and he passed away at 6 a.m."

Kadiatou holding photos from the past *(right)*. Ousmane's grave *(below)*. "If I could get cured tomorrow, it would make me so happy," said Ousmane at one point during his treatment. "This is really what I wish for."

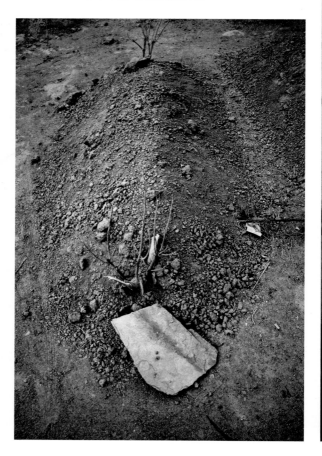

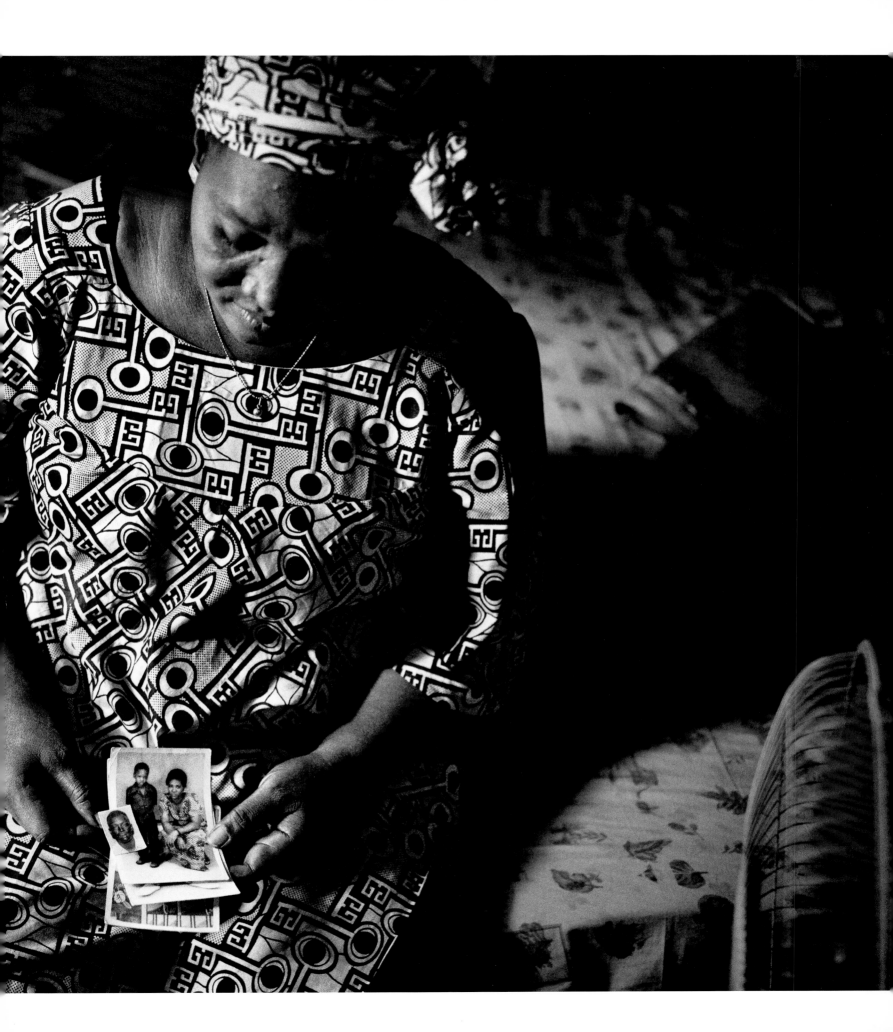

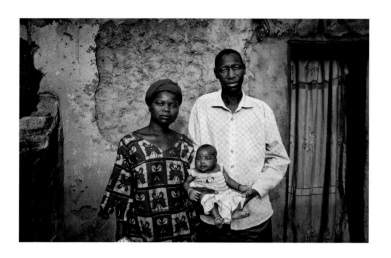

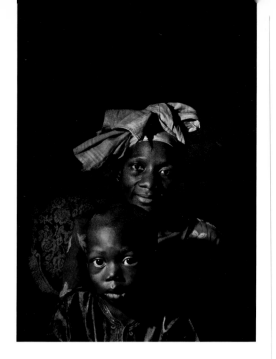

FATOUMATA YÉBESSÉ, 35

OCCUPATION: Domestic worker

When Fatoumata was expecting her second child, her elder sister, Djénéba, encouraged her to be tested for HIV. Djénéba herself was HIV-positive, and Fatoumata was given the same diagnosis. Fatoumata initially kept her HIV status a secret, confiding only in Djénéba. Fatoumata cried for several days, Djénéba said, and stopped eating. "I thought of my child straight away," Fatoumata said. "I thought I was creating a child who was carrying HIV, and that is why I was crying a lot." Fatoumata had previously lost her first husband and had a child who died at age two, perhaps of AIDS. "I told Fatoumata not to worry about it because people on television were talking about this and were saying that now there is a drug for this, that HIV no longer killed," says Djénéba.

Among Fatoumata's Dogon tribe in Mali, however, people with AIDS are often banished, and Fatoumata was worried that her husband might reject her. Fatoumata's counselor, Moussa Diabaté, went to the couple's home—they share one room in a large house—to explain to her husband, Ibrahim, that his wife was HIV-positive. Ibrahim, a deeply religious man, did not reject her. "It never crossed my mind," Ibrahim said. "I love her regardless of her disease. In the beginning she didn't want to say anything to me. I would ask her why she was crying. I promised her that our relationship would be long-lasting, and that nothing would ever make me reject her." Ibrahim also agreed to be tested; he is negative. Despite Ibrahim's understanding, Djénéba has advised her sister to keep her condition hidden. "This will remain a secret. I will carry this to my grave," Djénéba says. "And Fatoumata needs to do the same thing." Fatoumata and Ibrahim's baby, a girl, was born in January of 2008.

MARIAM DEMBÉLÉ, 31
KASSI KEÏTA, 3

OCCUPATION: Accountant

Before the birth of Kassi, the youngest of three children of Mariam, a government accountant, and Sounkoun, a math teacher, Mariam felt "fine," she said. But when Kassi was 2, Mariam was diagnosed with HIV, and put on ARV treatment. In the meantime, Kassi too became sick with ailments including fever, lip sores and lack of appetite. Mariam took him to a number of medical centers and Kassi was finally admitted to the Gabriel Touré Hospital in Bamako with malnutrition and diarrhea. He was found to be HIV-positive and started on ARV treatment immediately. At the beginning of his treatment, Kassi's pain and distress were obvious in his body language.

Despite their jobs, Mariam and her husband struggle to provide food and school fees for Kassi's brother, Souleymane, 8, and sister, Dicko, 5. (Mariam and Sounkoun's first-born child died of malaria.) The family lives in two rooms of the Keïta compound, but because they fear being ostracized, they have not informed the extended family of their illness. During Mariam's five-month hospital stay, only her niece came to visit her. Since then, Mariam has found a support group for people living with HIV. She has returned to work full-time, leaving Kassi to be looked after by his grandmother. "I was very scared; I didn't think he would get better," Mariam says. She is heartened by his rapid response to treatment: "Now he's getting better, I want him to go to school. He's eager, very eager. I say, 'You must wait until you're healed.' He says, 'I am healed, I can go to school.' I tell him, 'Yes, you are going to go.'"

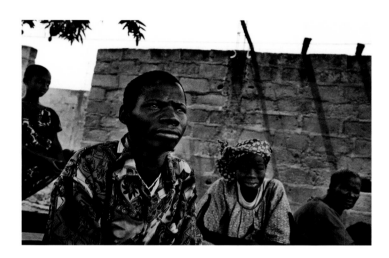

MASSAMAN KEÏTA, 31
FATOUMATA CAMARA, 20
OCCUPATION: Farmers

Massaman and Fatoumata, both from the Koulikoro region in western Mali, were married five years ago. They made their living farming millet and cotton. But Fatoumata became ill three years ago and stopped working a year later. Then Massaman, too, fell sick and had to stop working. In order to survive, they sold the few oxen they owned and then, too weak to work but not yet knowing the cause of their illness, they left their rural village of Kara, located 50 kilometers from the capital of Bamako, to be treated.

Though Massaman was initially not keen to be tested for HIV, after being counseled the couple tested together, and began ARV treatment at the same time. Since then they have lived with Fatoumata's family, in a four-room house surrounded by mango trees. "We are the first case in our family," says Massaman. "In our village, there are quite a lot of people who have it but they are hiding it, like we are." Fatoumata has suffered more seriously from AIDS-related illnesses. "This is the most difficult period of my life," Massaman said soon after starting the treatment. "My wife is very, very weak. All my efforts are focused on looking after my wife because I do not want to abandon her. And there is no one I can rely on." In Mali, as in many countries, husbands often reject their HIV-positive wives, regardless of their own status, making this couple's mutual support all the more extraordinary. Both have flourished with the ARV treatment. Massaman began making handicraft lamps to sell in neighboring markets, and Fatoumata is doing housework. "I feel like I was awakened from the dead," Massaman says. "I never imagined that I could be how I am today."

OUSMANE SOW, 32
OCCUPATION: Tire repairman

Ousmane used to work repairing tires at a garage near the town of Kayes in western Mali, where his father's family lives. "Before I started to feel ill, I used to have a lot of energy," Ousmane said. "But then I really felt that there was something in my body. I started to notice marks, such as spots. I told myself, 'Nothing bit me there, what are these spots?'" Ousmane did not get along with his father. Afraid of rejection, he was reluctant to ask him for help. So when he became ill, he turned to his mother for support. His parents had separated when he was born, and his mother, Kadiatou, is a secretary at the National Blood Transfusion Center in Bamako. Ousmane came to the capital to seek his mother's care, and she persuaded him to take an HIV test. "She took my blood," said Ousmane. "She is the one who told me that I really have HIV/AIDS." But he found it hard to accept his status, returning to the clinic for treatment only three months later.

By then Ousmane was gravely ill. Despite Kadiatou's salary, she finds it hard to make ends meet, and she struggled to help support and house Ousmane. "I go to bed and cannot fall asleep," she said at one point during her son's treatment. "It's always on my mind. When a child is sick in front of a mother who is poor, it's really difficult." By the time Ousmane began ARV treatment, living a homeless and precarious existence, it was too late. "He did not have the chance to get cured," his mother said. "I see people who get cured. I was not expecting him to die. But that was his destiny; that was God's will." Ousmane died on January 20, 2008.

SNAPSHOT: HIV AND AIDS IN MALI

OVERALL POPULATION: 12.2 million

NUMBER OF PEOPLE LIVING WITH HIV AND AIDS: 130,000

HIV PREVALENCE AMONG ADULTS: 1.3 percent

NUMBER OF PEOPLE ON ANTIRETROVIRAL (ARV) TREATMENT: 12,172

NUMBER OF PEOPLE WHO NEED ARV TREATMENT: 30,000

NUMBER OF CHILDREN LEFT ORPHANED BY AIDS: 70,000

GROUPS MOST AFFECTED BY THE HIV EPIDEMIC IN MALI: Prevalence is higher among women than men, possibly reflecting patterns of infection in polygamous marriages. This in turn poses a greater risk of infection in children born to HIV-positive women.

MALIAN SOCIAL ATTITUDES TOWARD HIV AND AIDS: Social stigma is considerable and gender-based discrimination is common, with men—who often infect their wives—frequently rejecting spouses who become HIV-positive.

AVAILABLE TREATMENT FOR PEOPLE LIVING WITH HIV AND AIDS: Initially ARV treatment was centralized in Bamako, the capital. Comprehensive HIV programs are now present throughout the country.

HIV TREATMENT CHALLENGES: Stigma and fear prevent many people from being tested, especially women, who risk losing their homes if they are found to be HIV-positive. This fear makes the usual types of prevention activities and counseling more difficult.

Satyaveni

KUMAR

india

VEERA BABU

vijaya

photographs by jim goldberg

MOHAN RAO

ASSIGNMENT: INDIA

One of the nicest sounds I hear when I'm home in San Francisco is Arnie, my downstairs neighbor, watering his ornamental garden. He's mostly a sweet and quiet man, but there has been many a scary moment when, his breath weak and his mind crazy, I have called paramedics to revive him.

When I visit Arnie I am always amazed to see, spread out on his dining-room table, his current regimen of pills. (Today I counted 23.) He says it's all worth it, even with the side effects, because maybe "I can see my grandchildren grow."

The people I met in India didn't take as many pills as Arnie. Some were lucky to have family around. Sadly, most couldn't tell a soul about their HIV status.

The cul-de-sac of 12 houses where the very poor families lived was a bit of an exception. People could relax, be themselves. Except for Karuna, the seven-year-old girl from one of the most destitute families. She tried to skip, she wanted to laugh, but the disease made her lethargic. Officially, she was too healthy to be treated; her CD4 count was too high. She sat there expressionless, flies on her face, wanting to lie down. If she did, her parents would slap her on the head to keep her conscious.

The slaps made me cringe, so I tried to make her laugh by calling out "Karunaaaa, Karunaaaa, Karunaaaa...," making fun of my American accent.

Karuna had little to eat. Her father, Mohan Rao, was on ARV treatment and doing better. He was able to work, but had lost his painting job when the boss found out about his disease. Karuna's mother, Venkata—also HIV-positive—was hoping to go back to work, picking chilis so she could make $1.50 a day and help feed her family.

I am home now as I write this, and I can hear Arnie's TV blaring. I have to make dinner for my daughter, Ruby. I am thinking of Karuna, and wondering if she is still alive. It makes me sad.

All parents worry about their children, and about leaving them as orphans. I know that I am lucky to be able to call out, "Rubyyy, Rubyyy, Rubyyy...," and know that my daughter will laugh. **—Jim Goldberg**

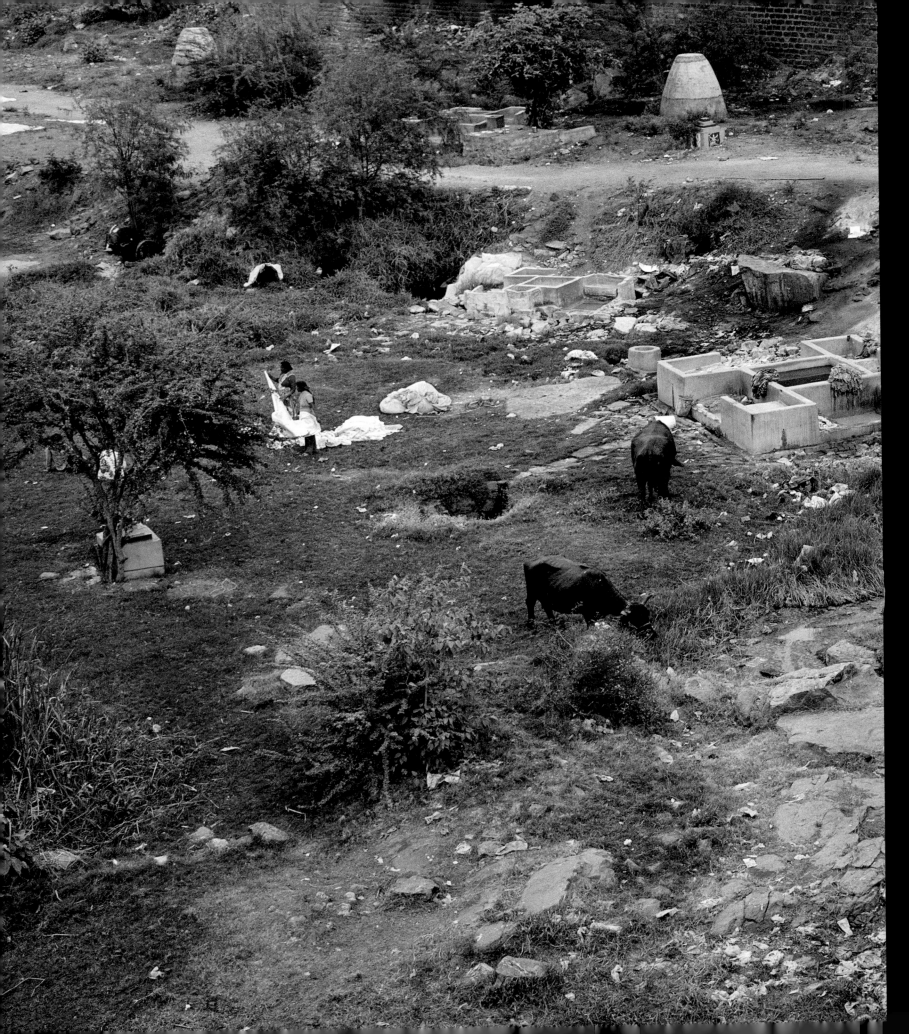

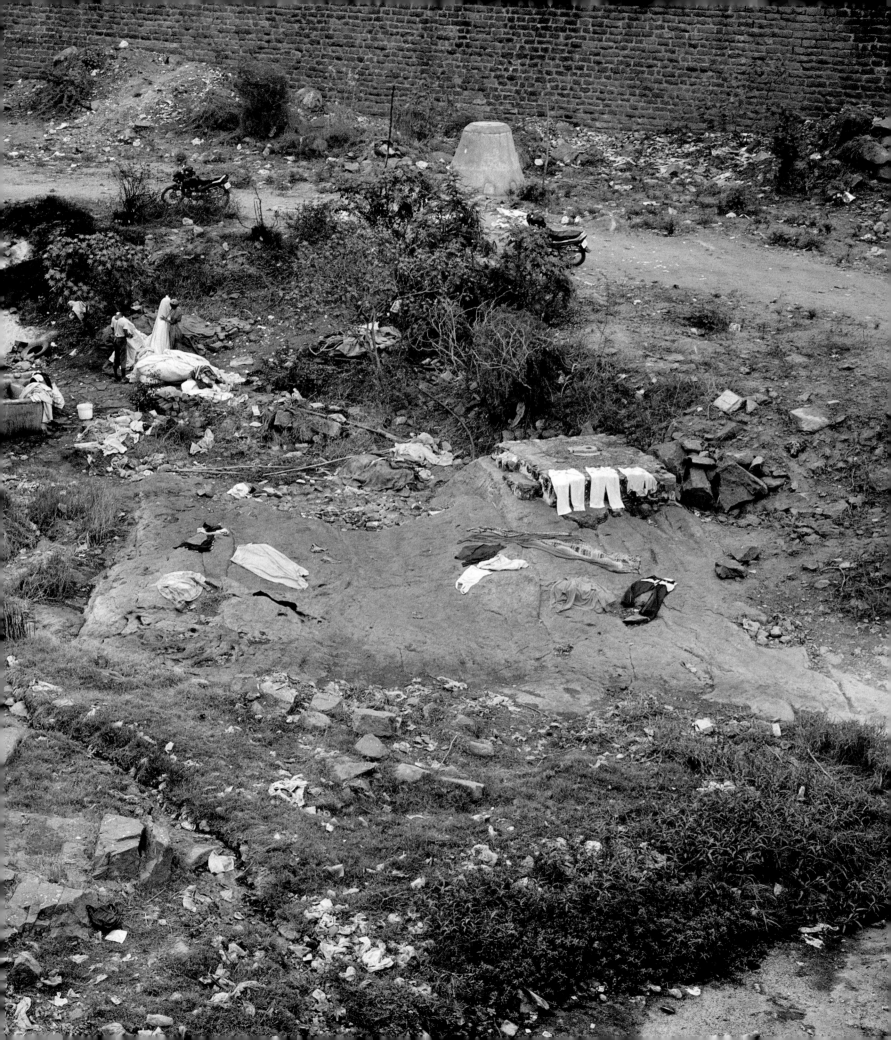

VIJAYA SARADHI MADASU
PEDDAPURAM

"This is a disease that does not evoke sympathy. People feel sorry if you are affected with cancer, but with this disease people say it is intentionally self-inflicted. And in my case, even more so because I come from a good family, and people say, 'He knew everything.' It pained me to continue among colleagues and employees of the college. I thought of attempting suicide. But later I decided to live, at least for the sake of my young daughter. It is enough if I live for the next 10 years."

A teaching assistant, Vijaya left his job when he became too ill because of HIV-related tuberculosis. Vijaya and his wife, Jayasree, decided to abort their second child after learning they were both HIV-positive. Their six-year-old daughter, Amrutha, is HIV-negative.

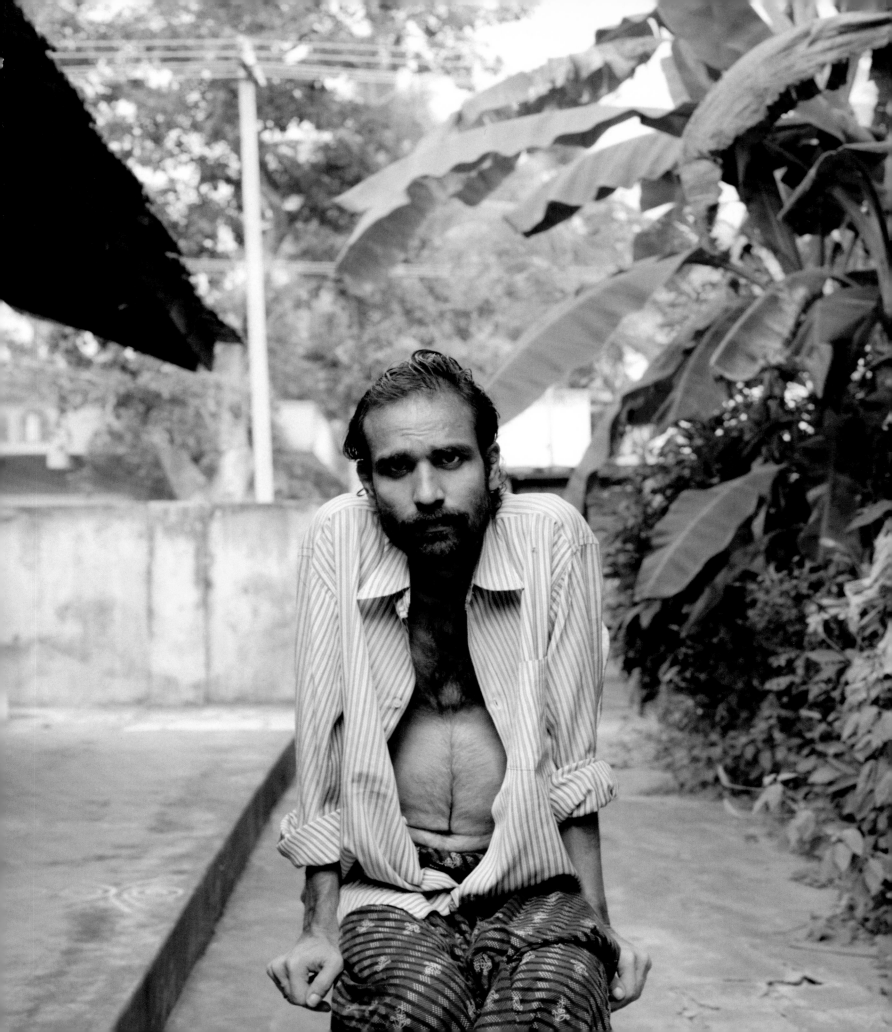

I COME FROM A GOOD FAMILY BUT I HAD THE BAD HABIT OF GOING TO PROSTITUTES FOR MANY YEARS.

NOW ME AND MY WIFE HAVE HIV.

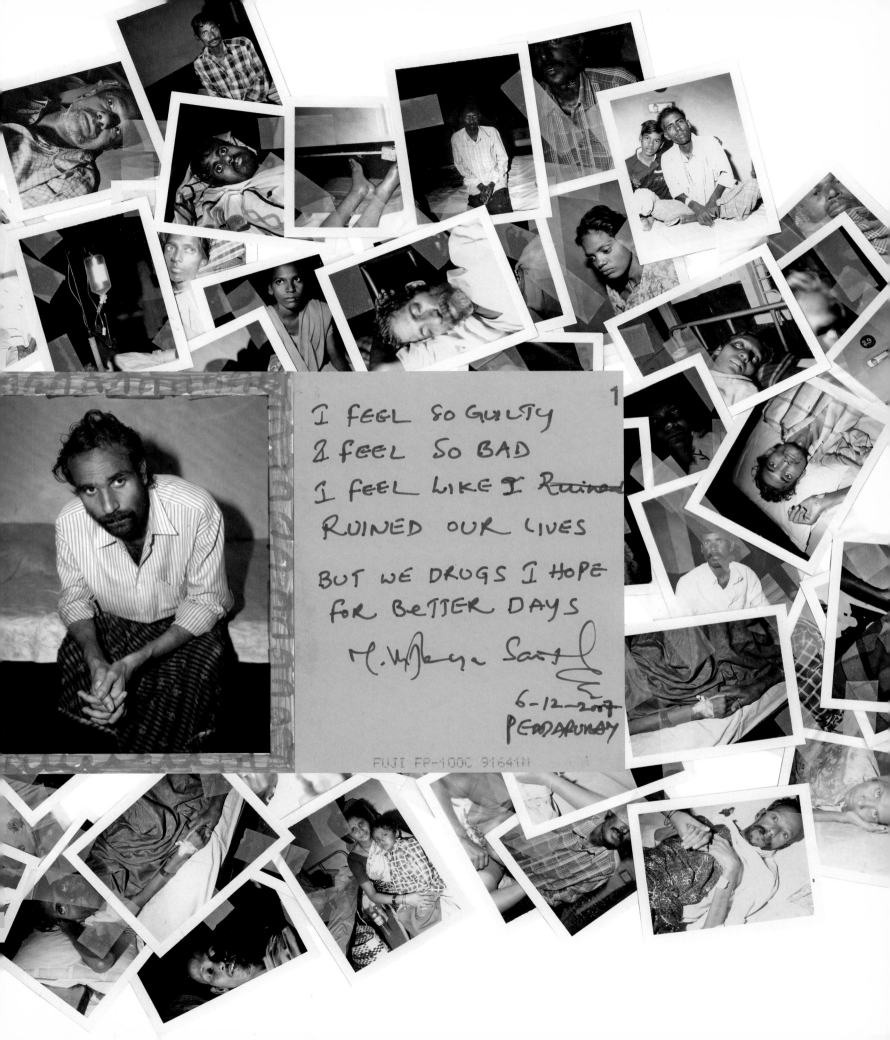

I FEEL SO GUILTY
I FEEL SO BAD
I FEEL LIKE I ~~Ruined~~
RUINED OUR LIVES

BUT WE DRUGS I HOPE
FOR BETTER DAYS

M. Vijaya Santh

6-12-2007
PEDDAPURAM

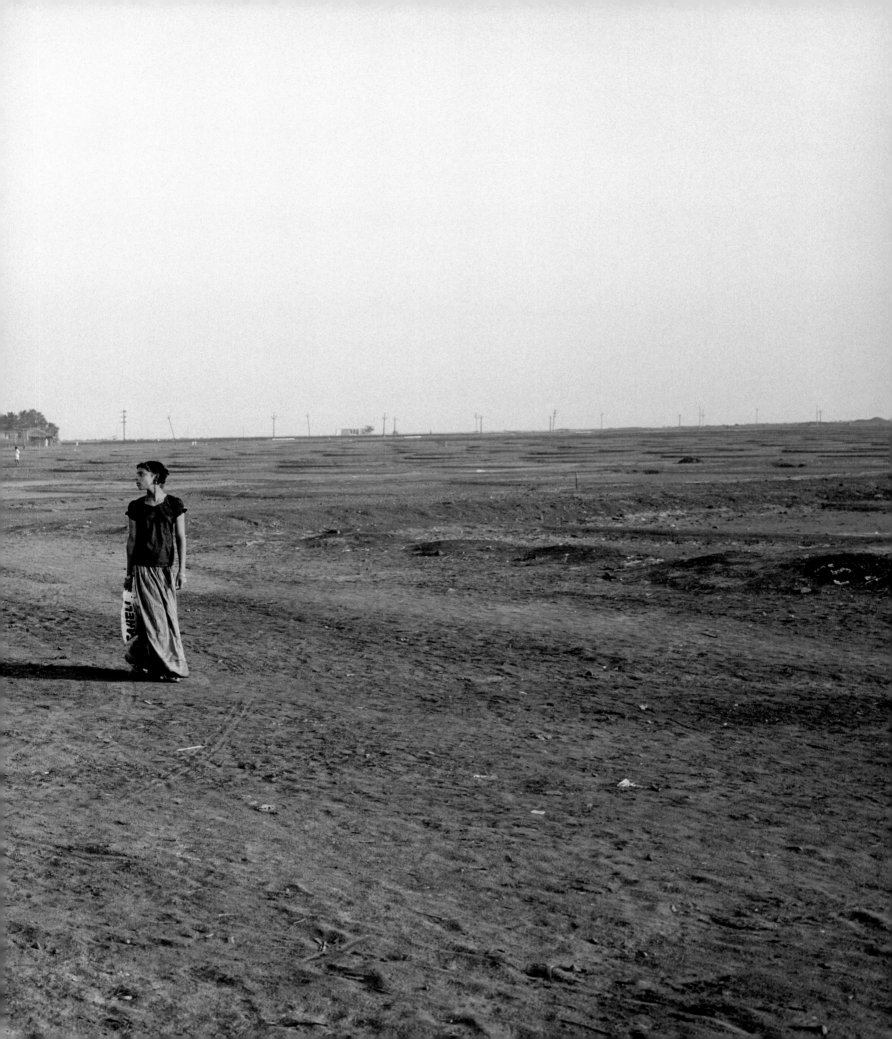

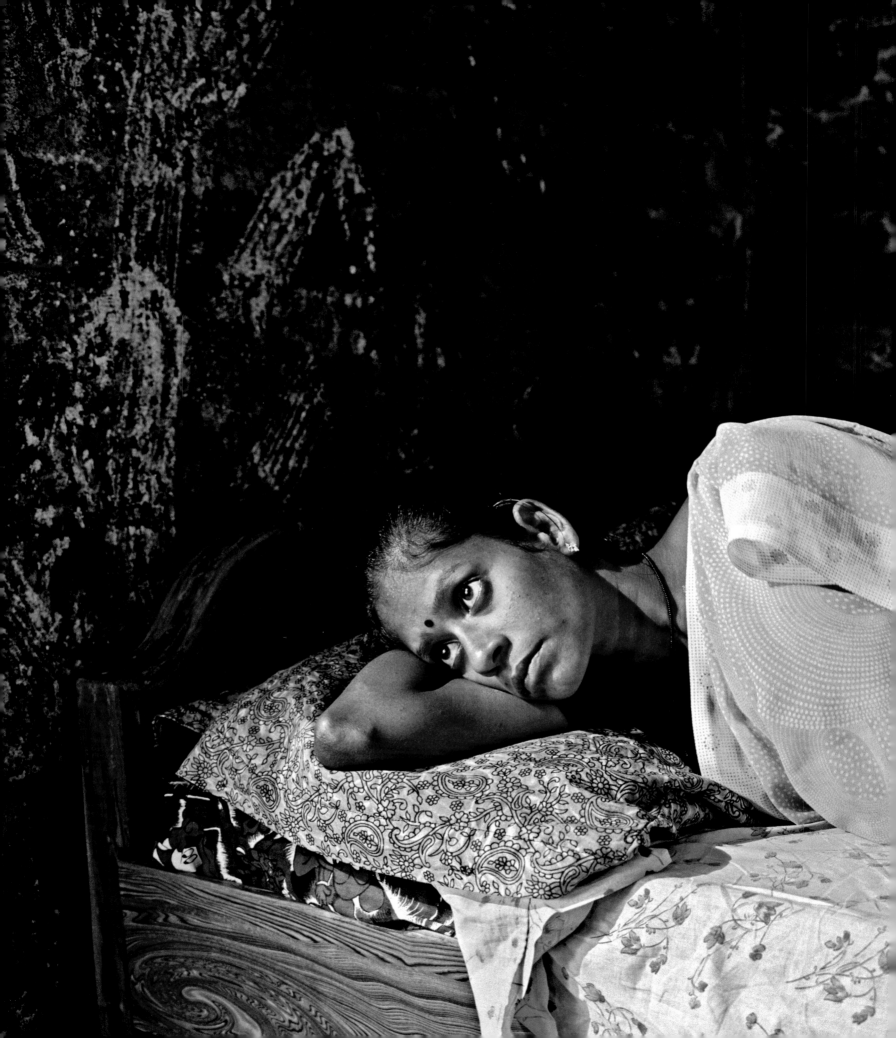

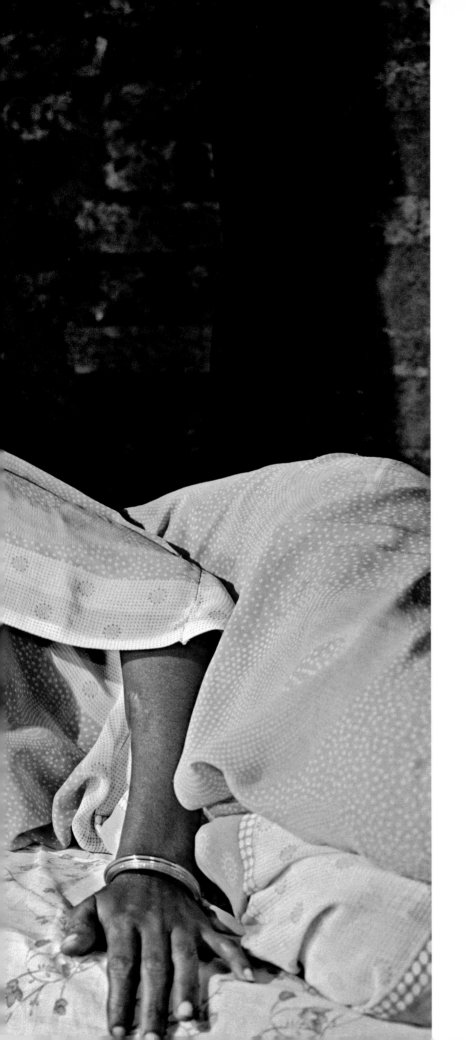

"I got angry that he [her husband, Ravi] gave me such a disease. For about a month, I didn't even talk to him. My mother reconciled us, saying, 'What is over is over.' But I just don't like sleeping together anymore. That is where there is trouble between us… Now, I want to educate my daughter well. I put her in school with the hope that she can stand on her own feet. We have to make our daughter independent. After that, whatever happens to us doesn't matter."

Satyaveni, 23, resting on her bed at home.

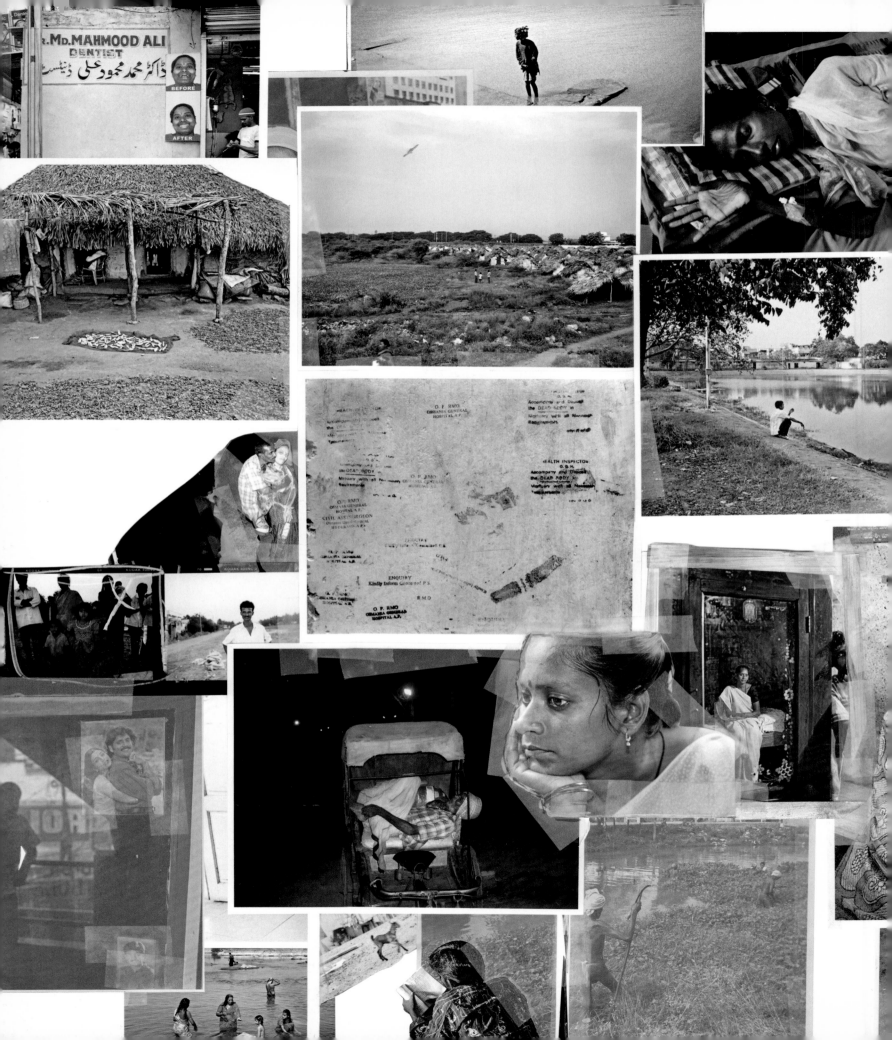

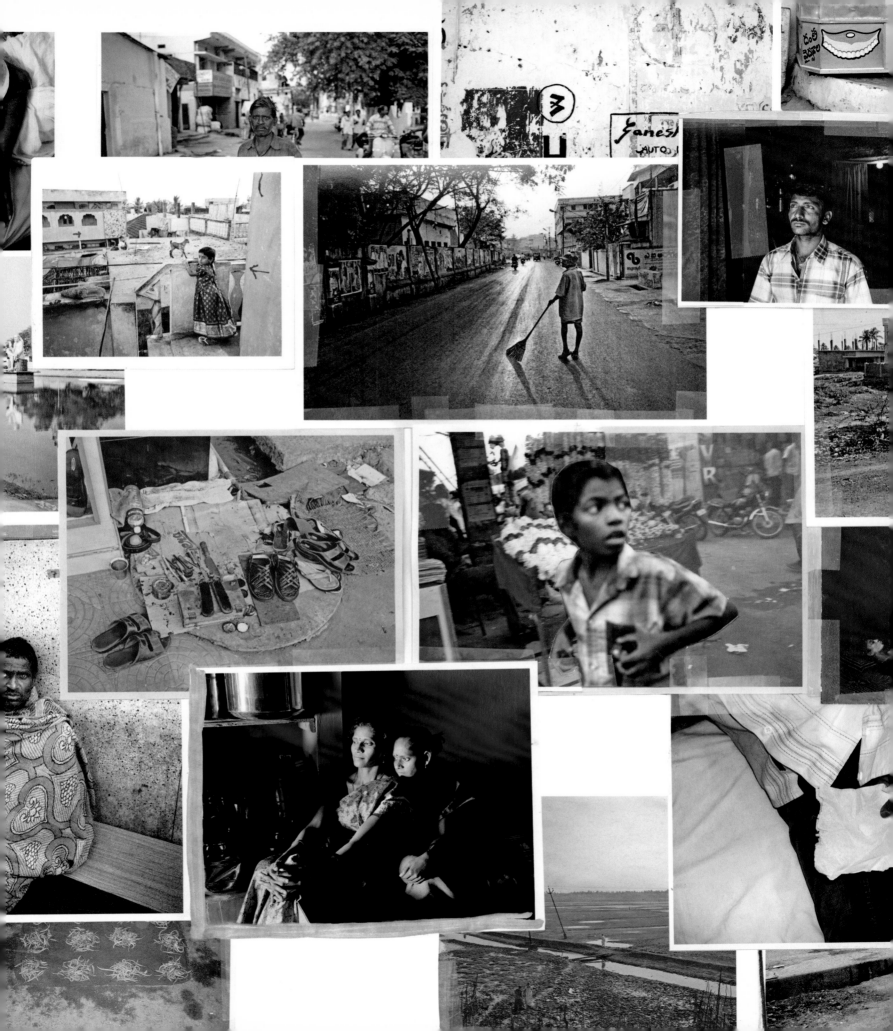

"My name is Satyaveni. My health is not well. I am feeling very weak with some skin diseases. In the beginning I was very angry with my husband for many days because he infected me with HIV. Now I have only one desire, which is that my family should be happy with good health."

—SATYAVENI KAMADI

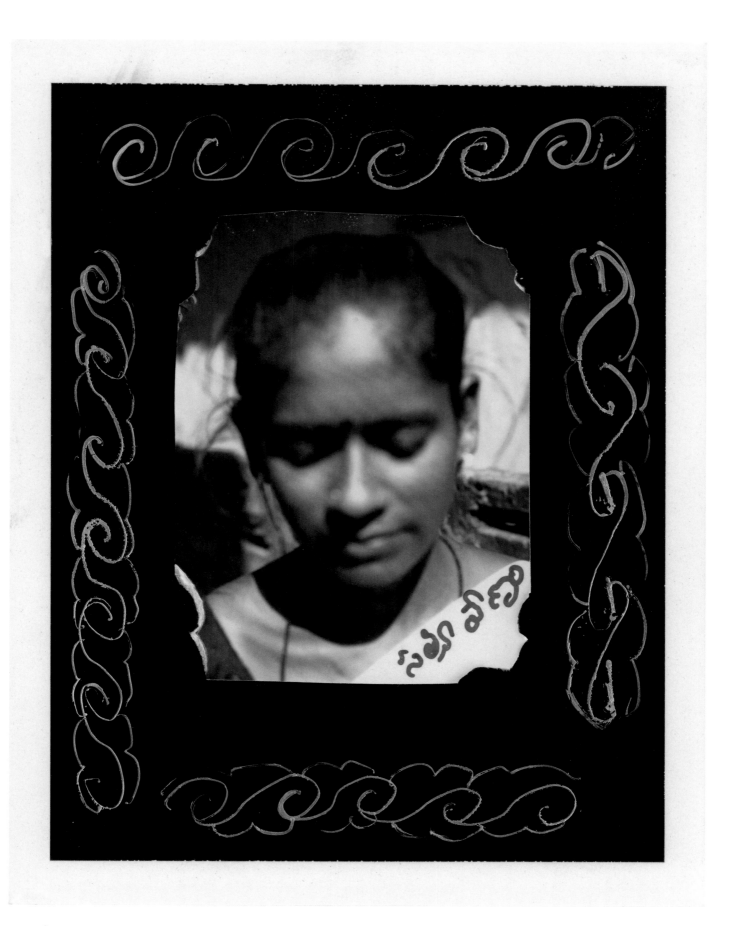

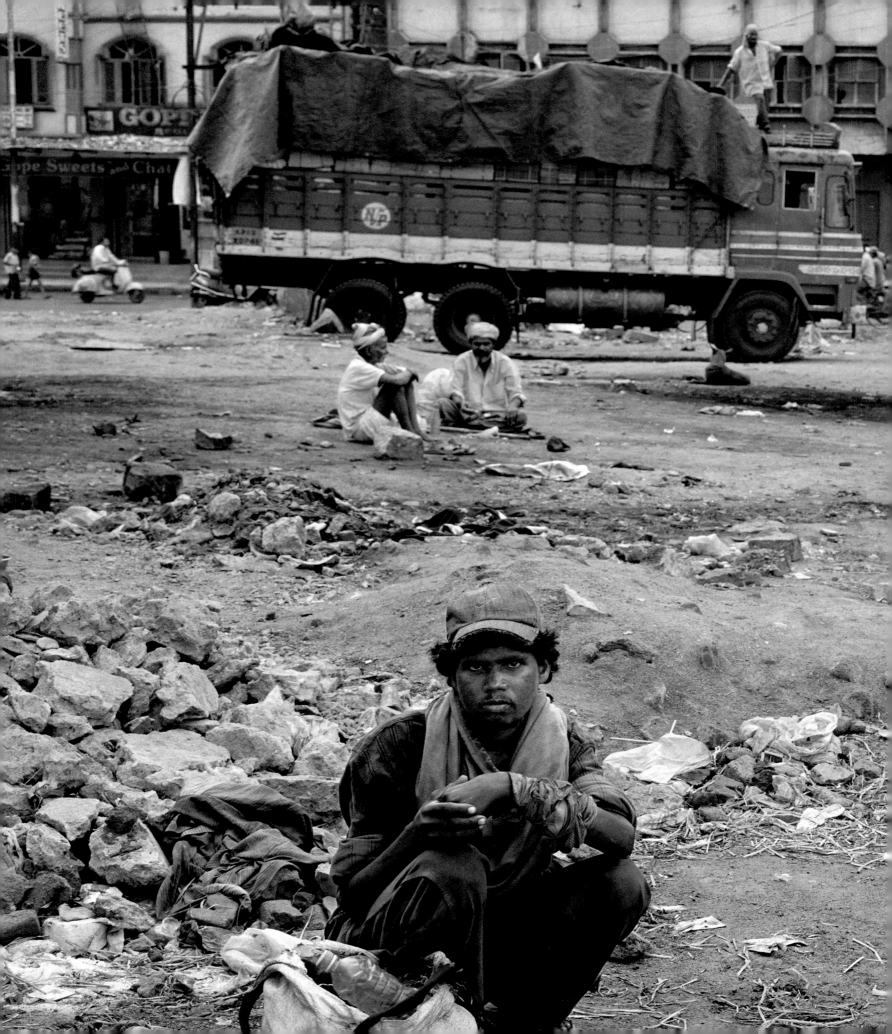

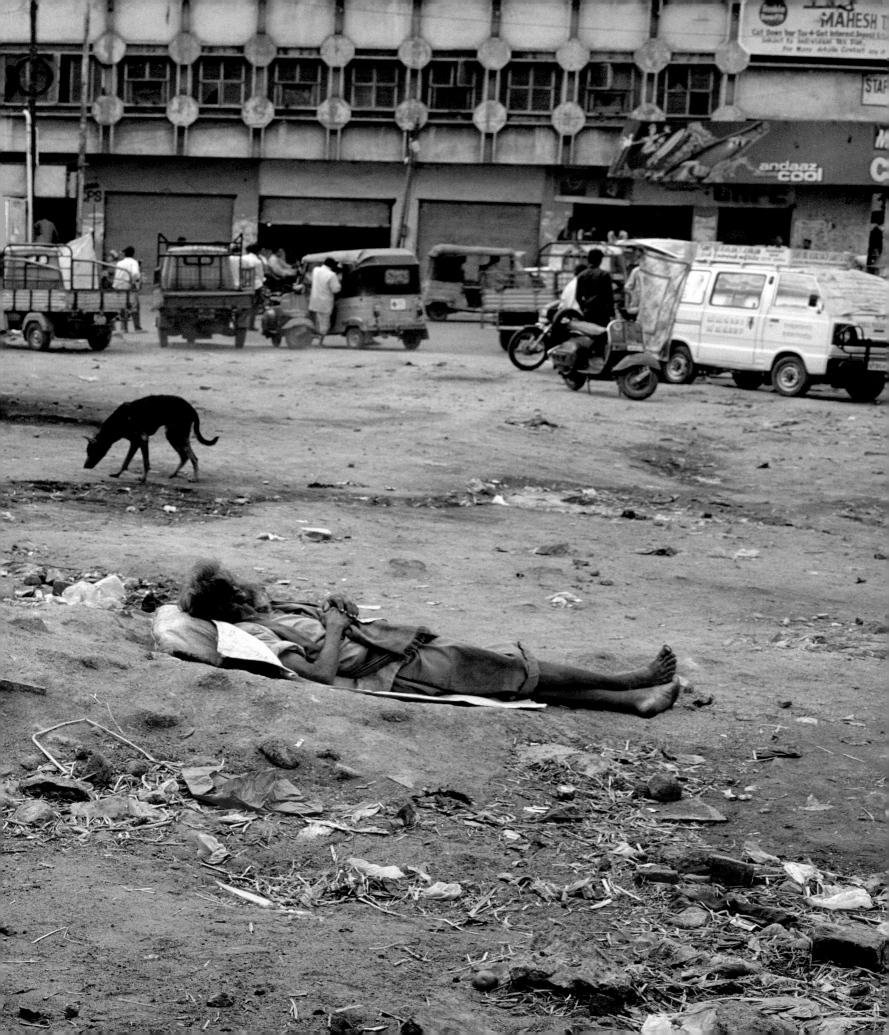

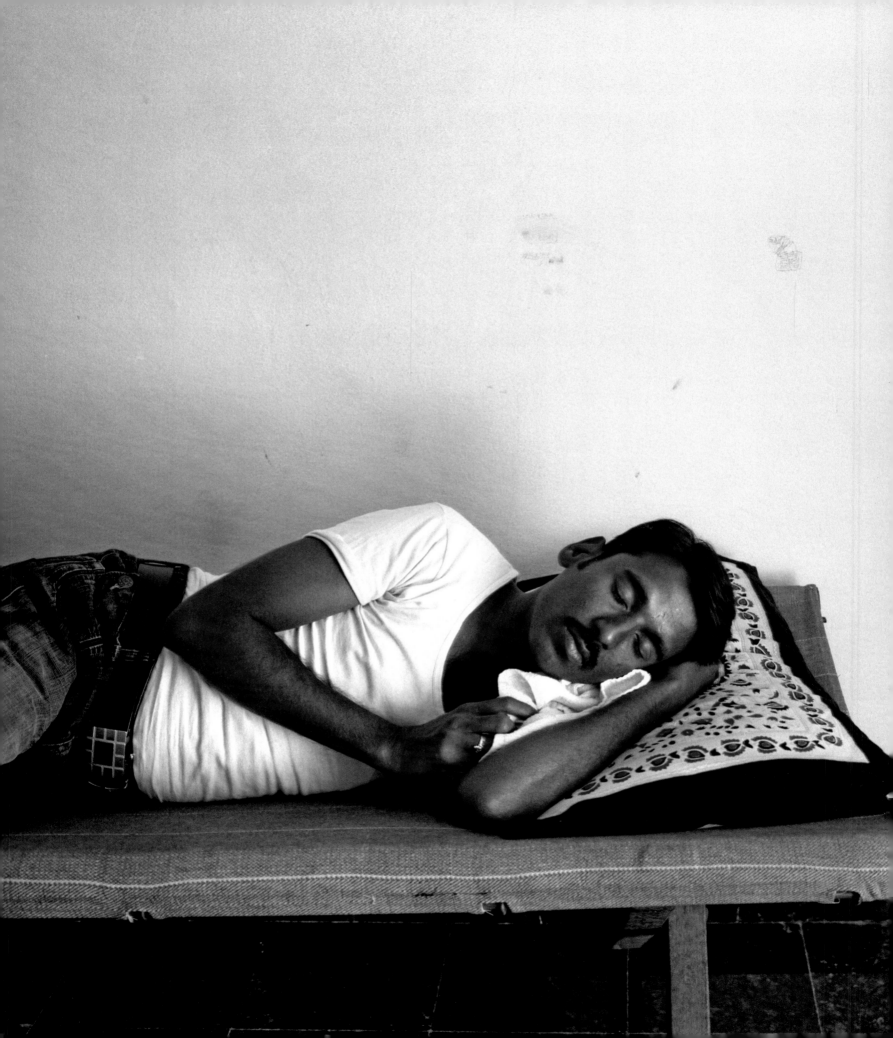

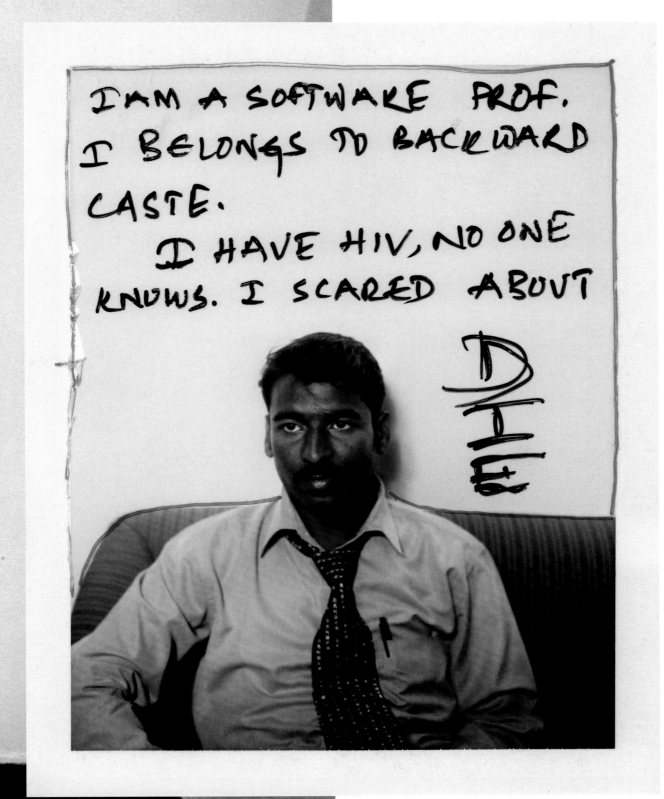

Kumar, 30, abandoned his search for an arranged marriage upon learning that he was HIV-positive.

BEFORE AFTER

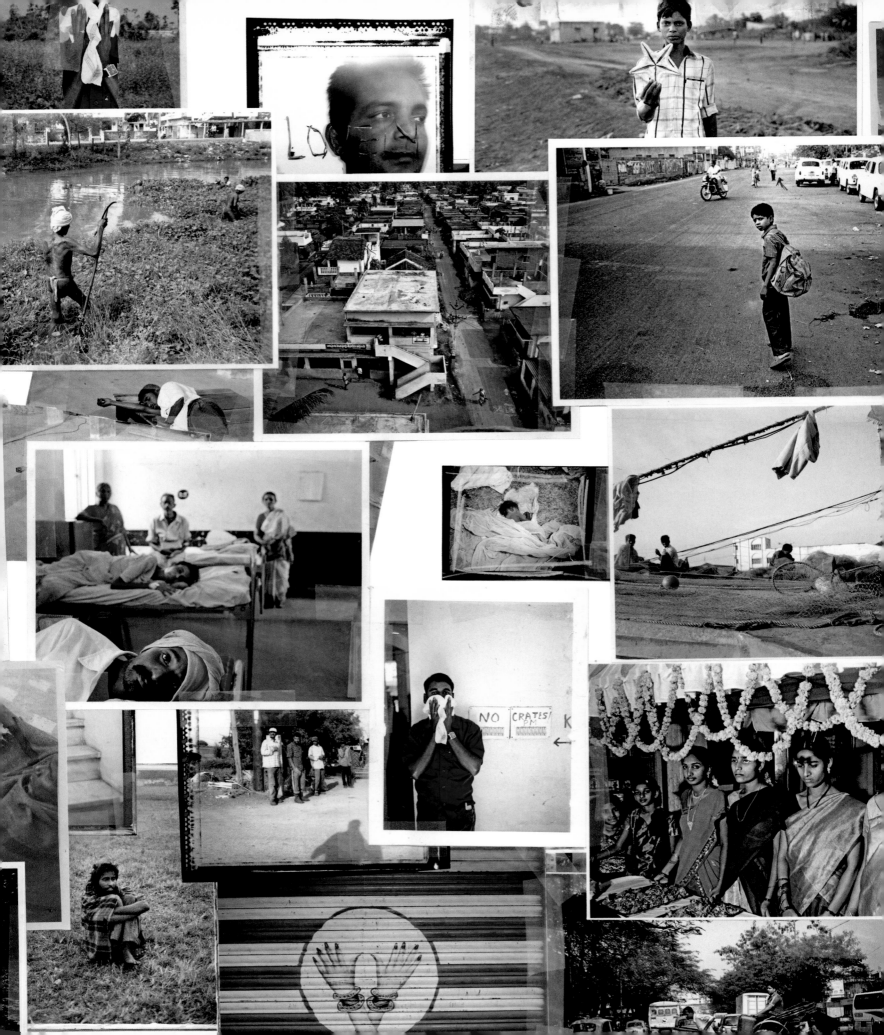

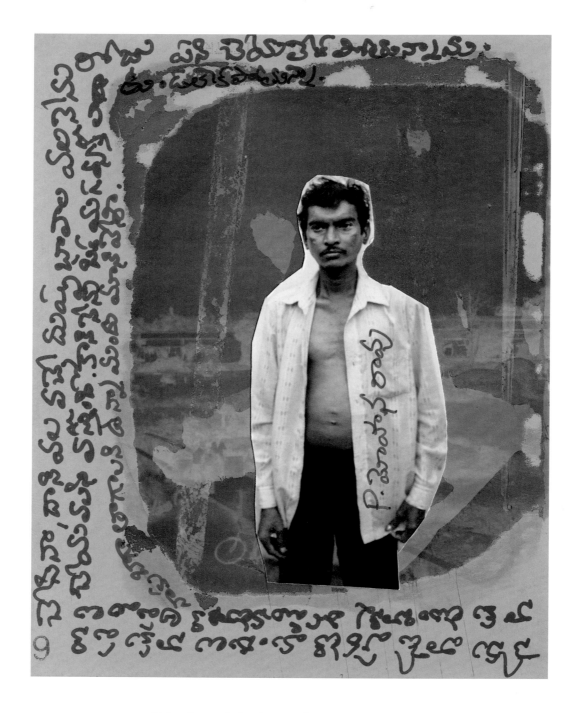

"The drugs help, but I often have side effects
that keep me from working every day. I have to borrow money all the time.
I want to feed my family and be a man, but I can't.
The thing I miss the most is getting drunk."
—MOHAN RAO PAPALA

Mohan Rao's daughter, Karuna, age seven *(opposite)*, is, like her father, HIV-positive.

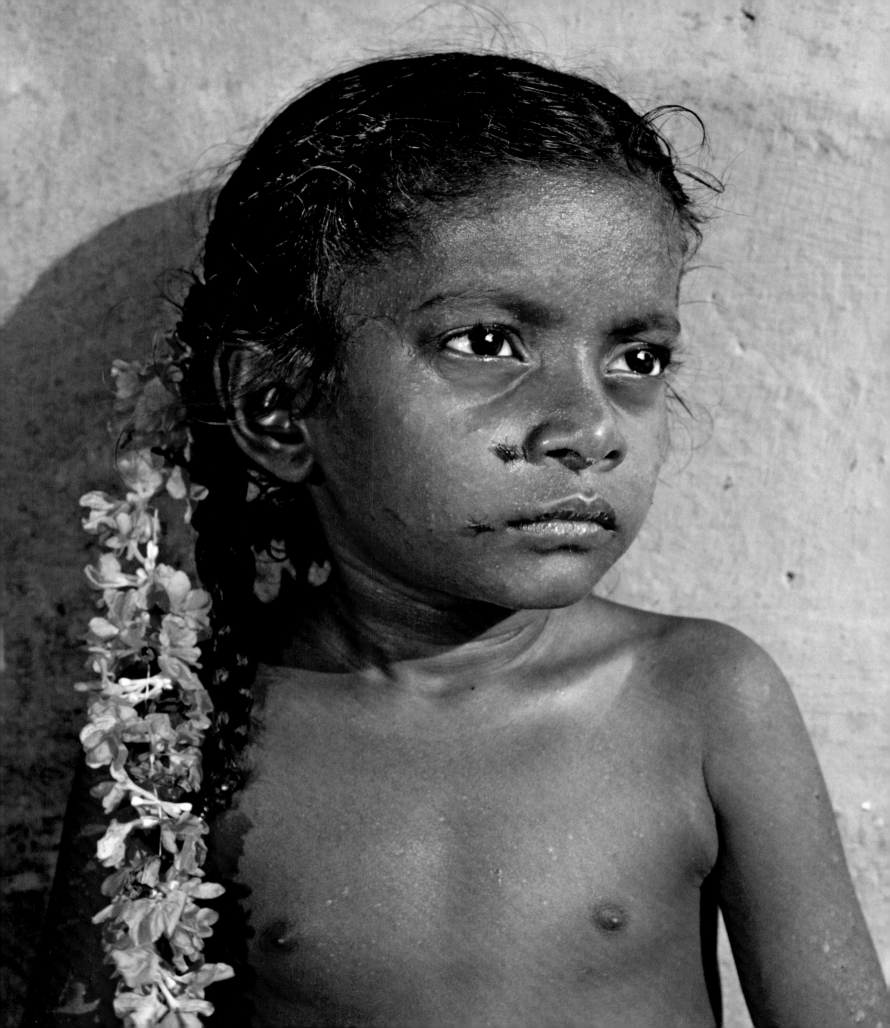

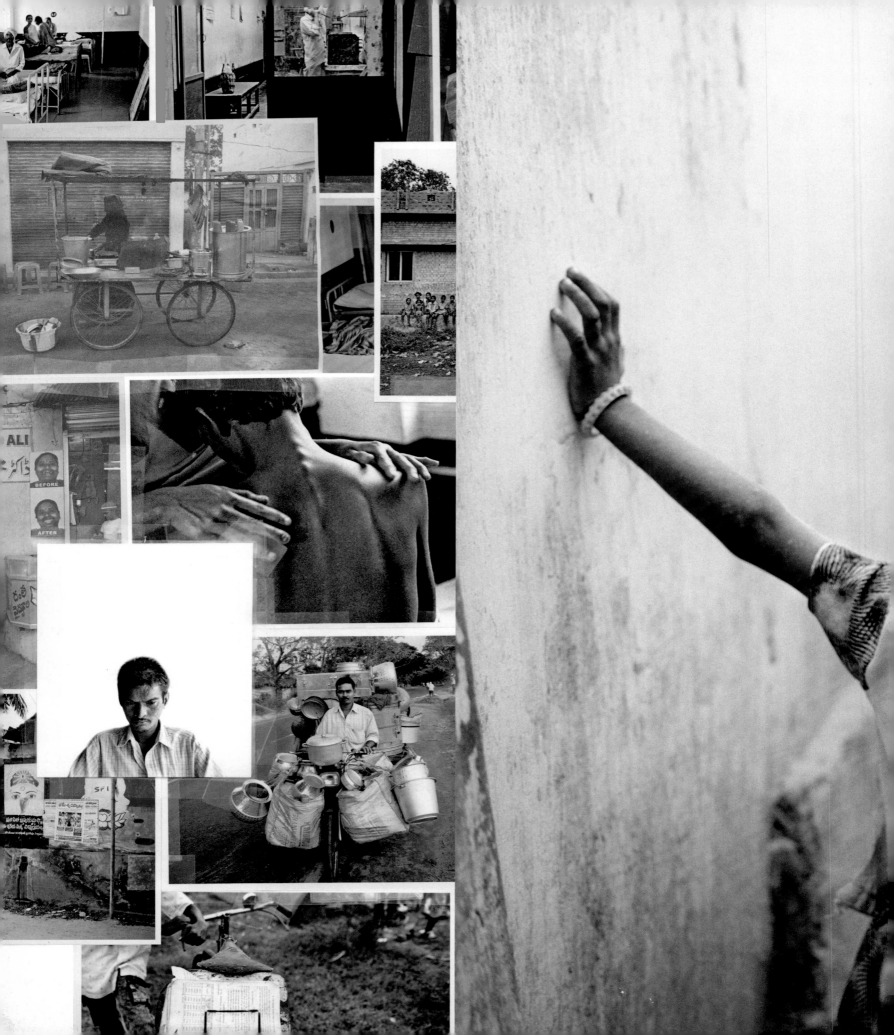

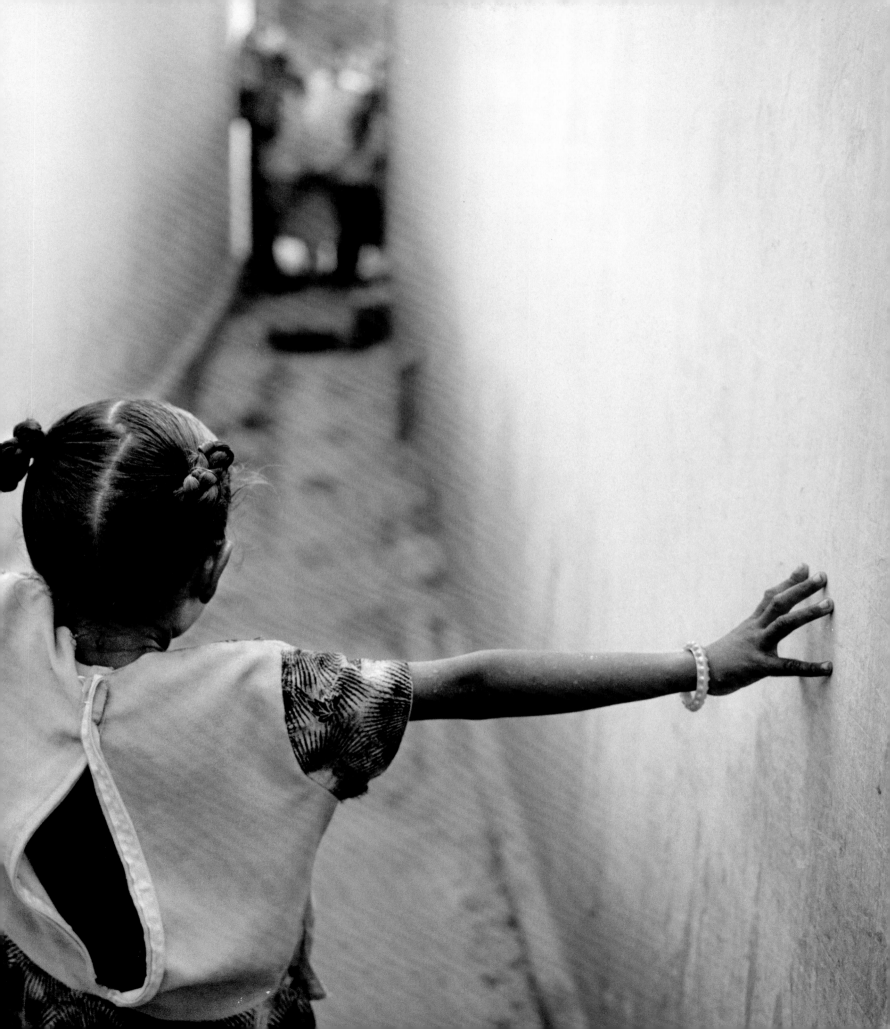

An HIV-positive pimp and sex worker act out a typical roadside encounter in rural India.

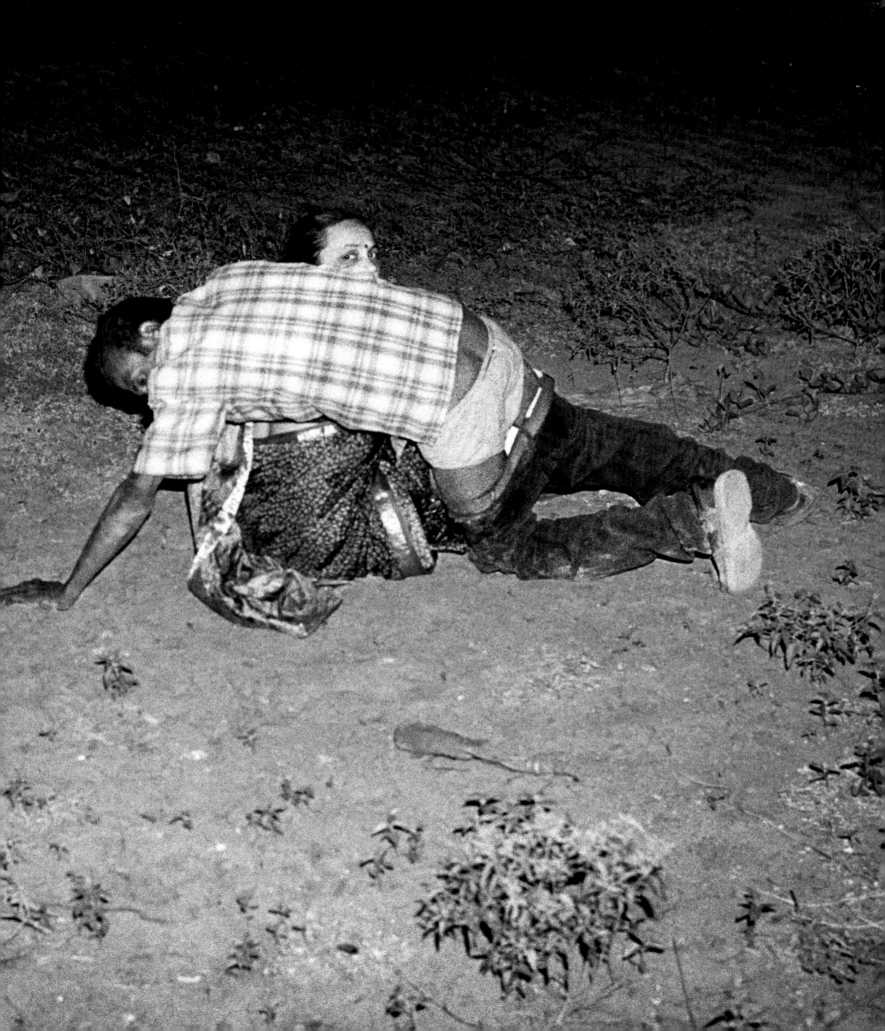

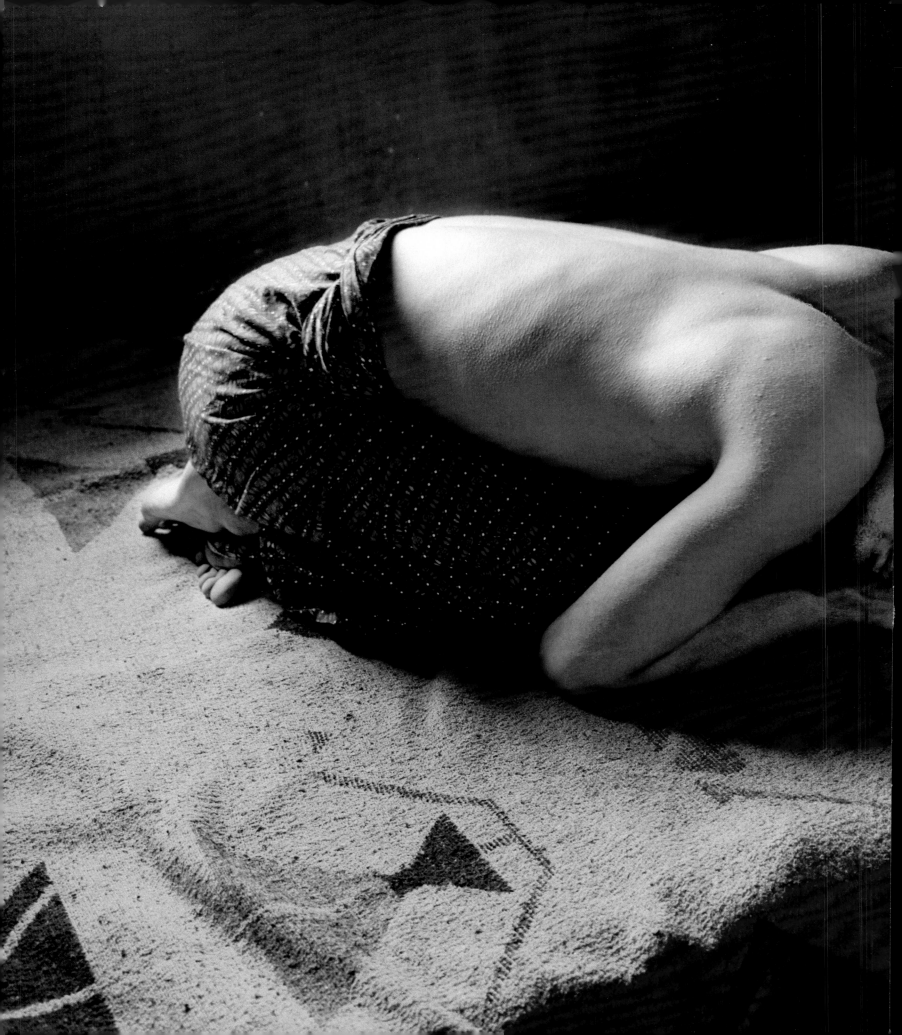

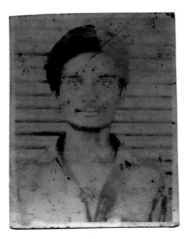

"After coming to know that we contracted AIDS, we [referring to a gay friend] both were scared. We thought we would not live longer. We never knew that we should have safe sex by using a condom. We thought of committing suicide. Later, we got confidence after hearing that we can live by using antiretroviral medicines."

Veera Babu in March 2008 at his mother's home, where he now lives.

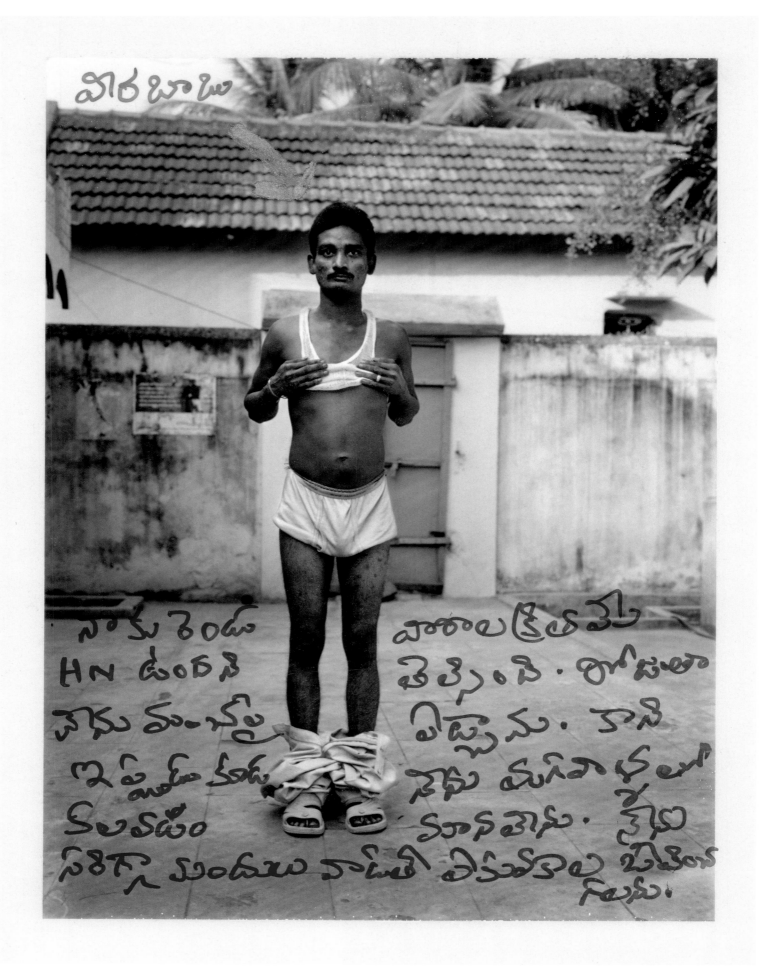

ITS BEEN 2 WEEKS
SINCE I FOUND OUT I
HAVE AIDS.

NOW I STAY IN BED ALL
DAY AND CRY

(BUT I STILL LIKE HAVING
SEX WITH MEN + BOYS

I LIVE WITH THE
HOPE THAT IF I TAKE
MEDICINE MY LIFE
WILL STAY LONG)
VEERA BABU

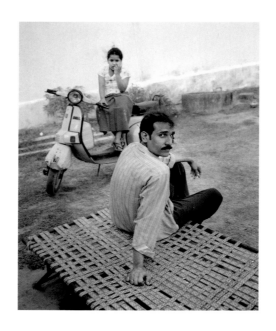

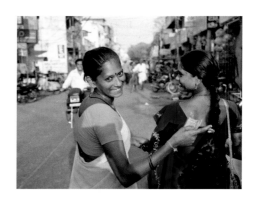

VIJAYA SARADHI MADASU, 36

OCCUPATION: College tutor

Vijaya Saradhi Madasu comes from a well-regarded family in Peddapuram, part of the region of India with the highest prevalence of HIV. Life seemed good for Vijaya and his wife, Jayasree, 32. Both are university graduates, and Vijaya has been a teaching assistant for more than a decade at the same private college where his father taught. They have one daughter, Amrutha, six.

But in 2004, in the sixth month of Jayasree's second pregnancy, they learned they were both HIV-positive, and aborted the child. Jayasree also chose to be sterilized. Vijaya says he contracted HIV from a prostitute five years ago, and while almost suicidal about his diagnosis, he then decided "to live for my daughter." Despite her husband's frequent "going outside" their marriage, Jayasree has chosen to stick with him: "Though I am angry with him, I did not lose my love for him," she says.

In mid-2007 Vijaya began antiretroviral (ARV) treatment. After a few rocky months, he returned to work. His promotion to tutor has been "like a rebirth" for him, and he is now determined to live long enough to see Amrutha, who is HIV-negative, grow up.

SATYAVENI KAMADI, 23

OCCUPATION: Wife, mother

Satyaveni Kamadi and her husband, Ravi Kumar, 28, had seen each other for only five minutes before their families decided it was a match. Fifteen days later, they were married in their southeastern fishing town of Kakinada, about 500 kilometers east of Hyderabad. They soon had a daughter, Hema Latha, now five. All three are HIV-positive.

Satyaveni had tested HIV-negative, but five months into her second pregnancy, suffering from discharge, joint aches and fatigue, she was diagnosed as HIV-positive. She aborted the baby. Ravi also discovered then that he was HIV-positive and had a vasectomy. Satyaveni began antiretroviral (ARV) treatment later than planned because she was also suffering from TB, but her health and outlook improved quickly. Ironically, having HIV has expanded her horizons: She joined a women's HIV support group and hoped to enroll in a tailoring course for HIV-positive women. Both parents are focused on Hema's future. "We have to educate our daughter well," says Ravi. "We have to make her independent. After that, whatever happens to us doesn't matter."

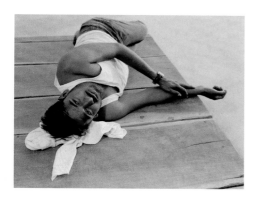

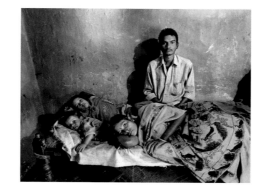

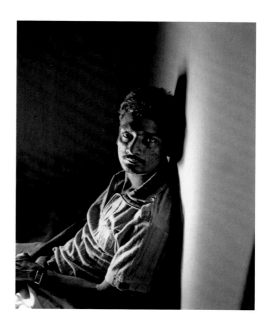

NAGASAMUDRAM KUMAR, 30

OCCUPATION: Software engineer

Nagasamudram Kumar was eight months into the search for a wife, through a matchmaking agency, when he finally sought medical treatment for his frequent fevers. He discovered he had typhoid. Then came the bombshell: He was also HIV-positive. A software engineer who lives with his mother in a suburb of Hyderabad, he became too ill to work. Kumar was so shocked by his diagnosis that he repeatedly retested himself at different facilities, willing a different result: "After 10 days, slowly I started to accept that the results were positive."

Kumar immediately abandoned his search for a wife but was unwilling to start antiretroviral (ARV) treatment. As his condition worsened, he relented. He also joined an association of people living with HIV and soon revived his marriage plan, hoping for a "positive alliance"—marriage with an HIV-positive woman. Even so, social pressures weigh heavily on Kumar, and he has found it difficult to talk with family members about his diagnosis. Beyond marriage, his major goal is to develop a foundation he set up while still in college. It provides assistance for orphans and helps people living with HIV to find housing.

MOHAN RAO PAPALA, 31

OCCUPATION: Painter, day laborer

Unschooled and illiterate, Mohan Rao Papala and his wife, Venkata Lakshmi, and their two children, Karuna, 7, and Rama Krishna, 2, live in the poorer part of Peddapuram. Both parents and Karuna are HIV-positive. They used to depend on Mohan Rao's painting and on Venkata's agricultural day labor to make ends meet, but sickness has drastically reduced Mohan Rao's income. He found out three years ago that he had TB, but had his HIV status confirmed only in mid-2007. Venkata was shattered by her husband's HIV diagnosis, knowing he was infected because of an affair he had when she was pregnant. "I cried a lot within the confines of the four walls," says Venkata of her reaction.

After months on antiretroviral (ARV) treatment, Mohan Rao's recovery was slow but steady. He still feels isolated from his former colleagues, who are reluctant to hire him, and one of his brothers, who has stopped speaking to him because he is HIV-positive. When Venkata works, Karuna has to stay home from school to look after her little brother. Yet her future is both her parents' major concern. Says Venkata, "We want her to lead a quality life."

VEERA BABU MOGILI, 40

OCCUPATION: Recycler, occasional sex worker

Veera Babu Mogili knew as a teenager that he was gay. But social convention led him to get married at 25. Veera Babu had no schooling at all, and he is illiterate. He and his wife, who was wealthier and more educated, had three children, one of whom died. His wife left him about a year before he began treatment, both because he was sick, he says, and because they had begun to quarrel.

Veera Babu, who now lives with his mother, buys old newspapers and iron for recycling. But he sometimes gets paid to have sex with other men, and was most likely infected through unprotected sex. His closest friend, Lova Raju, is also gay, HIV-positive, and on ARV treatment. They consider each other "sisters." They are both still highly sexually active, often with several partners each night, but now use condoms to avoid infecting others. Since beginning ARV, Veera Babu's health, outlook, and energy level have improved. But while he knows that being HIV-positive is very dangerous, he avoids confronting reality. He does worry about his poverty and indebtedness, and about who will look after his aging mother if he dies.

SNAPSHOT: HIV AND AIDS IN INDIA

OVERALL POPULATION: 1.13 billion

NUMBER OF PEOPLE LIVING WITH HIV AND AIDS: 2.4 million

HIV PREVALENCE AMONG ADULTS: 0.36 percent. There is great variation among regions. Overall, however, prevalence in the southern states is five times higher than in the northern states.

NUMBER OF PEOPLE ON ANTIRETROVIRAL (ARV) TREATMENT: 158,000

NUMBER OF PEOPLE WHO NEED ARV TREATMENT: Not yet determined.

GROUPS MOST AFFECTED BY THE HIV EPIDEMIC IN INDIA: India's AIDS epidemic has been fueled mainly by the unprotected sex practiced by sex workers, their clients, and their respective partners. Other high-risk groups include injecting drug users, men who have sex with men, and migrant workers.

INDIAN SOCIAL ATTITUDES TOWARD HIV AND AIDS: Although there is growing awareness and tolerance due to widespread and effective treatment, the majority of the HIV-positive are reluctant to disclose their status publicly.

AVAILABLE TREATMENT FOR PEOPLE LIVING WITH HIV AND AIDS: Antiretroviral treatment is available throughout the country; the government has begun to strengthen efforts to prevent transmission of the disease from mother to child.

HIV TREATMENT CHALLENGES: Extreme poverty and lack of adequate food can make treatment less effective. The tradition of arranged marriage has also led to frequent extramarital sexual activity, especially during wives' pregnancies and after delivery, when by custom the wife will stay with her parents or extended maternal family, away from the husband. This is an important factor in the spread of HIV among the heterosexual population.

ABOUT THE PHOTOGRAPHERS

JONAS BENDIKSEN Norwegian, b. 1977

Jonas Bendiksen began his career at the age of 19 as an intern in Magnum's London office, before leaving for Russia to pursue his own work as a photojournalist. Throughout the several years he spent there, Bendiksen photographed stories from the fringes of the former Soviet Union, a project that was published as the book *Satellites* (2006).

His work often focuses on isolated communities and enclaves. His book and multimedia installation on the growth of urban slums across the world, *The Places We Live*, was published in 2008.

Bendiksen has received numerous awards, including the Infinity Award from the International Center of Photography, a World Press Photo Award, first prize in the Pictures of the Year International Awards, and the 2008 National Geographic Grant for Photography. His documentary of life in a Nairobi slum, Kibera, published in *The Paris Review*, won a National Magazine Award in 2007.

He lives in Oslo with his wife, Laara, and son, Milo.

JIM GOLDBERG American, b. 1953

Jim Goldberg is a professor of art at the California College of Arts and Crafts and a member of Magnum Photos. He has been exhibiting for more than 30 years, and his innovative use of images and text makes him a landmark photographer of our times. He began to explore experimental storytelling and the potential of combining images and text with *Rich and Poor* (1977–85), where he juxtaposed the residents of welfare hotel rooms with the upper class and their elegantly furnished home interiors to investigate the nature of American myths about class, power, and happiness. In *Raised by Wolves* (1985–95), Goldberg worked closely with and documented runaway teenagers in San Francisco and Los Angeles to create a book and exhibition that combined original photographs, text, home-movie stills, snapshots, drawings, and diary entries as well as single- and multi-channel video, sculpture, found objects, light boxes, and other 3-D elements. He is currently working on a yet-to-be-titled book on migration in Europe, to be published in 2009 by Steidl. His other books are *Hospice, It Ended Sad But I Loved Where It All Began*, and *War Is Only ½ The Story*.

Goldberg's work is in numerous private and public collections, including The Museum of Modern Art in New York City, the San Francisco Museum of Modern Art, the Whitney Museum of American Art, the Getty Museum, the Los Angeles County Museum of Art, the Corcoran Gallery of Art in Washington, D.C., the Museum of Fine Arts in Boston, the Library of Congress, the National Museum of American Art, and the Art Institute of Chicago, among others. He is the winner of many awards, including a Guggenheim Fellowship, three National Endowment for the Arts grants, and France's 2007 Henri Cartier-Bresson Award.

His fashion, editorial, and advertising work has appeared in numerous publications, including *W*, *Details*, *Flaunt*, *The New York Times Magazine*, *Esquire*, *The New Yorker*, *Rebel*, *GQ*, and *Dazed and Confused*. He lives and works in San Francisco.

ALEX MAJOLI Italian, b. 1971

At the age of 15, Alex Majoli joined the F45 Studio in Ravenna, working alongside Daniele Casadio. While studying at the Art Institute in Ravenna, he joined the Grazia Neri Agency and traveled to Yugoslavia to document the conflict there. He returned many times over the next few years, covering all major events in Kosovo and Albania.

Majoli graduated from art school in 1991. Three years later, he made an intimate portrayal of the closing of an insane asylum on the island of Leros, Greece, a project that became the subject of his first book, *Leros*.

In 1995 Majoli went to South America for several months, photographing a variety of subjects for his ongoing personal project, *Requiem in Samba*. He started the project *Hotel Marinum*, on life in harbor cities around the world, in 1998. That same year he began making a series of short films and documentaries.

After becoming a full member of Magnum Photos in 2001, Majoli covered the fall of the Taliban regime in Afghanistan, and two years later the invasion of Iraq. He continues to document various conflicts worldwide for *Newsweek*, *The New York Times Magazine*, *Granta*, and *National Geographic*.

Majoli lives and works in New York and Milan.

STEVE MCCURRY American, b. 1950

Steve McCurry, universally recognized as one of today's finest image-makers, has won many of photography's top awards. Best known for his evocative color photography, McCurry, in the finest documentary tradition, captures the essence of human struggle and joy. A member of Magnum Photos since 1986, McCurry was born in Philadelphia and graduated *cum laude* from the College of Arts and Architecture at The Pennsylvania State University.

McCurry's coverage of the Russian invasion of Afghanistan won the Robert Capa Gold Medal for Best Photographic Reporting from Abroad, an award dedicated to photographers exhibiting exceptional courage and enterprise. He is the recipient of numerous other awards, including Magazine Photographer of the Year, awarded by the National Press Photographers Association. He has also won an unprecedented four first prizes in the World Press Photo Contest and the Olivier Rebbot Memorial Award twice.

A high point in his career was the rediscovery, after almost two decades, of Sharbat Gula, the previously unidentified Afghan refugee girl whose portrait many have described as the most recognizable photograph in the world today.

McCurry's work has been featured in every major magazine in the world and frequently appears in *National Geographic* magazine, with recent articles on Tibet, Afghanistan, Iraq, Yemen, and the temples of Angkor Wat, Cambodia. "Most of my images are grounded in people," McCurry says. "I look for the unguarded moment, the essential soul peeking out, experience etched on a person's face. I try to convey what it is like to be that person, a person caught in a broader landscape that you could call the human condition."

He has published many books, including *The Imperial Way* (1985), *Monsoon* (1988), *Portraits* (1999), *South Southeast* (2000), *Sanctuary* (2002), *The Path to Buddha: A Tibetan Pilgrimage* (2003), *Steve McCurry* (2005), *Looking East* (2006), and *In the Shadow of Mountains* (2007).

PAOLO PELLEGRIN Italian, b. 1964

Paolo Pellegrin was born in Rome. He has been a *Newsweek* contract photographer since 2000 and became a Magnum member in 2005.

In 1995, Pellegrin's reportage on AIDS in Uganda won first prize in the "Daily Life" category of the World Press Photo awards. In 1996,

his work on AIDS in Uganda won the Kodak Young Photographer Award-Visa d'Or, and he was selected to be a part of the World Press Photo Master Class. He also won Italy's EuroFuji Award.

Pellegrin's book, *Children*, containing images of children in Uganda, Romania, and Bosnia, was published in 1997. His work on children in Bosnia won first prize at the International Photofestival in Gijón that same year. Another book, *Cambodia*, published in 1998, resulted from his collaboration with Doctors Without Borders. In 1999 he was awarded third prize in the "Portraits" category in the World Press Photo competition. In 2000, he won first prize in the "People in the News" category for his work on Kosovo, and received an Honorable Mention for the Hansel-Mieth Award for a story on Albania. He was also the recipient of the prestigious Hasselblad Grant. He was awarded the EuroFuji Award/Italy for 2001 and the Leica Medal of Excellence, also in 2001.

In 2002, Pellegrin won the Hansel-Meith Award for a story on a Bosnian village; he also won first prize in the World Press Photo awards in the "People in the News" category for his work in Algeria, as well as an Honorable Mention for the Robert Capa Gold Medal Award. That same year, his book *Kosovo: The Flight of Reason* was published. In 2003, he was awarded the Borsa di Studio Marco Pesaresi in Italy. He also received the Overseas Press Club Olivier Rebbot award in 2004 and second prize in the World Press Photo awards for stories about Yasser Arafat's funeral. In 2005 he won first prize in the World Press Photo "Portraits/Stories" category for his work covering the funeral of Pope Jean Paul II, as well as third prize in the "Arts and Entertainment" category for images of New York City's Fashion Week.

He is also one of the creators of *Off Broadway*, a touring exhibition and installation. Pellegrin lives in New York City and Rome.

GILLES PERESS French b. 1946

In 1972, after studying political science and philosophy, Gilles Peress began using photography to create books and museum installations around socio-political issues. His books include *Haines: A Village Destroyed*, *The Graves: Srebrenica and Vukovar*, *The Silence: Rwanda*, *Farewell to Bosnia*, and *Telex Iran*.

His work has been exhibited and is collected by The Museum of Modern Art, the Metropolitan Museum of Art, the Whitney Museum of American Art, and PS1, all in New York; the Art Institute of Chicago; the Corcoran Gallery of Art in Washington, D.C; the San Francisco Museum of Modern Art; the Getty Museum; the Walker Art Center and the Minneapolis Institute of Arts; the V&A in London; the Musée d'Art Moderne, the Picasso Museum, and le Centre National d'Art et de Culture Georges Pompidou in Paris, among others.

Peress has received many awards and fellowships, including a Guggenheim Fellowship, National Endowment for the Arts grants, a Pollock-Krasner Foundation fellowship, the W. Eugene Smith Grant in Humanistic Photography, and the International Center of Photography Infinity Award.

Peress is Professor of Photography and Human Rights at Bard College and Senior Research Fellow at the Human Rights Center, UC Berkeley. He joined Magnum Photos in 1971 and served multiple times as vice-president and president of the co-operative.

ELI REED American, b. 1946

Eli Reed began his photography career as a freelancer in 1970. His work from El Salvador, Guatemala, and other Central American countries attracted the attention of Magnum in 1982. He was nominated to the agency the following summer, and became a full member in 1988.

Reed photographed the effects of poverty on America's children for a film documentary called *Poorest in the Land of Plenty*, narrated by Maya Angelou. His video documentary *Getting Out* was shown at the New York Film Festival in 1993 and was honored by the 1996 Black Film-makers Hall of Fame International Film and Video Competition in the documentary category. In addition, he has worked on many films, including *A Beautiful Mind*, *8 Mile*, *The Missing*, and *The Jackal*.

Reed's work includes a long-term study of Beirut (1983–87), which became his first, highly acclaimed book *Beirut: City of Regrets*. His photographs have appeared in *Life*, *Time*, *GQ*, *U.S. News & World Report*, and many other magazines. Exhibitions of his work have been held at the Leica Gallery in New York and the Perfect Exposure Gallery in Los Angeles, among others. His book, *Black in America*, which documents the African-American experience from the 1970s through the end of the 1990s, is among his most celebrated works.

Reed studied pictorial illustration at the Newark School of Fine and Industrial Arts, from which he graduated in 1969. In 1982 he was a Nieman Fellow at Harvard University. He has lectured and taught at the International Center of Photography, Columbia University, New York University, and Harvard University. Reed currently serves as Clinical Professor of Photojournalism at the University of Texas in Austin.

LARRY TOWELL Canadian, b. 1953

Larry Towell's business card reads, "Human Being." Experience as a poet and folk musician has done much to shape his personal style.

In 1984 he became a freelance photographer and writer, focusing on peasant rebellion and the landless. He is the author of 13 books, including: *No Man's Land*, which won the Prix Nadar, *The Mennonites*, which won a British Design and Art Direction award, and *El Salvador*, winner of the Golden Light Award. Other awards include the inaugural Henri Cartier-Bresson Award, the Hasselblad, Oskar Barnak, and Alfred Eisenstaedt awards, as well as a W. Eugene Smith grant in Humanistic Photography. He also is the recipient of the New York International Independent Film and Video Festival Achievement in Filmmaking award.

Towell's work has been exhibited and collected by The George Eastman House, The Fondation Henri Cartier-Bresson, Vancouver Art Gallery, the Art Gallery Ontario, the Canadian Museum of Contemporary Photography, the Archive of Modern Conflict (UK), FOAM (Amsterdam), The Kunsthalle Erfurt (Germany), The National Portrait Gallery (Edinburgh), and The Stephen Bulger, Leica, and Zelda Cheatle Galleries in Toronto, New York, and London.

Towell is known for his innovative live performances incorporating original music poetry, video, and stills.

He joined Magnum in 1988, and has served as vice-president for the past three years.

His most recent book, *The World from My Front Porch*, is based on his own family in rural Ontario, where he currently sharecrops a 75-acre farm.

BOOK DESIGN AND PRODUCTION

Yolanda Cuomo Design, NYC

PRODUCER

Kristi Norgaard

EDITORS

Annalyn Swan and Peter Bernstein, ASAP Media

WRITER AND ASSOCIATE EDITOR

Adèle Sulcas

COPY EDITOR

Allan Fallow

TRANSLATORS

French translation: Jean-Luc Pierre Ben Ayoun
Italian translation: Maria Galetta

PROJECT DIRECTORS

Jon Lidén
Rosie Vanek

ACCESS TO LIFE PROJECT CREDITS
Concept Development: Adèle Sulcas, Jon Lidén, Rosie Vanek

THE GLOBAL FUND
Executive Producer: Jon Lidén
Producer & Project Manager: Rosie Vanek
Project Administrator: Beatrice Bernescut
Project Launch Administrator: Cheryl Toksoz

MAGNUM PHOTOS
Managing Director: Mark Lubell
Project Manager: Shoka Javadiangilani
Creative Director: Claudine Boeglin
Exhibition Coordinator: Danielle Jackson

MAGNUM PHOTOGRAPHERS
HAITI Jonas Bendiksen
INDIA Jim Goldberg
MALI Paolo Pellegrin
PERU Eli Reed
RUSSIA Alex Majoli
RWANDA Gilles Peress
SOUTH AFRICA Larry Towell
SWAZILAND Larry Towell
VIETNAM Steve McCurry

WRITERS/PRODUCERS
HAITI J. Coll Metcalfe
INDIA Virginia Marsh
MALI Alain Devalpo
PERU James Boothroyd
RUSSIA Brett Brune
RWANDA Kat Patterson
SOUTH AFRICA Barbara Valentino & Adèle Sulcas
SWAZILAND Adèle Sulcas
VIETNAM Karen Emmons

MAGNUM IN MOTION
Claudine Boeglin (Creative Director), Adrian Kelterborn (Lead
Multimedia Producer), Tia Dunn, Olivia Wyatt, Joe Zorilla (Multimedia
Producers), Jin Young (Print Designer), Sam Ottenhoff (IT Architect),
group94 (Flash Designer), Martin Fuchs (html Designer),
Bjarke Myrthu (Post Producer), Meagan Young (Web Manager),
Jeff Zemetis (Podcast Editor), Jessica Talley (Production Manager)

LAUNCH EXHIBITION, 2008
Bill Horrigan (Curator), Danielle Jackson (Exhibitions and Cultural
Projects, Magnum), Megan Parker (Director of Digital Imaging),
Tom Wall (Production Coordinator, Magnum)

COUNTRY HEALTH INSTITUTIONS & ORGANIZATION
HAITI: Fondation SOGEBANK, Zanmi Lasante, Partners in Health Haiti

INDIA: Staff and leadership of INP+, TNP+, Freedom Foundation,
Guntur facility

MALI: CLSL (Cellule de Coordination du Comité Sectoriel de Lutte
contre le SIDA du Ministère de la Santé), ARCAD-SIDA (Association
de Recherche de communication et d'accompagnement à Domicile
des Personnes Vivant avec le VIH/SIDA), CESAC de Bamako (Centre
d'écoute, de soins, d'animation et de conseil), Hôpital Gabriel Touré

de Bamako, USAC de la CENAM, Commune IV de Bamako, USAC,
Commune V de Bamako, USAC de Koulikoro, Centre Jigiya,
Association JIGI de Sikasso, CERKES, Association KENEDOUGOU
Solidarité de Sikasso

PERU: CARE

RUSSIA: Open Health Institute

RWANDA: Ministry of Health of the Government of Rwanda, TRAC
Clinic, Kigali, Rwinkwavu Hospital, PIH (Partners in Health), Remera
Health Clinic, Rwamagana Hospital, Nyagatara Hospital

SWAZILAND: NERCHA (National Emergency Response Council on
HIV/AIDS), Baylor International Pediatric AIDS Initiative, Mbabane VCT
Centre, Mbabane Government Hospital, Swazi National Network of
People Living with HIV and AIDS

SOUTH AFRICA: Health Department of the Provincial Government
of the Western Cape, Nolungile Clinic, Khayelitsha, Michael
Mapongwana Clinic, Khayelitsha, Hannan Crusaid Clinic, Gugulethu,
Planned Parenthood Association of South Africa, Western Cape,
TAC (Treatment Action Campaign)

VIETNAM: Administration of HIV/AIDS and Control (VAAC),
Ministry of Health of Vietnam

IN-COUNTRY LANGUAGE & PROJECT SUPPORT
HAITI Leneus Joseph, Dr. Evan Lyon

INDIA Mrs. B.S. Kala, Miss B. Anuradha,
Mrs. Aruna Seeramsetty, Mr. Subba Rao

MALI Matthieu Fernandez Da Silva

PERU Guadalupe Alegria, Alicia Lueridan Oviedo, Sonia Parodi

RUSSIA Andrey Dakar

RWANDA Lucien Mubumbyi, Felly Kimenyi,
Jean-Claude Mugenzi, Gabriel Gabiro

SOUTH AFRICA Elizabeth Seabe, Isaac Mangwana

SWAZILAND Sylvia Khuzwayo, Nomsa Lukhele, Lulu Vilakati

VIETNAM Doan Bao Chau, Le Thi Mai Huong, Jennifer Olsen

ADDITIONAL PROJECT SUPPORT (GLOBAL FUND)
Annie Ballard, Robert Bourgoing, John Busch, Nicolas Demey,
Emma Kennedy, Lynne Mbabazi, Lashonda Steward

SPECIAL THANKS
Annalisa D'Angelo, Sarah Bacon, Khaki Bedford, Daria Birang, Ed Burns,
Sue Brisk, Philip Brookman, Corcoran Gallery of Art, Washington,
Nina Doran, Paul Farmer, Valeria Federici, Fenton Communications,
Joseph Finneran, Friends of the Global Fight (U.S.), Moshe Gabby,
Allie Gallo, Nicolo Giudice, Kristin Guiter, Lai Ling Jew, Serena Kefayeh,
Forest Kelley, Phil Kline, Dani Lachowicz, Susan Levine,
Jasmin Lim, Liz Lovern, Jon McGrath, Susan Meiselas, Matt Murphy,
Laura Nelson, Peter Norrman, Tobha Nzima, Elizabeth Parr,
Kate Phillips, Podium Arts, CMJ Printing, Karen Probasco,
Sheila Roche, Alessandro Sala, Luca Santese, Susie Stockwell,
Jennifer Sweeney, Christy Turlington, Justin Van Prooyen,
Leslie Wilson, Isaac Wingfield, Sameer Zavery

First Aperture edition
Printed by Cantz, Germany
10 9 8 7 6 5 4 3 2 1

Library of Congress Control Number:
ISBN 978-1-59711-105-8

The staff for the Aperture edition of Access to Life includes:
Juan García de Oteyza, *Executive Director*;
Lesley A. Martin, *Publisher, Books*;
Matthew Pimm, *Production Director*

Aperture Foundation books are available in North America through:
D.A.P./Distributed Art Publishers
155 Sixth Avenue, 2nd Floor
New York, N.Y. 10013
Phone: (212) 627-1999
Fax: (212) 627-9484

Aperture Foundation
books are distributed outside North America by:
Thames & Hudson
181A High Holborn
London WC1V 7QX
United Kingdom
Phone: + 44 20 7845 5000
Fax: + 44 20 7845 5055
Email: sales@thameshudson.co.uk

aperturefoundation
547 West 27th Street
New York, N.Y. 10001
www.aperture.org

The purpose of Aperture Foundation,
a non-profit organization,
is to advance photography in all its forms
and to foster the exchange of ideas
among audiences worldwide.